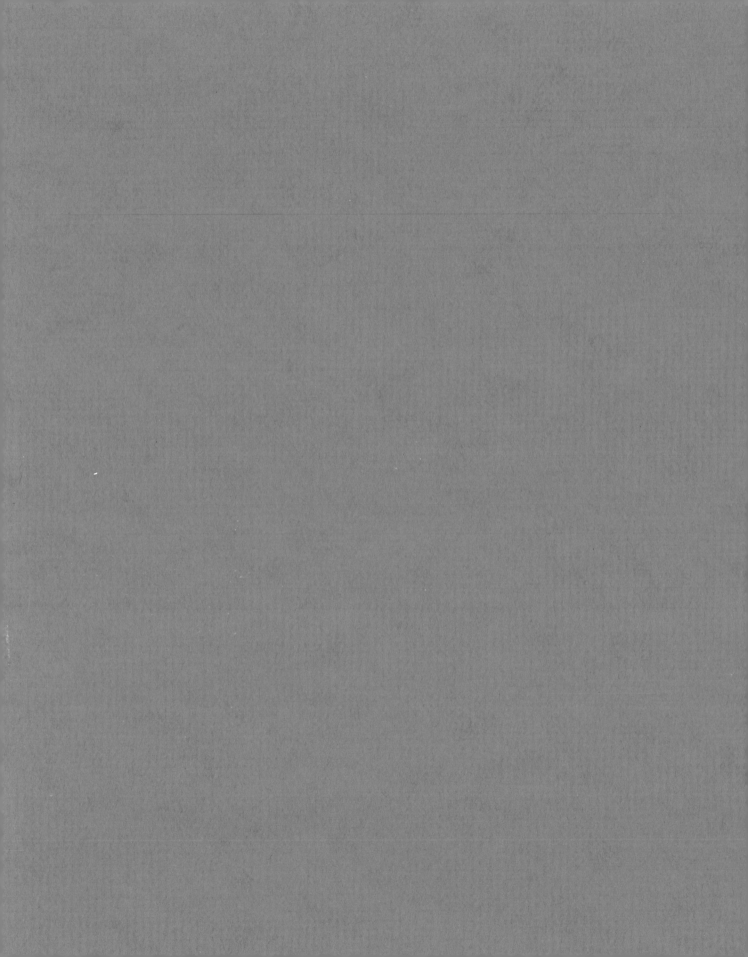

CLAYWORK Form and Idea in Ceramic Design

# CLAYWORK

## Form and Idea in Ceramic Design

### SECOND EDITION

**Leon I. Nigrosh**

Davis Publications, Inc.,
Worcester, Massachusetts

Photography by **Bill Byers** and **Stephen DiRado**
Drawings by **Donald Krueger**

**To Maya,** my finest work of art

**Front Cover:** Shellie Z. Brooks
*Floating Basket: Haleakala I*
Press-molded cast earthenware slabs,
   unglazed underglaze
10 × 14 × 14″ (25 × 36 × 36 cm)
Photo: Tom Lang

**Back Cover:** Author
Thrown porcelain, luster glaze
Platters: 10″ (25 cm) and 16″ (41 cm)
   diameter
Globe: 7 × 7 × 6″ (18 × 18 × 15 cm)
Cylinder: 9 × 4 × 2¹/₂″ (23 × 10 × 6 cm)

Printed in the United States of America
Library of Congress Catalog Card Number: 85-73422
ISBN: 0-87192-173-1 Cloth
       0-87192-176-6 Paper

Design: **Jane Pitts**

10 9 8 7 6 5

# Preface

A good friend once asked me how it felt to be useless. He was amazed that I was working clay by hand in the second half of the twentieth century. Machines today have taken over, providing the populace with all the ceramic dishes, lamps, ashtrays, and doorknobs it will ever need, and more. The studio potter using ancient time-consuming methods is no match for modern industry. In reaction, some clayworkers have rejected the entire ten thousand year heritage of clay to make either nonfunctional decorative objects or disfunctional objects, such as teapots that do not work, as propaganda diatribes against their supposed lost stature in the community.

However, within our society there is, or can be, an important place for a person who makes things of clay. A sensitive clayworker can create objects of simplicity, beauty, and life to fill a growing need for the human touch in our steadily depersonalizing existence.

Working in clay is also self-satisfying. From the inception of an idea through the actual shaping of the material, choosing the color and controlling the fire, one is in total personal command of the project. The success is all due to you—but so too is failure. A harmony is developed between yourself and nature, for no matter how adept you become with the skills of working in clay, natural forces always loom to either assist or resist those labors. You must have feeling for the material and understand it thoroughly in order to draw anything of value from it. To make a clay bowl is one thing; to make that bowl a work of art is quite another.

This book is for beginners as well as for those with experience who want to make art of clay. Conceived as a basic studio course, it is also an up-to-date reference presenting many examples of contemporary American clayworks. It explores ceramics from its beginning to the present. Photographs taken especially for this book show time-honored forming methods along with modern timesaving ways to accomplish similar results. Of particular importance, the book provides picture sequences photographed as if the reader were actually performing the operation. Not only are the traditional decorating techniques described, but included for the first time are discussions of recent experimentation with decal methods and photo imagery on clay.

Principles of ceramic design, often overlooked in other books, are offered here to help the reader increase the aesthetic value of his or her clay objects. And a chapter on the basics of marketing explains how to get started selling ware and how to receive a fair market price for it.

The technical side of ceramics often frightens newcomers to clay and some old hands as well. Clayworkers have especially been uneasy visitors to the chemistry laboratory. It is reassuring to know that a number of chemical components do not pertain to the glaze process. To bring the necessary information to the studio, all the chemical formulas in this book have been separated into the essential oxide relationships instead of the usual more complex chemists' formulas. A detailed discussion of the properties of each raw material used in glaze formulation has been included in the appendix along with element formula weight charts.

Additional information regarding possible health hazards in the work area is also included.

To help translate concept into reality and creative idea into created form, every effort has been made to present a concise explanation of the many aspects of claywork.

# Acknowledgments

Many people deserve thanks for helping me to write the book, including all of those clayworkers who submitted photos for consideration, and especially those who are represented in these pages. Specifically, I wish to thank James Winegar for allowing me to publish his kiln building plans and both Gerry Williams and Victor Spinski for their help in presenting the information on photo resist. Ceramic engineer O. Mason Burrows performed an inestimable service in helping to clarify the mysteries of glaze formulation. A word of thanks is due Howard Kottler for his provocative, if not cynical, questions as to the need for another ceramic book, which kept things in focus, I hope. The critical comments by Angelo Garzio from the artist-teacher's standpoint and those of my friend and student Linda Freedman were valuable guideposts in the refining of the manuscript. The staff of Davis Publications deserves a note of appreciation for their assistance in developing and designing this volume.

I would also like to thank Robert Fishman for his pictures on extruding, Laura Schlein for her information about crystalline glaze, and Zeljko Kujundzic for pictures and information about solar kilns. Thanks to my studio assistant, Kim Salathé Weller, who helped pull all the bits and pieces together.

L.I.N.

# Contents

## Health and Safety in the Studio

In the past few years many studio potters and educators have become increasingly concerned about health and safety hazards in the arts, particularly in the field of ceramics.

Through the centuries, potters have occasionally fallen victim to a variety of hazards including the inhalation of fumes from salt firings; prolonged skin contact with copper, iron, and other compounds; and (along with their patrons) the excess ingestion of lead.

Hazards to clayworkers do exist. The best approach toward reducing or eliminating these problems is a sensible and logical one, rather than an attitude of alarm and panic.

Throughout this book information relating to possible health and safety hazards is noted in **bold face**. Included also is important information regarding proper ventilation for kilns, spray glazing, and clay preparation.

Suggestions about safety masks, gloves, equipment, and clothing are offered in the appropriate sections of the book.

Primary in the search for safety in the studio or classroom is proper attitude, awareness of potential difficulties, and a willingness to change old habits or create new ones.

DO NOT SMOKE IN A WORK AREA

DO NOT EAT IN A WORK AREA

# Introduction

Clay appeared on earth long before living beings. It was therefore inevitable that humans would eventually begin to examine and to apply their imagination to the abundant amorphous material. From these early tactile ventures, a rich panoply of objects, both crude and refined, has continued to be created, evidencing the strides that humankind has made over tens of thousands of years. In many instances, the only remaining evidence of bygone civilizations is fired clay objects unearthed in archaeological digs. These broken pieces of clay provide the barest hints of the growth and decline of many peoples. Moreover, a curious similarity has been noted in the shape and decoration of some objects from cultures separated by thousands of miles and many centuries. If enough clayworks can be found, maybe the true story of humanity will someday be known.

Because soft clay can be easily modeled into any shape and then fired to permanency, it continues to be used as both a form of expression and a practical convenience. During the Neolithic Age, ten or twelve thousand years ago, the growth of agrarian civilization produced an ever increasing demand for storage containers and cooking utensils, which were often carved stone vessels and woven hemp baskets. Unfortunately, the former were laborious to make and the latter had a short life span. To make baskets more durable and waterproof, people lined them with mud; but eventually, these baskets rotted and new ones had to be made. At some point a useless basket was probably cast on an open fire, and later, in the smoldering ashes, small hard pieces of clay were found. This became the way pots were first made—by pressing clay into baskets which were then burned away. Crosshatched indentations on the surface of ancient shards now displayed in many museums

serve as evidence to support this theory. Even after other forming methods came into use, the crosshatch design persisted as an important decorative motif in many cultures.

Fertility fetishes provide other examples of early clayworks. Crudely formed and hardened by simply being thrown into a fire, these objects have survived the centuries to serve as mute reminders of the human capacity for creativity and the desire for self-perpetuation.

Pottery forms also had an important part in burial ceremonies. Often, as in pre-Columbian South America, death masks or portrait urns were made either to mollify the gods or store the souls of the departed.

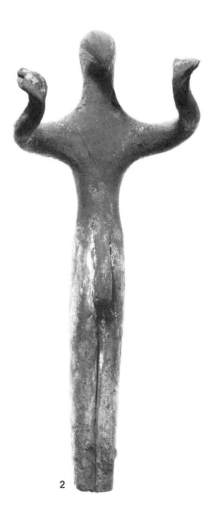

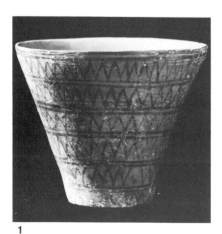

1  Prehistoric Vase
Earthenware, slip decoration
Ragy, Iran
Polished earthenware, black paint
6 × 7″ (15 × 18 cm)
Courtesy: Museum of Fine Arts, Boston
    University Museum Fund

2  Fertility Figure
Earthenware
Predynastic Egypt
7″ (18 cm) high
Courtesy: Museum of Fine Arts, Boston
    Sears Fund

9

**3** Portrait Urn
Painted earthenware
Pre-Columbian Mexico
16⁷/₈ × 8 × 9″ (43 × 20 × 23 cm)
Courtesy: Worcester Art Museum

**4** Nigerian Potter, Adi Musa
Photo: Jean M. Borgatti

3

4

The evolution of ceramic techniques moved from simple hand forming methods through coil building and slab forming and culminated in the discovery and use of the potter's wheel. Many cultures never attained the sophistication of the wheel and others, even today, still rely chiefly on coil building for all their work.

Ceramics eventually fell under the spell of mass production and industrialization. At first, care was still taken to insure the integrity of each ceramic object. However, as the needs of the Western world grew and greater numbers meant greater profit, the quality of ceramic design and execution began to deteriorate. Clayworkers attempted to adapt their products to changing life-styles in each society. Inevitably a level of demand was reached where only machinery could meet the needs of the public, and the individual potter was unable to compete economically with the machine. However, the world over, some studio potters continued to work, providing personalized utilitarian objects, but their influence on society as a whole remained at a low ebb for years. It was really not until after the Second World War, that interest in the creating and collecting of claywork was actively renewed in this country. The advent of inexpensive electric kilns for home studios also helped to popularize ceramics.

The growth of interest in ceramics here and subsequently abroad has been due primarily to a return of humanistic concerns. Weary of the glass and steel monoliths that overspread our landscapes, we are returning to the earth in a variety of ways. Home gardening, home sewing—the do-it-yourself ethos—are all individual expressions in reaction to the products of a mass society. What more obvious a medium with which to express oneself than that abundant, amorphous material that so fascinated ancient people. We have come full circle, returning to civilization's earliest experiment in creativity—clay.

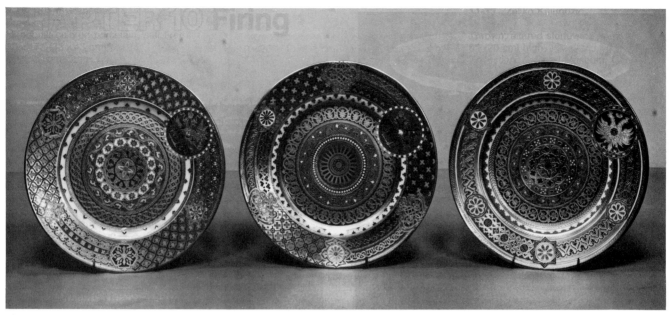

5

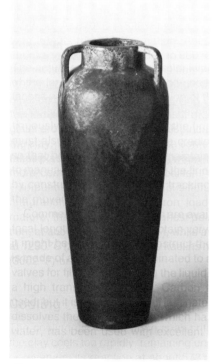

6

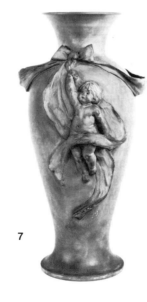

7

**5**  Russian Service Plates
19th century
Porcelain, gold-encrusted
9$^1$/$_2$" (24 cm) diameter
Courtesy: Wadsworth Atheneum, Hartford
Photo: E. Irving Blomstrann

**6**  Merrimac Ceramic Company
Vase
20th century
Stoneware
15$^1$/$_4$" (39 cm)
Courtesy: Worcester Art Museum

**7**  Franz Dengler, ca. 1800
Vase
Earthenware
15" (38 cm)
Courtesy: Worcester Art Museum

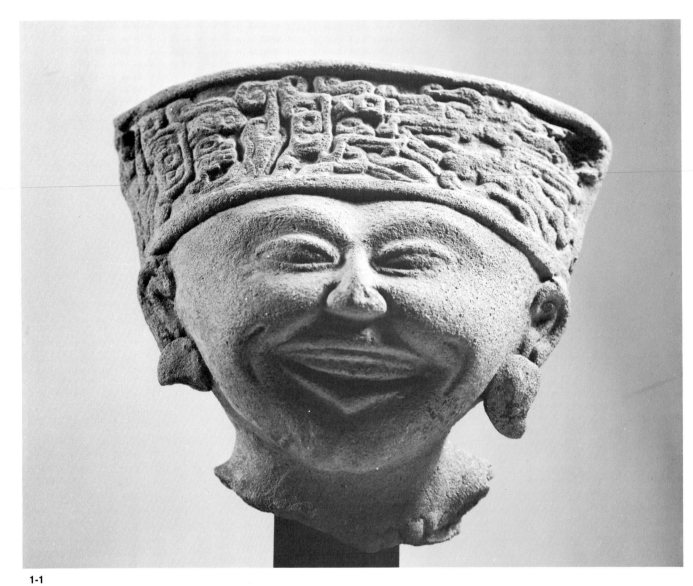

1-1

**1-1** Laughing Head
Mexican, 300-900 A.D.
Terra Cotta
7 x 7 x 4″ (18 x 18 x 10 cm)
Courtesy: Worcester Art Museum
  Gift of Mr. and Mrs. Harold Kaye

# CHAPTER 1 Clay

## How Clay is Formed

The earth was once a mass of molten material. As the planet cooled, the heavier materials began to settle into relatively distinct layers. The surface layer formed by this cooling is made up of what is known as igneous rock. This cooled molten rock consists of almost 60 percent silica and about 15 percent alumina, both important elements in the ceramic process. Eons ago, water, wind, ice, and the expansions and contractions of the planet began to pulverize the rock, depositing silica and alumina particles along with other minerals and organic matter all over the globe. The resulting conglomerate is clay. Every day, new clay is being formed by the decomposition of rock while at the same time new rock is being formed by natural heat and pressure fusion of clay. The chemical formula for clay in its unfired state is:

$$Al_2O_3 \cdot 2SiO_2 \cdot 2H_2O$$

This formula of one molecule of alumina to two molecules of silica and two of water is an ideal one which does not take into consideration the many metal oxides and organic matter found in clay. Localized variations and amounts of these additional materials account for the different types of clay deposits found on the surface of the earth.

Primary, or residual clays, are those which remain in the site where they were formed. Secondary, or sedimentary, clays have been transported by water, wind or glacier from their original site. Primary clays are characterized by their coarse grain, high refractory or heat resistant quality, low plasticity, and their whiter fired color. All of these characteristics are due to the fact that the clays have not been moved and have few, if any, impurities. As secondary clays are transported farther away from their parent site, they become naturally more finely ground and contaminated with organic matter and minerals. Because of this, the clays are less refractory, more plastic, and fire from tan to brown or black. **1-2**

## Types of Clay

Clays may be broadly classified in descending order of purity in relation to the ideal chemical formula, and they are described in that order here.

*Kaolins or China Clays* are white firing, highly refractory, relatively nonplastic primary clays. Scattered deposits of kaolin exist in Europe, North America, England and Asia, but not to the extent of other types of clay. Kaolins are highly regarded for their purity, or lack of contamination, and are essential in the production of chinaware, porcelain, and many industrial ceramics. Kaolins have a melting point of 1800°C (3272°F) and poor plasticity because of their coarse grain structure. To improve workability and lower the maturing temperature, other clays and materials are often used in combination with kaolins. Because kaolins are pure clays, they provide a good source for alumina and silica in glazes.

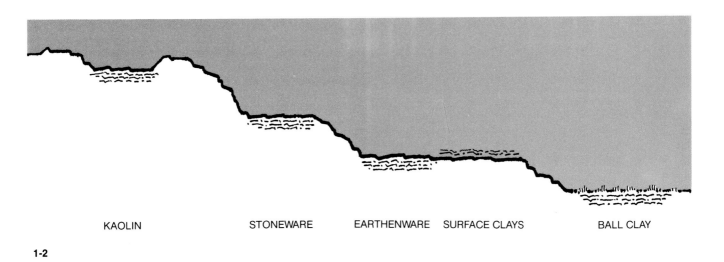

KAOLIN      STONEWARE      EARTHENWARE   SURFACE CLAYS      BALL CLAY

1-2

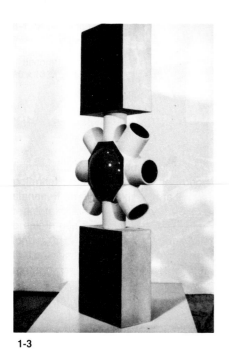

1-3

**1-3**  Pat Lay
Slab-built and thrown stoneware
sculpture
48″ (122 cm) high

**1-4**  Vase
Tarascan (State of Colima)
Terra Cotta
8 × 16 × 14″ (20 × 41 × 36 cm)
Courtesy: Worcester Art Museum

**Stoneware Clays** are secondary clays which fire from buff to brown or grey, are refractory and, generally, fairly plastic. The fired color and maturing temperature of stonewares depend upon the amount and kind of impurities such as iron, feldspar or calcium which might be present in the deposit. Stoneware clays are often used by studio potters because they are easy to handle, and have a long firing range, between 1177° and 1306°C (2151°- 2383°F), and good vitrification, or hardness, when fired. Although some stonewares can be used alone for throwing or forming, mixtures of stoneware and other clays and materials are often used for improved workability, texture and color. **1-3**

**Fireclays** may vary greatly in color and plasticity, but they all have a high resistance to heat. Because of this quality, fireclays are used to make firebricks for kilns and furnaces, kiln furniture and other refractory parts for boilers and smelters, as well as insulating brick. Fireclays are often mixed with stoneware clays to increase refractoriness, improve texture, and give interesting variations in color.

**Earthenware Clays** are highly contaminated with iron oxide and, therefore, generally fire red to black. Because of large amounts of impurities, earthenware clays do not become vitreous when fired and often begin to melt at temperatures above 1050°C (1922°F). The plasticity of earthenware can vary from sticky to grainy nonplastic, depending on the location of the deposit. Some clays are unusable because they contain mineral fragments which might explode or soluble salts which cause scumming and discoloration. Many clay outcroppings can be made usable with minor alterations such as washing away salts or adding other clays. **1-4**

Terra cotta is a type of coarse grained nonvitreous earthenware which is most often used for sculpture.

**Ball Clays** are sedimentary clays found near coal deposits or in swamp areas. Because they are contaminated chiefly by organic matter, ball clays are quite plastic. The fine grain size of the clay imparts a high shrinkage rate of some 20 percent and makes it difficult to use by itself. However, a combination of coarse-grained, less plastic kaolin and ball clay often makes a workable, high-firing white clay body. When used in conjunction with other clays, ball clays impart increased plasticity, improved dry strength, and better vitrification.

**Surface Clays** such as *adobe* are nonplastic, sandy, and suitable mainly for making sun-dried brick. *Shale* can be pulverized, water-soaked for a long period of time and then

1-4

**1-5**

used for the manufacture of brick, roof, and drain tile and other rough clay products. *Soil clays*, sometimes called Gumbos, are usually too contaminated and sticky to be very useful. **1-5**

**Slip Clays** naturally contain enough fluxing agents, such as feldspar and certain alkalies, to perform as glazes when fired above 1201°C (2194°F). Although there are some white firing slip clays, most fire tan to black, as do Albany Slip Clay and Blackbird Clay.

**Bentonite** is a fine particled volcanic ash clay which can be used in small amounts as a plasticizer in clay bodies. Bentonite will also act as a flotative in glazes when used in amounts of 3 percent or less. In either case, it is best to dry mix all the ingredients before adding water because bentonite tends to gum up if added to a watery solution, forming little clumps in the clay or glaze. Do not use in slipcasting bodies. It is so fine-grained it fills pores in plaster molds and prevents water absorption.

## Clay Bodies

It is possible to work with many clays just as they come from the ground. Often, however, they do not possess certain desired characteristics such as color, plasticity, strength, or fired density. By mixing two or more clays and adding other materials, these effects can be produced in what is called a clay body. In order to do this intelligently, it is first necessary to know the physical properties of the materials to be used.

## Tests for Clay

When choosing a clay with which to work, three important qualities should first be determined: plasticity, shrinkage, and porosity.

*Plasticity* is that quality of clay necessary for good workability. If a clay is too plastic or sticky, it will not handle easily. If it is less plastic, or short, the clay will not take much stress when it is used.

To determine the amount of water needed to make a clay plastic, weigh one hundred grams of powdered dry clay. Fill a 100 cubic centimeter (cc.) graduated cylinder with water. Slowly mix the water into the dry powder until the clay has developed a plastic quality. First record the amount of water used to make the clay plastic and then the additional amount necessary to develop stickiness. This will give the range of water content in which the clay is workable. The cubic centimeters of water equal the percentage of water of plasticity (1cc. of water weighs 1 gram).

A simple test for plasticity is to roll a pencil-thick coil of clay and wrap it around a finger. If the coil cracks, the clay is short and will not work well.

Aging the clay will improve its plasticity. Clay which has been moistened, well mixed, and stored for at least three weeks (the Chinese aged clay for whole generations!) will have improved plasticity. This is due to a chemical breakdown caused by organic matter contained in the clay. A small amount of vinegar added to the water in the clay will help induce decomposition. Plasticizers such as bentonite or commercial chemicals can be helpful, but should be used sparingly.

Kneading the clay thoroughly before use aligns clay particles and will improve plasticity.

To decrease plasticity, less plastic or non-plastic fillers, such as grog (prefired clay), sand, or organic materials like sawdust, can be added.

**1-6** Shrinkage Bars
Fired, Unfired

1-6

*Shrinkage* occurs in stages. The initial shrinking of the clay takes place when it dries as water evaporates. Additional shrinkage happens in the bisque, or first, firing when the chemically combined water is driven out. Further shrinkage occurs in the upper heat ranges when chemical compounds in the clay begin to fuse.

To test for shrinkage, make a number of clay bars, 13 centimeters long, 4 cm. wide and 1 cm. thick. A line 10 cm. long is drawn on the face of each bar. Allow the bars to dry, and as they do, either sandwich them between newspaper and light boards above and below or turn them over frequently to avoid warping. When dry, measure the line and determine the dry shrinkage by the following calculation:

$$\frac{\text{Wet Length-Dry Length}}{\text{Wet Length}} \times 100 = \text{Percent Dry Shrinkage}$$

This formula states, for example, that if the dry length of the bar is 8.5 cm., that number is subtracted from the wet length of 10 cm. leaving 1.5 cm. This is divided by the wet length 10 cm., giving the number .15 which is multiplied by 100 to show a dry shrinkage of 15 percent.

$$\frac{10-8.5}{10} = \frac{1.5}{10} \times 100 = 15\%$$

For those whose minds go numb at the sight of a mathematical formula, there is an easier way to measure shrinkage. Using a centimeter ruler, simply count back from 10 cm. to the actual dry measurement. The number of millimeters the bar has shrunk equals the percent dry shrinkage.

Next, the bars are fired to temperature and the lines measured again. The fired shrinkage is then calculated:

$$\frac{\text{Dry Length} - \text{Fired Length}}{\text{Dry Length}} \times 100 = \text{Percent Fired Shrinkage}$$

The total shrinkage is the sum of the Percent Dry and Fired Shrinkages.

Natural shrinkages can vary from 10 to 25 percent, with a rate of between 12 to 15 percent considered good. Clay bodies can be formulated to have zero shrinkage or even be made to expand slightly when fired. This is most often done only for exacting industrial and scientific items.

*Porosity* is the measure of maturity of a fired clay. The more vitrified the clay, the less water it will absorb. To test for porosity, first weigh unglazed fired samples of the clay. Then soak the samples in water overnight or boil them in water for two hours. Blot the samples immediately after withdrawing them from the water and weigh them again. The absorption is calculated as follows:

$$\frac{\text{Saturated Weight} - \text{Dry Weight}}{\text{Dry Weight}} \times 100 = \frac{\text{Percentage}}{\text{Absorption}}$$

The formula states that if a dry sample weight of 100 grams is subtracted from a saturated weight, for example, of 106 grams, it leaves 6 grams. This is divided by the dry weight of 100 grams, giving the number .06, which is then multiplied by 100 to show absorption to be 6 percent.

$$\frac{106 - 100}{100} = \frac{6}{100} = .06 \times 100 = 6\%$$

Generally, earthenware has an absorption rate of 4 to 10 percent; stoneware, 1 to 6 percent; porcelain, 0 to 3 percent.

Firing a clay to a higher temperature or adjusting the amount of fluxes used in a clay body will reduce porosity and make the clay more vitreous and serviceable when fired.

Any clay or clay body, whether it is dug from the ground, purchased from a commercial supplier, or formulated in the studio should undergo all the preceding tests before being used.

## Formulating a Clay Body

The materials needed to formulate a clay body fall into three broad categories: plastics, nonplastics or fillers, and fluxes. Clays are not only the basics needed for color and texture but they are the *plastics* of the clay body. Particle size of the clays used will have a bearing on overall handling qualities. For instance, coarse grained clays will work well for modeling large objects, whereas fine grained clays will not. Because of

its fine grain size, a ball clay can help increase clay body plasticity, but for the same reason it greatly increases shrinkage. The different particle sizes and refractory rates of two fireclays will often help control workability, vitrification and color of a clay body better than a single fireclay.

*Fillers* such as calcined clay, grog (ground-up prefired clay), talc, flint, or organic materials can be added to a clay body to control drying and warping as well as dry and fired strength. The compounds remain in the clay, forming chemical bonds which improve fired qualities in a clay body. The organic materials aid in the handling and drying of clay work, but burn out during firing, which makes the finished ware lighter in weight.

*Fluxes* such as natural feldspars or commercial frits control the fusion point and relative density of a clay body at a given temperature. Many clays naturally contain some fluxes. Often it is necessary to add feldspar from 10 to 20 percent by weight to give the clay body high strength with minimum fired absorption and to increase its coefficient of thermal expansion for better resistance to temperature shock.

The actual ingredients which go to make up a clay body depend upon a number of things. Is it to be a body for throwing, casting, or handbuilding? Which clays are available, either from the ground or commercially? What firing temperature is to be used? What fired color and texture are wanted? As complicated as all this might seem, it is well to remember that ancient potters took the materials at hand and fashioned many beautiful objects which still survive. In other words, keep it simple. Most natural clays have an amazing flexibility in firing range and handling capabilities. No amount of theoretical calculating will develop a workable clay body without actual batches being mixed, made into objects and fired to find out if they work. Take a clay from the ground or a box and work with it. Test it for plasticity, shrinkage, and porosity. Keep notes. Then, if necessary, begin a series of alterations. Add grog for tooth, a darker clay for color, increase the feldspar for better fusion and so forth until the clay does just what is desired.

If clay is dug from a riverbank or other deposit, it should be allowed to dry. Break the dry clay into small pieces and pass it through a window screen to remove any stones or other foreign matter. Next, pour the dry clay into a container of water and stir vigorously. After the clay has settled for a few hours, siphon the top water to draw off any unwanted organic matter, soluble salts and lime. Refill the container with water and repeat the process to be certain that most of the salts and lime are removed. Siphon off all the water and pour the clay onto plaster bats, wooden boards, or a clean floor and allow it to stiffen.

1-7

## Mixing Clay

Once a clay has been tested and proved satisfactory, large amounts should be mixed and stored for aging and later use. If commercial clay is used, it usually comes ready mixed in plastic bags. Be certain there are no holes in the bags. Otherwise, water will evaporate and the clay will become too hard. It will have to be completely dried, broken up, slaked in water, and stiffened again.

Dry clay should be mixed in a well ventilated area. Use an exhaust hood at the rear of the mixing area to provide the best way of drawing away airborn clay particles. To minimize contact with clay and mineral dusts, wear coveralls, a hat, shoes, rubber gloves, eye protection, and a NIOSH approved dust respirator. Clothes should be washed after each mixing session.

Many individuals and schools use clay blungers to mix large batches of clay. Basically, the blunger is a large barrel, which is filled with water. Dry clay is added. The mixture, or slurry, is then whipped with a motorized beater and poured onto plaster or wooden bats to stiffen. Others use pugmills or doughmixers to prepare clay. In both cases, the clay body is usually mixed by dry proportions in a container and scooped into the machine while water is being added. The advantage of pugmills and doughmixers over the blunger method is that they require only the amount of water necessary to mix the clay and therefore drying bats are not necessary. Some pugmills have an added advantage in that they de-air the clay which makes it ready for immediate use without kneading.

17

**1-8** Pug Mill
Courtesy: Peter Pugger

1-8

For those who do not have access to such equipment, there is a simple method for mixing large amounts of clay:

Place four 2 x 4 boards in a square on the floor. Lay a large sheet of industrial plastic over the boards to form a shallow basin. Evenly spread a thin layer of mixed dry clay ingredients over the plastic. Then lightly spray water on the clay to dampen, but not soak, it. Spread another layer of dry clay on top and dampen again. Continue this process until all the materials have been spread out and dampened. Then gather up the corners of the plastic sheet and tie them together to form an air-tight bag. After the clay has been allowed to age, it is ready to use.

## Preparing Clay for Use

It is important to emphasize again that clay that is too soft or too stiff and filled with hard chunks or air bubbles is difficult to use. For best results, clay should be de-aired and have an even consistency.

Two basic methods for preparing clay are used worldwide. One is the Western method, called *wedging*; the other is the Far Eastern way, *kneading*. To wedge, a convenient amount of clay is first patted into a cube. **1-9**, The cube is then sliced diagonally in half, using a wire. Holding a wedge in each hand, first one portion is raised overhead and slammed down on the board and then the other is slammed on top of the first, just slightly behind the closest edge, forcing air out of the clay. **1-10**, This lump is then sliced diagonally again and the procedure is repeated ten to twenty times until the clay is thoroughly mixed. If improperly done, air bubbles will remain in the cube, making it difficult to use. The major drawback to this method is that the physical strength required to lift the wedges overhead limits the amount of clay that can be prepared at one time. Other minor drawbacks are the noise and the possible "shot-gunning" of wet clay bits around the studio caused by slamming the clay.

Kneading has many advantages over wedging. Greater amounts of clay can be processed at one time, it is quieter and, because the whole body comes into action, does not require as much effort. This method can best be executed on a sturdy canvas-covered table, 30 to 32 inches high, or by kneeling on the floor. **1-11**, A ball of clay is first pushed out of round firmly with the palms of both hands, keeping the arms straight and using the shoulders and back to exert pressure. With either hand, lift the far end of the clay and raise it forward over the leading edge with a quarter twist. Push down and away with both hands. Repeat this procedure using the same hand to lift each time. **1-12**, A rhythmic rocking motion of the body will be created which will facilitate this operation. **1-13**, The quarter twist motion shapes the clay into a spiral, or cornucopia, exposing an everchanging clay surface which allows air bubbles to break out at the base while thoroughly mixing the clay. If the clay is only rolled, air will remain trapped inside. Continue to knead in this manner at least 15 to 20 times to insure full homogenization. There is no need to slice the clay to check for consistency if the process is well executed. Slicing is more often counter-productive in that it makes more air pockets which must then be kneaded out when the pieces are recombined.

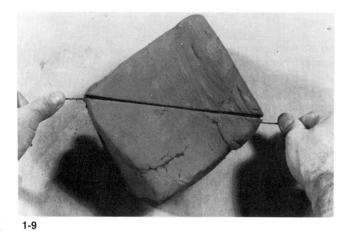

1-9

1-10

1-11

1-12

1-13

If the clay is too soft for use, continue to knead. If the clay is quite stiff, cut the ball into thin slices and alternate them with layers of thick slurry to form a "Dagwood sandwich." Then knead everything together until the clay is plastic and workable.

# CHAPTER 2 Pinch

The pinch method was the first method to use only the potter's hands to shape the clay. By inserting the thumb of one hand into a ball of clay and lightly pinching with thumb and fingers while slowly rotating the ball in the palm of the other hand, a small pot can be rapidly made. **2-1, 2-2, 2-3**

If cracks appear in the clay because the pinching is drying it too fast, do not smear water on the clay, but simply moisten the fingertips by pressing on a damp sponge. If the clay is too soft and the form starts to flop about, put the piece aside until it stiffens and work on another shape while waiting.

Instead of forcing this method to make some pre-established form, work with the clay, not against it. **2-4, 2-5, 2-6,** Experiment with the size of the ball and the way the fingers are held in relation to the thumb. Can tall thin pots be made? How wide can a form be shaped? By freeing the mind of preconceived ideas and working with the clay, simple elegant shapes can be created in the same manner ancient raku teabowls were formed.

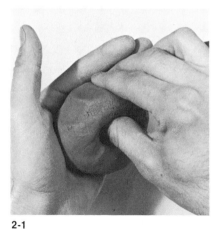

2-1

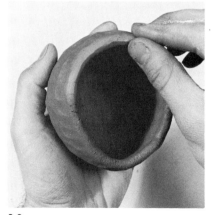

2-2

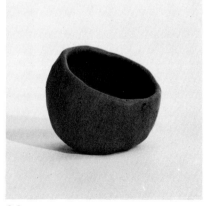

2-3

**2-7**  Raku Teabowls
19th Century Japanese Yamashiro ware
left: 4 1/2″ (11.4 cm) diameter
right: 4″ (10.1 cm) diameter
Courtesy: Museum of Art, Rhode Island
  School of Design, Providence, R.I.
  Gift of Isaac C. Bates

**2-8**  Nancy Selvage
*Raku Form*
12 × 6″ (30.4 × 15.2 cm)

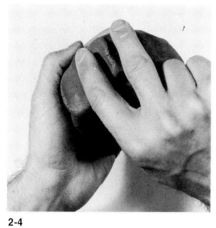

2-4

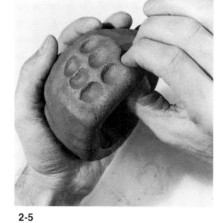

2-5

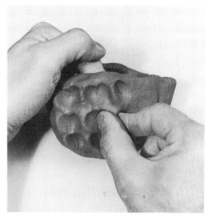

2-6

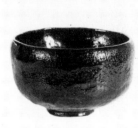

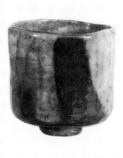

2-7

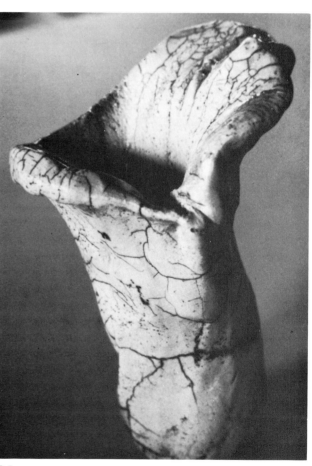

2-8

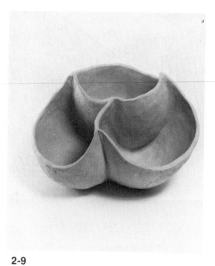

2-9

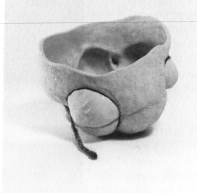

2-10

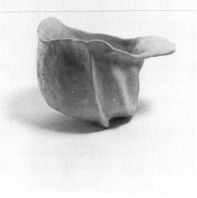

2-11

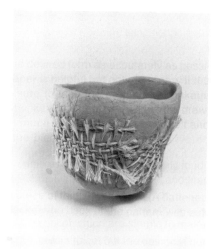

2-12

Take a ball of clay and poke two or three holes in it. Then pinch out each hole. **2-9**

Wind some twine or yarn around a ball of clay and then pinch it out only where the form is not constricted. **2-10**

Try pinching a form using a torn lump of clay instead of a rounded ball. **2-11**

The textures that can be devised using only the fingers or simple tools are almost limitless.

Pieces can also be textured by first wrapping a ball of clay with grass, a leaf, or a piece of burlap, and then pinching the form. **2-12**

22

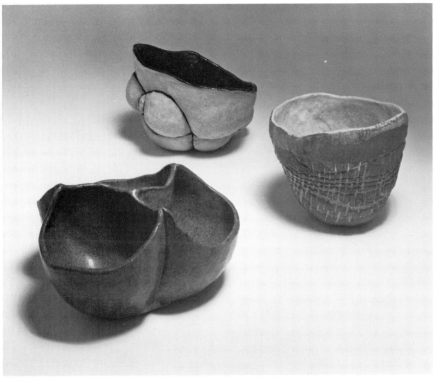

2-13

Another method for making pinch pots, used by some American Indians, is to pat the clay ball against the elbow to form larger, wide-mouthed pots. Other methods using sticks, fists, and so on have often been suggested for making larger pinch pots. Obviously, there is a practical limit to size and larger pots can best be made with other techniques.

Simple cut forms may be placed upside down on the lip to equalize the drying. More complex joined pieces should be covered with lightweight plastic and allowed to set slowly so that they will not come apart from having been dried too rapidly.

Pots should be made with thin, even walls. As clay is fired, the chemically combined water turns to steam. If the clay is too thick, the steam cannot escape rapidly enough, pressure builds up, and the pot will explode.

The use of the pinchforming techniques can be extended far beyond simple vessel forms. Multiple pinch pieces can be assembled in many different ways, producing wall pieces, freestanding works and other sculptural objects.

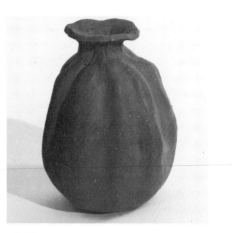

2-17

2-14

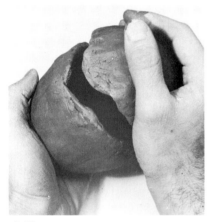

2-15

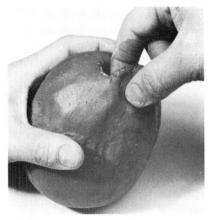

2-16

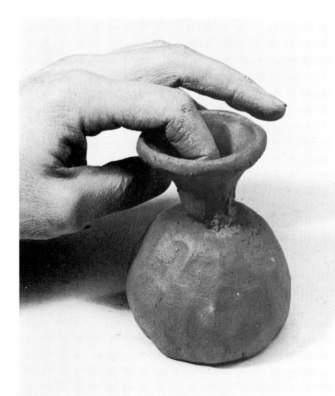

2-18

With imagination many different objects can be made although the pinch technique itself may be limiting. **2-14**, Using two hemispheres joined securely lip to lip, a pot can be made twice as big. **2-18**, A smaller pot sealed bottom to bottom with a larger one can produce a footed form. Clusters of small pinch pots can be made into cactus planters or sculptures.

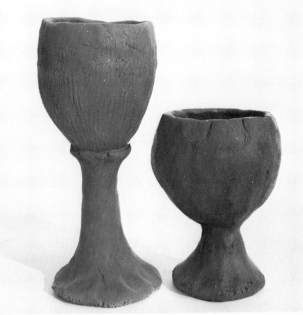

2-19

2-20

2-21

25

**2-22** Eva Marie Adjoian
Pinch-form Wall Piece
Stoneware, cord, beads, paint
35 × 12 × 3″ (89 × 30 × 8 cm)

**2-23** Nadine Hurst
Pinch-formed pot
Unglazed, burnished, sawdust fired
4¹/₂ × 6″ (11 × 15 cm)

**2-24** Barbara Walch
Teapot
Pinched-formed stoneware, unglazed, iron
  wash, reduction fired
6 × 6 × 10″ (15 × 15 × 25 cm)
Photo: Suzie Cushner

2-22

2-24

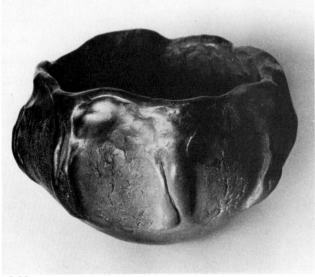

2-23

**2-25** Barbara Walch
Teapot
Pinch-formed stoneware, unglazed, iron
  wash, reduction fired
10 × 7 × 6″ (25 × 18 × 15 cm)
Photo: Tommy Elder

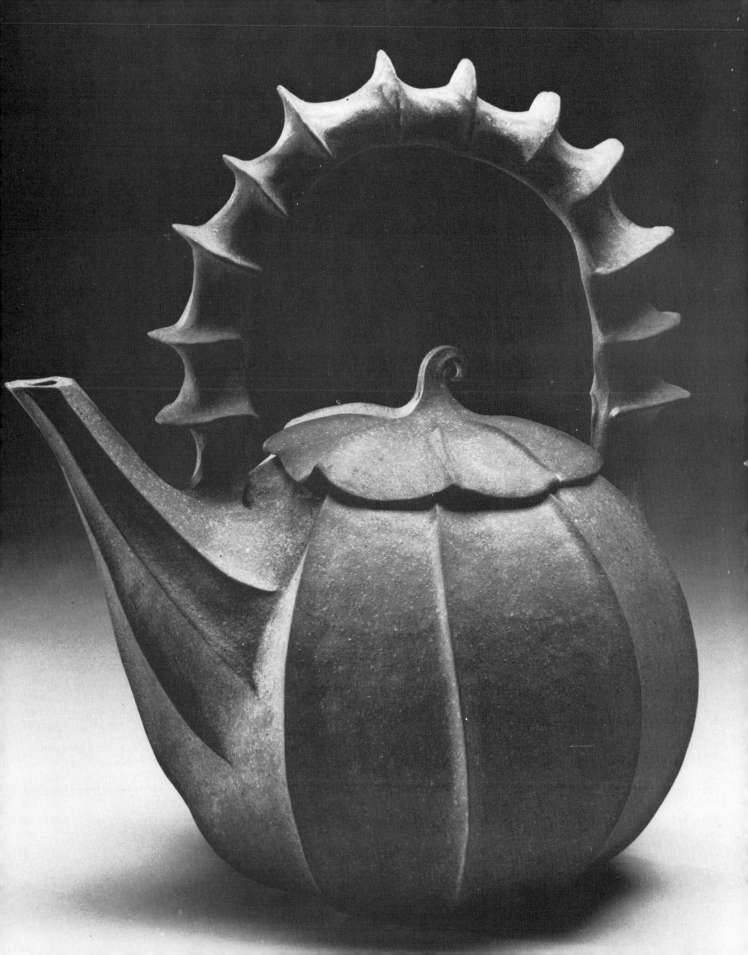

# CHAPTER 3 Coil Building

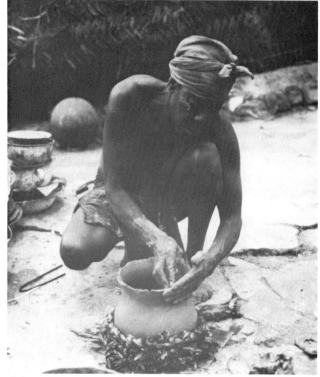

3-1

3-2

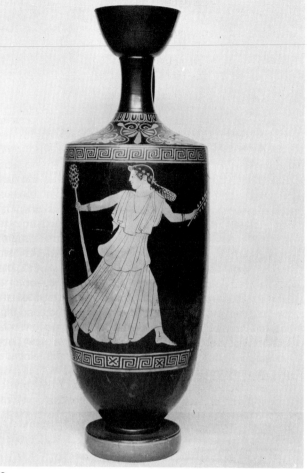

3-3

**3-1,** For centuries coil building has been the primary method of making pottery. It still holds that position in some cultures today even though the introduction of the potter's wheel has rendered traditional coil techniques virtually obsolete. In contemporary ceramics the coil method can be used to best advantage, contrary to some current thought, by placing less emphasis on total symmetry in favor of asymmetrical forms. **3-2,** Instead of using templates or other aids to make perfectly round objects as did the Greeks and others, organic forms seem more reasonable to attempt.

The technique of making organic forms is fairly simple. Start by flattening and forming a piece of kneaded clay into the shape

**3-1** Nigerian Potter
Photo: Jean M. Borgatti

**3-3** Lekythos
Greek, 470-460 B.C.
Red slip on black earthenware
15″ (38 cm) high
Courtesy: Wadsworth Atheneum, Hartford

desired for a base. The thickness of the base can range from 3/8 to 3/4 of an inch depending on the proposed size of the finished object. **3-4,** The base should be placed on a plaster bat or wood slab on top of a bench wheel, if available, for ease in building.

**3-5,** To make a coil, squeeze out a long rope of well kneaded clay by hand. The more symmetrical the rope, the easier it will be to roll. **3-6,** Lay this on a table and roll it back and forth, applying light even pressure, keeping hands parallel with the table, and using the full length of the fingers and palms. Short, quick rolling with only fingertips or palms will result in flat, uneven coils. Rolling from the center out or from the ends to the center of the coil makes no difference as long as it is done evenly. There is no real saving in rolling a number of coils before use. The time taken to make each coil can actually assist

in construction, allowing a slight stiffening of the form as the work progresses.

**3-7,** Flatten one end of the first coil, then press it firmly all around the top of the base until the other end slightly overlaps. **3-8,** Seal the entire inside seam vertically using a finger or wooden tool. Then evenly smooth away all the sealing marks. It is important that this first coil be placed directly on top of the base. Otherwise the piece may come apart in drying or firing.

Each succeeding coil should be squeezed and rolled in the same manner and firmly attached to the preceding one. **3-9,** Joining the coils smoothly on the inside helps insure against drying cracks, and provides visual contrast to a textured exterior. It also makes the interior easier to clean, which is an important design feature in utilitarian objects.

**3-4**

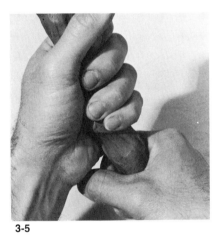

**3-5**

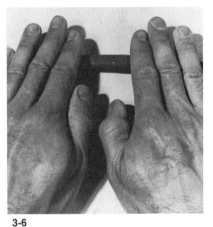

**3-6**

**3-7**

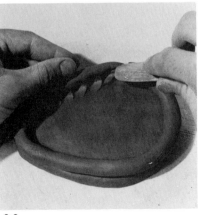

**3-8**

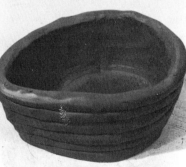

**3-9**

29

**3-12**  Karin Reichert
Basket
Woven, extruded, low fire clays, unglazed
8 × 6″ (20 × 15 cm)
Photo: William Reichert

**3-13**  Ceremonial Vessel
Clay and rope
Bendel State, Nigeria
Photo: Jean M. Borgatti

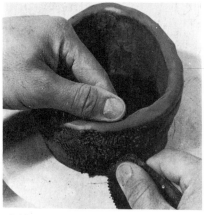

3-10

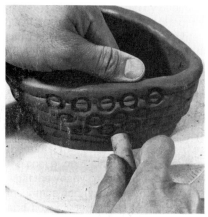

3-11

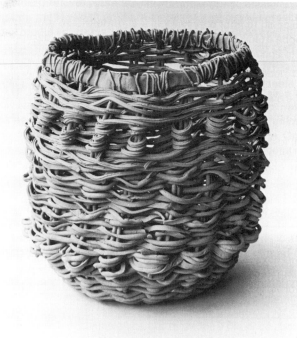

3-12

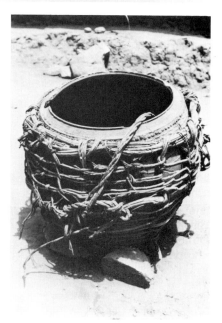

3-13

Textures can be made by fingers, tools, stamping, paddling, and other means. The coils themselves can be used as built-in decorative surfaces by making swirls, holes, bumps, or by varying the height of the coils.

If a smooth surface is sought, or larger forms are desired, a wider coil can be used. To make a wide coil, squeeze and roll out a thick coil and then flatten it. The height of the coil is thus increased while keeping a thin width.

**3-14** Gail Seavey
Coilbuilt porcelain sculpture
22 × 8 × 8″ (55 × 20 × 20 cm)

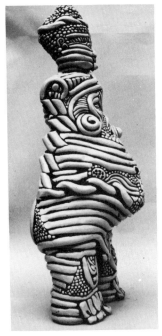

3-15

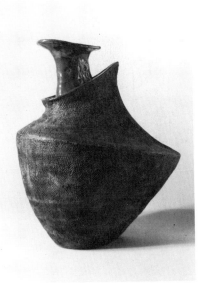

3-15, Coils can also be made by first rolling a thick slab of clay and then cutting it into strips with either a knife or loop tool. This gives a sharper exposed edge to the coils when they are used.

3-14

3-16

3-17

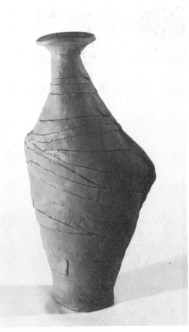

3-18

31

**3-19**  Hand Extruder
Courtesy: Robert Brent Corp.

**3-20**  Edward Harkness
*Minerva*
Coilbuilt and thrown stoneware, salt glaze
31″ (79 cm) high
Photo: Michael Tylick

3-19

## Extruders

The use of clay extruders can be very helpful in the construc-
tion of large or intricate forms which require the use of evenly
made coils. Coils can be produced from string thickness to the
thickness of an arm. Obviously, either extreme could be dif-
ficult to use in most coil building, so choose coil size with com-
mon sense. Dies used in an extruder could be cut to give coil
extrusions interesting grooves or make coils in flat cross-
sections.

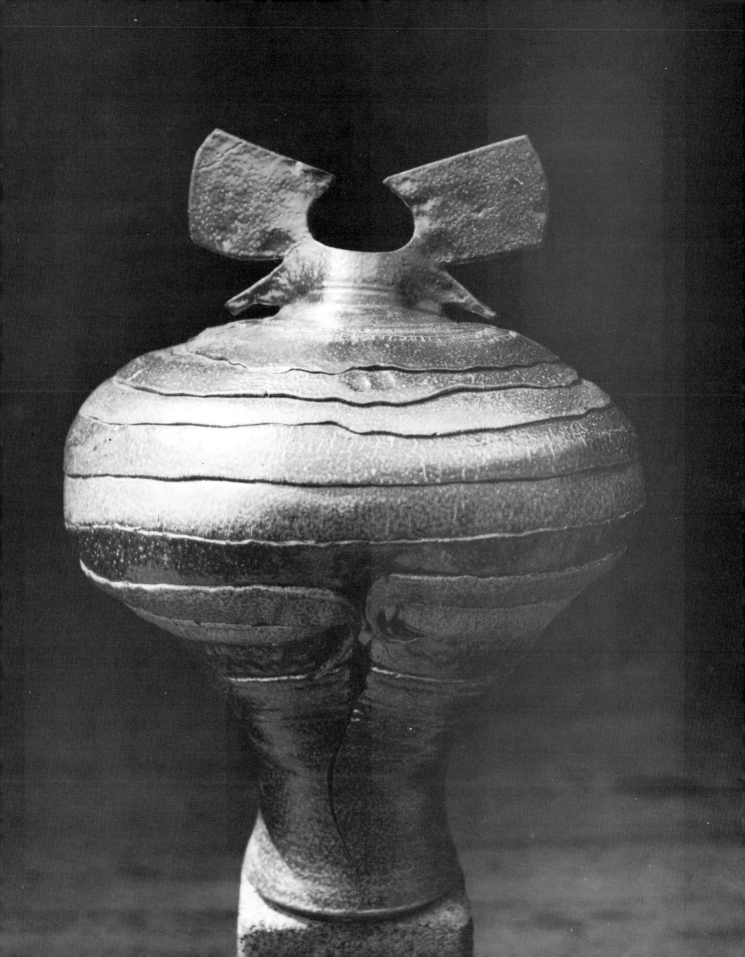

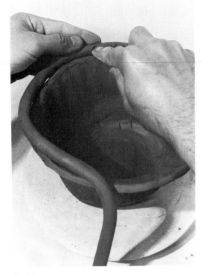

3-21

3-22

3-23

**3-21,** To build a bulging form, each coil is placed toward the outer edge of the coil below. **3-22,** To constrict a form, coils are placed toward the inner edge of those underneath.

It is often better to work on more than one object at a time. As coil forms grow, they tend to become quite wobbly and adding more coils could cause collapse. Momentum is not lost, however, if work is continued on a second piece while the first is allowed to set up.

**3-23,** After some initial experimentation with coil rolling, building, and texturing, sketching is suggested before larger or more complex forms are attempted. Sometimes forms can best be built in sections which are assembled after having stiffened. Spouts, pedestals, or other appendages should be made separately and added to the basic form after setting up, instead of trying to build from the bottom up and inviting untimely collapse.

Very large or wide bowl forms are best built upside down on the rim. In this way the weight of the soft clay is distributed as a dome, which is less apt to collapse than if the form were cantilevered outward. It is unnecessary to roll an extremely long

34

coil the entire circumference of the form. Sections of reasonable length can be conveniently joined to make the full distance needed.

As the form is built upward, it is wise to paddle the topmost coil down to provide additional strength. Paddling can also help define the shape of a pot after the clay has set up. **3-25,** Paddles can be anything from spoons to an elaborately rope-wrapped or carved wood mallet.

Scoring and wetting the top coil is really only necessary after the work has been allowed to stiffen. The top coil should be roughened by using a toothed scraper or hacksaw blade and then wetted with vinegar. Because it is a mild acid, vinegar can soften clay faster and better than plain water or slurry.

If the diameter of a form becomes too wide, cut small wedge-shaped pieces from the rim. Score the edges and seal them together. Done at intervals around the top, this closes the diameter of the object to the desired measurement.

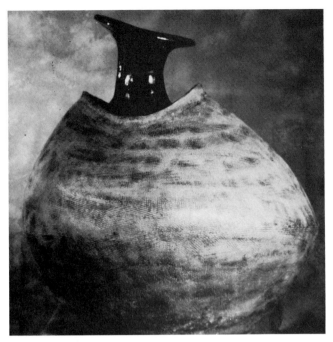

3-24

## Paddle and Anvil Technique

The paddle and anvil method can be used to shape and thin large coil built pieces. Start by using thick coils to construct a form with the usual building methods. As the piece begins to take shape, hold a stone or curved block of wood (anvil) against the inside wall of the form. Opposite the anvil, beat against the outside of the coil wall with a wooden paddle, while slowly turning the piece. For added surface interest, use a paddle that has been carved in some pattern or wrapped with rope or burlap. **3-26**

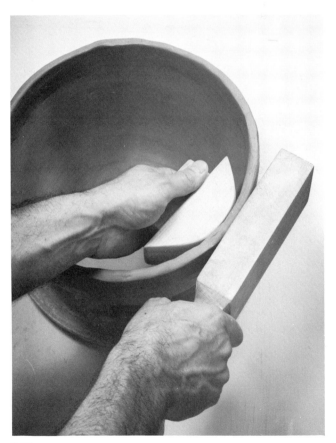

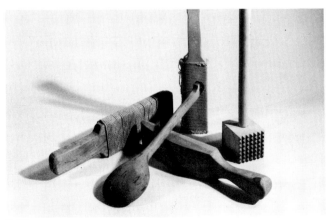

3-25

3-26

**3-27**  Louis Mendez
*Mitosis*
Patchbuilt stoneware, iron oxide wash,
  unglazed
30 × 24 × 20" (76 × 61 × 51 cm)
Photo: the author

**3-28**  Margot Baxter
Clock
Coilbuilt stoneware
10" (25 cm) diameter
Photo: the author

**3-29**  Penelope Jencks
*Beach People - Sharon*
1981
Handbuilt terra cotta, unglazed
Lifesize
Photo: the artist

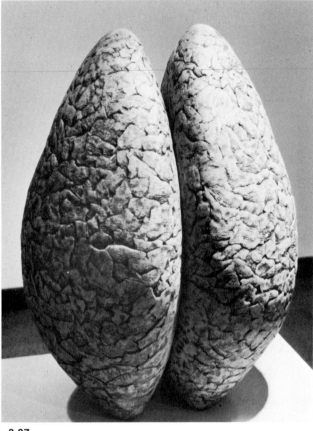

3-27

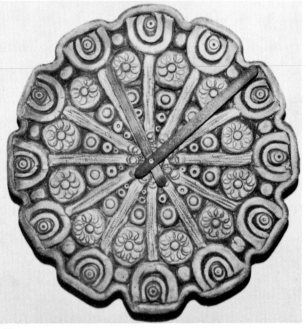

3-28

3-29

## Patch Method

The patch method of construction is a slight variation on the usual coil method. Instead of rolling long even coils to build forms, flatten pieces of clay into patties and join them in the usual manner to make forms with a different surface texture.
**3-27**

Once a piece has dried, there is virtually no way that new soft clay can be added. Soaking the pot in water or applying more vinegar may seem to soften the pot, but when it is later fired, the added clay will often come away. Therefore, when working on large pieces, keep the lower portion covered with plastic so that it will stiffen but not dry. If an unfinished piece is to be stored, a light misting of water from a spray bottle before wrapping it in plastic will help equalize the moisture content and keep the clay workable.

It is essential that coil pots be allowed to dry slowly and evenly because each joint is a potential crack in drying or firing.

36

**3-30** Bottle
Peruvian, 5th century A.D.
Coilbuilt earthenware, paint
6¹/₂″ (17 cm)
Courtesy: Worcester Art Museum

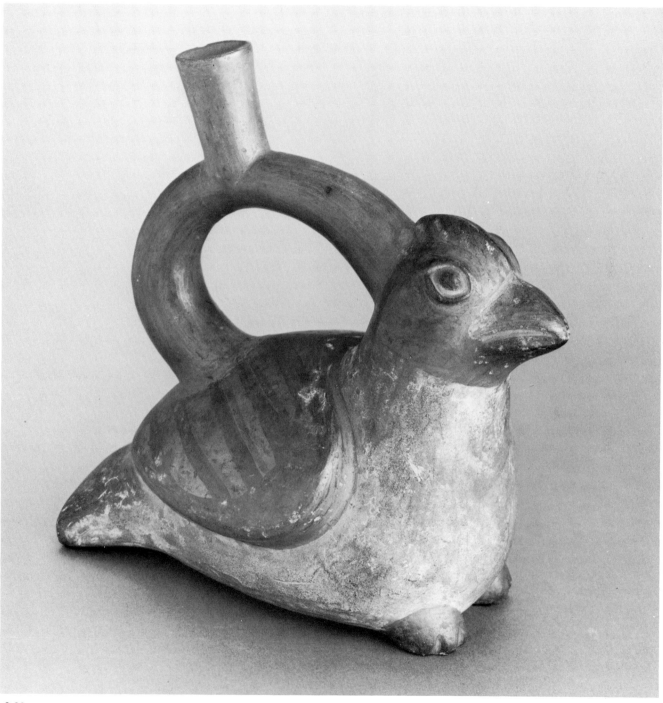

**3-30**

# CHAPTER 4 Slab Construction

There are a few methods of making clay slabs, the most obvious of which is to pound the clay flat by hand. Another method, preferred by Far Eastern potters, calls for a wire stretched tightly between two upright sticks cut with a series of equidistant notches. **4-1,** The wire in the bottom notch is pulled through a squared block of clay and then raised a notch for each successive pass.

The easiest way to make slabs of any size is known as the "pizza method." **4-2,** After kneading the clay thoroughly, flatten it slightly by patting. **4-3,** Lift it up by the farthest edge and, without letting go, throw it down against a tabletop or floor with a pulling motion, allowing the far end of the clay to hit first.**4-4,** Repeat the process by grasping the far edge, lifting, slamming the clay down away from the body, and pulling back with a swinging motion until the slab is stretched slightly thicker than the desired thickness. Alternate this action by picking up the slab by a side edge and slapping it down. In this way a relatively squared slab can be made with little effort. If a larger slab is required, two or more small slabs can be joined by welding the edges together until the desired size is obtained.

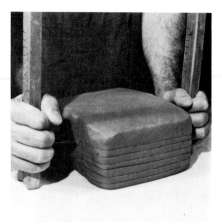

4-1

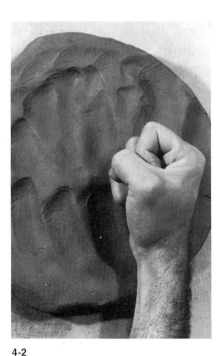

4-2

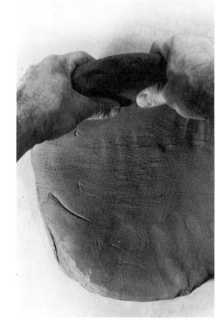

4-3

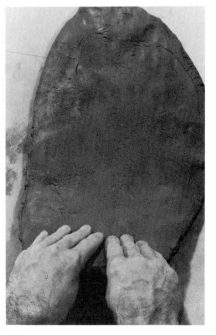

4-4

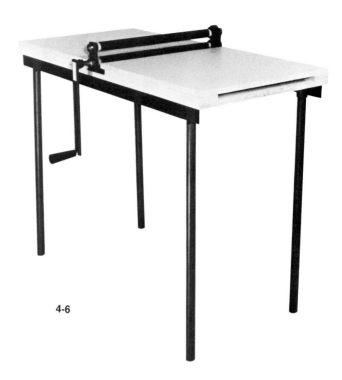

4-6

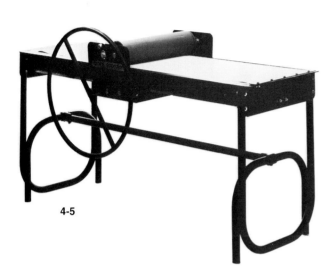

4-5

The slabs are then placed on the floor on top of canvas, burlap or other textured material. Parallel guide sticks, such as two yardsticks, are positioned on either side of, but not touching, the clay. The clay is covered with canvas and a large rolling pin or metal pipe is placed on top of the center of the slab resting firmly on the guide sticks. Stand on the pipe and roll evenly to one end. Replace the pipe in the center and roll to the other end. This method, utilizing body weight, is less tiring than the conventional way of pushing the pipe by hand. If there are ripples in the clay after the first rolling, peel off the top layer of the cloth and turn the clay over onto it. Remove what was the bottom cloth to allow free movement of the clay, set the guide sticks, replace the cloth and roll again.

The thickness of the guide sticks depends on the size of the object to be constructed. Most slab objects can be built within a range of 3/16 inch to 3/4 inch wall thickness. Thicker slabs do not necessarily make stronger pots. In fact, if clay walls are too thick they can hamper the natural drying and firing processes, causing strains and possible splitting.

When making large slabs for wall panels or murals, lay out the clay in workable widths with spaces between for the guide sticks. Fill in these spaces after rolling.

To minimize deformation after the slab is rolled, peel off the top cloth, turn the clay over onto it and remove the bottom cloth before any cutting is done. At this time the pieces are cut to size, using a potter's knife or a pizza cutter. If a flat-sided object is to be made, the pieces should be left to stiffen without

moving them. If, however, the slabs must be stored, stack them one on top of another, alternating several sheets of newspaper with each slab. The paper will absorb moisture from the clay and aid in slow, even drying. Wrap the stack in plastic and place the package on a board so that it may be moved without bending the slabs.

## Slab Rollers

Recently, slab-rolling machinery has become commercially available. Because even smaller machines of good quality are relatively expensive, be certain that the investment is warranted before buying one. The major advantage in using a slab roller is that it can turn out very large slabs of consistent thickness without a great deal of muscle power. However, like other machines, they need to be kept in good condition. Drive boards can go askew, rollers can become misaligned, and motors can fail without proper care.

If the major thrust of the studio is to work on large wall pieces, make tiles, or work on large slab-built forms, then a slab roller could be a great time saver. If an occasional candy dish is all that is desired, the slab roller could become just a very expensive work table.

**4-7** Harriet Goodwin
*Mesaverde Dream Series #6, 1984*
Slab-built earthenware, slips
24 × 20 × 20″ (61 × 51 × 51 cm)
Photo: Michael Cohen

**4-9** George Wolfkeil, ca. 1800
*Hard Times in Jersey*
Slab-built earthenware dish, slip
  decoration
12¼ × 15⅝″ (31 × 40 cm)
Courtesy: Wadsworth Atheneum, Hartford
Photo: E. Irving Blomstrann

Texture can be readily achieved in slab building by rolling out the clay on highly articulated fabrics, such as shag rugs. thermal blankets, burlap, canvas, netting, and even lace. Other surfaces can be created by lightly beating the slab with rope-wrapped or carved paddles, meat tenderizers, broken branches or whatever the imagination can conceive. The contrast of smooth and rough surfaces on simple slab forms can turn an ordinary pot into something more aesthetically interesting.

**4-8,** Simple plates or trays can be formed from a freshly rolled and cut slab by turning up and smoothing the edges.

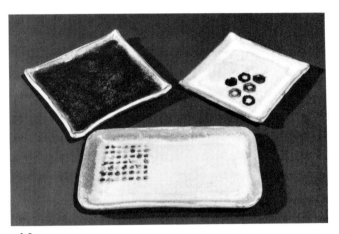

4-8

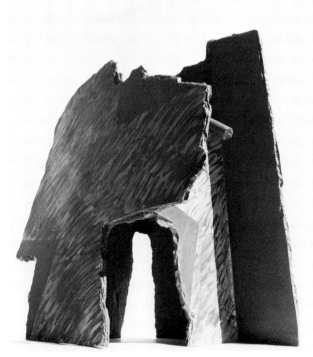

4-7

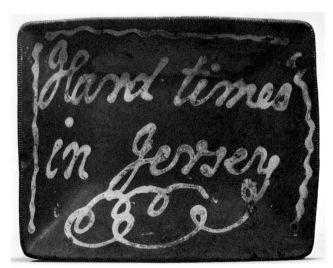

4-9

**4-10**   Jamie Fine
Pot, 1983
Slab-built stoneware, slip
10 × 11 × 11″ (25 × 28 × 28 cm)
Collection: Detroit Institute of Art
Photo: Robert Hensleigh

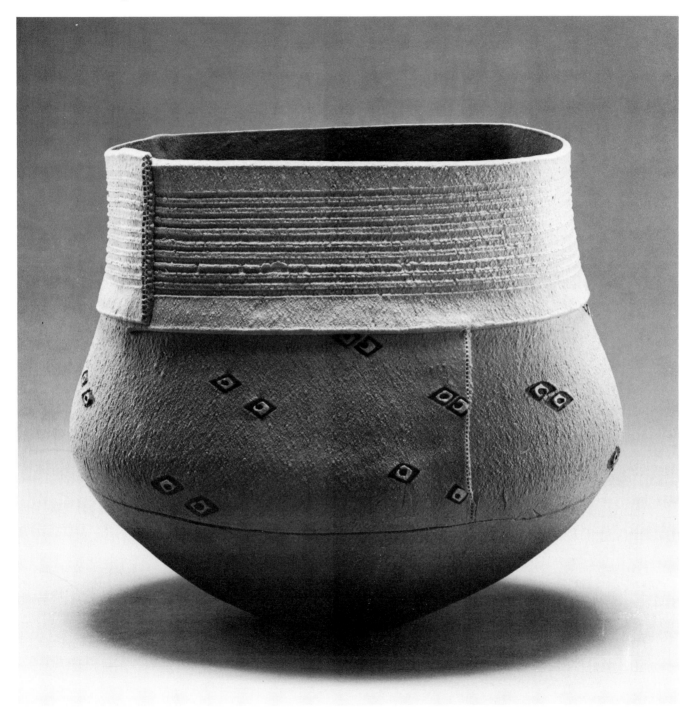

**4-10**

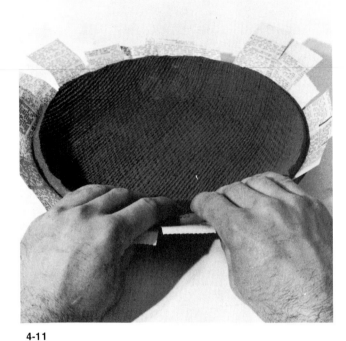

4-11

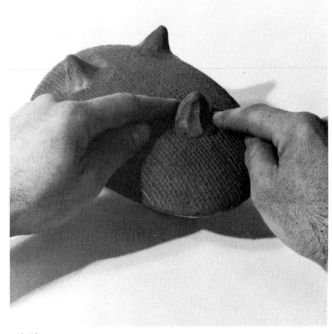

4-13

4-12

## Molds

**4-11,** Shallow baking tins or plates can be used as *press molds,* by first lining them with strips of newspaper to prevent the clay from sticking. **4-12,** Soft slabs can be laid into shallow plaster press molds or over plaster *drape molds.* **4-13,** Feet and handles can be added when the clay has stiffened. Bisque fired clay forms can also be used for press or drape molds. **4-15**

**4-16,** Two molded slabs can be joined to form the body of a larger object. Score the edges with a toothed scraper or hacksaw blade, soften them with vinegar and seal firmly together, using thin coils to fill the seams if needed. **4-17,** Spouts, handles, or other appendages can be added for interest as well as function.

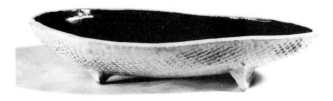

4-14

4-16

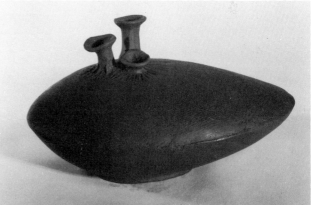

4-17

4-15

**4-18**  Rima J. Schulkind
*Amphora in Orbit*
Slab-built earthenware, luster glaze
22 × 36 × 26″ (56 × 91 × 66 cm)
Photo: Richard Rodriguez

**4-19**  Carolyn Sale
Sculpture
Slab-built stoneware, underglaze, steel
   base
21 × 15 × 6″ (53 × 38 × 15 cm)
Photo: Lee Fatherree

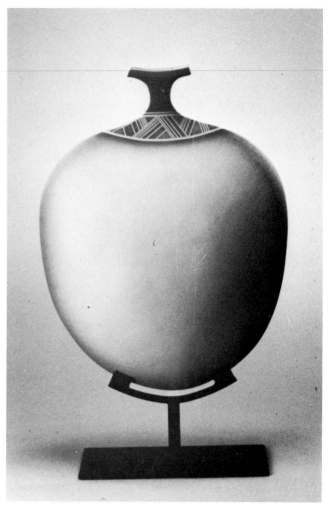
4-19

4-18

44

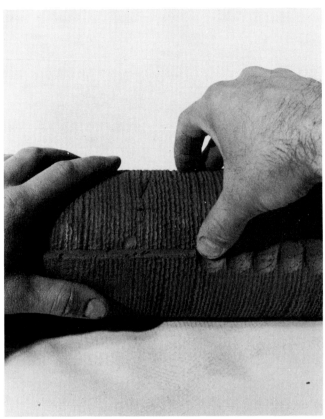

4-20

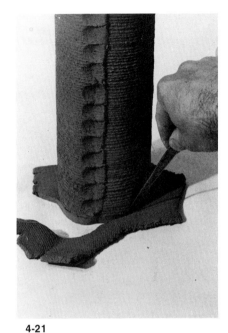

4-21

## Cylindrical Forms

Cardboard mailing tubes can be used to form cylindrical objects. Wrap the tube with newspaper to prevent the clay from sticking. **4-20,** Roll a soft slab around the tube and press the edges together, perhaps leaving finger marks as the decoration. For a smooth cylinder, bevel the edges before joining. **4-21,** Stand the tube upright on a clay slab and cut around the tube to make a base. Weld the base to the cylinder. After a short time to allow some stiffening of the clay, remove the cardboard and paper. Clay shrinkage will make later removal very difficult. Seal the interior seams. Finish the top of the clay cylinder by smoothing, tearing, or cutting.

4-22

45

To cap the cylinder, simply invert it onto a clay slab and repeat the process used to make a base. At this point firm joining can be accomplished by paddling all the seams.

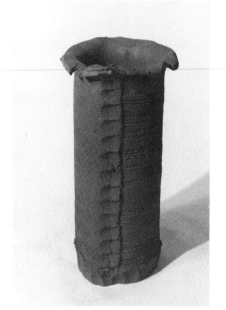

4-23

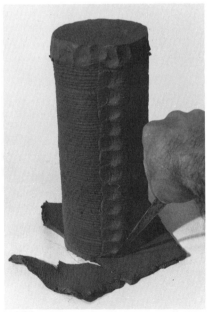

4-24

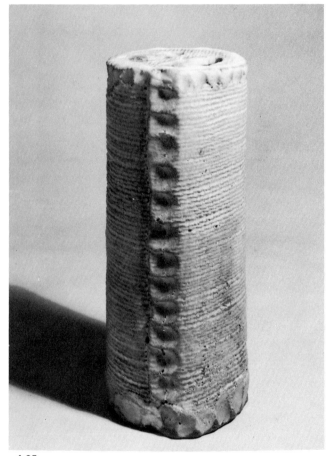

4-25

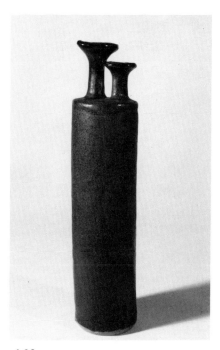

4-26

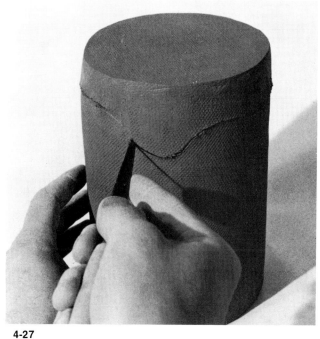

4-27

**4-26,** To make a bottle from a capped cylinder, one or more spouts are added and a hole for each cut through the top slab. When cutting a hole, slice it in two or more pieces. This allows easy removal of the pieces by shaking them out when the bottle is dry or after the bisque firing.

**4-27,** Canisters can easily be built from a capped cylinder by making a cut all the way around near the top. With the cover removed, weld all the interior joints and seal each with a narrow coil. **4-28,** A small slab strip welded to the inside top of the cylinder acts as a flange to hold the cover.

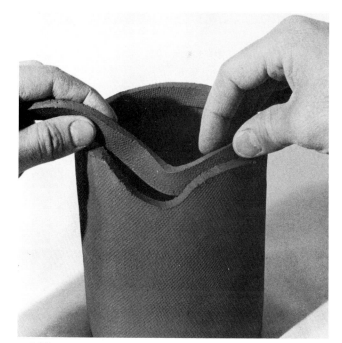

4-28

47

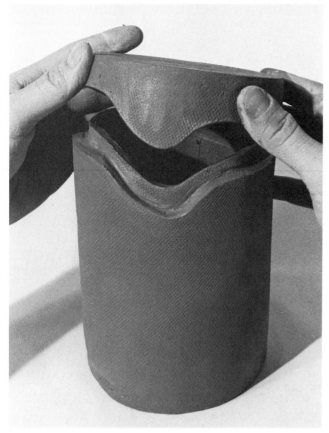

4-29

4-32

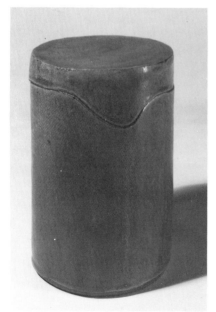

4-30

By cutting a hole in the side and adding feet, a horizontal planter can be made from a capped cylinder. **4-31**

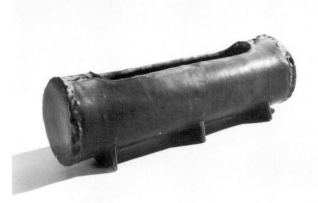

4-31

4-33

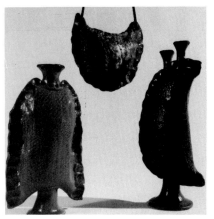

4-34

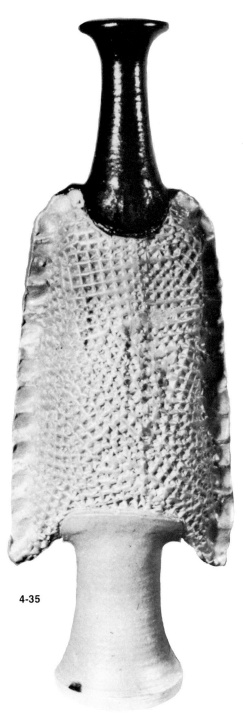

**4-35** Author
Bottle
Slab-built, thrown stoneware
16″ (41 cm) high

4-35

## Bag Forms

Clay can be wrapped around crumpled newspaper. **4-32,** After preparing a slab, place loosely crumpled newspaper in the center, bring one end of the slab over the paper and firmly pinch the slab together all around. Trim the excess clay away. This basic form can be used for many different objects. With the fold at the bottom or side, a spout and pedestal can be added. With the fold at the top, a large hole can be cut in the folded area and a small hole pierced near the top of each side to make a hanging planter.

Changing the length or width of the slab and the size of the paper wad will lead to other interesting shapes. After the piece is completed, allow it to dry slowly. If it is possible to remove the paper before firing, do so—otherwise the paper can be burned to ash in the bisque firing.

**4-36** Margot Baxter
Slab-built stoneware vase, feathers
7¹/₂ × 5″ (19 × 13 cm)
Photo: the author

**4-37** Sandy Hastings
*Torn Paper*
Slab-built low fire clay, underglaze
20″ (51 cm) high
Photo: Dory McNair

4-36

4-37

50

**4-38** Natalie Surving
*Blue Tailed Lizard*
Slab-built, extruded porcelain, stains
13 × 12 × 11″ (33 × 30 × 28 cm)
Photo: Ralph Gabringer

**4-39** Dennis Parks
Slab-built stoneware urn, salt glaze
30″ (76 cm) high

**4-38**

**4-39**

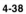

51

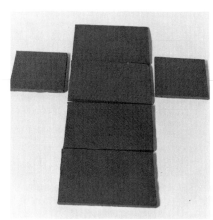

4-40

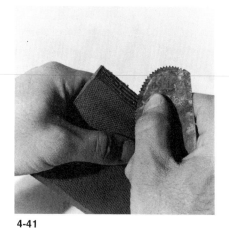

4-41

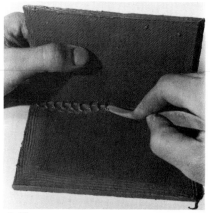

4-42

## Box Forms

**4-40,** To construct a box form, a rolled out slab is cut into properly measured pieces which are allowed to become firm but not quite leather hard. The side slabs are beveled at 45° on the edges to be joined at the side seams. This increases the joining area and makes invisible corner joints. **4-41,** All the surfaces to be joined are then scored and coated with vinegar. **4-42,** Stand one side piece on top of the base slab and join the two, inside and out, by working the clay from one piece to the other with a finger or wooden tool. **4-43,** A small coil of clay is then smoothed into the interior joint as an added seal. The next side is added to the base in the same way and firmly pressed and pinched to the first side. All seams are joined, welded, and coil-filled in this manner until the sides are securely attached to the base and each other. The top joining surface of each side is scored and coated with vinegar along with the facing area of the top slab to be attached. The top is set on the box and secured to the exterior. Liberal use of a paddle is recommended throughout the joining process to insure firm joints and square, sharp corners.

While the box is still sealed, any additional squaring, decorating, or carving should be done. The air trapped inside prevents the box from deforming.

A number of objects can be made using the basic box technique. For example, the closed form may be transformed into a covered container by cutting around the top. **4-44,** For a level cut, draw a guideline by measuring upward from the table at each corner.

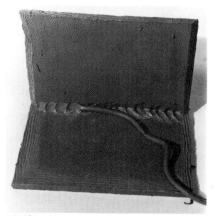

4-43

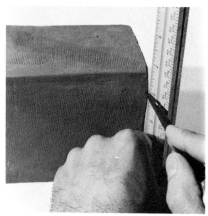

4-44

**4-47**  Nancy Peterson
Recipe box
Slab-built stoneware
$5^1/_2 \times 6 \times 4^1/_2''$ (14 × 15 × 11 cm)

**4-48**  Nancy Peterson
Dome container
Slab-built stoneware
$8^1/_2 \times 7^1/_2''$ (22 × 19 cm)

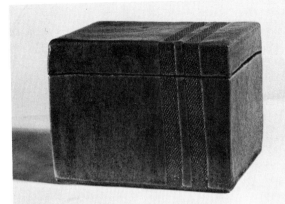

4-46

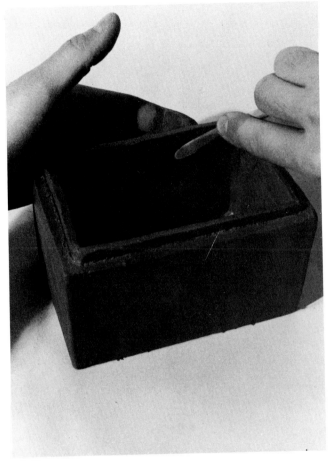

4-45

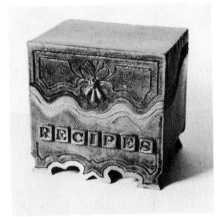

4-47

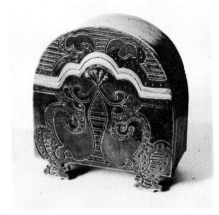

4-48

With the box open, the interior joint of the top is welded and sealed with a coil. **4-45,** A thin slab strip is attached to the inside top of the walls as a flange for a close fit and to prevent the cover from falling off. The cover is then replaced and the box allowed to dry slowly. By drying both top and bottom together, warpage is minimized.

**4-49** Sandy Hastings
*Peeling Basket*
Slab-built low fire clay, underglaze, luster
  glaze
26 × 10 × 10″ (66 × 25 × 25 cm)
Photo: Dory McNair

**4-50** John Costanza
Slab-built stoneware sculpture, luster
glaze
10 × 6″ (25 × 15 cm)

**4-51** Author
Vase
Slab-built, thrown stoneware, reduction
  fired
30″ (76 cm) high

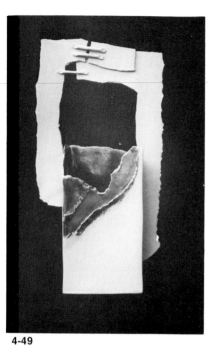

**4-49**

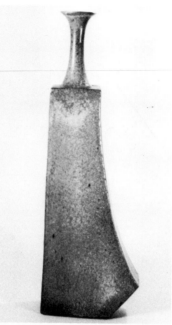

**4-51**

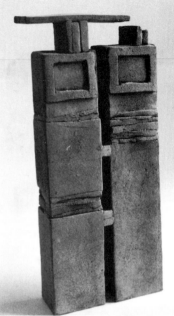

**4-52** Christopher Bartlett
*Watchtower*
Slab-built stoneware
14 × 5 × 2″ (36 × 13 × 5 cm)

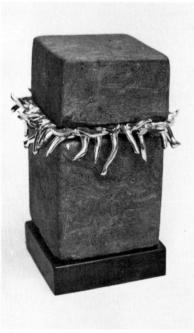

**4-50**

**4-51,** To make a squared slab bottle, a closed rectangular form is constructed and the spout or spouts are added to the top and welded on. The holes are cut in the top in two or more pieces for easy removal after drying.

**4-53,** A rectangular slab planter is simply a box without a top. Slab feet, handles, a center-divider, or a rim may be added.

Stiff slab forms need not be rectangular. **4-54,** As an example, by using the same construction methods, a candle lantern can be made with three sides. All stiffened sides to be joined are beveled and, along with the top and bottom, scored, coated with vinegar, and welded together into a closed triangular form. An inch or so from the bottom at the corners, draw a line around for a cupped bottom. Draw a design on each of the sides as well as the top. Plan the design carefully. If the holes are too large, the lighting will be harsh and unappealing. Do all the cutting. After removing the cover, attach a narrow slab around the interior edge of the bottom to act as a flange. Smooth all the cut edges, replace the top, and dry slowly.

**4-55**  Bottle
Japanese Taketori ware
Slab-built stoneware
9³/₈″ (24 cm) high
Courtesy: The George Walter Vincent
   Smith Art Museum, Springfield, MA

**4-56**  Susanne G. Stephenson
Slab-built stoneware, low temperature
   glaze
10 × 18 × 19″ (25 × 46 × 48 cm)

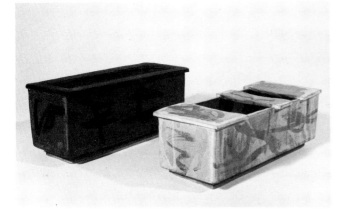

4-53

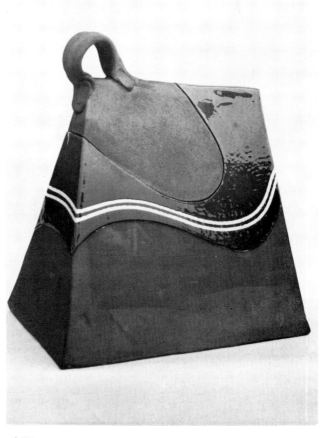

4-54

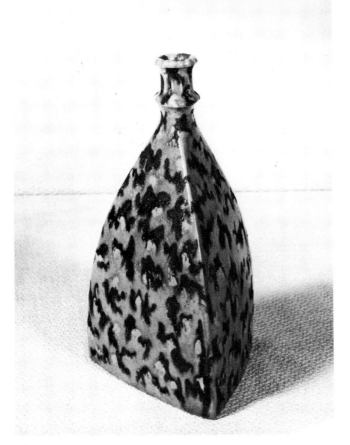

4-55

4-56

**4-57** Sweet Meat Dish
19th century Japanese Kioto ware
Slab-built stoneware, underglaze
  decoration
Courtesy: The George Walter Vincent
  Smith Art Museum, Springfield, MA

**4-58** John W. Conrad
*Rejoice*
Slab-built stoneware, fused stained glass
24 × 16 × 2½″ (61 × 41 × 6 cm)

**4-59** Marilyn Levine
*Jacket #7*
Slab-built stoneware
35 × 24 × 5″ (89 × 61 × 13 cm)
Photo: Robert Boni

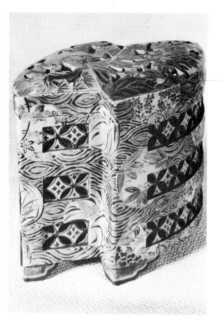

4-57

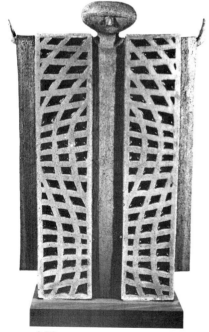

4-58

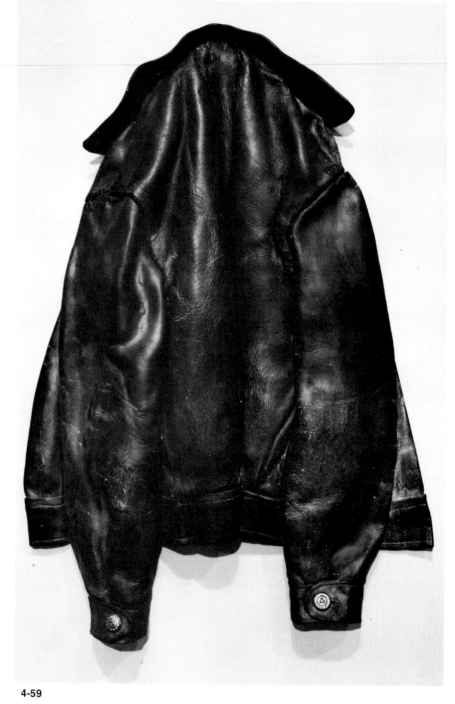

4-59

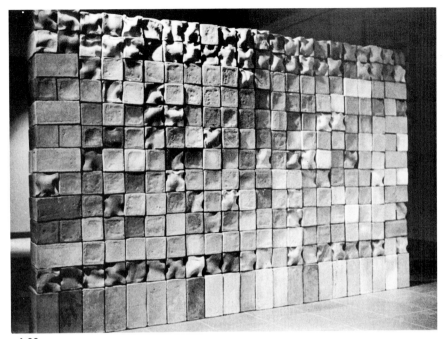

**4-60** Jim Stephenson
Clay block wall
Slab-built stoneware
10 x 7 x 1′ (3 x 2 x .3 m)

4-60

## Large Forms

Because of its easy construction technique, slab building lends itself to creating large-scale works. As the forms get bigger, technical problems might arise. When building big slab forms, it is advisable to add some sawdust, grass clippings, coffee grounds, or other organic material to the clay before rolling the slabs.

The addition of organic material increases the wet strength of the clay and reduces shrinkage and warping in drying. When the clay is fired, the material burns out leaving an interesting texture and making the finished object lighter in weight. The addition of grog helps in the first and second instances, but it is added weight and has practical limits of addition. Ten to twenty percent is normal. Too much grog makes the clay short and less workable.

An easy way to add the sawdust, if a claymixer is not available, is to slice thin slabs of clay and sprinkle on handfuls of dampened sawdust. Stack the slices together, knead well and repeat the process. For thorough amalgamation, store the clay in closed plastic bags for at least a day—a week is better—before using.

Some potters have introduced chopped fiberglass into clay for the same reasons. An advantage to using the fine fiberglass strands is that instead of burning out in the fire, they melt to silica and become an integral part of the clay. Noncoated fiberglass cloth can be used to give slabs greater tensile strength while still plastic and when dry. The slabs are made by dipping the cloth into thick slip deflocculated with sodium silicate or Calgon. Without deflocculation, the clay will shrink away from the cloth and crack. The thickness of the slabs can be controlled by the number of cloth layers stacked together. Caution is advised when using this material, however, as some individuals are prone to "fiberglass rot," an extremely uncomfortable rash.

Chopped nylon fibers, available from many ceramic suppliers, can also be added to clay. When thoroughly mixed in, the nylon forms a matrix which makes the soft clay quite durable for constructing paper-thin slab objects. Clay with chopped fiberglass can also be used successfully on the wheel, but clay containing nylon cannot.

57

**4-61** Barbara Grygutis
Fountain, Union Bank, Tucson, Arizona
Slab-built and thrown stoneware
6 and 4′ (1.8 and 1.2 m) high
Photo: Ray Manley

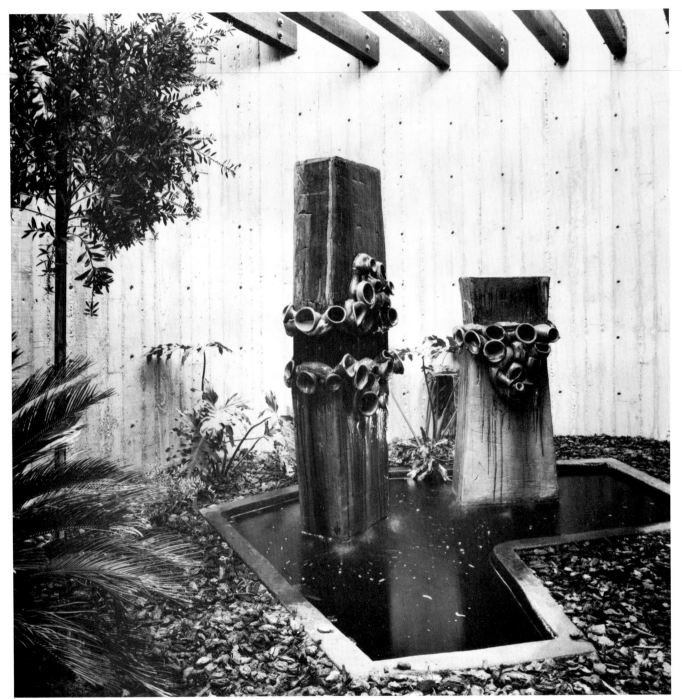

4-61

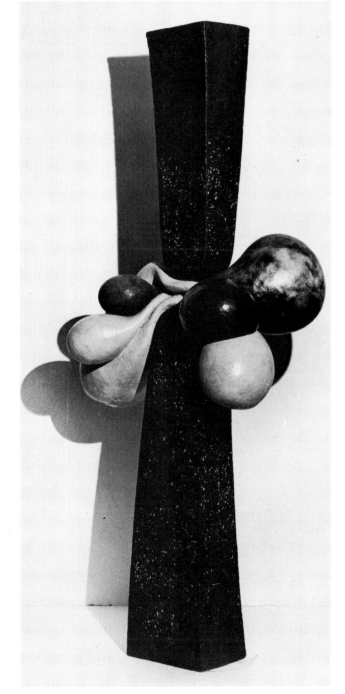

**4-62**  Helen Richter Watson
Sculpture
Slab-built and thrown earthenware, luster
  glaze
72 × 25 × 18″ (183 × 63 × 46 cm)

4-62

The only differences in method when constructing with large slabs instead of small ones are that the large slabs should be somewhat thicker, should be stiffened slowly before using, and require slower drying. Elaborate armatures, complex interior bracing, and super weight are all unnecessary if care is taken at each step. Often, to avoid slumping, it is better to construct a form on its side or longest dimension, dry it, and bisque fire it in this position.

To prevent warping or cracking during drying or firing, a large or complex sculpture form should be put on top of a clay *shrinking slab.* This slab, made at the same time as the sculpture, dries and shrinks at the same rate and serves to protect the base of the object from distorting.

During construction, liberal use of a paddle is recommended. A slight outward bow to the sides and top will prevent the concave look some slab works have after they have been fired. This occurs because the outside surface and edges of a slab dry faster than the inside, causing uneven shrinkage.

4-63

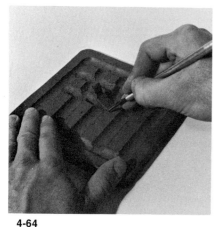

4-64

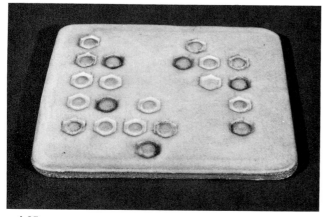

4-65

## Tiles

To make a tile, roll out a slab about 1/2 inch thick and cut it to size. Then stamp, cut, or carve a design. **4-64,** When the tile has stiffened to almost leather hard, turn it over and carve a waffle pattern on the back. This will allow the tile to dry more evenly and reduce warping. For minimum warping, place sheets of newspaper on the top and bottom of the tile and put everything between plaster or wooden boards to dry.

The waffle cut also serves to make the fired piece lighter in weight. Additionally, it provides more "teeth" to grip with when the tile is to be glued onto another surface.

## Trivets

A trivet is just a single tile on which to place a warm container. In this case, the waffle cut has an additional advantage in that it diffuses heat when the trivet is used.

## Extruded Forms

Extruders can be used to make bigger forms than just the simple coils mentioned earlier. Large scale barrels can be fitted to some extruders so that entire pieces can be produced at one time. Die kits are available from extruder manufacturers. Original design dies can be cut from plywood, sheet metal, or thick plexiglas. The edges of the design should be beveled to ensure smooth, clean extrusions.

In the example of the bread pan shown, two dies were cut from plywood. Each one was reinforced with metal brackets to prevent distortion during use. **4-66,** One die, was cut to the shape of the sides and bottom of the pan. **4-67,** The other die was cut for the ends. **4-68,** The first die was clamped to the barrel of the vertically mounted extruder and clay pushed through it to the desired length. The clay was cut off and set aside. The second die was then used in the same manner. The end pieces were then joined to the side extrusion in the usual way, the handles trimmed, and the piece set aside to dry. **4-69**

Extruders can also be fitted with dies to make entire tiles, either flat or in relief. It is best to have the extruder mounted horizontally so that the tiles can be extruded directly onto boards to minimize warping.

**4-69** Robert Fishman
Bread pan
Extruded stoneware
3 × 12 × 6″ (8 × 30 × 15 cm)

4-66

4-67

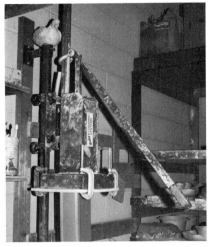

4-68

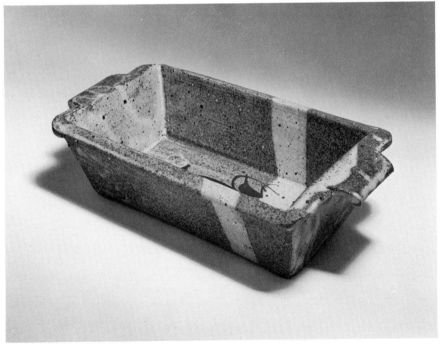

4-69

61

**4-70**   Paul Fajnor
Hors d'Oeuvres Tray
Extruded stoneware
4 × 12″ (10 × 30 cm)
Photo: Norm Landis

**4-71**   Jim Stephenson
*Interwoven*
Extruded whiteware
16 × 16″ (41 × 41 cm)
Photo: the artist

**4-72**   Nan Kirstein
*Sun*
Slab-built, carved earthenware, unglazed
$^1/_2$ × $5^1/_2$ × $5^1/_2$″ (1 × 14 × 14 cm)
Photo: C. W. Kirstein

4-70

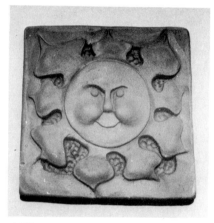

4-72

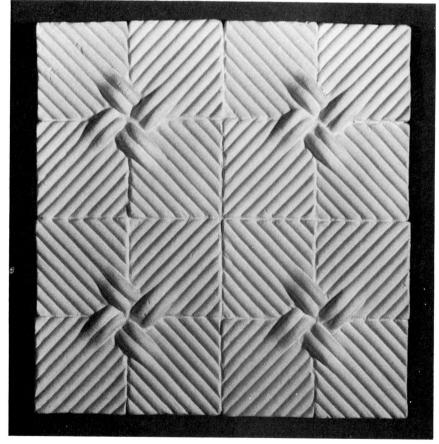

4-71



**4-73** Tile
Spanish, 15th century
Earthenware, paint
14 x 18 x 1″ (36 x 46 x 2.5 cm)
Courtesy: Worcester Art Museum

**4-74** Madeline Landing Pots and
Robert Paul Massaro
Tilework
Incised earthenware, underglaze, unglazed,
plexiglas
60 x 30″ (152 x 76 cm)
Photo: Jason Jones

## Low-Relief Panels

Low-relief panels and tabletops are made in the same way as a trivet. When making these items it is advisable to work from a drawing that takes into account the shrinkage of the clay when fired. If the clay shrinks 15 percent, the drawing should be 15 percent greater than the final table or frame.

After rolling a large slab of proper thickness, the drawing is placed directly on the clay and traced with a dull pointed stick or pencil. Only after all the incising, adding of clay, texturing and correcting have been completed should the clay be cut into pieces of manageable size. It is visually more effective if cuts can be made along lines of the composition rather than the standard horizontal-vertical grid slices. When the clay has stiffened to not quite leather hard, turn over the pieces and waffle cut them. If some parts of the relief are higher than the others, it is important that they be hollowed to the same thickness as the rest of the work to avoid splitting or explosion in the kiln.

4-73

## Setting Tiles

To firmly attach the glaze fired pieces, the tabletop or panel must be clean, uncoated, and have a slightly roughened surface. It is not necessary to use cement beds or grout to adhere the tiles. Best results have been obtained using CMC 2001 tile setting mastic. TEC 122 mastic is also acceptable. Follow directions on the label. Many other brands of ceramic tile mastic will not accept the weight of handmade tiles held in a vertical position, so test sampling is recommended. GE Silicone II also works well when joining clay to wood or other materials.

The advantage to using mastic or silicone sealer is that, unlike cement beds or epoxy glues, they never become completely hardened and brittle. This quality allows these materials to expand or contract with normal temperature changes and prevents the tiles from falling off or breaking.

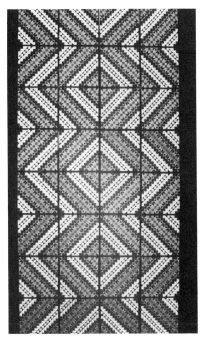
4-74

63

**4-75** Author
*The Garden*
Slab-built earthenware, wood
14 × 34″ (36 × 86 cm)
Collection: Mr. and Mrs. Joseph Epstein

**4-76** Author
Candelabra
Slab-built stoneware, wood
54 × 22″ (137 × 56 cm)
Collection: Mr. and Mrs. Milton Smith

**4-77** Bonnie Johnson
*Make a Joyful Noise*
Slab-built earthenware, unglazed
32 × 23 × 4″ (81 × 58 × 10 cm)
Photo: Steve duFour

4-75

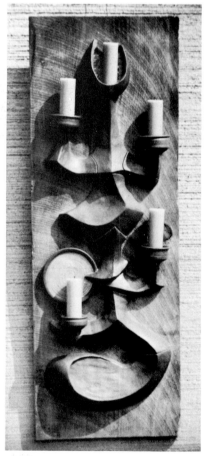

4-76

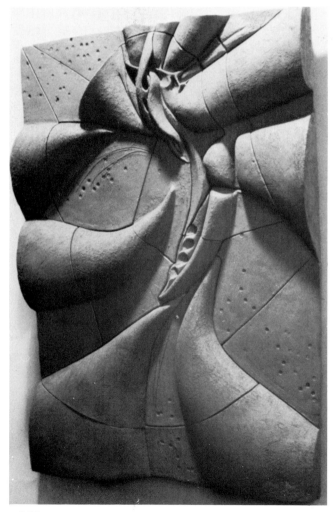

4-77

64

4-78

## Architectural Murals

Clay is most effective in architectural murals when used in high relief. The procedure is much the same as in making smaller wall panels. If depth is anticipated in the mural, slab sections of 2 or 3 inches thick should be rolled out. In this case a departure from the usual pizza method of making slabs is advisable. Slamming fistfuls of clay down on a canvas-covered floor will prevent air pockets. Heavy paddling before rolling will also help. After rolling, the surface is modeled to completion. Sections not being worked should be kept covered with plastic. Occasional misting with water will keep the clay workable until the entire piece is completely modeled. When the work is done and the clay stiffened to almost leather hard, the mural should be cut into convenient pieces. The pieces are then hollowed to a thickness of about 3/8 inch throughout to facilitate drying. Leave a rim on the underside of each piece at least 1-inch wide to provide sufficient bearing surface for tile mastic to adhere to when mounted on wood panels. **4-78**

When the fired mural is to be a permanent installation, the cavity of each piece should be filled to level with neat cement or dryset mortar. This gives a greater bearing surface to each piece before being set into a fresh mortar bed which has been laid up on the wall.

If the mural is to be in a public place, check local building codes to be certain that required installation techniques are used.

4-79

**4-80 and 4-81** Terry Rorison
Before and after restoration of Trushel
  Wood Israel Building, Pittsburgh, PA
Press molded stoneware
Photos: Roy Engelbrecht

4-80

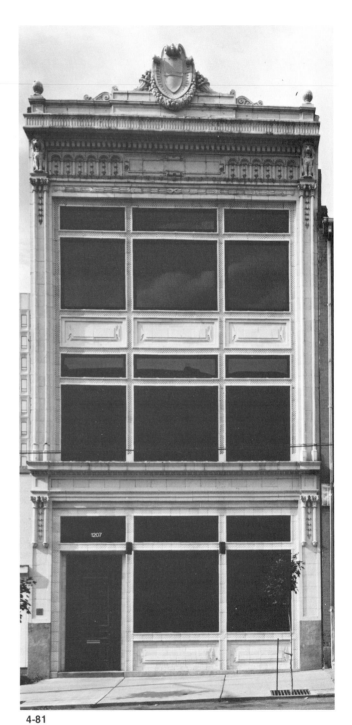

4-81

**4-82**  Ken Vavrek
*Back Track*
Stoneware
35 × 79 × 13″ (89 × 201 × 33 cm)
Photo: the artist

**4-83**  Author
*City of Waltham*
Stoneware, low fire glazes
8 × 8′ (2.4 × 2.4 m)
Waltham Super  Market
David Abrahams Associates, Architects

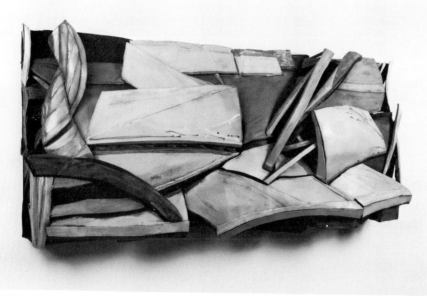

4-82

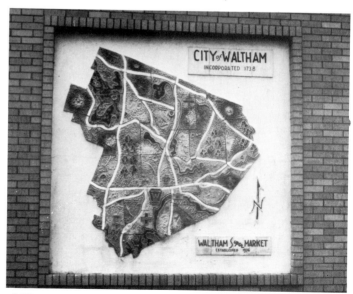

4-83

67

# CHAPTER 5 Throwing

The magic of the potter's wheel has often been the motivation that brings many people to ceramics, only to discover that throwing can be just plain hard work. The techniques described in this chapter have been used successfully by the author in his own work and to teach others of all ages and backgrounds. Some similarities to other methods may be noted, since there is no one correct way. Of course, the best way to learn to throw is to sit at a wheel and do it.

## The First Steps

It is essential that well kneaded clay of the proper consistency be used for throwing. After kneading, good studio practice calls for cutting and making clay balls which are then weighed. In this way it will soon be learned how much clay is needed to make an object of a certain finished size.

To start, three-pound balls of clay are recommended. With this easy-to-handle amount, most people can throw a cylinder 4 inches wide and 8 inches high with little difficulty.

The basic wheel types will be discussed in the chapter on Kilns, Wheels, and Studio Equipment. What is most important is that the wheel be smooth running and comfortable to the user. A sitting position is recommended, although some potters prefer to stand.

A few basic hand tools, either purchased or homemade, are needed. An elephant ear sponge or other thin, natural sponge is important for applying or removing water, a pin tool or hatpin aids in trimming uneven tops of pots, a wooden knife is used to trim excess clay from the base of the pot, and a twisted wire or nylon fishline is needed to cut the pot from the wheelhead. A container of very thin slurry placed near the wheel is necessary to provide a lubricant. Clay absorbs clear water and rapidly softens. .

To protect the hands from possible skin problems due to prolonged immersion in slurry or water, use a *barrier cream.* This is applied to the hands before immersion, forming a protective shield—unlike creams or oils which are used after skin drying and cracking has already occurred. One of the most effective creams is Kerodex 71 for wet work, manufactured by Ayerst Laboratories and available through most pharmacies.

Sit close to and comfortably over the wheel, with all tools, water, and clay within reach. **5-2,** Drop a ball of clay on the center of the wheelhead while the wheel is either still or slowly turning. Try not to mash the ball out of shape when doing this. Great controversy exists over which direction the wheel should turn. Generally, right-handed people turn the wheel counterclockwise and left-handed people will be most com-

5-1

fortable with the wheel turning clockwise. If the wheel is turning counterclockwise, the right hand will be the top hand and the left, the side hand. Clockwise, the reverse is true. Once this has been determined, do not vary positions.

The following method works well for both small and large amounts of clay, with no changes in positions needed. The side hand elbow should rest against the hipbone allowing the back to lend needed pressure. The top hand arm should be locked firmly against the side of the body, allowing the shoulder to apply pressure. In this way the body does the work and the arms and wrists will not tire so easily.

## Centering

Centering the clay on the wheel is the important first step in making any pot. If not done successfully, it will hamper all the other steps necessary to bring a pot to completion.

5-2

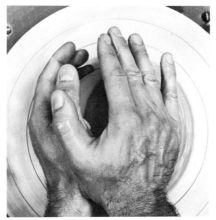

5-3

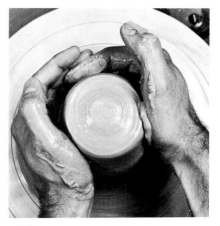

5-4

Lubricate the clay and hands with a thin film of slurry. Too much water will make the clay too soft to handle. Bring the wheel to top speed when centering. The faster the wheel is turning, the less time and pressure are required to move the clay.

**5-3,** With the side hand resting against the side of the clay, slowing increasing downward pressure should be applied just behind the center of the ball with the top hand palm securing the clay firmly to the wheelhead. Pressure should then be gradually increased with the palm of the side hand used to center the clay. Quick motions with either hand or undue changes of pressure will force the clay off center. Lubricate the clay sparingly as needed by applying slurry on the ball with the sponge.

## Forming a Cone

After the clay has been put relatively on center, bring the top hand down the side directly opposite the side hand. **5-4,** Both palms then slowly squeeze the clay upward into a narrow cone. Two or three passes should accomplish this. It is important to use slowly diminishing even pressure, or the top of the cone might be torn off. The top hand palm then pushes the cone down while light pressure is applied by the side hand to guide downward movement. **5-5,** With the side hand braced, the clay can move nowhere else but on center. Repeating this important process three or four times helps center the clay *inside* the ball as well as outside, making it more elastic and workable.

## Opening a Hole

The next step is to open a hole in the center of the ball. The simplest method is to place both palms opposite each other on the sides of the spinning ball with the thumb tips touching the center, and the arms still braced against the body. Arch the thumbs and push them downward into the clay until they are about three-quarters of an inch from the bottom. **5-6,** Do not raise the wrists or in any way alter the position of the hands, for this upsets control of pressure. Instead, if the thumbs do not reach all the way down, push the walls of clay downward with the web between thumb and index finger of both hands. Increasing pressure by the palms will prevent the ball from going off center. **5-7,** When the correct depth is reached, push both thumb tips toward the palms to widen the hole. **5-8,** Then cup the palms slightly under the ball to collect the clay at the base.

The foregoing procedure must be carried out each time a pot is to be made. If any part of it is incorrectly or poorly done, the pot will not succeed.

An alternate method of opening the hole can be used by those who have difficulty coordinating their thumbs or when working with very large amounts of clay. **5-9,** Instead of placing the thumbs over the center of the ball, position all the fingers of the top hand together over the spinning ball of clay, with the thumb resting on the side hand for leverage. **5-10,** Push the fingers into the clay to the proper depth and squeeze toward the side to widen the hole.

It should be noted that long finger nails will hamper any work in throwing clay and should be trimmed as short as possible.

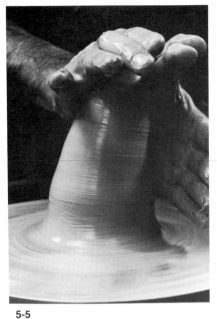

5-5

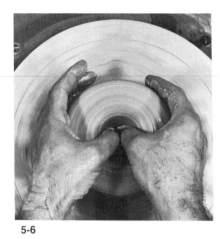

5-6

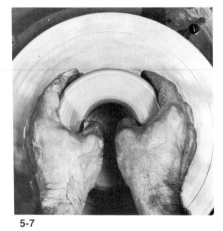

5-7

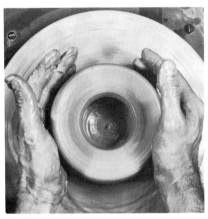

5-8

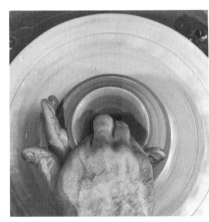

5-9

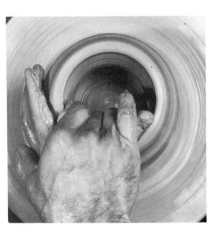

5-10

## Making a Cylinder

After opening the hole, the position of the hands and arms are changed. The arms should now be braced against the sides of the body. **5-12,** With both palms facing and fingers pointing straight down, the side hand goes inside the hole and the top hand directly opposite on the outside with both thumbs interlocked. It is essential that the hands be held in this manner, otherwise the motion of the wheel will be counter to the direction of the hands and the fingers will dig in and cut the clay rather than allow it to slip through.

Starting at the bottom of the hole, cup the fingers slightly and increase the pressure of the fingertips in a pincers fashion. With the wheel turning rapidly, begin to draw the hands upward, pulling the clay. The outside hand must move up a bit first to get directly opposite the inside hand: otherwise the clay will tend to move out instead of up. Slowly reduce the pressure near the top, leaving a slightly thicker rim. **5-13,** Too much pressure might tear off the upper portion and destroy the cylinder. Apply light, even lubrication only when required.

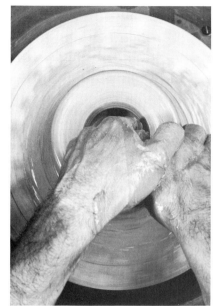

5-12

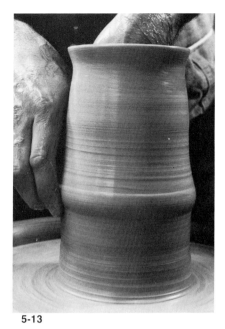

5-13

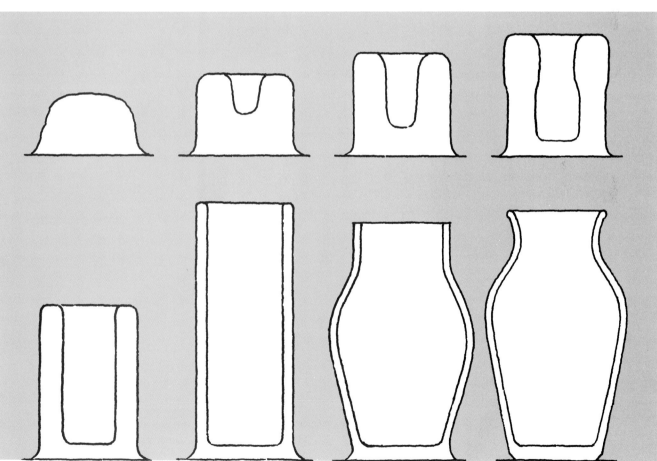

5-11

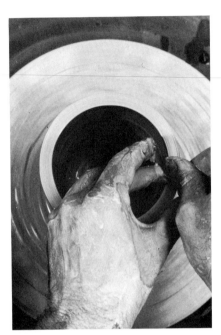

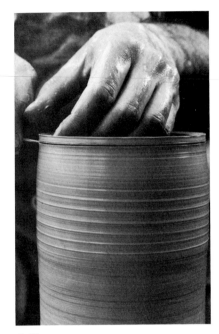

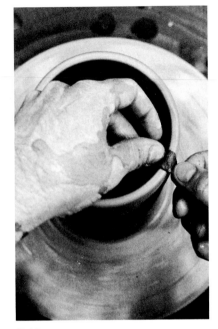

5-14

5-15

5-16

Repeat these hand movements. Start at the bottom each time and slowly decrease the pressure between the fingertips as the top is neared. **5-14,** At the top, slight downward pressure with the thumb or index finger will keep the lip level. As the cylinder grows taller the wheel should be allowed to slow down proportionately. If the wheel remains at too high a speed, centrifugal force will carry the top off center and the piece will invariably collapse. If the cylinder walls are uneven or large spirals appear in the walls, the ratio of wheel speed and up-ward hand motion must be corrected. The slower the wheel turns, the slower the hands should rise. In order to keep the hands perpendicular to the wheel while pulling up the clay, the forearms remain braced against the sides, while the elbows slowly slide to the rear. This action prevents the hands from moving in an arc.

The pin tool can be used to correct an uneven lip. Locking the arms against the side of the body for stability, grasp the pin with the outside hand, leaving enough pin to pass through the cylinder wall. **5-15,** Slowly ease the pin through the moderately spinning cylinder until the point touches the waiting inside hand, then quickly lift up. **5-16,** This leaves a smooth, level lip which can then be thickened and rounded with a sponge or piece of leather. A thick rim looks better than a knife edge, holds glaze better and helps prevent the cylinder from warping.

## Removing a Cylinder

Cutting a piece from the wheel is a simple three-step process. First, hold the wooden knife in the outside hand like a pencil. **5-17,** With support from the other hand, make an angled cut into the base of the moderately turning cylinder to remove excess clay. **5-18,** Next, make a flat cut underneath the excess to free it from the wheelhead. Then take the excess from the wheel. **5-19,** Finally to cut the finished cylinder free, grasp the cutting wire firmly in both hands and draw it taut beneath the slowly turning cylinder, across the wheelhead toward the body. **5-20,** Remove the piece from the stopped wheel by opening wide the index and second fingers of both hands and lifting

72

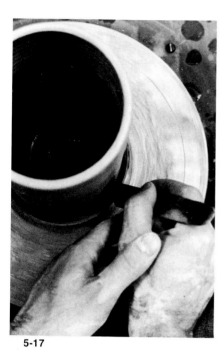

5-17

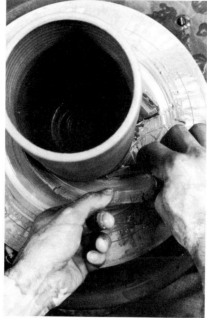

5-18

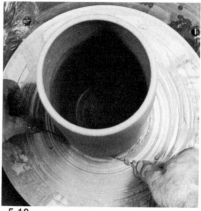

5-19

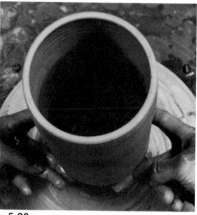

5-20

lightly under the cut base, giving the wheel a slight turn to break the friction.

**5-21,** Pot lifters can also be used to take a piece off the wheel.

The preceding processes should be repeated continually until a natural rhythm is developed between wheel, clay, and potter. Because the cylinder is the basis for all other forms made on the wheel, it is extremely important to master its formation before attempting to go on to other shapes.

A good test of skill is to raise a 3-pound ball of clay into a 4-inch diameter, 8-inch high, even-walled cylinder in three pulls. If it takes more pulling or if the cylinder is not the proper size, it is an indication that the technique has yet to be mastered.

One way to check on the shape of a pot while it is in progress is to set up a mirror on the opposite side of the wheel. With this, a full view of the work may be seen without having to let go or change position.

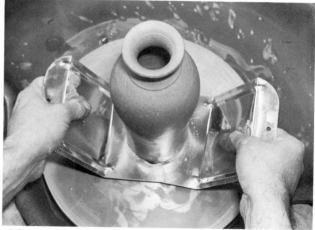

5-21

5-22

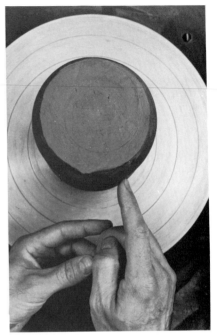

5-23

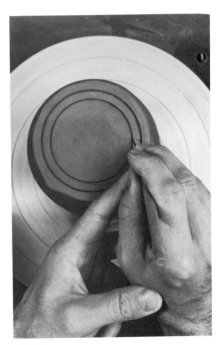

5-24

## Trimming

After the cylinder has been removed from the wheel, it should dry slowly until it is stiff enough to be turned upside down for trimming.

**5-22,** A wide variety of trimming tools are commercially available in many different styles. It is also possible to make trimming tools using spring steel, bandsaw blades, and the like. In either case it is important that the cutting edge be kept sharp and the loop stiff to prevent "chatter" marks when trimming. If these marks should appear on a pot, they can be easily removed by trimming the pot as the wheel is turned in the opposite direction. The tool should, of course, be sharpened before being used again. Round wire modeling tools are generally not successful when used for trimming.

Before putting a pot on the wheel to trim, feel the wall thicknesses to gauge the amount of work needed. To center a pot for trimming, invert it on a slightly wet, slowly turning wheel and tap it into center.

**5-23,** A safer way to secure the pot to the wheel is to invert it on the slowly turning dry wheel and hold a finger near the side of the pot. If the finger touches in only one place, stop the wheel and move the pot a short distance directly away from where the finger touched. Continue to do this until the pot is centered. Secure the pot with three or four equally spaced clay lumps, being careful not to damage the rim. When first learning to trim, use a pin tool to mark the exact location of the foot-ring on the bottom of the pot. A ring that is too narrow will cause the pot to wobble, while a ring that is too wide will make the pot look bottom-heavy.

74

Normally a footring the thickness of the pot wall and no deeper than 1/4 to 1/2 inch is all that is necessary.

After the foot has been trimmed, it should be smoothed with a wooden tool or piece of leather. Trimming marks are very obvious in heavily grogged clay. **5-26,** Rethrowing over the marks with a wooden tool will push the grog back into the clay and make the marks less noticeable.

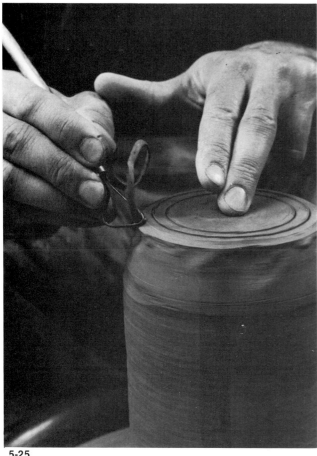

5-25

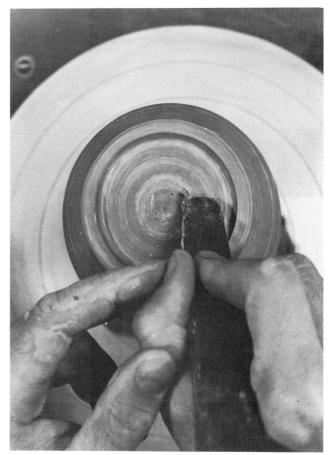

5-26

Secure the outside hand arm against the side of the body or leg and hold the trimming tool with the cutting edge at a 45° angle to the clay surface. Place the inside hand arm against the leg or side and rest the thumb of that hand against the other hand for support. The middle finger should also rest lightly on the center of the pot to help prevent the pot from accidentally flying off the wheel. **5-25,** Bring the wheel up to throwing speed and gently begin to cut away the excess clay. If properly done, long strips of clay should literally fly off the pot. If the tool gets stuck in the clay, remove the pot and allow it to stiffen some more. If short, grainy pieces of clay come off, the pot is too stiff to trim well and should be disposed of. It is sometimes possible, however, to soften the clay by scoring concentric rings into the pot with the pin tool and wetting the area with a sponge before proceeding.

## Trimming Chuck

When footing a bottle or other narrow-necked form, which might fall over when it is inverted, a trimming chuck should be used for better stability. The chuck can be a flowerpot, jar, or hand-thrown and bisque-fired cylinder made especially for this purpose. Center the chuck on the wheel and secure it with three equally spaced lumps of clay. The clay sticks better if the bisque chuck is first soaked in water. Invert the bottle into the chuck, center, secure it, and trim. **5-27,** An inexpensive carpenter's level can be helpful with centering.

Chucks can also be used when trimming pots with rims too wide to rest on the wheel head. Center and secure the chuck and invert the pot onto it.

"Wet" chucks can also be helpful when trimming. Center some clay on the wheel and throw a thick-walled cylinder. Open it to the width necessary to safely support the bottle to be trim-

med. **5-28,** Cover the rim of the cylinder with a piece of cloth, secure the bottle in the chuck and trim. **5-29,** A solid mound of clay can be centered and shaped to the inside curve of a large bowl and used as a chum. Trimming wheelheads are now commercially available. **5-30**

Some potters prefer not to foot at all but simply throw a thinner base and smooth the bottom, to save time. However, a foot serves many purposes, not the least of which is an aesthetic one. A good foot elevates the pot making it seem fuller and more rounded. It also provides a good place to end the glaze, allowing the clay color to show and preventing a runny glaze from sticking the pot to a kiln shelf. A foot also provides a smaller, more even surface to rest on a kiln shelf. A flat bottom might catch on the shelf and warp the pot.

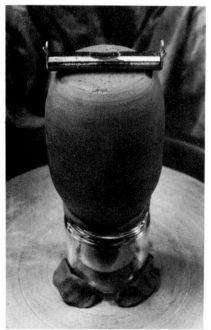

5-27

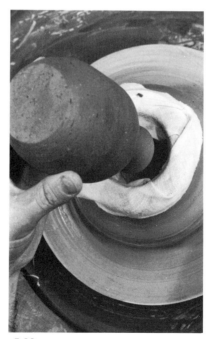

5-28

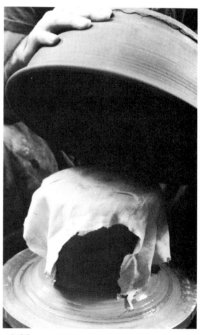

5-29

**5-30** Giffin Grip
Courtesy: Cutter Ceramics

**5-31** John T. Forgey
Drum
Thrown stoneware, animal skin
17 × 9″ (43 × 23 cm)

**5-32** Daisy Brand
Thrown stoneware urn
19 × 14″ (48 × 36 cm)

5-31

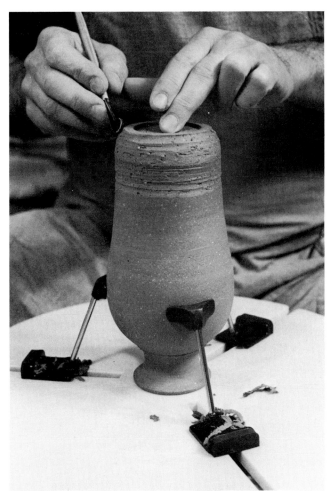

5-30

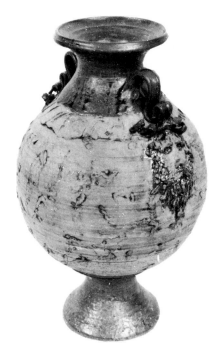

5-32

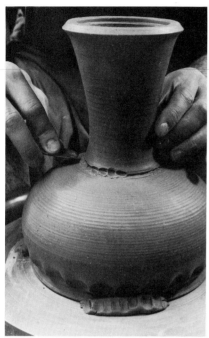

5-33

5-34

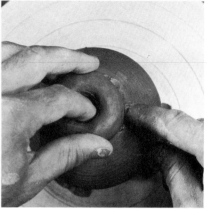

5-35

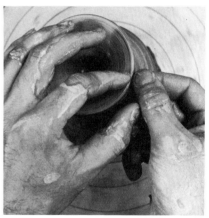

5-36

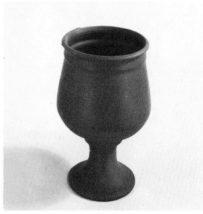

5-37

## Pedestals—Feet

Instead of trimming deep into a thick base, a taller foot or pedestal can be made separately and attached. Allow it first to stiffen, invert it, and trim it. Then trim the bottom of the pot without a foot. Score the surfaces of pot and foot where they are to be joined and coat with vinegar. Place the foot on top of the inverted pot and check for center. **5-33,** Check the foot for level before sealing the parts together. Add coils to insure a firm joint.

Another way to make a pedestal foot is to throw it directly on top of a trimmed pot. Do not remove the pot from the wheel after it has been trimmed without a foot. Score the bottom and coat it with vinegar. **5-35,** Secure a donut of soft clay to it. With a light touch, center the donut and throw a cylinder with an outward flare at the top. Keep enough extra clay at the lip to make a broad rim for the pot to stand on.

Slowly dry the piece upside down, then fire upright.

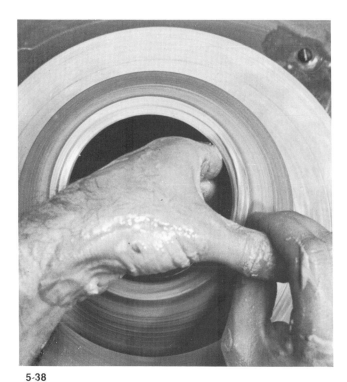

5-38

5-39

## Making a Bowl Form

The next logical step after learning to throw a straight-walled cylinder is to make a bowl form. All of the procedures necessary to make a cylinder must first be carefully carried out; properly kneading clay, centering, opening a hole, and pulling up the wall. Assuming a 3-pound ball of clay is used, the wall is made thicker and shorter than the usual finished cylinder. With the wheel turning at moderate speed, place one finger of the outside hand lightly against the side of the rim. **5-38,** Starting at the bottom with the inside hand, slowly raise the fingers upward while gently pushing out. After two or three light passes, a thin walled bowl is complete. Finish the rim with a damp sponge or piece of leather, cut away the excess clay from the foot, and gently remove the bowl from the wheel.

This technique is known as the *stretching method*, for in actuality that is what is being done to the clay walls. The inside hand is stretching the clay outward from the center while the outside finger prevents the wall from going out of round. Care must be taken not to stretch the clay too thinly because stretch marks will appear and, if the wall is taken out too far, it will split open. If marks begin to appear, it is an indication that the walls are becoming too thin. This may be remedied by using the outside hand to push inward while the inside hand steadies the lip.

Ribs made of metal, wood, or rubber can be used to aid in stretching large pieces. Overuse of these tools can render the finished work slick and lifeless.

**5-41** Steve Haworth
Thrown stoneware bowl
18″ (46 cm) diameter

**5-42** Jim Cantrell
Thrown and cut stoneware bowl
5 × 15″ (13 × 38 cm)

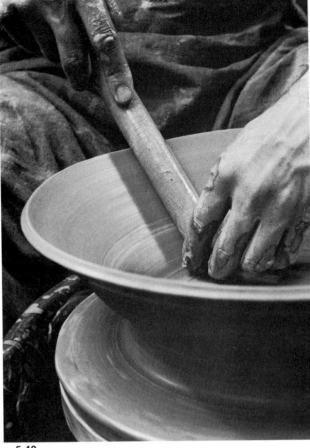
5-40

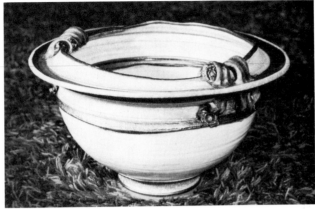
5-41

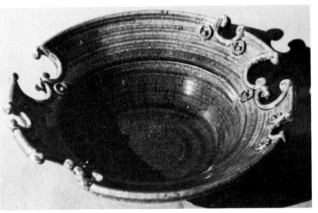
5-42

If larger or wider bowls are to be made, a round bat, which is a clay form support, should be used. Bats can be made of wood, fiberboard, linoleum, or other stiff material, but generally, plaster bats are best. To secure a bat to the wheel, spread a small amount of thin slurry over the wheelhead and on the underside of the bat. Press the bat onto the wheel with a twisting motion until it no longer moves . If the bat does not adhere in a few seconds, scrape off the slurry and start again or use another bat.

Large bowls are made in the same way as small ones, except that wheel speed becomes a very important factor. The wider the bowl, the slower the wheel should turn. **5-39,** Centrifugal force from a rapidly spinning wheel might cause the bowl to open too fast and collapse.

Another way to make a wide bowl utilizes a smooth stick. After a wide low cylinder is thrown, the inside hand holds the end of the stick near the bottom of the cylinder, while the outside hand slowly lowers the stick onto the rim of the moderately spinning cylinder. **5-40,** Pressure is continued until the desired curve of the wall is attained. Then the bowl is finished as usual. Carefully remove the bat by sliding a spatula or long knife under it to break the suction.

When making bowls, or any other pots for that matter, experiment with the shape of the rim. Often a simple form can be made much more expressive or elegant by the way in which the rim is finished.

## Plates

A plate or platter is just a very wide, low cylinder, but a somewhat different technique is employed to insure against splitting. **5-43,** After securing a bat to the wheelhead, center a well-kneaded ball of clay in the usual manner, but continue to press the ball down and outward until it is almost the desired diameter. **5-44,** Then, using the braced inside hand, begin to open a hole in the center by moving the hand partway to the outside. Change the direction of the inside hand and push down and back into the center. This action of throwing toward the center compacts the strained clay and helps prevent the plate from "S-crack" splitting while it dries. Continue to open outward and push back until the bottom of the plate reaches the final diameter. Make all the necessary changes to finish the bottom before pulling up the wall. **5-45,** Raise the wall, make a rim, and finish the lip in the usual way. **5-46,** The rim can also be made by opening it with a stick. By using these methods, the common accident of collapse by overextending the plate rim is prevented. Cut the excess clay away from the base with a wooden knife. Remove the bat from the wheel without releasing the plate. Later when the plate has stiffened, it can simply be lifted from the bat with no cutting wire needed.

To dry large plates or platters more evenly, first place a few sheets of newspaper across the stiffened plate rim. Carefully place a board on top and then invert everything. As the plate continues to dry, the plaster bat will separate from the clay by itself. To prevent the bottom of the plate from bowing upward while drying, place a small weight on the center.

In this way, thinner, flatter bottoms can be made which later require only a minimum of trimming. **5-47,** On very wide platters a double foot rim can help prevent slumping when the piece is fired. Dry the finished plate slowly, upside down on a thin bed of fine grog or a cushion of newspaper sheets to prevent warping.

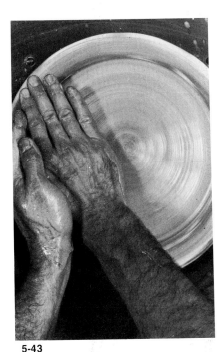

5-43

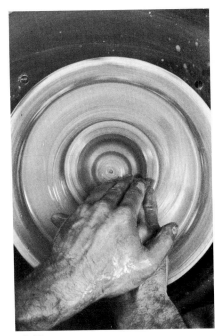

5-44

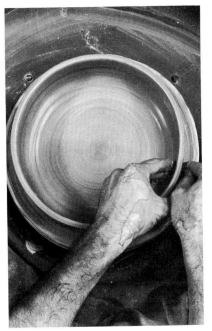

5-45

**5-48**  Robert Parrott
Thrown and cut stoneware plate
22″ (56 cm) diameter

**5-49**  Nancy Peterson
Mirror
Thrown stoneware, coil decoration
12″ (30 cm) diameter

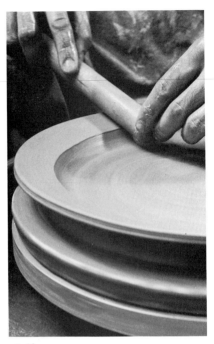

5-46

5-47

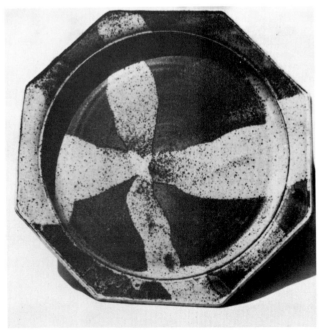

5-48

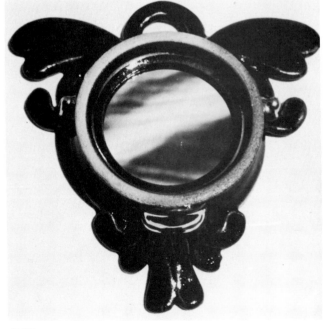

5-49

82

## Throwing off the Hump

Many production potters use a technique of throwing which enables them to make numerous pieces at one sitting without having to knead separate balls of clay. This method is known as *throwing off the hump,* or *lump.* It is also very useful for making small pots, covers, or spouts.

   After kneading a large ball of clay, center it on the wheel and pat it into a cone shape. **5-50,** Draw the desired amount of clay to the top and center it, using the normal method. Throw the object as usual. **5-51,** Trim excess clay from its base, making a deep notch below the bottom of the pot. **5-52,** Slow the wheel down, pass a cutting wire through the notch to release the pot, and remove it. Recenter the top of the hump and continue throwing.

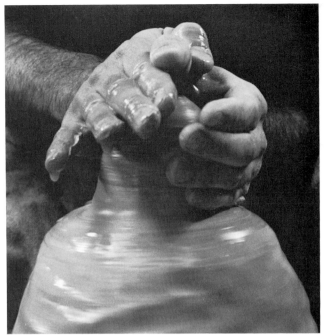

5-50

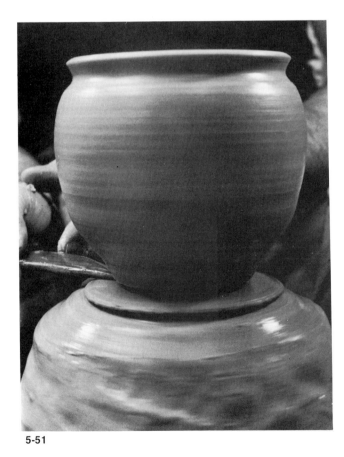

5-51

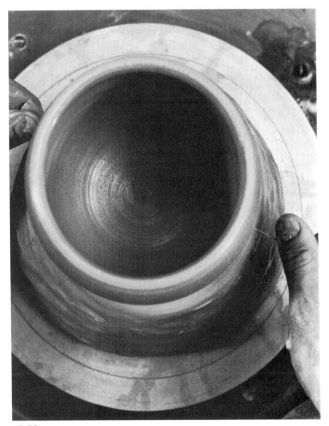

5-52

## Bottles

Bottles also begin as cylinders. **5-53,** A straight bottle form can be made by pulling the upper portion of a cylinder a bit taller with a thinner wall. **5-54,** With both hands directly opposite each other on the outside, use the tips of thumbs and index fingers to slowly squeeze in and upward on the moderately spinning cylinder. Repeat this action, called *collaring* or *necking,* keeping thumbs and fingertips equally spaced to avoid twisting the clay. Each time a pass is made, the clay wall becomes thicker. **5-55,** After two or three squeezes put a finger inside and outside the neck and pull up the clay wall. Continue collaring until the neck is well formed. Then finish the lip, cut excess clay from the bottom and remove as usual.

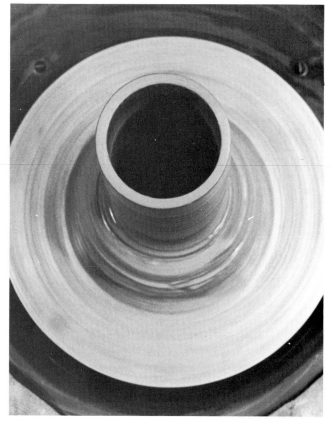

5-53

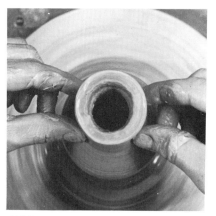

5-54

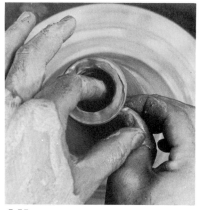

5-55

**5-57** Bette Casteel
*Blue Plum Bottle*
Thrown stoneware, reduction ash glaze
6¹/₂ × 3″ (16 × 8 cm)

**5-58** David Atkinson
Thrown and assembled stoneware bottles
14 × 8 × 7″ (36 × 20 × 18 cm)

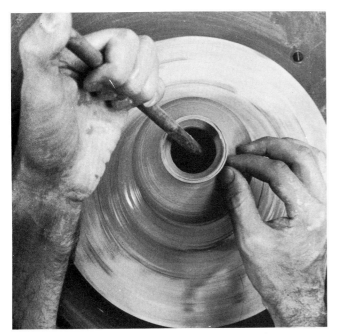

5-56

5-57

To make a rounded bottle, after the cylinder is thrown, only partially neck the top. **5-56,** Then insert a sponge-on-a-stick or a throwing stick into the bottle and stretch the lower portion of the form to the desired curve. Hold the throwing stick as shown, with the thumb on top to keep it steady. The neck is then finished in the usual manner and the bottle is cut from the wheel.

For added fullness in a bottle form, stop the wheel just before finishing the lip and gently blow into the bottle. If the walls are evenly thin, the entire form will expand and round out. Then finish the lip as usual.

5-58

## Pitchers

For best results in making a pitcher, it is first necessary to throw a thin-walled cylinder. **5-59,** Stretch some fullness to the form and collar it near the top. **5-60,** To make the spout, pinch in the lip using the tips of the thumb and index finger. **5-61,** Then, while the thumb and finger are still in position, draw the inside of the lip over the outside with a moistened finger of the other hand. This allows the pitcher to pour without dripping. Cut excess clay from the base and set the pitcher aside to stiffen.

## Handles

In order to make a handle, first shape a small piece of clay into a cone. **5-62,** Holding the clay in one hand, wet the other and grasp the clay, drawing downward while evenly reducing pressure. Repeat this procedure until the clay has been pulled longer than the desired length. Wet the hand only when necessary to prevent the clay from becoming too soft. If splits appear in the handle, break off the clay at this point and continue to pull if there is enough clay. Otherwise, start again with more clay. To give the handle more grace after making the clay long enough, position the thumb in front of the clay and curve the index finger behind. **5-63,** Then apply light pressure while drawing the hand downward to create a groove and alter the profile of the handle from round to wide and thin. **5-64,** Next, take the bottom end of the clay and swiftly bend the handle to connect the end to the lump. Set this down on the lump and allow it to stiffen while trimming the pitcher.

When the pitcher and handle are ready to join, cut the handle from its lump, score the ends and matching points on the pitcher, soften these with vinegar, and then press the handle firmly to the pitcher. **5-65,** Seal all joints carefully, adding a tiny coil if needed to smooth the handle into the form.

**5-66** It is also possible to pull a handle directly on a pitcher. Simply attach a cone of clay onto the wall of a leather hard pitcher. Hold the pitcher horizontally and draw the handle downward until it is pulled to the desired length. Turn the pitcher upright and attach the bottom of the handle to the pitcher.

Either method can be used to make handles for cups and vases as well.

## Drying

Allow the finished pitcher to dry slowly under plastic. Because the handle tends to dry faster than the body of the pitcher, the handle may be wrapped with a strip of damp cloth to help equalize drying. A better way to slow the drying would be to coat the entire handle and joined areas with wax resist. The wax later burns away in the bisque fire.

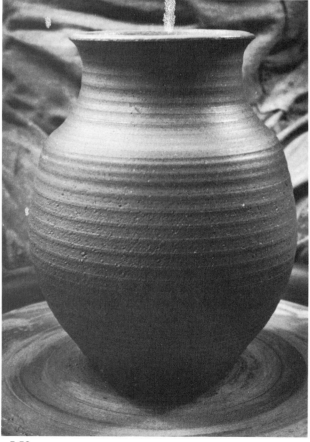

5-59

5-60

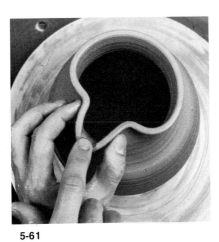

5-61

5-63

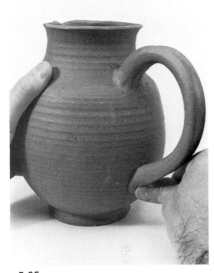

5-62

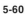

5-64

5-65

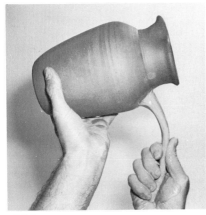

5-66

**5-67** Robert Parrott
Pint, quart and two-quart pitchers
Thrown stoneware

**5-68** Georgette Zirbes
Thrown stoneware pitcher and mugs
Pitcher: 9″ (23 cm) high

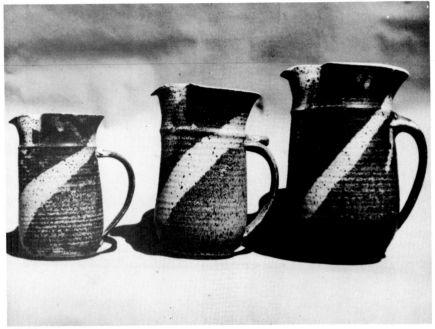

5-67

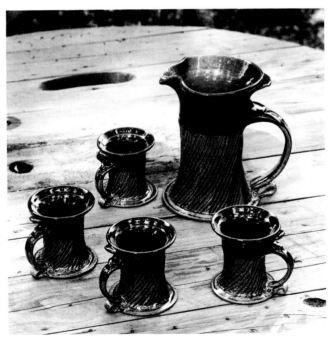

5-68

## Covered Containers

Think of a covered container as a bowl with a plate on top and it becomes simple to make. The important factor to keep in mind is that somehow the plate, or cover, must be made to fit well. There are many different configurations that the lips of the bowl and cover could take, but basically they fit into three categories. The first is a smooth-lipped bowl with the retainer flange as part of the cover, the second with the flange as part of the bowl and the third a "rose petal jar" type with a domed cover that fits over the bowl's upturned lip. To be sure that the cover fits well, a measuring stick or pair of calipers is useful. It is important that the bowl and cover be made during the same session; otherwise the shrinkage might be different and prevent a good fit.

### Cover with flange

To make the first type of container, with the flange in the cover, throw a bowl with a smooth rim. **5-69,** Accurately measure the inside diameter of the rim and set the bowl aside. Throw a shallow bowl about the same diameter as the first, leaving a little extra clay at the rim. **5-70,** Slowly widen this bowl until the caliper tips measure into the middle of the rim. Lightly push down the clay on the outer portion of the measurement until a flange of about 1/4 inch stands upright. **5-71,** Using a wooden tool or fingernail make sure that the flange is properly square before finishing the outer edge of the lip. Always check the measurements before cutting the cover off the wheel. It is better to have the flange a hair wider than the given measurement to insure a snug fit later. A measurement that is too narrow causes sloppy, loose fitting covers. The variation in shrinkage is caused by differences in the orientation of clay particles in the horizontally thrown cover and vertically thrown bowl.

When the parts are leather hard, trim the bowl as usual and then trim the cover without a foot. While the cover is still secured to the wheel, weld a small donut of very soft clay onto the center of the dome. **5-72,** With a very light touch, throw an open knob. Knobs or handles can also be hand fashioned, if desired, but must not be made too thick or closed because they will explode in firing. After trimming, place the cover on the bowl and set both aside to dry slowly. Drying and firing the pieces together helps prevent undue warping.

5-69

5-70

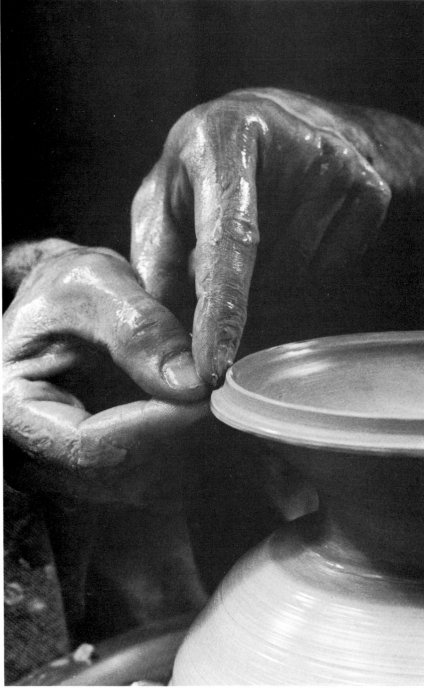

5-71

5-72

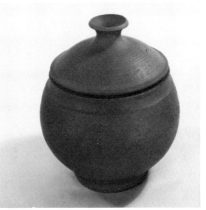

5-73

**5-74** Author
Ox-blood covered jar
Thrown porcelain, reduction fired
12 × 7 × 7" (30 × 18 × 18 cm)
Collection: Mr. and Mrs. Oliver Emerson
Photo: John I. Russell

**5-75** Author
Garden lantern
Thrown stoneware, electric light
28 × 9 × 9" (71 × 23 × 23 cm)
Collection: Donald and Mary Melville

**5-76** John Perri
Thrown stoneware covered jar, ash glaze
16 × 12" (41 × 30 cm)

5-74

5-75

5-76

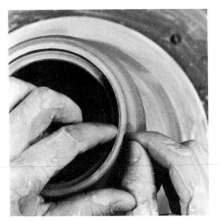

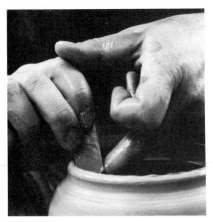

5-77

5-78

**5-80** Author
Celadon covered jar
Thrown porcelain, reduction fired
11 × 5 × 5″ (28 × 13 × 13 cm)
Photo: John I. Russell

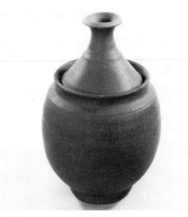

5-79

## Bowl with flange

The second type of bowl and cover combination has the flange inside the bowl. To do this, a bowl is thrown the normal way but extra clay is left at the rim. **5-77,** Once this has been done, gently push the inner half of the rim downward at least 3/8 to 1/2 inch. Try to make the flange level and squared out from the wall. A square cut wooden tool helps. **5-78,** Finish the edge of the flange and lip. Take a measurement of the inside diameter of the lip before removing the bowl from the wheel. The cover is a shallow bowl with its outside diameter slightly larger than the caliper measurement to allow for shrinkage. When leather hard, the cover is trimmed and a knob added as before. Trim the bowl and allow both parts to dry together.

## "Rose petal" cover

The third kind of container is often used for storage because, if properly made, it provides a better seal at the cover than the others. To achieve this end, the bowl is thrown taller than the desired height. **5-81,** The lip is slowly coaxed inward toward the center by moving the outside hand over the inside hand, which remains stationary. **5-82,** Move the outside hand back and reverse the procedure, holding the outside hand still and raising the inside hand to stand the lip upright. **5-83,** Use a wooden tool to square the exterior of the flange. Take the measurement of the outside diameter of the flange and throw a dome-like cover whose inside diameter equals the measurement. After trimming, dry and fire the pieces together. A more traditional version of the rose petal jar has a third part, a lid which fits on the lip inside the cover. This added piece is thrown as a small bowl the diameter of the inside of the jar rim, with an outward turning lip extending just to the outer edge of that rim. **5-84**

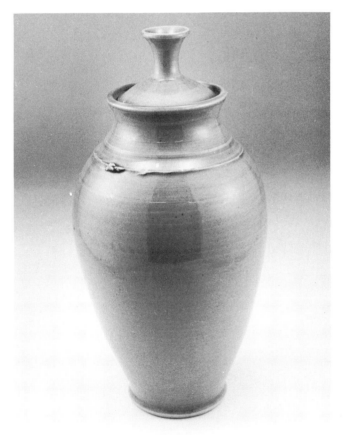

5-80

**5-85** Madeline Landing Pots and
Robert Paul Massaro
Covered jar
Thrown, incised stoneware, underglaze,
unglazed
6″ (15 cm) diameter
Photo: Jason Jones

5-81

5-82

5-83

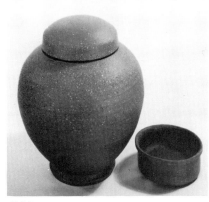

5-84

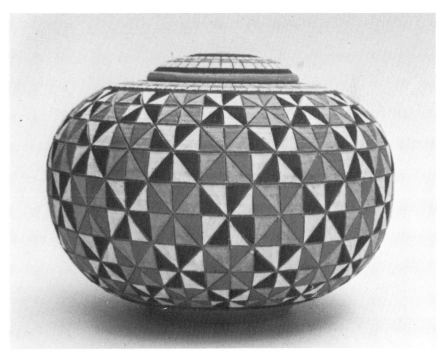

5-85

5-86

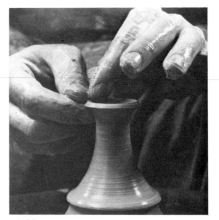

5-87

5-88

5-89

## Teapots

The true test of skill regarding ability to throw well on the wheel is the execution of a teapot. The challenge is to make it well balanced, easy to handle, with a spout that pours without dripping and a cover that fits snugly. If each of the objects previously discussed has been successfully mastered, a good teapot can be made with little difficulty.

Teapots are generally made in four parts: body, cover, spout, and handle. The first three parts should be thrown and properly measured at the same sitting, then allowed to stiffen equally. **5-86,** The body of the teapot should be made thin-walled, full, and with a small opening at the top. **5-87,** The cover should be made upside down with a long flange to prevent it from falling out during pouring. **5-88,** Make the spout like a bottleneck with a flaired rim and sharp edge to pour without dripping.

**5-89,** When the parts are ready to trim, pull a handle large enough to grip with the whole hand and graceful enough to complement the shape of the body.

Trim the body and the cover so that they fit together. Then throw a knob on the cover using a small donut of soft clay. **5-90,** If an exhaust hole is desired, it might be best drilled in the center of the knob instead of elsewhere on the cover where it might detract from the design.

5-90

94

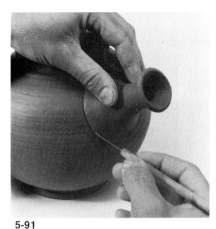
5-91

Line up the spout so that it is at a good pouring angle and not too low on the body. **5-91,** The tip of the spout must rise above the maximum liquid level; otherwise the tea will run out. **5-92,** After the spout alignment has been marked on the body, drill a number of small holes with a potter's knife or drill bit inside the mark. These aid in the smooth flow of liquid and keep tea leaves from pouring out. **5-93,** Score the surfaces to be joined, apply vinegar, and weld the spout to the body. **5-94,** Align the handle directly opposite the spout, mark the spots where it is to be joined, score the surfaces, apply vinegar, and weld the handle firmly to the body. **5-95,** Replace the cover and allow everything to dry slowly. Wax resist can be used on the handle, knob, and spout tip to retard drying.

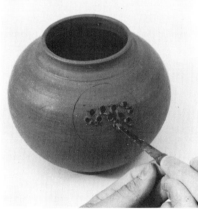
5-92

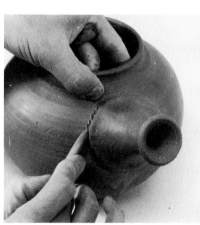
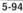
5-93

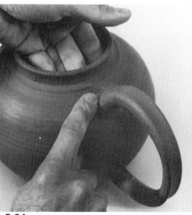
5-94

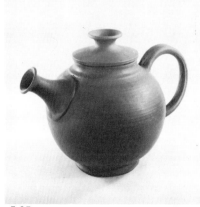
5-95

**5-96** William A. Coombs
Thrown stoneware teapot
11 × 8″ (28 × 20 cm)

**5-97** Ragnar Dixon Naess
3-legged Teapot on Warmer
Thrown, incised, carved stoneware,
    reduction fired
Teapot: 6 × 6 × 6″ (15 × 15 × 15 cm)
Warmer: 3 × 4 × 4″ (8 × 10 × 10 cm)
Photo: the artist

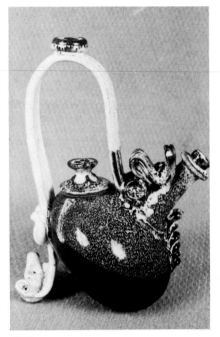

5-96

5-97

5-98

**5-98** Jinny DePaul
Teapot
Thrown, handbuilt porcelain, reduction
 fired
11″ (28 cm) high
Photo: Mark A. Regan

**5-99** Ragnar Dixon Naess
*Scorpion Teapot*
Thrown stoneware, reduction fired
5 × 10 × 7″ (13 × 25 × 18 cm)
Photo: the artist

5-99

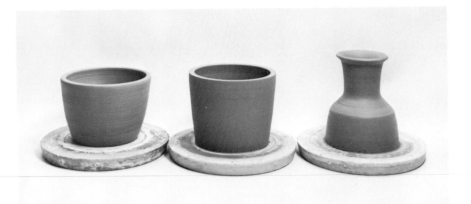

5-100

## Large Thrown Vases

There are several ways to throw large pieces. One way is to center a great amount of clay and attempt to bring it into shape on the laboring wheel.

### Joined pieces

**5-100,** Another method is to throw separate pieces to be fitted together after they have stiffened. First, throw a sufficiently thick-walled base on a bat. Throw the next section on a bat, but shape it as a ring in an inverted position. Throw the next ring on a bat in an upright position, and so forth in alternating positions until all the needed pieces have been made. The reason for alternating the pieces is so that when they are joined, bat rims will rest against bat rims and free rims against free rims. This compensates for the uneven drying that naturally occurs.

Measure each piece with a rule or large calipers as it is being thrown so that each rim will make a good match when all are finally joined. As soon as the sections are stiff enough to handle, remove them from the bats and gently stack them in position. Wrap the stack tightly in plastic and leave it alone at least a day to allow the moisture content in the clay to even out.

When the clay has set up sufficiently for trimming, take the base from the stack, invert, and trim it. Recenter the trimmed base right side up. Score the rim and apply vinegar to it. Score and vinegar the rim of the next ring and invert it onto the rim of the base. If everything has been properly measured and thrown, the fit should be very close. **5-101,** Join the pieces and trim the joint. Continue to do this until all the pieces have been joined and trimmed. When all the parts have been joined, the entire piece can be given a final trimming, if necessary. Then wrap the piece in plastic and allow it to dry very slowly.

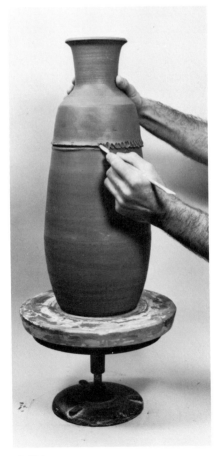

5-101

5-102   Japanese Potter
Photo: the author

5-103   Don Reitz
Vase
Thrown stoneware, salt glaze
50″ (127 cm) high

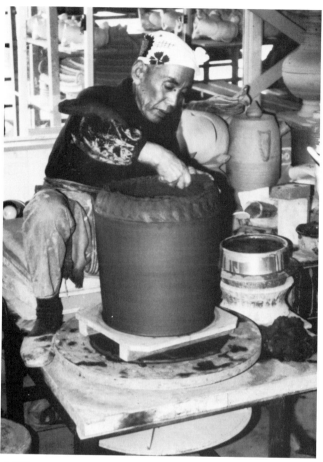

5-102

## Coil and throw

This method allows for a continuing throwing cycle without having to measure or use additional bats.

Throw a thick-walled base section in the usual manner. Next, roll a thick coil and place it on top of the rim of the base. Secure the two carefully. Starting slightly below the joint, continue to throw the coil upward. Be careful not to throw too thinly. Continue to add coils and pull them up until the piece starts to get wobbly. Either remove the piece from the wheel and allow it to set up, or stiffen the clay by heating it. If a heatlamp or torch is used, keep the work revolving on the wheel while it is being dried. Some potters suspend a high-wattage light bulb inside their work to provide continuous heat as they throw. When the clay has stiffened enough, continue with the process until the piece is finished. Remove the piece, wrap it in plastic, and allow it to dry slowly.

These methods make it possible to throw large smooth-walled forms without exerting great amounts of physical energy.

By simply leaving the joints visible, very striking large vase forms can also be constructed with the same methods.

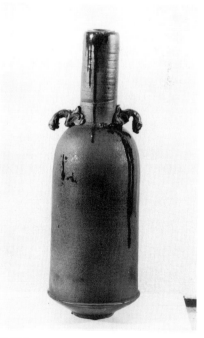

5-103

## Hollow Ring Forms

Hollow ring or donut forms are most easily thrown on a bat. First, knead a sufficient amount of clay and roll it into a thick coil. **5-104,** Place the coil on the bat, making a circle the approximate size of the desired ring. Do not butt the ends of the coil together. Instead, overlap them carefully so that there is no lump in the ring.

With the wheel turning, carefully apply pressure to the ring until it is running smoothly with no unevenness in height or width. **5-105,** Then, with thumb or finger, gently press a groove into the center of the ring and push downward until the clay is a bit thicker than the desired wall thickness. **5-106,** Next, pull each wall upward, curving it outward and then in toward the other. **5-107,** Carefully close the two walls together so that they are firmly joined with no seam showing. Trim the base inside and out with a wooden knife. Remove the bat from the wheel. **5-108,** When the donut has stiffened, invert it on the bat, and trim away the excess clay. Donut forms can be used to make traditional pilgrim bottles, sculptural pieces, or a variety of works. **5-109**

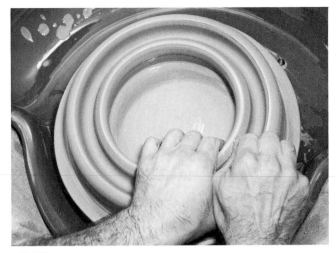

5-105

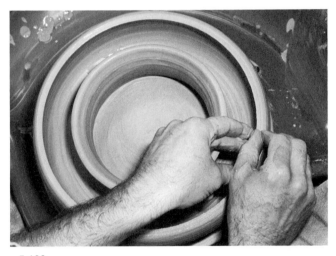

5-106

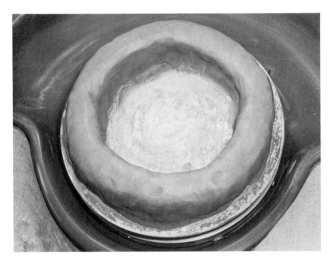

5-104

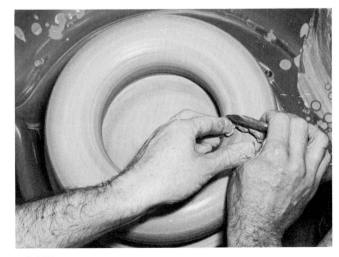

5-107

100

**5-110**  Michael A. Guadagno
*Cactus Mirror*
Thrown, handbuilt porcelain
14¹/₂ × 12″ (37 × 30 cm)

**5-111**  Joel Moses
*Spiral Geometric* Double walled pot
Thrown stoneware, raku fired, tape resist
7¹/₂ × 16 × 16″ (19 × 41 × 41 cm)
Photo: Mike Pocklington

5-108

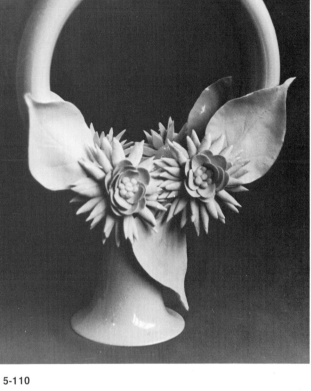

5-110

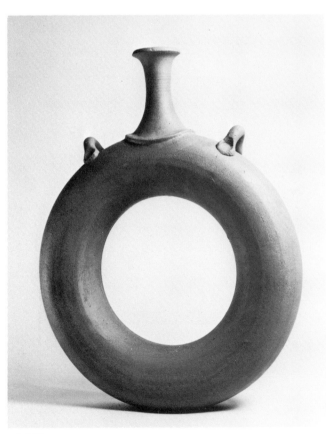

5-109

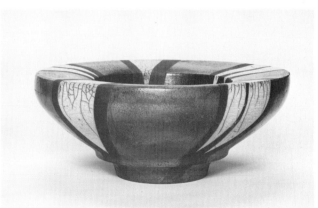

5-111

**5-112** Turker Ozdogan
*Gordian Knot*
Thrown hollow ring stoneware form
92 × 22" (234 × 56 cm)

**5-113** Gary T. Smith
Thrown stoneware sculpture
28 × 18" (71 × 46 cm)

## Large Sculptural Forms

Large sculptural forms can be constructed using wheel thrown parts. It is often best to have a sketch with dimensions of the object to be built. After planning the sizes and joining of the pieces, all the parts should be thrown, trimmed and allowed to stiffen before being assembled. The assembly process is the same as before, scoring the surfaces to be joined, applying vinegar, and then welding the parts together, adding tiny coils if needed. It is very important that a sufficient number of holes are drilled in all strategic points to allow steam to escape during the firing. The form must be completely hollow with no enclosed spaces or solid parts. A well-executed figure with a blown-off arm could result if a hole is inadvertently left out.

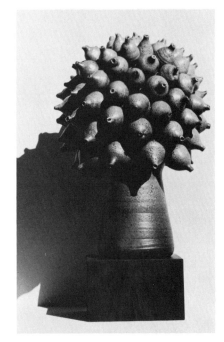

5-112

5-113

**5-114** Victor Spinski
*Machine Form*
Thrown and molded earthenware, luster
  glaze, decals
5¹/₂′ (2 m) high

5-114

## Dry Throwing

Dry throwing is an advanced technique that can be used to successfully throw very large, thin-walled pots without the usual problems of wobbling and collapse. The major advantage of this method is that because no water is used in throwing, the pot does not get soft and slump. In fact, during the throwing process, the clay actually becomes stiffer, allowing more time to refine the form.

For best results the clay must be well homogenized and stiffer than usual. At first, amounts of 5 to 10 pounds should be used until the process becomes familiar. Amounts of 25 to 50 pounds or more can be easily thrown after sufficient practice.

Centering is carried out using normal wet methods. After the hole has been opened, completely dry the hands. From this point on slurry is not used. The hands must be held in the vertical pincers position, directly opposite each other. Only the tips of the fingers should touch the clay wall. Most difficulties with this method occur because the fingers are not properly positioned.

Because the clay is stiff, the wheel can be turned faster for throwing, but to prevent twists, pulling up must be done more slowly.

Bring the cylinder up to an even thickness on the first few pulls. Then draw up the top third much thinner than the rest. Pull the middle third next and then the bottom portion. Between each of these pulls, make a full length draw to keep the cylinder centered. After pulling the clay to its full height, the stretching method can be used, dry, to complete the form. Either the fingers or throwing ribs can be used, provided they are kept dry.

To make a narrow neck, throw the top section in and upward, using one hand inside and the other outside. The usual necking method does not work well in this case. A dampened sponge to smooth the lip is all the water necessary to finish the piece. Remove the pot from the wheel in the regular way.

Because the clay is stiff to begin with and tends to set up faster than usual when drying, care should be taken that it is dried evenly.

**5-115**  Doug Blum
*The Horn*
Thrown stoneware stem, porcelain
  globes, electric lights, unglazed
36 × 22 × 12″ (91 × 56 × 30 cm)
Photo: Silversun Studios — Jim Kane

**5-116**  Arretine Bowl
Merrimac Pottery Company, ca. 1910
Unglazed earthenware
7¹/₂″ (19 cm) diameter
Courtesy: Worcester Art Museum

5-115

## Jiggering

Before the first century, the Romans were jiggering with bisque molds to produce multiples of a clay object. The early Chinese used a similar technique to produce multiples of finely carved bowls and plates.

Originally, the British used two terms to identify the process. *Jiggering* meant using a turning bat to form the interior of an object when clay was pressed onto it. *Jollying* denoted the method of using a bat to form the exterior of a piece when clay was forced inside it. Today jiggering is generally used to describe both methods. In either case, a plaster bat is placed on a wheel with a dropped or bucket head, or a flat wheelhead with guide pins to lock the bat in place. **5-118,** Clay is then sandwiched against the bat by a wooden or metal template mounted on a pivoting arm that is fixed to a vertical brace on the wheel. The bats are contoured for use in making wide plate or platter shapes, or simple cup or pot shapes with no undercuts. The templates are cut in profile to form the underside and foot of a plate or to make the interior of a pot. Additionally, the template is designed to control the final thickness of the clay wall. While only one template is needed for each design, many bats must be used to make the technique a worthwhile production method. Jigger bats in various contours and jigger arm assemblies are commercially available. For information on making plaster jigger bats, see Chapter 12.

For flat work, cut a slab of well-wedged clay and paddle it onto a bat secured to the wheel. As the bat is spinning, lower the template slowly and firmly onto the clay until the edge presses against the rim of the bat. Hold the template in this position for a moment to be certain the clay shape is correct. Keep a damp sponge ready to provide lubrication for the clay if needed.

Once the piece has been pressed, remove the bat from the wheel, replace it with another, and repeat the process. Allow the clay forms to stiffen until they can be safely removed from the bats.

For cup or pot shapes, the clay must be pre-formed before the template can be effectively used. Either throw the basic shape on a wheel and place it in the bat, or put a ball of clay into the bat and draw it against the side of the spinning bat by hand. Then use the template to press the final form.

5-116

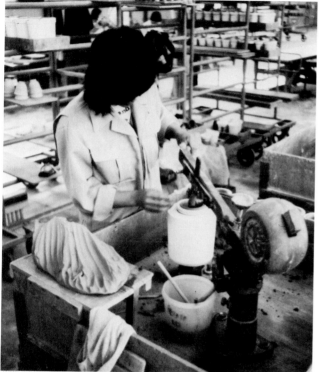

5-117

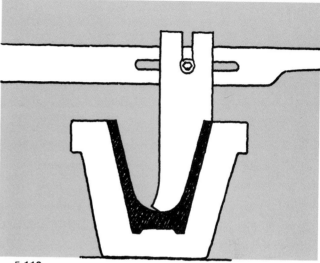

5-118

# CHAPTER 6 Design in Clay

**6-1** Author
Teapot
Thrown porcelain
6 x 9 x 6″ (15 x 23 x 15 cm)

**6-2** Christina Bertoni
Untitled 1975
Slab-built earthenware, china paint
6 x 9 x 6¹/₂″ (15 x 23 x 17 cm)
Photo: the artist

When first working in clay, the main concern is just to make an object hold together. Once this has been accomplished the imagination is free to explore the development of a good design.

Good design is a combination of vision and common sense. It is akin to the difference between looking and seeing. Looking both ways before crossing a street involves merely a quick glance to insure survival. Seeing an object involves a conscious effort to focus not only the eyes but the mind as well; to actively discern the object's parts; to compare its shape with objects of a similar nature; and to decide its individual merits. While the public cannot see an object until it is a *fait accompli*, for the artist, a work must be visible in the mind's eye before it is ever constructed.

While technical facility is an important part in the execution of a ceramic form, no amount of expertise can substitute for the lack of a well conceived design.

The following principles of design apply universally without regard to time, place or media. They will serve as an invaluable guide to developing well designed ceramic objects.

**A purpose should be evident in the work.** For example, a utilitarian object should, by its design, fulfill its intended function in the best possible way. This does not mean that it must follow traditionally assigned silhouettes. Some designs have remained relatively unchanged over time because they are pleasing and serviceable. Others have not changed due to force of habit or lack of imagination. In either case, designs should be looked at critically, with a constant eye toward improvement. Just because teapots have for centuries had one handle and a pouring spout, it is not necessary to stay rigidly within that format. A teapot may not require a typical handle if there is another way to lift it.

**6-3** Jim Cantrell
Pitcher
Thrown stoneware
10″ (25 cm) high

**6-4** Thom Collins
Sculpture
Thrown stoneware
19 × 20″ (48 × 51 cm)

**6-5** Edward Camp
*Free Form No. 3*
Thrown porcelain, lacquer
29 × 11 × 9″ (74 × 28 × 23 cm)

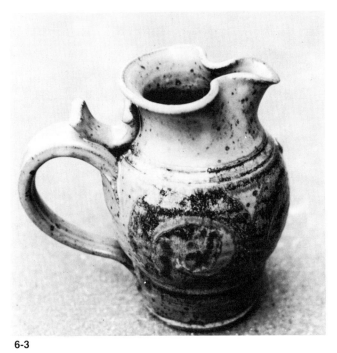

6-3

6-4

6-5

**The parts of an object should reflect their importance.** A small-bodied pitcher with a large spout might make a better watering can. If the main function of a pitcher is to hold liquid, then the body should obviously be larger than the spout. The spout need only be sufficient to direct the flow of liquid. The handle should be large enough to hold comfortably for lifting, transporting, and pouring.

**Balance is an important consideration.** In most clay ware, symmetry is automatically imposed because the object must balance to stand upright. Symmetry is not necessary as long as the central axis of a form falls within the circumference of its base. A piece should also have a visual axis around which all the parts eventually converge in a manner that can stimulate and please the viewer. Odd numbers of appendages, spouts, feet or handles can offer a dynamic balance that even numbers do not.

**6-6**   Mary Lou Alberetti
Raku sculpture
15 × 20 × 15″ (38 × 51 × 38 cm)

**6-7**   Dan Gunderson
*Dancing With My Chair*
Thrown low fire clay, underglaze
20″ (51 cm) diameter
Photo: Judith Durick

**The form of the object should be developed in harmony with the materials used.** Work done in clay can exploit its flexible plastic quality, emphasize volume or bulk, or utilize texture to enhance the surface.

**Contrast creates impact.**   A simple cylindrical form, for example, can provide a ground over which a complex surface treatment can easily move. A subdued surface on a multi-spouted organic form directs the interest to its convolutions of volume. In either case, if form and surface are both boldly executed, confusion will dominate, and the total object will be less effective. Contrasting color is also a way to draw attention to the significant part or parts of a form. The plain colored interior of a pot offers good contrast to a more actively colored exterior. To achieve dynamic contrast between positive and negative space, one should be greater than the other. For example, a bowl which is wider than it is deep has more visual appeal than another with equal dimensions.

6-6

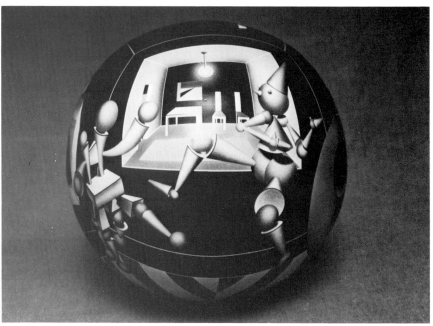

6-7

108

**6-8**  Gordon Orear
Sculpture
Thrown stoneware, brass
14¹/₂ × 13¹/₂″ (37 × 34 cm)

**6-9**  Author
Fountain
Slab-built and thrown stoneware
40 × 17 × 17″ (102 × 43 × 43 cm)

6-8

6-9

**Simplicity can make the most elegant statement.** A work which expresses a well conceived idea can motivate the viewer to thoughts and emotions even beyond those intended by the artist. This does not mean that for an object to be effective it must be plain. Even a sprawling, multiunit form can have simplicity if there are no extraneous parts to detract from the whole.

109

**Tactile quality is part of the experience of a work.** People like to touch ceramic objects. Drinking or eating from smooth ceramic surfaces makes either activity more pleasurable. Sculptural forms which play rough areas against smooth, capture light and offer both a visual and a physical tactile sensation.

**Boldness and exaggeration give life to an object.** Weak curves, lazy linear changes from belly to shoulder of a vase, a thin or non-existent lip, all contribute to a lackluster form. A high bulging shoulder which sweeps inward to a narrowed neck finishing in a well articulated lip can elevate a vase and make it seem larger and fuller.

6-10

**6-10**  Sophia Fenton
*Sea Urchin*
Slab and coilbuilt stoneware
15 × 13″ (38 × 33 cm)

**6-11**  Joel Moses
*Floating Lid Container*
Thrown stoneware, raku fired
15 × 7 × 7″ (38 × 18 × 18 cm)

**6-12**  Helen Richter Watson
*Sculpture No. 3*
Slab-built and thrown stoneware, luster
  glaze
68″ (173 cm)

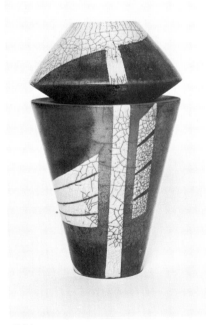

6-11

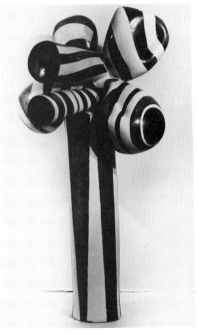

6-12

6-13

6-14

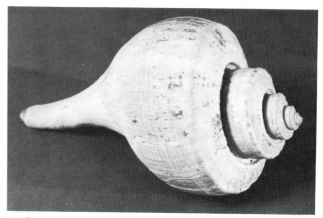

6-15

**Proportion can create strength and excitement in a form.** It can also kill it. A tall narrow vase appears to continue its upward movement while a short, squat form seems heavy and dull. For a start, a ratio of 3:1 can be applied to the proportions of an object. A piece will often have more interest if its height is three or more times its width. The same is true of an open form which has its width three or more times its height. This is not intended to be a hard and fast rule, but more often than not, a relationship such as this does help create a more impressive form. The volume proportion of an object can exert control over its visual weight. Using the same ratio of thirds, a form with its greatest width at the top will have a *dynamic* or light appearance. A similar form with its widest part in the lower third will appear *static* or heavy. One with the widest part in the middle will be *neutral*.

**Each object has its own optimal weight.** For instance, if a cup feels heavier than it ought to, its aesthetic appeal is immediately diminished. Using thin slabs and coils or throwing thin walls will usually give the most satisfactory results. It is probably not possible to make a clay object too light. On the other hand, if an object needs to give the impression of solidity, as in the case of a pedestal planter, it is often advisable to have more weight in the pedestal than is actually needed.

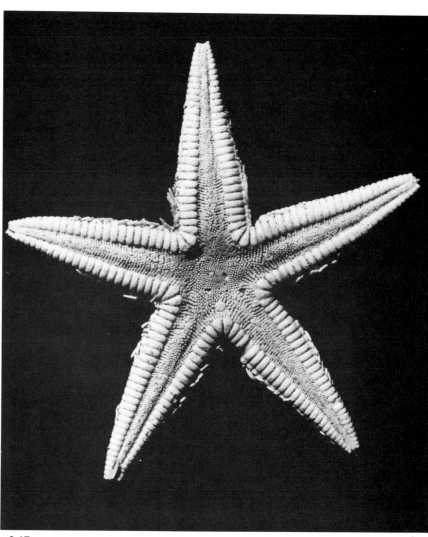

6-17

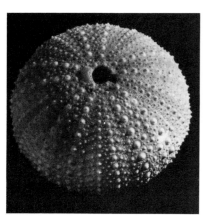

6-16

6-18

**Proficient execution is necessary to carry an idea to successful resolution.** If the work is sloppily joined, poorly thrown, or carelessly glazed, the best ideas and intentions are lost.

### The final ingredient

All of the foregoing considerations must be present to some degree just to make an object serve its intended function! Something more is needed to elevate a form beyond the prosaic. Call it style, grace, or beauty, it is this quality that separates the artist from the artisan, the aesthetic from the merely efficient.

**6-19**  Space Shuttle Challenger
Courtesy: National Aeronautics and
Space Administration

**6-20**  Terminal Building
Dulles International Airport
Architect· Eero Saarinen
Photo: the author

**6-21**  City Hall, Toronto, Canada
Architect: Viljo Revell
Photo: the author

6-19

6-20

6-21

## Evolution of the clayworker

Some people feel that a person is born with artistic sensitivity. Others feel that this sensitivity can be learned. In all probability, each person has an innate artistic understanding which needs only to be brought out and honed to a fine edge. Formal study can hasten this process and offer a wide range of exposure to ideas and influences. Individuals can gain insight on their own as well as in school. To be creative requires action. Inspiration does not strike like lightning; it develops. Imagination can be stimulated by historical and contemporary ceramic works. Direct copying, however, is plagiarism and makes no useful contribution. Examine the work of designers in other disciplines and media—fashion, automotive, architecture, painting, film. Look at designs in nature—growth forms, crystalline structures, geometric progressions. Develop a sense of curiosity; find out what makes things work. Make sketches of ideas and keep notes.

Be dissatisfied with the end product. Try to improve on a form and continue to develop it toward a better solution. A masterpiece is not made, but it may grow with time. Even then it is great only to those who see greatness in it.

Movement in ideas and forms should continue. Making a "hot item" and reproducing it endlessly can bring about stagnation. The clayworker stops developing, the form ceases to grow, and the viewer/buyer appreciation does not advance. Situations change, needs change, conditions of life change; and the clayworker should be attuned to these changes.

113

**6-22**  Vase
19th century Japanese Satsumi ware
Thrown stoneware, underglaze,
    overglaze, slip decoration
14¹/₂ × 12″ (37 × 30 cm)
Courtesy: The George Walter Vincent
    Smith Art Museum, Springfield, MA

**6-23**  Richard Shaw
*Couch and Sinking Ship*
Handbuilt earthenware, acrylic paint
15 × 14 × 36″ (38 × 36 × 91 cm)
Courtesy: Quay Gallery

## Evolution of a form

In the evolution of a form there is first the recognition of that form as an object of some use. As the understanding of the object increases it is taken into its second stage, becoming highly refined to gain its ultimate utility. The third stage brings the object beyond utility into the realm of the symbolic. For instance, the Paleolithic hand axe was a crude, hand-held stone implement for pounding. As the ages progressed the axe was made of metal, refined and shaped until it could cut in a single stroke. The final step occurred when the axe became a ritual implement made of jade or jewel-encrusted gold, which stood as an emblem of power.

The same is true today of clay. The crude concave mud form which held liquid came to a high state of refinement in Chinese and Japanese ceramics which have been emulated for centuries. In recent times a number of clayworkers have taken the third step and elevated their work beyond utility, into the symbolic.

What of these nonutilitarian objects? What kind of criteria are necessary to understand them? The new wave of ceramics appears, at first, to throw aside function and negate all the principles of design. Victor Papanek states in his book, *Design for the Real World,* that "the cancerous growth of the creative individual expressing himself egocentrically at the expense of the spectator and/or consumer has spread from the arts [and] overrun most of the crafts.... No longer does the artist, craftsman, or in some cases the designer, operate with the good of the consumer in mind; rather, many creative statements have become highly individualistic, autotherapeutic little comments by the artist to himself."

This is too often, but not always, the case. If the concept of a work is carefully thought out, if its story, political or satirical social comment are well expressed, then the design elements will usually fall into place. The color, size variation, shape, and position of its parts may not be as important as the strength of the statement. Upon closer examination, many examples of this direction in claywork do adhere relatively closely to the basic principles of design—balance, contrast, boldness, simplicity and proportion, with the overriding principle being its purpose, that of stimulating the viewer's emotions and thoughts. However, if the execution of the object does not evidence technical proficiency, it will fail to rise above the autotherapeutic stage.

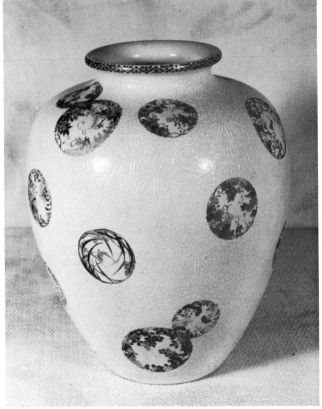

6-22

6-23

114

# CHAPTER 7 Traditional Decorating Techniques

Most people cannot resist the urge to decorate a plain surface, whether it be a stretched canvas, a subway wall, or a clay pot. All too often they succeed only in diminishing the value of the original object. This is particularly true of ceramics. For centuries the potter's work was regarded as just a form upon which the renderings of an accomplished decorator were to be placed. Although this holds true even today in some commercial operations, most potters now make and decorate their own work. Unfortunately, many of them overdo it. If decoration is thought of as an integral part of a design, the results will be much more effective.

Each of the techniques described earlier has its own set of intrinsic decorations: pinch marks, coil lines, texture from the rolling surface, or throwing ridges. Often these are interesting enough in themselves to make a pot exciting to look at and hold. Additional methods of decorating can be introduced at different stages and conditions of the clay. Some decorations can be applied when the clay is still plastic, others when the clay has stiffened to the leather hard state or when dry and still others after the bisque fire.

Although most of the examples shown here have been executed on wheel-thrown pieces, there is no reason why they cannot be effectively adapted to other shapes.

## Plastic

While the clay is still plastic, it may be *pressed* or *pinched* with the fingers to create a relief decoration. When doing this, support the wall of the pot from inside to prevent deforming. On a thrown piece, it is best to press or pinch while the pot is still on the wheel so that the rim can be recentered after the clay has been worked. **7-2, 7-3**

*Stamping* a repeat decoration on a pot can be done with many found objects: for instance, a stone, seashell, or piece of wood. Support the wall while pressing a dry stamp against the pot. A stamp, made by modeling a piece of clay with a small stump attached to the back, should be dried and bisque fired.

**7-1** Vase
Chinese, K'ang-hsi Period (1662-1722)
Thrown porcelain, polychrome overglaze
18 1/2 × 8 5/16″ (47 × 21 cm)
Courtesy: Worcester Art Museum

**7-1**

**7-4** Author
Hanging planter
Thrown stoneware, pinched decoration
7 × 11″ (18 × 28 cm)

7-2

7-3

7-4

7-5

7-6

7-7

**7-6** Vase
Egyptian, ca. 2nd century B.C.
Earthenware, stamped decoration
3″ (8 cm) high
Courtesy: Museum of Fine Arts, Boston
 Egyptian Expedition Fund

**7-7** Steve Haworth
Plate
Thrown stoneware, stamped decoration
15″ (38 cm) diameter

**7-9** Katalin Radnoti
Thrown stoneware, stamped decoration,
low temperature glaze
22$\frac{1}{2}$″ × 13$\frac{1}{2}$″ (57 × 34 cm)

**7-13** Bowl
Mexican, ca. 750-900
Earthenware, modeled decoration
6$\frac{1}{2}$″ (16 cm) high
Courtesy: Museum of the American
Indian, Heye Foundation
Gift of Harmon W. Hendricks

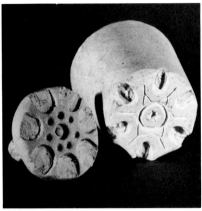

7-8

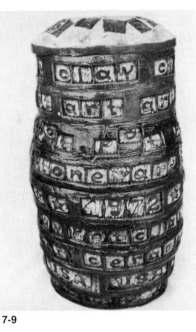

7-9

7-10

Plaster poured into a small paper cup can be carved into sharply defined decorations after it has hardened. In each case, a design that is undercut will pull on the clay and not print well. **7-5, 7-8**

Decorative textures can be *scratched* into the surface of a pot with a toothed scraper, sawblade, twig, comb, or any other similar object. **7-10**

Small coils, cut bits, patches, or a thick paste of clay can be *modeled-on* or *appliqued* directly to the plastic wall of a pot while still soft. Harder clay pieces must be applied using vinegar. **7-12**

Following the bisque fire, a glaze which thins out, or breaks, over protruding parts should be used to achieve the maximum effect of the relief surfaces thus created.

**7-11** Leon F. Moburg
Bottle
Thrown stoneware, scratched decoration
8 × 6″ (20 × 15 cm)

7-11

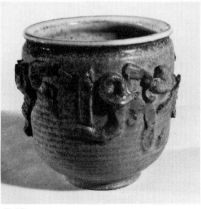

7-12

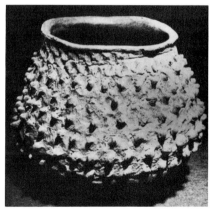

7-13

**7-14**  Madeline Landing Pots and
   Robert Paul Massaro
Covered jar
Thrown, incised stoneware, underglaze,
   unglazed
4¹/₂″ (11 cm) diameter
Photo: Jason Jones

**7-15**  Marsha Silverman
*Pod*
Thrown, carved porcelain
5¹/₂ × 7 × 7″ (14 × 18 × 18 cm)
Photo: the artist

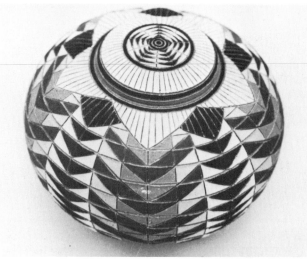

7-14

7-15

## Leather Hard

When the clay has reached the leather hard state, trimming tools, dentist tools, or other sharp instruments can be used to *incise,* or carve in, decorative motifs. These same tools can be used to *pierce,* or cut through, the clay form. **7-16, 7-17**

*Excising* is done by carving away the background around a decoration, leaving the image in a raised relief. Use a thicker-walled pot for this method to allow sufficient depth for the carving. **7-20**

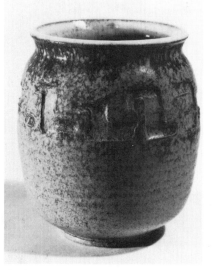

7-16

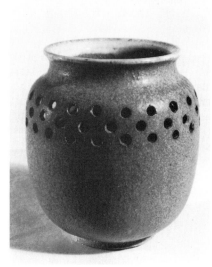

7-17

**7-18** Incense Burners
19th century Japanese Arita ware
Cast porcelain, pierced decoration
left: 10¹/₂ × 5″ (27 × 13 cm)
right: 6¹/₂ × 4¹/₂″ (16 × 11 cm)
Courtesy: The George Walter Vincent
  Smith Art Museum, Springfield, MA

**7-19** Lynn Gervens
Jar
Thrown, carved, pierced porcelain
7 × 5¹/₂″ (18 × 14 cm)
Photo: Richard Freierman

7-18

7-19

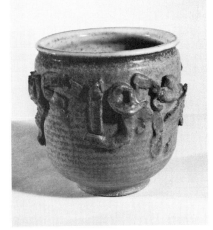

7-20

119

**7-21** Mary Louise McLaughlin
Vase, ca. 1900
Thrown, carved porcelain
8″ (20 cm) high
Courtesy: Worcester Art Museum

**7-22** Lydia Yin
*Round Vessel* (detail)
Thrown, carved, pierced porcelain
9″ (23 cm) high
Photo: Clayton Adams

**7-23** Vase
14th century Mayan
Earthenware, excised decoration
8 × 7¹/₂″ (20 × 19 cm)
Courtesy: Museum of the American
   Indian, Heye Foundation
   Gift of Harmon W. Hendricks

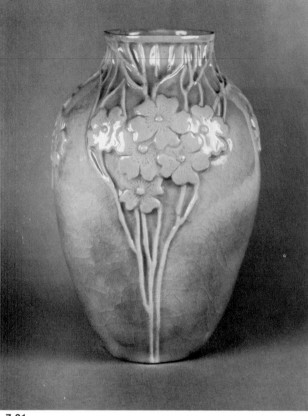

7-21

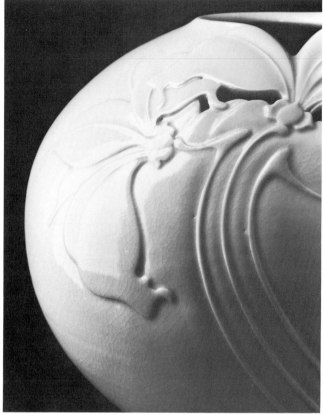

7-22

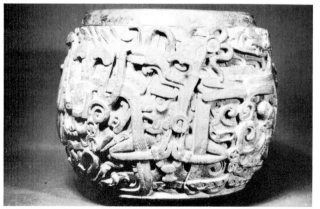

7-23

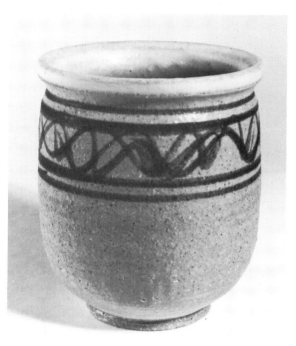

7-24

Decorating with colored *washes, slips,* or *engobes* is carried out essentially in the same way, although the three materials differ somewhat from each other. A *wash* is nothing more than a coloring oxide, such as copper carbonate, iron oxide, or cobalt oxide, mixed with water. Very little colorant is needed to give a strong tint. A *slip* is a clay slurry to which colorant has been added. *Engobes* are glaze materials combined to make colored clay-like slurries. **7-24**

All of these materials can be brushed, poured, dipped, or sprayed on a pot in thin coats to provide decorative color in contrast to the clay body. Slips of different colors are sometimes built up in layers, resulting in a low relief decoration known as *pâte-sur-pâte.* **7-26**

7-25

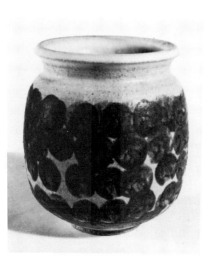

7-26

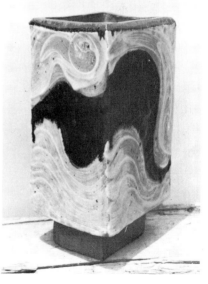

7-27

**7-28** Bottles
19th century Japanese Agano ware
Thrown stoneware, stippled engobe
    decoration
11¹/₂″ (29 cm) high
Courtesy: The George Walter Vincent
    Smith Art Museum, Springfield, MA

**7-30** Wayne L. Bates
*Extra-large Bowl*
Thrown white stoneware, sgraffito slip
    decoration
7 × 18″ (18 × 46 cm)
Photo: the artist

**7-31** Wm. D. Cruit
Platter
Thrown white stoneware, sgraffito slip
    decoration, reduction fired
19″ (48 cm) diameter
Photo: Hollmarc Productions

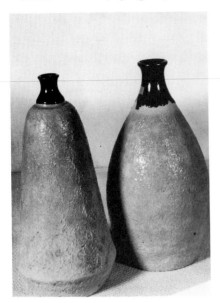

7-28

7-30

7-29

7-31

After a thin coat of slip has been applied to a pot, a *sgraffito*
design can be scratched through it with a pin tool to bring out
the clay color. **7-29**

**7-33** Covered Jars
18th and 19th century Japanese
Thrown stoneware, mishima decoration
left: 21¹/₂″ (55 cm) high
right: 3″ (8 cm) high
Courtesy: The George Walter Vincent
   Smith Art Museum, Springfield, MA

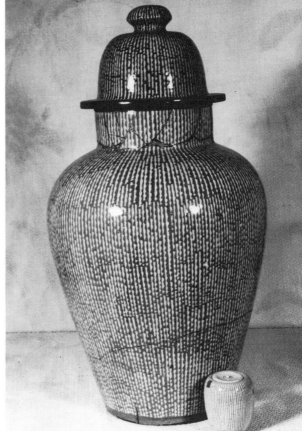

7-32

7-33

A *mishima*, or inlayed, decoration can be made by first carving a design into a pot. The carving is then filled with thick colored slip. After the slip has set up, the excess is scraped away, leaving a smooth, flush surface. This works best when the clay and slip have the same shrinkage factor. Ideally, the colored slip should be made from the clay body being used.

123

*Slip trailing* can best be accomplished using a plastic squeeze bottle or a syringe. In earlier times, a goose quill on the end of a small bisque fired bottle did the job well. Depending upon the viscosity of the slip, the decoration will either run, lie flat, or make a thick relief. Mix the color into the slip and strain it through a 60-mesh sieve to remove any lumps. Make a few practice trailings to check the consistency of the slip before using it on the actual piece. Keep the trailer close to the surface and squeeze the bulb with steady pressure. **7-34**

Trailed slips can be *combed* or *feathered*. Pour an even coat of slip over a freshly made platter. Trail a simple design immediately, using one or more colored slips. Then draw a comb with few teeth or a feather tip lightly through the slip to create zigzag effects. Tap the platter lightly to settle the slips. **7-37**

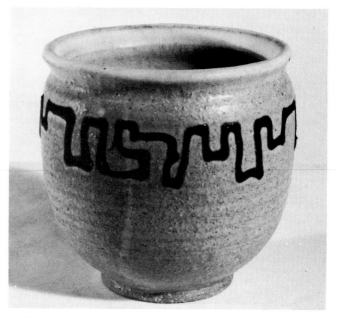

**7-34**

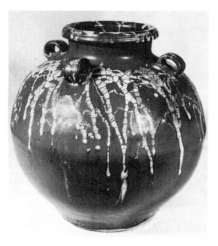

**7-35**

**7-35** Water Jar
18th century Japanese Kyushu ware
Thrown stoneware, slip trailed
13³/₄ × 15″ (35 × 38 cm)
Courtesy: The George Walter Vincent
    Smith Art Museum, Springfield, MA

**7-36** Douglas Fey
Jar
Thrown earthenware, slip trailed
11 × 6″ (28 × 15 cm)
Photo: the artist

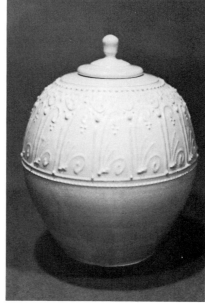

**7-36**

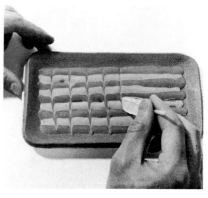

**7-37**

**7-38**  James White
Baking Dish
Thrown earthenware, slip trailed,
    feathered
2¹/₂ × 10″ (6 × 25 cm)
Photo: the artist

**7-40**  Tripod Vase and Cover
Wedgewood Jasper ware, 1786
Blue and white cast porcelain
7⁷/₈ × 5¹/₂″ (20 × 14 cm)
Courtesy: Wadsworth Atheneum, Hartford
Photo: E. Irving Blomstrann

7-38

7-40

7-39

*Sprigs* are low relief clay decorations made from shallow press molds with no undercuts. After a sprig stiffens and shrinks it can be dropped out of the mold and firmly joined to the pot with vinegar. **7-39**

*Burnishing* low fire clay ware not only creates a smooth shiny surface but helps to compact the clay and make it less porous by rearranging the random clay platelets into an ordered overlapping formation. To accomplish this, simply rub a smooth hard object such as a spoon or stone against a leather hard clay object. Rub with a circular motion and cover just one small area at a time. Burnishing can be done in a straight line motion, but for best results it should all be in the same direction. Support the clay wall from the other side while rubbing.

**7-41** Nancy Gilson
*Bamboo* Vase
Thrown porcelain, burnished, incised
  terra sigillata, sawdust fired
19 × 6″ (48 × 15 cm)
Photo: Ronald Slate

**7-43** Dish
Bombay, India
Earthenware, engobe
10¹/₂″ (27 cm) diameter
Courtesy: Worcester Art Museum
Bequest of Mary N. Perley

Repeating the process two or three times will give better fired results than if a piece is burnished just once. A thin coating of vegetable oil between rubbings can help to control drying shrinkage while work continues on a piece. If a cloth is used to burnish instead of a spoon, a semi-gloss finish will result.

A suitable slip (one that is either made of the clay body being used or one that has been found to be compatible) can be brushed onto leather hard ware and burnished as soon as the moisture has been absorbed. In this manner, subtle colors can be introduced to decorate unglazed ware.

After a piece has been completely burnished, slip can be applied decoratively and left unburnished, creating a contrast of texture as well as color.

Burnishing can sometimes be done on dry ware by wetting an area and immediately rubbing it smooth. However, if the surface is too dry, burnishing will only leave scratchmarks.

Protect burnished ware from water spots until it is time to fire it. Water will mar the unfired surface and the entire piece will have to be sanded and reburnished—if it is still damp enough to do so.

Burnishing gives best results when fired to low temperatures. Above cone 06 (991°C/1816°F) molecular changes in the clay cause the shiny effect to disappear, leaving only a surface smoother than usual. When fired in oxidation, burnished ware appears to have a high gloss surface. In reduction firing, the burnished area sometimes takes on a rich iridescence as well.

## Dry

Clay can also be decorated after it has dried. *Engobes* or *oxide washes* can be applied to the surface by brushing. They can be poured, sprayed, or dipped as well, but must be thinned beforehand to prevent undue buildup. **7-42**

*Wax resist* can be used to brush a decoration on before applying an engobe or oxide wash over it. The wax prevents the engobe or wash from adhering to the decorated area. **7-44**

A *stencil* made of Japanese rice paper, paper towel, or newspaper can be placed against the clay before brushing or spraying on an engobe. **7-45, 7-46**

Commercially prepared *underglazes* or *underglaze pencil* can be used to draw decorations on dry clay. **7-48**

7-41

7-42

7-43

7-44

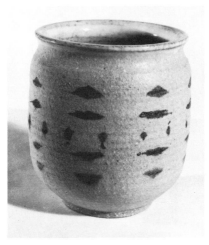

7-45

**7-47**  Mary Havener
Vases
Slip cast low fire clay, stencil decoration
Disc vase: 9″ (23 cm) diameter;
  half-round vase: 6″(15 cm) high
Photo: Mikael Carstanjen

7-46

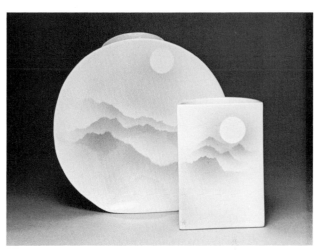

7-47

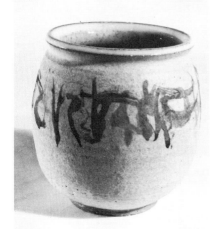

7-48

127

**7-49** John Goodheart
*A Potter's Odyssey*
Slab-built earthenware, luster glaze,
    underglaze pencil
20 × 14 × 6″ (51 × 36 × 15 cm)

**7-50** William Wilhelmi
*Phoenix Unfrequent*
Covered cakeplate
Thrown earthenware, underglaze pencil,
    metal finial
14 × 12″ (36 × 30 cm)

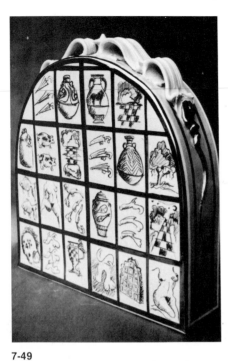

7-49

## Bisque

Some of the decorating techniques just mentioned can also be used on bisque fired ware. Applying *engobes* and *oxide washes* to a bisque fired piece allows the color to be absorbed into the glaze instead of the clay, which occurs when applied to drywork. **7-51**

After applying *engobes* or *oxide washes, sgraffito* through them to the bisqued clay for more delicate lines than when the technique is used on leather hard clay. **7-53**

*Wax resist* can be used to brush on a decoration before the work is glazed. Because wax prevents glaze from adhering to the bisque, the clay provides a color and texture contrast to the glazed surface after the firing. **7-54**

*Underglazes* can also be applied to bisque fired ware.

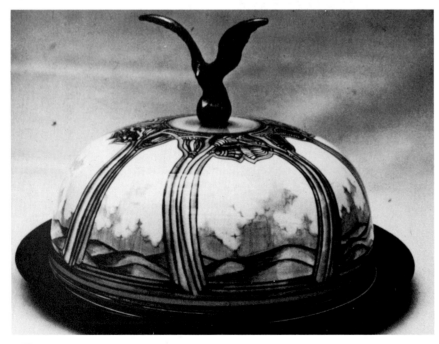

7-50

7-51

128

I

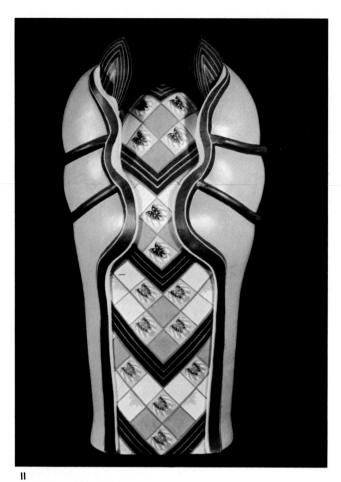

II

I   Doug Blum
*Three Light Lily*
Thrown stoneware and porcelain,
   unglazed
30 × 14 × 12″ (76 × 36 × 30 cm)
Photo: Silverson Studios—Jim Kane

II   Charles Malin
*Soft Chevroned Mollusca*
Slab-built earthenware, terra sigillata
   decoration
30 × 16 × 6″ (76 × 41 × 15 cm)

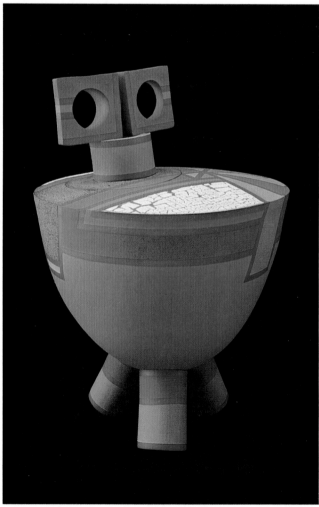

IV

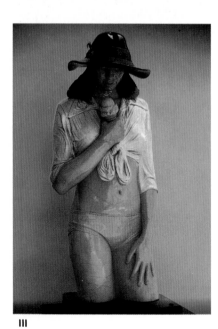

III

**III** Marc Sijan
*Figure*
Slab-built raku
Life-size

**IV** Patricia Fahie
*Container with Lava Glaze*
Press-molded, extruded, slab-built
  earthenware
15 × 9¹/₂ × 9¹/₂″ (38 × 24 × 24 cm)
Photo: Ralph Gabriner

**V** Author
*Bi-Coastal Odyssey*
Slab-built porcelain, luster glaze
60 × 24 × 1¹/₂″ (152 × 61 × 4 cm)
Collection: Mr. and Mrs. Joseph Epstein

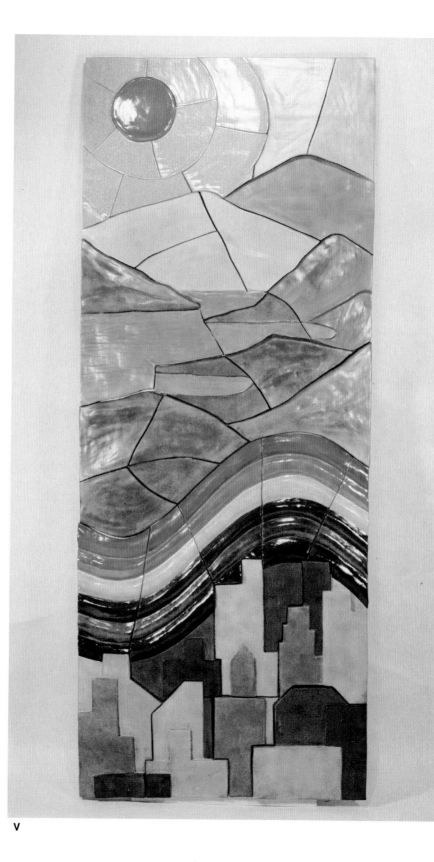

V

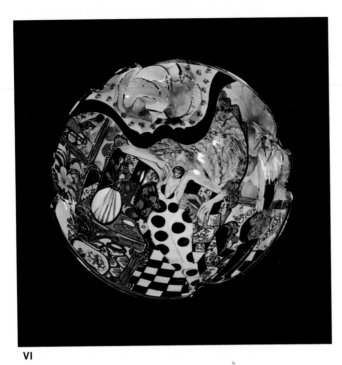

**VI**

**VIII**

**VII**

**VI** Laney K. Oxman
Bowl
Slab-built earthenware, decals,
    underglaze, luster glaze
5 × 15 × 15″ (13 × 38 × 38 cm)
Photo: Ronald Petersen

**VII** Laura Shlien
Vase
Thrown porcelain, crystalline glaze
6″ (15 cm) high

**VIII** Robert M. Winokur
Covered jar
Thrown stoneware, ash glaze
20″ (50 cm) high

**IX**   Author
Temple jar
Thrown porcelain, luster glaze
12″ (30 cm)

**X**   Curtis and Suzan Benzle
*Summertime III*
Inlaid colored porcelain, incised
11 × 8″ (28 × 20 cm)

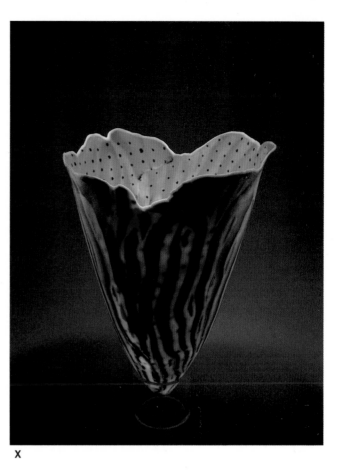

X

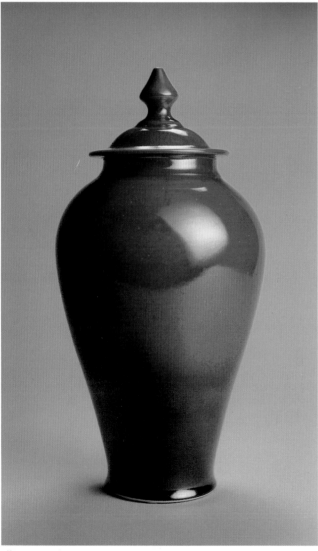

IX

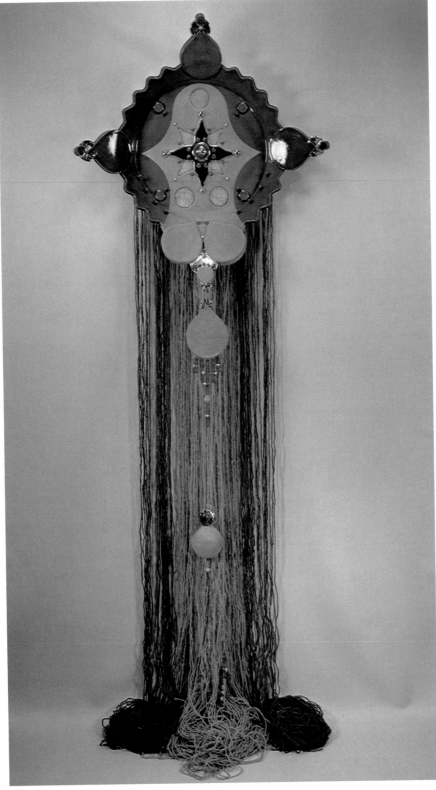

XI

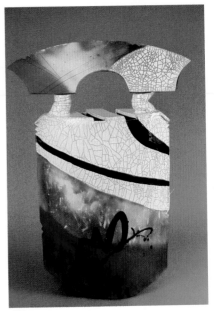

XII

**XI**  Georgette Zirbes
*Spiritual Connection*
Stoneware and fiber, luster glaze
81″ (206 cm) high

**XII**  George Whitten
*Sculptural Vessel*
Slab-built raku
32 × 24 × 8″ (81 × 61 × 20 cm)
Photo: Bob Barrett

XIII

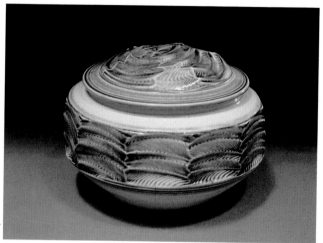

XV

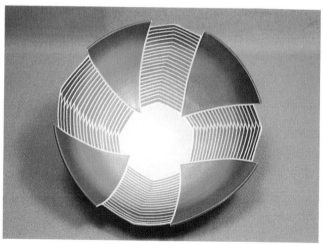

XIV

XVI

XVII

**XVI**  Sandra Wyner
Pitcher
Slipcast white earthenware
9 × 8 × 5¹/₂″ (23 × 20 × 14 cm)
Photo: Fred G. Hill

**XVII**  Kaete Brittin Shaw
Teapot
Slab-built colored porcelain
16 × 13 × 5″ (41 × 33 × 13 cm)
Photo: Bob Hanson

**XVIII**  John Goodheart
*Night Ray*
Thrown earthenware, impressed, sprigged,
   engobe decoration, luster glaze
24″ (61 cm) diameter

**XIX**  Judy Miller
Teapot
Slab-built stoneware, underglaze,
   overglaze, luster glaze
12 × 7 × 2 ¹/₂″ (30 × 18 × 6 cm)
Photo: M. Lee Fatherree

**XIX**

**XVIII**

**XX** Lydia Yin
Platter
Thrown porcelain, underglaze watercolor
  and pencil
16″ (41 cm) diameter
Photo: Clayton Adams

**XXI** Dick Studley
Bottle
Thrown Egyptian paste
16″ (41 cm) high
Photo: Morgan Rockhill

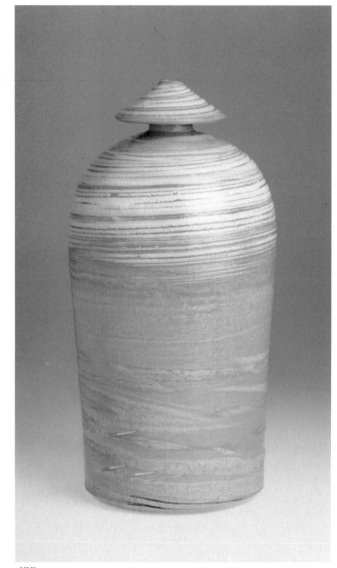

XXI

XX

**XXII**

**XXII** Author
Vase
Thrown porcelain, local reduction
8″ (20 cm) high

**XXIII** Dorothy Hafner
*Lightning Bolt Punch Bowl with Spoon*
  ©*1984*
Handbuilt porcelain, underglaze
8¹/₂ × 13 × 13″ (22 × 33 × 33 cm)
Photo: S. Baker Vail

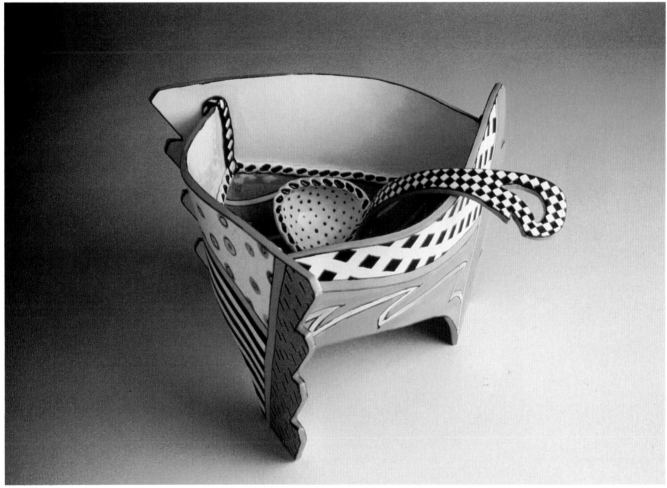

**XXIII**

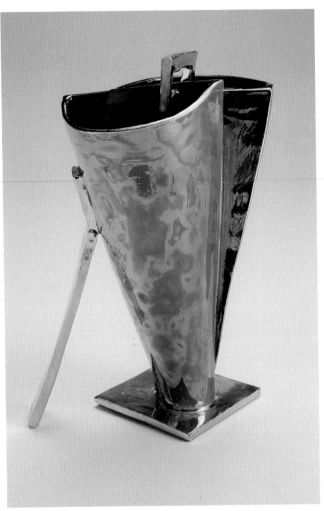

**XXIV**

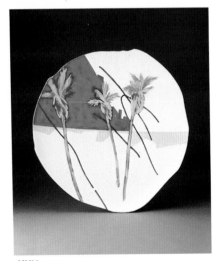

**XXV**

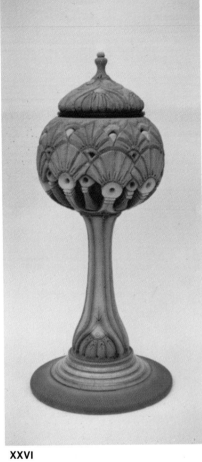

**XXVI**

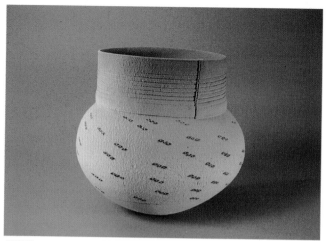

**XXVII**

**XXIV**   Rima Schulkind
*Clamped Vase*
Slab-built earthenware, underglaze, luster
11 × 8 × 4″ (28 × 20 × 10 cm)
Photo: Richard Rodriguez

**XXV**   Beth Changstrom
*Three Palm Trees with Graphics Platter*
White stoneware, underglaze, overglaze
19″ (48 cm) diameter
Photo: Susan Cummins

**XXVI**   William Wilhelmi
*Lotus Jar*
Thrown and pierced earthenware,
  unglazed underglaze
13 × 5″ (33 × 13 cm)

**XXVII**   Jamie Fine
Pot
Pressmolded white stoneware, airbrushed
  slips, unglazed
9 × 9″ (23 × 23 cm)

**XXVIII**   Jinny De Paul
*Basket Form*
Thrown and altered porcelain
17″ (43 cm)

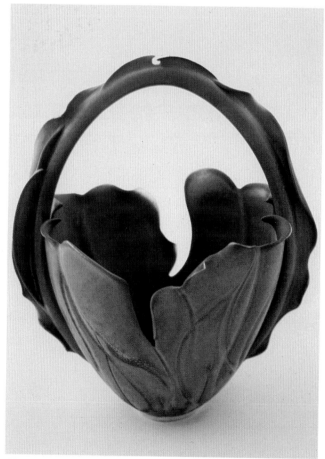

**XXVIII**

**XXIX** Jim Cantrell
Hanging beverage server
Thrown stoneware
16 × 15″ (41 × 38 cm)

**XXX** Carolyn Brice Brooks
Vase Form
Drape-molded colored porcelain,
 unglazed
9¹/₂ × 6¹/₂″ (24 × 17 cm)
Photo: Gail Marie Fisher

**XXIX**

**XXX**

**XXXII**

**XXXI**

**XXXI**   Susanne G. Stephenson
Box
Slab-built porcelain, reduction, low
   temperature and luster glazes
$14^1/_2 \times 10 \times 17''$ ($37 \times 25 \times 43$ cm)

**XXXII**   Harvey Sadow
*Chesapeake Veneer Series #63*
Thrown and expanded stoneware, slips,
   multiple fired raku
$14 \times 13''$ ($36 \times 33$ cm)
Photo: Paul Kennedy

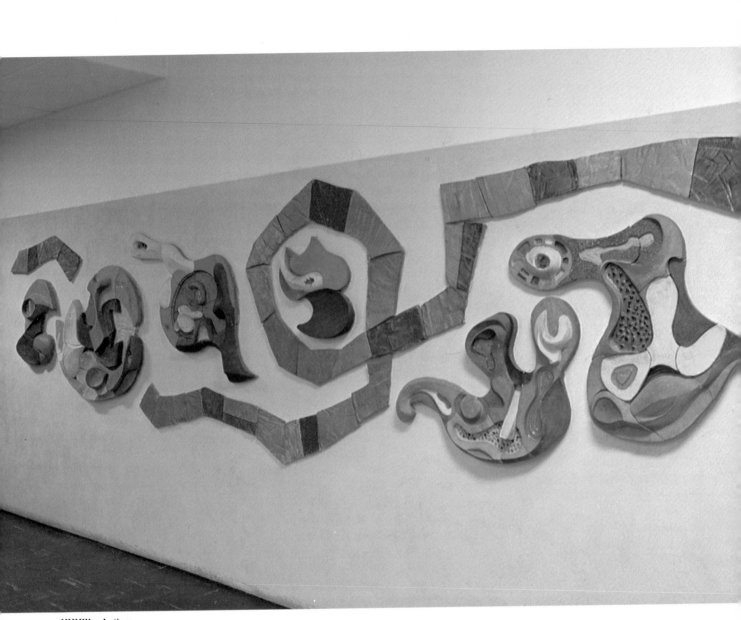

**XXXIII** Author
*Life Forms*
Slab-built stoneware, glaze, slip, fused
  stained glass
4 × 18 feet (1.2 × 4.5 m)
Courtesy: Rochester Institute of
  Technology
Photo: Edvard Deering

**7-52** Plate
18th century Chinese
Cast porcelain, underglaze decoration
9⅝″ (24 cm) diameter
Courtesy: Worcester Art Museum
  John Chandler Bancroft Collection

**7-55** Bette Ann Libby
*Cerius Nautilus Platter*
Thrown stoneware, wax resist
15″ (38 cm) diameter
Photo: Erik Borg

7-52

7-54

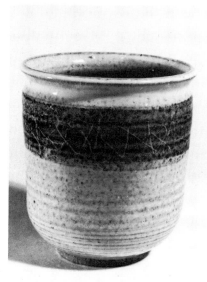

7-53

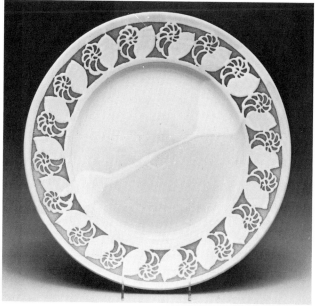

7-55

**7-56** Lydia Yin
*Cylinder Vase 1983*
Thrown porcelain, underglaze watercolor
    and pencil
11¹/₂″ (29 cm) high
Photo: Clayton Adams

**7-57** Dorothy Hafner
*Sonar Serving Tray* ©1983
Porcelain, underglaze
17″ (43 cm)
Photo: S. Baker Vail

**7-58** Christopher Hoffman
Wall Plate
Thrown low fire clay, underglaze, stencils
22″ (56 cm) diameter
Photo: the artist

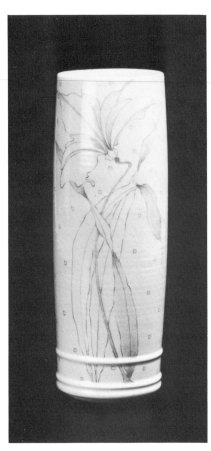

7-56

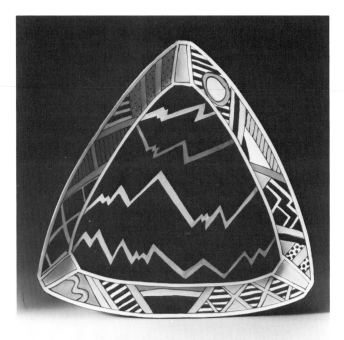

7-57

7-58

## Glaze Application

Improperly applied glaze can detract from the appearance of an otherwise well formed ceramic object.

Before glazing, the piece should be clean and free of dust and hand oils. With the eyes shielded, blow off any dust. Wiping will force the dust into the clay pores. Oily pieces should be washed with soap, rinsed, and thoroughly dried before glazing.

If it seems necessary, a quick swipe on the bisque with a damp sponge just before glazing will reduce glaze absorption and prevent an application that is too thick. This can be better controlled, however, by adjusting the viscosity of the glaze before use.

Wax will prevent glaze from being absorbed into the bisque and should be applied to the foot or anyplace else that glaze is not wanted, such as lips and rims of covered containers. If wax drips onto parts of a piece that are to be glazed, scrape and then sand it off; otherwise the glaze will not adhere. Unwanted wax can also be melted off with a lighted match, or the entire piece can be put into a kiln and heated to 200°C (392°F), which will volatilize all the wax. Reapply the wax when the piece has completely cooled.

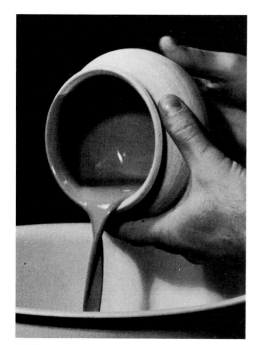

7-59

## Pour

The interior of nearly all pots can be glazed by pouring. After properly mixing and sieving a glaze, it is poured into a pot to about half full. **7-59,** Rotate the pot three or four times while tipping it slowly over a bowl, allowing the glaze to run out. If excess glaze runs down the outside of a piece, allow it to dry and then brush it off with a toothbrush or other stiff brush. Wiping with a wet sponge will only force the glaze into the clay pores.

If a pot, such as a lantern, has holes cut through it, cover them with masking tape before pouring glaze inside. After the glaze has dried, remove the tape. In the case of a teapot, cover the spout opening with a neatly trimmed piece of masking tape before pouring the inside. Leave the tape on until after the outside has also been glazed, preventing the outside glaze from running into the interior. When the glaze has dried, remove the tape and touch up the lip with a small brush.

After the inside has been glazed, the work should be allowed to dry thoroughly before attempting to glaze the exterior. Glaze powders adhere to the pot because the water is drawn into the bisque wall. If more glaze is applied to the outside soon after the inside has been glazed, the clay will not absorb the proper amount of water and the coating will be too thin. Forced drying often has the opposite effect. A pot warmed under a heat lamp or in a kiln absorbs too much water and causes a thick glaze coat.

The quickest way to coat the outside of most ceramic objects is by pouring. **7-60,** Invert the piece onto a funnel, jar,

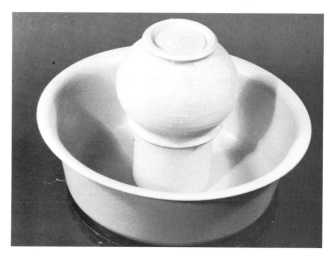

7-60

or similar support placed in a bowl on a bench wheel. Two sticks, metal rods, or a grate can be used to support large objects over a bowl.

**7-61,** Fill a pitcher with glaze and then pour the glaze over the piece while turning the wheel around three or four times. A large syringe filled with glaze can also be used for pouring. Wait until the shine disappears, then remove the pot and let it dry completely.

When pouring glaze on a piece with a handle, such as a cup or pitcher, glaze the handle first and then rotate the pot while pouring to give it an even coating.

After the pot has completely dried, clean the foot well by scraping off excess glaze with a knife or cleanup tool. Then remove all traces of glaze with a wet sponge.

Removing glaze from the foot and bottom of a pot is known as *dry footing,* which must be done if pots are to be fired directly on the kiln shelf. Aside from eliminating the need for stilts or pins (which have a nasty habit of breaking) to support the pot during firing, dry footing also has an aesthetic function. It shows the fired clay color in contrast to the glaze.

When inside and outside glazes are different, it is often more pleasing to have the inside glaze on the rim as contrast to the outside color. To do this, carefully scrape all the glaze from the rim when dry and reapply two or three coats of the interior glaze with a small brush. An alternate method of doing this is to brush wax over the inside glaze on the rim before pouring the outside color. This prevents the outside glaze from adhering to the glazed rim. After pouring, simply wipe the excess glaze off the wax with a damp sponge.

Lumps of glaze on the rim, caused by pouring, should be carefully smoothed away with a fingertip after the glaze has dried to prevent running in the fire.

If cracks or pinholes appear in the glaze after it has dried, it is an indication that the glaze coating may be too thick. Try smoothing over and filling in the holes by gently rubbing the glaze with a circular motion of the fingertips. Chipped off pieces may be filled in by gently dabbing on fresh glaze with a finger or small brush. If there are too many cracks, drips, holes, or an uneven surface, it is best to scrape off the glaze, wash the piece, thoroughly dry it, and start again.

Several glazes can be poured on the outside of a pot if they are applied immediately, one after another. However if the piece is allowed to dry before another glaze is applied, the first glaze will be pulled off because of the rapid re-wetting. A syringe or spoon can be used to selectively pour glazes over small areas.

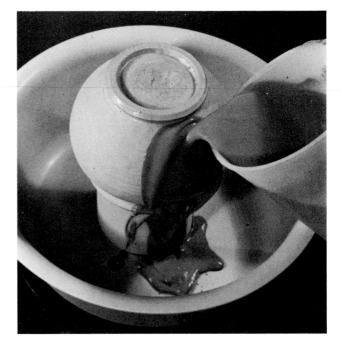

7-61

**7-63** J. David Broudo
Thrown and paddled stoneware bottles
Oxide decoration, dipped in ash glaze
6 to 18″ (15 to 46 cm) high

## Dip

Small objects can be quickly glazed by dipping. Hold the pot by the foot or bottom and dip it at an angle into a bucket of glaze. Turn the piece back and forth two or three times to cover it evenly with glaze and then remove it. Another way to dip a slightly larger piece is to fill the inside to the top with glaze and hold for about five seconds. Then turn the pot over and immediately plunge it into the glaze for about five more seconds. Remove the pot from the glaze and continually turn it to prevent glaze from accumulating on one part of the lip while it dries. A pot can be dipped into more than one glaze for added interest. **7-62**

Another method of dipping, requiring somewhat more dexterity, can also be employed, but a little practice is needed to master it. The pot is first pressed upside down into the glaze, then swiftly jerked upward—but not out of the glaze. It is then plunged back down and shaken slightly. The upward jerk creates a partial vacuum which is filled by glaze on the downward motion.

Attempting to glaze large pieces with this method often requires the preparation of too much glaze to make it worthwhile.

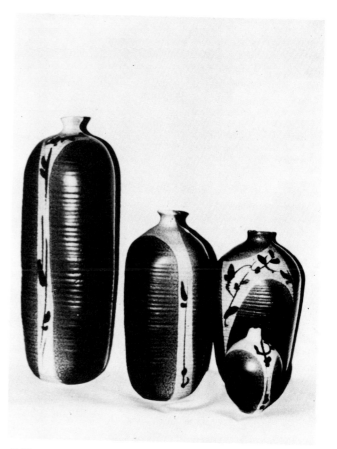

7-63

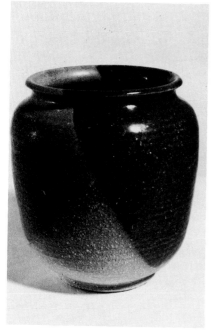

7-62

## Brush

Brushing on a glaze is not as easy to do properly as it might appear. Too many people attack a pot with a brush as if painting the side of a barn. First, good quality brushes should always be used. Japanese hare's fur or goat hair brushes are recommended for their ability to hold large amounts of glaze. If these are not available, other high quality, soft, long natural bristle brushes can be used. To allow two or three even applications to be brushed on, the glaze should be thinned.

Charge the brush well by dipping the bristles fully into the glaze with a stirring motion. This will also prevent the glaze from settling in its container.

When applying the glaze, do not hold the brush perpendicular to the object. It should be held at a slight tangent, lightly touching the surface to allow the bisque wall to draw the glaze off the brush. **7-64,** Because glaze comes off the brush heaviest at the start of the stroke and lighter at the end, each stroke in one direction should be immediately covered starting from the other end. Brushing should continue at a steady pace until the entire piece is covered. If too much time elapses between coatings, later brushstrokes will pull off earlier applications.

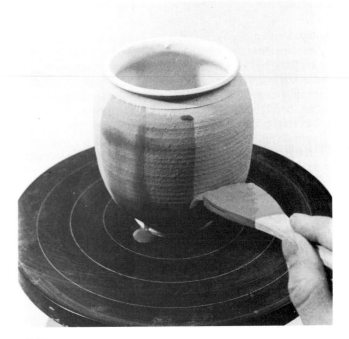

7-64

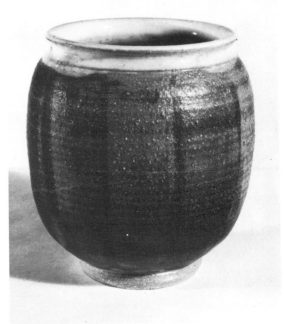

7-65

134

## Spray

Spraying is the technique which will give the most even glaze coating. **If spray glazing is to be done regularly, proper equipment is essential.** Work should be done in a spray booth with a good exhaust fan and exterior ventilator filter system. For safety, use a quality air compressor with a medium duty spray gun capable of at least 25 psi (pounds per square inch). Wear a NIOSH approved respirator when spraying to prevent inhalation of the dry powders. It is also a good idea to wear plastic safety goggles to shield the eyes from airborne particles.

Place the object to be glazed on a bench wheel in the booth. Mix the glaze through at least a 60-mesh sieve to the smooth consistency of light cream. Fill the spray gun and hold it approximately eighteen inches from the object. Spray with a slow vertical sweeping movement while slowly revolving the bench wheel. If the gun is too close to the work or is not moved enough, the glaze will pile up and run. **7-66,** Keep the gun and object moving to prevent glaze from building up a shiny wet surface. Spray from above and below the object to insure an even glaze coating. **7-67,** Continue to spray until a fuzzy surface is built up. Then allow the glaze to dry before cleaning the foot well with a damp sponge.

If the inside and outside glazes are different, protect the previously glazed interior by inverting the pot or by covering the opening with a jar cap, paper or masking tape.

Unlike other glazing techniques, the sprayed glaze surface is quite powdery and therefore should be handled as little as possible to prevent smudging.

Major drawbacks to this technique are the wasted glaze sprayed into the booth and the amount of time consumed. The former can be scraped up periodically, a sample test fired, and possibly reused. The time lost can never be reclaimed.

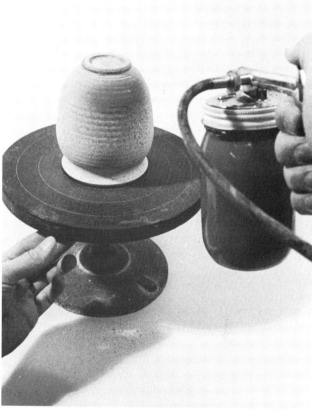

7-66

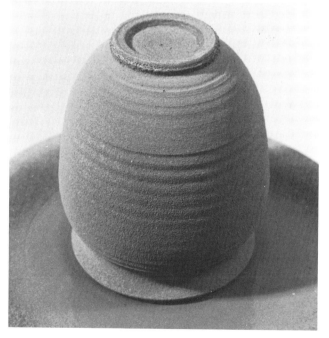

7-67

135

7-68

7-69

**7-71** Christine Rue
*Toucan Pitcher*
Handbuilt earthenware, majolica glaze,
  stencils
10 × 7 × 5″ (25 × 18 × 13 cm)
Photo: Jon Crispin

**7-72** Gerry Williams
Bottle
Thrown porcelain, brushed slips over
  glaze
10 × 4¹/₂″ (25 × 11 cm)
Photo: Bill Finney

## Other Decorating Techniques

**7-68,** After glaze has been applied to a pot, a *sgraffito* decoration can be scratched through to the bisque which will leave delicate lines in the fired glaze.

Applying glaze over glaze is known as *onglaze* decoration. Majolica and Faïence ware are early examples of this method. The technique gives best results when the base glaze has been sprayed on and the onglazes applied with light brushstrokes.

**7-69,** *Oxide washes* can also be applied on top of a glaze for striking decorative effects.

**7-70,** *Glaze/wax/glaze* is a decorating method achieved by immediately brushing a wax resist decoration onto a freshly glazed pot and then applying a different color glaze over it.

*Colored clays* can produce attractive results when used for decorating ceramic objects. They also provide an interesting alternative to multiple glazing for colorful effects.

Additions of 1 to 15 percent by weight of a coloring oxide or commercial body stain will give a pronounced color to a clay. While virtually any clay can be colored, best results are achieved when using a white or light colored body. Clays can be colored darker, but not lighter.

Test samples of the colored clay should be made before large amounts are mixed. Such colorants as copper carbonate,

7-70

7-71

7-72

**7-73**  Vase
12th century Chinese Tz'u-Chou ware
Thrown earthenware, sgraffito through
glaze
18³/₄ × 13³/₈" (48 × 34 cm)
Courtesy: Worcester Art Museum
  Gift of Alfred K. Pearson

**7-74**  Scalloped Plate
16th century Italian
Earthenware, majolica decoration
11" (28 cm) diameter
Courtesy: Worcester Art Museum

**7-75**  Niderviller, ca. 1775
*Plate with Plums*
Earthenware, faïence decoration
10" (25 cm) diameter
Courtesy: Wadsworth Atheneum, Hartford
Photo: E. Irving Blomstrann

chrome oxide, and iron oxide in amounts from 1 to 5 percent will give good color. Weaker colorants such as vanadium stain and iron chromate need percentage additions of 5 to 15 percent for reasonable color. Cobalt carbonate and other strong stains are best used in amounts under 2 percent. Too much colorant can actually act as a flux in the clay body and cause it to fuse and begin to melt.

To add the colorant to small amounts of clay, poke a hole in a ball of clay and sprinkle in the colorant along with a few drops of water. Then carefully knead the clay until the colorant is thoroughly mixed in. For larger amounts of clay, the colorant is best added to a dry mix. Keep different colored clays separate. Use a different piece of canvas or plaster when kneading each clay to prevent the colors from contaminating each other.

The colored clays can be kneaded into or pressed onto pinch forms. Coil built pieces can be constructed from different colored coils. Slab objects can be made by first rolling colored clays into a base slab and then constructing the pieces in the usual way. Wheel thrown pieces can be made from colored clays partially kneaded together.

Press molds and drape molds can be used to keep intricate patterns from becoming distorted.

7-73

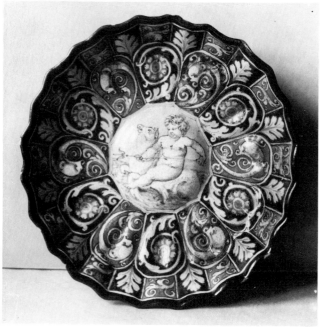

7-74

7-75

137

**7-76** Elijah Mayer
Covered dish, 18th century
Carved basalt stoneware
5″ (13 cm) high
Courtesy: Worcester Art Museum
  Gift of Mrs. Kingsmill Marrs

7-76

Care should be taken to prevent the clay colors from muddy-
ing each other on the exterior of the object. If this does hap-
pen, a light sandpapering or scraping after the ware has dried
should restore color definition. In the case of thrown ware, the
entire piece may need to be lightly trimmed to bring out the
color variations.

For the most brilliant color effects, the work should be fired
with a clear gloss glaze. Subtle colors can be attained with
semi-matt glaze. However, even with no glaze, most colored
clays offer pleasing results when fired.

Colored clay effects can be achieved at all temperatures and
atmospheres—provided the colorants are properly chosen.

7-77

**7-77** Cow Creamer
Bennington Pottery 1850-60
Scroddled Ware colored clay decoration
6¹/₂ × 5″ (16 × 13 cm)
Courtesy: Wadsworth Atheneum, Hartford
Photo: E. Irving Blomstrann

138

**7-78** Ellen Grenadier
Tray
Handbuilt colored porcelain, salt fired
13 × 17″ (33 × 43 cm)
Photo: Tom Lang

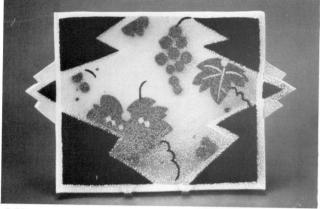

7-78

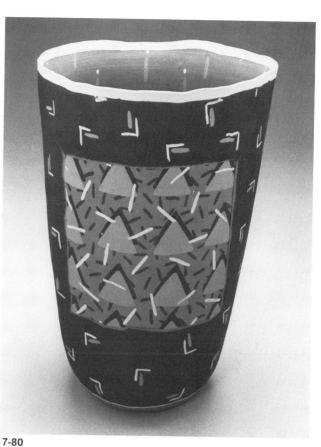

7-80

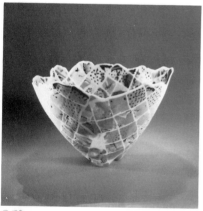

7-79

**7-79** Curtis and Suzan Benzle
*Indiana 1984*
Press-molded inlayed colored porcelain,
 incised
5 × 7″ (13 × 18 cm)
Photo: C. Benzle

**7-80** Carolyn Brice Brooks
Vase form
Drape-molded inlayed colored porcelain,
 unglazed
9¹/₂ × 6¹/₂″ (24 × 17 cm)
Photo: Keith Dannemiller

**7-81** Beth Forer
Plate—woven pattern
Handbuilt colored earthenware, nerikomi
 (neriage) technique
6″ (15 cm) diameter
Photo: Bobby Hanson

**7-82** Beth Forer
Square Form—bow-tip pattern
Handbuilt colored earthenware, nerikomi
 (neriage) technique
12 × 12″ (30 × 30 cm)
Photo: Bobby Hanson

7-81

7-82

**7-83** Patrick Siler
Box
Slab-built colored clay
8 × 8 × 8″ (20 × 20 × 20 cm)

**7-84** Amphora
Greek, ca. 6th century B.C.
Earthenware, black figure decoration
24¹/₂ × 14⁵/₈″ (62 × 37 cm)
Courtesy: Worcester Art Museum
   Austin and Sarah Garver Fund

**7-85** Charles Malin
*Succulently Plaid*
Slab-built earthenware, terra sigillata
   decoration
30 × 16 × 6″ (76 × 41 × 15 cm)

*Terra sigillata,* although actually denoting early Roman stamped ware, has come to refer to early Greek and Roman earthenware decorated with a shiny dark surface. The coating is not a glaze but a refined clay slip. Terra sigillata is usually prepared from a low temperature red clay as follows: Mix a thin slip of 20 percent clay and 80 percent water (distilled, if possible). About 1/10th of 1 percent of a deflocculant can be added to keep the clay particles in suspension. Ball milling will help make a homogeneous slip but is not necessary if the slip is thoroughly mixed. Allow the slip to settle in a container for at least a day. Drain off the standing water. Then take out the top third of the clay slip for use and discard the remainder. If desired, the slip may be diluted and mixed again. After it has settled, another usable portion can be drawn off and its remainder discarded.

Terra sigillata should be applied very thinly on damp or dry ware. A heavy coating could crack during drying and shrinking. To achieve a harder, glossier finish, the terra sigillata coated surface may be burnished before firing with the back of a spoon or other smooth instrument. Firing terra sigillata at cone 06 (991°C/1816°F) or lower brings out the color and shiny surface. At higher temperatures the surface tends to dull. Most terra sigillata fires from red to ochre to brown in oxidation and to black in reduction. If colors other than the natural tones are desired, a batch of 30 percent dry terra sigillata and 70 percent water with 3 percent colorant added can be used. Cobalt, copper, chrome, manganese, and stains will give interesting colors. Although a well fired terra sigillata may give the appearance of a glaze, it does not make the ware waterproof.

7-83

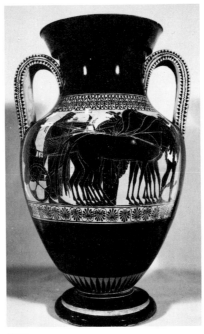

7-84

7-85

140

# CHAPTER 8 Adapting Commercial Decoration Techniques

Over the past few years, contemporary clayworkers have begun to draw upon certain commercial processes to broaden the possibilities for embellishing the surfaces of their work. These decorations are applied after the ware has been finished and glaze fired. For sharp bright effects, the ware should be fired with a hard gloss glaze. It is possible to use matt glazes with these techniques, but results may vary because of the inherently rougher surface.

Before applying decoration with any of these techniques, the ware should be cleaned with denatured alcohol or acetone **(both of which are toxic),** and thoroughly dried.

**Proper kiln ventilation is especially important when firing overglaze, luster glaze, or decals.** For more specific information on kiln ventilation see Chapter 10.

**8-1**  Vase
19th century Japanese Satsumi ware
Thrown stoneware, overglaze decoration
14 1/2 × 12″ (37 × 30 cm)
Courtesy: The George Walter Vincent
  Smith Art Museum, Springfield, MA

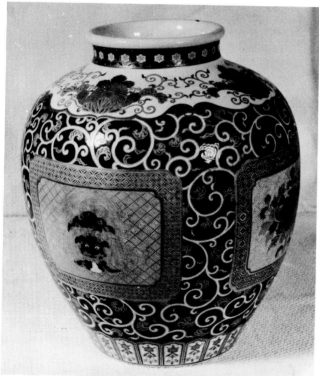

8-1

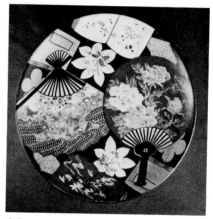

8-2

8-3

**8-2**  Plate, one of a pair
Chinese, T'ung-Chih period (1862-1873)
Porcelain, overglaze enamel
10″ (25 cm) diameter
Courtesy: Worcester Art Museum
  Bequest of Mrs. W. C. Thompson

**8-3**  Hichozan Shimpo (ca. 1850)
Platter
Porcelain, overglaze enamel
14″ (36 cm) diameter
Courtesy: P. F. Bear Oriental Art and
  Antiques

141

**8-4**  Ka-Kwong-Hui
Vase
Thrown earthenware, overglaze
  decoration
20 × 13″ (51 × 33 cm)

**8-5**  John Goodheart
*Night Rainbow*
Thrown earthenware, impressed,
  sprigged, engobe decoration, luster
  glaze
24″ (61 cm) diameter

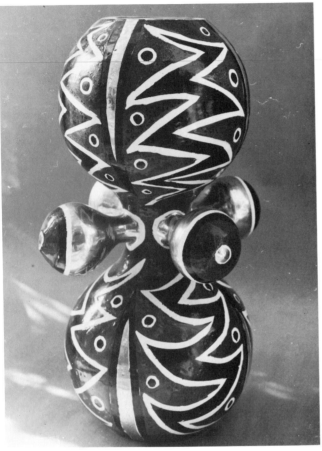

8-4

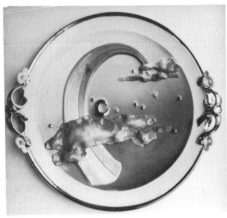

8-5

## Overglaze

In earlier times, decorators ground their own combination of overglaze pigments and fluxes in a medium of various oils and turpentine. Today, many companies have developed a large array of ready mixed colors which can be applied directly from the jar. It is important to note which type of medium, such as mineral spirits or lavender oil, is used in a particular overglaze. Thinning with the wrong medium can spoil the decoration.

### Application

Overglazes should be applied with good quality camel hair brushes for lining and banding. Large areas can best be covered by using an airbrush, a refined version of the glaze spray gun. The usual glaze gun has too coarse a spray for successful overglazing.

Because overglazes are usually made of finely ground prefired ingredients, a thin coating is all that is required to afford good color. Mistakes should be wiped off immediately with a piece of cloth or cotton swab dipped in mineral spirits or the manufacturer's recommended thinner. The overglaze should be thoroughly dried before firing.

### Firing

It is important that overglazes be fired to the exact temperature recommended by the manufacturer. Many of the colors have extremely short firing ranges and overfiring by as little as 10 or 15 degrees could cause the color to disappear. Because a good oxidizing atmosphere is required, an electric kiln should be used. Overglazes fire in the range of cone 019 to 014 (668°-834°C, 1234°-1533°F.) Glass glazes, which react like overglazes, can be fired on glass as well as on fired glaze in the cone 022 to cone 020 (585°-625°C, 1085°-1157°F) range. Fired overglaze flaws can be removed by using a china paint eraser.

## Luster Glaze

The earliest known examples of luster glazing are those from the Mediterranean area dating from the early ninth century. These bowls and plates were first glaze fired then decorated with thinned glazes charged with salts of metals, such as copper, and fired again to a low temperature in a reducing atmosphere.

142

**8-6** Jug
British, 19th century
Mold-made earthenware, luster resist
6" (15 cm) high
Courtesy: Worcester Art Museum
  Theodore T. and Mary G. Ellis
  Collection

**8-7** Author
*Winged Vessels*
Thrown, handbuilt porcelain, luster glaze
Left to right: 7" (18 cm), 9" (23 cm), 6½"
  (17 cm) high

**8-8** Patti Warashina
*Airstream Turkey*
Handbuilt earthenware, luster glaze
20 × 10 × 6" (51 × 25 × 15 cm)

Although it is possible to prepare luster glazes in the studio, the procedures are long, costly, and relatively dangerous. Many of the chemicals are toxic and hazardous to the eyes. Fortunately, a number of companies market a large selection of ready-to-use metallic and pearlescent lusters along with liquid bright metals, such as gold and palladium.

Because lusters are in suspension and are not dissolved mixtures, the containers should not be shaken. Material which collects at the bottom should be discarded. If it is necessary to thin a luster glaze, use only the medium recommended by the manufacturer.

## Application

**When working with lusters, good ventilation is essential.** Simply opening a window is not enough. A fan that exhausts to the exterior is good; working in a spray booth is better. Use a NIOSH approved vapor respirator to prevent inhalation of toluene, chloroform, and other materials present in commercial lusters.

Lusters can be poured, sponged, brushed, or airbrushed onto a clean, dry, dust-free fired glaze. A hard gloss glaze will give the best fired results, but a matt surface can provide a more pastel look.

Apply the luster in a thin coat. Too thick an application will just powder off after firing. It is best to use a separate brush for each color because luster is difficult to remove completely from the bristles. Brushes should be cleaned with denatured alcohol or acetone **(both of which are toxic)** after each use. When working with an airbrush, clean it every time a different luster is used as well as when glazing is finished.

## Firing

An oxidation firing should proceed slowly to about 450°C (842°F) with the kiln door open to allow the escape of fumes from the organic medium. The kiln is then closed and fired to the recommended temperature. To insure good oxidation, the spy holes may be kept open for the duration of the firing. Most luster glazes mature in the firing range of cone 020 to cone 018 (625°- 696°C, 1157°-1285°F). Overfired lusters change color or burn out.

Luster glazes can be given great depth and brilliance by repeated reglazing and firing. Interesting effects can be obtained by mixing different luster glazes together, applying them and firing. Firing a transparent color luster glaze over a fired metallic luster can also bring about striking results.

To remove unwanted fired luster glaze, use a china paint or gold eraser. If the glaze should tarnish, it may be cleaned and buffed with a silver dusting cloth. Anything more abrasive could scratch the glaze off.

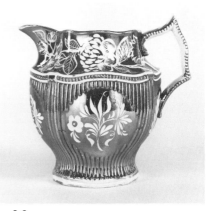

8-6

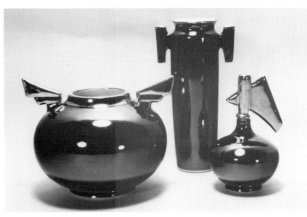

8-7

8-8

143

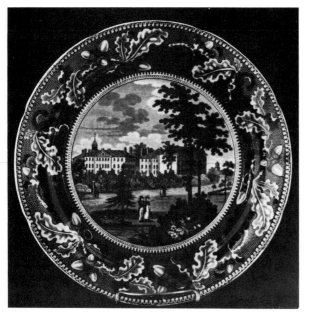

8-9

**8-9** Plate
Stevenson and Williams Company,
  ca. 1820
Cast earthenware, transfer print
10″ (25 cm) diameter
Courtesy: Worcester Art Museum
  Bequest of Grenville Norcross

## Decals

Used commercially since the 1800s, onglaze lithographs, or decals, are traditionally made by printing ceramic glazes on thin paper coated with gelatin or starch. The surface of the ware to be decorated is then coated with varnish or decal size. While the varnish is still tacky, the print is placed face down on the ware and rubbed with a dampened stiff brush until completely secured. After the varnish has dried, the heavy paper backing the decal is washed off. The ware is thoroughly dried for at least eight hours at room temperature and then fired.

### Application

The advent of *watermount* decals has made the entire process of application much easier. In this process, the image is lithographed right side up on simplex paper coated with soluble material. A thin coating of lacquer is applied over the print. To apply the decal, cut it out of its mounting sheet and place it in a pan of room temperature water. Sufficient time should be allowed only for the paper to become completely soaked. Prolonged soaking can spoil the adhesive quality of the lacquer. **8-11,** The decal is drained and then slid face up from its backing onto the clean ware and adjusted into position. **8-12,** Using a stiff piece of cardboard or a rubber squeegee, force all water and air bubbles from the center outward. Failure to do

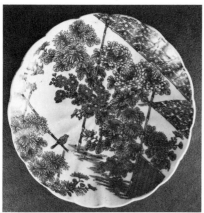

8-10

**8-10** Platter
Japanese, Meiji period
Press-molded porcelain, transfer print
12″ (30 cm) diameter
Courtesy: P. F. Bear Oriental Art and
  Antiques

8-11

8-12

8-13

**8-13** Author
*Bicentennial Commemorative*
Stoneware, decals, luster glaze
12″ (30 cm) diameter
Collection: Mr. and Mrs. Zalman Davlin

**8-14** Howard Kottler
*Look Alike Plate*
Cast porcelain, decals, luster glaze
10″ (25 cm) diameter

**8-15** Donald P. Taylor
*Technicolor Grant*
Thrown stoneware, artist's own decals
6¹/₂, 8 and 10″ (16, 20 and 25 cm)
diameters

this will result in poor resolution when the decal is fired. Surplus water and residue must be removed from the ware with a dry cloth.

Complicated forms can be decorated by first warming the ware and then molding on the decal with the fingers. The decal will stretch slightly to fit. Any wrinkles can easily be squeegeed out. Interesting and humorous effects can be developed by selectively combining portions of various decals.

Underglaze decals are used extensively in industry, but few studio potters have experimented with this method to date. The process is basically the same except that the decal is applied to bisque ware which is then glazed and fired to maturity.

Using the methods discussed in the silkscreen printing section, decals can be made by printing oil-based ceramic pigments or glazes directly onto starch covered paper or commercial decal paper. To ensure proper coverage of the glazes to be screened, and to preserve the screen as well, it is important that these materials be ground to a finer mesh than the screen. For instance, if a 130-mesh screen is used, then the glaze must be 140-mesh or finer to pass through. The materials can either be purchased in fine grinds or dry ground in a ball mill or with mortar and pestle.

Instead of mixing the glazes with water, better results can be obtained if a medium of equal parts of Damar varnish, boil-ed linseed oil and turpentine is used. The glaze is added to the medium until a thick creamy consistency is reached. An alternative mixture of about 40 percent glaze to 60 percent commercial silkscreen medium can also be used.

The image is printed on the prepared paper in the usual manner. As soon as the image dries, a thin coat of varnish or clear acrylic paint is applied to the entire surface. This combines with and bonds the ceramic materials. When the paper is soaked, the starch dissolves and releases the coated image. This is then applied to the ware as a watermount decal would be. The ware should dry completely for twenty-four hours before being fired.

**Firing**

As with luster glazes, the oxidation firing should start slowly with the door ajar until a temperature of about 450°C (842°F) is reached. The door can then be closed and the firing continued in a strong oxidizing atmosphere until maturing temperature. Most decals mature in the cone 020 to cone 018 (625°-696°C, 1157°-1285°F) range although some manufacturers recommend temperatures as high as cone 014 (834°C, 1533°F). Studio-made decals should, of course, be fired to their particular maturing temperatures, depending on which glaze materials have been used.

8-14

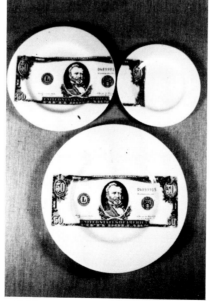

8-15

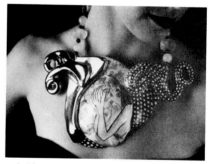

8-16

**8-16** Laney K. Oxman
Body Ornament
Handbuilt earthenware, underglaze,
decals, luster
Photo: Richard Rodriguez

## Acrylic Lift

This method is an easy way to mount pictures obtained from newspapers or magazines. First, blot denatured alcohol **(which is toxic)** on the chosen picture to loosen the ink. **8-17,** When this has dried, spray or brush five or six coats of clear acrylic paint over the surface. After the paint has dried completely, soak the picture in room temperature water for a half hour. **8-18,** Then remove it and gently rub off all the paper fibers, leaving only the ink impregnated in the acrylic. The acrylic image film can then be secured to a glaze fired object.

Apply a thin coat of acrylic paint to the surface of the object. When this coating becomes tacky, smooth the acrylic image into position and press out any air bubbles. Cover the image film with one or two thin coats of acrylic paint and let dry. The process is now complete with no additional firing. **8-19,** The disadvantage with this process is that the image can be scratched off.

A somewhat different method can be employed to make an acrylic positive film for photo silkscreen. As before, the chosen image is first blotted with denatured alcohol to loosen the ink.

8-17

8-18

8-19

**8-20**  Robert Cauvel
*Heartbreak Plate, 1983*
Thrown white earthenware, underglaze,
  Xerox lift
13″ (33 cm) diameter
Photo: the artist

**8-21**  Silkscreen Frame
Courtesy: Thomas E. Hanley

**8-22**  Thomas E. Hanley
*Cindy*
Photosilkscreen computer print
Low fire clay, colored slip
8 × 11″ (20 × 28 cm)
Photo: the artist

8-20

8-21

Next, cover a sheet of acetate with a thin coating of clear acrylic paint. Place the picture face down on the acetate and squeegee it on securely. After the acrylic has dried for at least an hour, soak the acetate in room temperature water for a half hour. Gentle rubbing will then remove all the paper fiber, leaving only the ink impregnated in the acetate. When the acetate is dry, it is ready to be used as a positive film in the photo silkscreen process.

## Silkscreen Printing

Silkscreen printing on a flat ceramic surface is similar to silkscreening on paper. A sturdy wood or metal frame stretched with screen fabric, a squeegee, some form of stencil, and ceramic pigments or glazes are all that is necessary.

### Screen

The size of the frame should be at least two inches (5cm) longer and wider than the size of the image to be printed. Screened frames are available from commercial screen suppliers. To make a frame, firmly secure four 2 × 2 inch (5 × 5 cm) wood strips at the corners with angle braces or corrugated fasteners.

The best fabric to use for the screen is silk. Nylon and other cloths are useful but do not stand up as well under repeated printings. The mesh size of the silk depends upon the materials to be screened. Open mesh sizes allow thick glaze, stain, or engobe to pass through. Finer sizes work best for overglazes and fine details. Silk comes in mesh counts from 74 (coarse) to 200 (fine).

To stretch the fabric, first cut it two inches (5 cm) larger than the outside dimensions of the frame. Dampen the fabric and then lay it over the frame. Align the warp and weft so that they are parallel with the sides of the frame. Using a heavy-duty stapler, fasten the fabric to the center area of one side of the frame. Pull the fabric across and staple it to the opposite side. Do the same for the other two sides. Stretch and staple the corners last. Cut away excess fabric.

Along all four sides, glue heavy-duty gummed paper tape to the inside of the frame continuing one inch (2.5 cm) out onto the fabric. Shellac the paper tape, overlapping a bit onto the fabric. This will prevent pigment from building up under the frame and smudging the printed image. **8-21**

8-22

147

## Stencil

A *paper stencil* is ideal for a short run (up to 15-20 prints) of a simple design. Cut or tear the desired shapes out of a large piece of paper. Avoid folds or wrinkles, which will allow the pigment to seep out from the stencil and spoil the image. Center the stencil under the screen. On top of the screen, block out unwanted areas with paper and tape. Put pigment on the screen. The first pull of the squeegee will attach the paper to the screen. The image can now be printed on wet or dry clay, bisque, glaze fired ware, or on decal paper. When printing is finished, remove all paper, tape, and the stencil from the screen. Wash all the pigment from the screen so that it will not clog the mesh and render the screen useless.

*Cut-film stencils* are best for long runs of complicated designs, fine lines, and sharp edges. Most films are laquer-based and work well with ceramic pigments. Some films are water soluble and can be used only with non-water based pigments. Be sure to choose the proper film for the medium in use.

Tape a larger piece of film over the design to be used. Carefully cut the outline of the design with a sharp X-acto blade. Cut just the film, not its backing. When all the cutting is finished, peel all the areas of the design to be printed from the backing.

Center the film face up under the screen. Adhere it to the fabric with the recommended solvent according to manufacturers' directions. When the screen is completely dry, gently peel away the backing. The screen is ready to print.

## Photo Silkscreen

The easiest way to acquire the necessary halftone photo silkscreen image is to take the desired positive or negative to a commercial printer and have it produced and screen mounted.

One method of producing a photo silkscreen in the studio is the Ammonium Bichromate Process. First, prepare at least two screens (one for a test) by tightly stretching and tacking or stapling swatches of 16-denier nylon onto sturdy wooden frames. Roughen the nylon surface with fine sandpaper. Then wash the screen well and allow it to dry.

Under darkroom conditions, with **proper ventilation**, prepare a formula of 1/4 teaspoon ammonium bichromate, 3 ounces distilled water and 3/4 ounce photo emulsion (Screen Star Photo Emulsion Bond #71 or equivalent). Apply a thin coat of this formula to the screen with a squeegee and let dry. Apply a second thin coat and let it dry.

If commercially prepared halftone is to be used, simply place it face down on the screen. If an acrylic lift acetate is to be used, place it face down on the screen and place a 90- or 130-mesh halftone transparency sheet on top of it. The image sheet is then covered with a clean piece of glass to keep it flat and in full contact with the emulsion surface.

To make a test screen exposure, first cover the screen with a cardboard. A 500 watt photoflood set 18 inches from the screen is turned on for a minimum of 3 minutes. By moving the board a few inches every 30 seconds, make a series of exposures. Remove the glass and image sheet. Wash the screen in cold water until a faint image is apparent. This may take from 2 to 15 minutes. When the screen is dry, it is ready to be printed. Choose the best exposure time for the final screen and prepare it accordingly.

An alternative method is to use a photosensitized film, such as McGraw 4571 or its equivalent, along with A and B developer. In an **adequately ventilated** darkroom, place the film sticky side down on a piece of clean glass. Put the chosen negative shiny side up on the film and place another piece of glass on top. Place a piece of cardboard over this. Make test strips by exposing sections of the film under a sunlamp at 30 second intervals for a total of at least four minutes. **Dark glasses should be worn to protect the eyes.** Remove the negative and place the film smooth side down on a piece of glass. Develop for two minutes and wash the film well. If the image is distinct, carefullly touch the screen down onto the sticky side of the film. Blot with crumpled newspaper to force the gel to stick to the screen. When the film color no longer comes off onto the newspaper, stop blotting and let the screen dry for 24 hours. Peel off the film backing and the screen is ready to print.

Printing glazes or ceramic pigments with a photo silkscreen is accomplished in the same manner as described in the section on printing decals.

Photo silkscreens can be used to print underglaze decorations on raw or bisque ware and overglaze decorations on fired engobes or glazes. The silkscreen obviously works best on flat or slight single curve surfaces because the wooden frame does not bend. If photo silkscreen prints are desired on curved surfaces, the image can be printed onto decal paper and applied with that technique.

After the printed images have completely dried, the ware can be fired to the maturing temperature of the glazes used.

The screen should be washed with kerosene **(a skin irritant)** and a soft toothbrush after each printing session.

8-23  Les Lawrence
Bowl
Thrown stoneware, silkscreen transfer
  decoration
18 × 8″ (46 × 20 cm)
Photo: Kay Colby

8-23

8-24 Author
Vessel
Slab-built stoneware, Picceramic
  photoprocess
17 × 6 × 4" (43 × 15 × 10 cm)

8-24

## Photoresist

Photoresist on glaze fired ceramics has undergone successful experimentation in at least three versions. One method involves a contact printed positive transparency, the second uses a projected positive transparency, and the third, a projected negative.

**Contact Transparency Method** This version works best on flat surfaces. Under **properly ventilated** darkroom conditions, a positive transparency is prepared from a black and white negative by exposure on Contrast Process Film. The negative is focused through an enlarger to the size of the print desired. Close the lens to its smallest aperture and expose the image. A typical exposure might be 10 seconds at f/16. Test strips should be made to arrive at the best time for the particular negative. Develop the film in Kodak DK 50 for 4 minutes, fix, wash, and dry. Other methods of making positive transparencies can also be used.

The transparency can be printed under yellow safelight conditions in a well ventilated darkroom. A coating of KTI-KPR Photo Resist is brushed or sprayed on glaze fired ware and dried either in a heating oven or by a small fan. A second coating is applied and dried. The transparency is placed face up in close contact with the dry resist surface by taping the edges and placing small weights on the darkest areas of the print. The picture is then exposed to a sunlamp or other ultraviolet light source. **Eyes should always be protected when using ultraviolet lamps.** A typical exposure with a 275 watt sunlamp is about 8 or 10 minutes at 12 inches. Make test strip exposures at 2-minute intervals to find the time best suited for the particular transparency.

To develop the image, ceramic overglazes are mixed with normal N-butyl acetate to a creamy consistency. The mixture is then brushed over the exposed emulsion. Development is instantaneous. Allow the surface to dry completely and then sponge off excess pigment under running water. Edges can be cleaned and image areas lightened with acetone **(which is toxic).**

Dry the ware completely and then fire to the proper temperature. Commercial overglazes offer the best results, but underglazes fired to cone 04 (1050°C, 1922°F) or oxides fired to cone 6 (1201°C, 2194 °F) or above can be mixed with the developer as well.

**Projected Negative Method** In this method, the need for a positive transparency is avoided. Processing occurs much like normal darkroom methods.

A special photoemulsion is prepared under red safelight conditions in the following manner. **Wear rubber gloves and a rubber or plastic apron when mixing and working with these chemicals.** In a glass container, 10 grams of gelatin is dissolved in 360 cc. of warm water. Add 32 grams of potassium bromide and 0.8 grams of potassium iodide and dissolve. Heat to 55°C (131°F) and hold at that temperature.

Dissolve 40 grams of silver nitrate in 400 cc. of water and slowly add to the potassium bromide solution, maintaining temperature and constantly stirring. Add 40 grams of gelatin to set the emulsion and allow to cool for 3 to 4 hours. When jelled, the emulsion is shredded through cheesecloth into 3 liters of room temperature water. Let stand for 3 minutes and then pour off the water. Repeat four or five times to wash away any soluble salts. Wash the emulsion under running water for 15 minutes and drain. The emulsion can then be refrigerated in a light proof container until it is needed.

The photoemulsion is used in this manner: Under red safelight, heat the emulsion to 55°C (131°F) in a glass beaker, then cool it to 40°C (104°F) and hold at that temperature. Apply the emulsion evenly over the ware by brushing, pouring or spraying. Dry it completely. Using a red filter on an enlarger, project the negative on the ware for focus and position. Shut off the enlarger and remove the filter. Make a normal print exposure test strip to find the best time for the negative in use. A typical exposure might be f/8 for 20 seconds at 12 inches. Develop in Dektol for about 2 minutes, fix, and then wash in cool water for 10 minutes. After the ware has completely dried, edges can be cleaned by using household bleach. The dry ware is then fired to 866°C (1591°F).

# CHAPTER 9 Glazes

9-1

An unfired glaze is a dry mixture of powdered inorganic materials which, when heated, will melt to form a viscous liquid. Upon cooling, this liquid hardens into a glassy condition. For ease of application, the unfired glaze is usually mixed in water to make a reasonably stable suspension.

Fired glaze is used primarily for its decorative effects. A glaze can also render a ceramic object nearly impervious to liquids and acids, giving it practical utility, provide a protective coating against weathering and discoloration, and can give additional strength. A fired glaze is very much like a thin layer of glass fused to a ceramic surface which has the chemical and physical characteristics of bottle or window glass.

Obsidian is an example of glass occurring in nature. It is formed by volcanic action which intensely heats minerals within the earth. The molten material is then expelled and slowly cools, forming glass. Manufactured glass is also composed of earth materials. It consists of about 75 percent pure sand or silica ($SiO_2$) and fluxing materials, such as soda ash ($Na_2O \cdot CO_2$) and limestone ($CaO \cdot CO_2$). The addition of fluxes reduces the temperature required to melt the sand from about $1750°C$ ($3182°F$) to less than $1500°C$ ($2732°F$), and reduces the softening temperature of the refined glass to about $1000°C$ ($1832°F$).

The useful properties of a glaze, however must be quite different from window or bottle glass. An unfired glaze must be able to stay suspended in water for a reasonable time without dissolving. It must be ground fine enough to mix easily, dry without cracking on a ceramic surface, and remain hard enough to allow handling without damage before firing. While in the kiln, the glaze must have a composition that will mature satisfactorily at the desired temperature. After firing, the glaze must cool to fit the ceramic form without cracking or splintering. Of course, the glaze should also look and feel pleasing.

To accomplish all these ends, a glaze must be carefully compounded from a number of ingredients, each serving an important part in the performance of the glaze. Because every one of these materials has its own particular qualities which can react favorably or unfavorably in a glaze, it is necessary to know these properties before attempting to formulate a glaze. A complete listing of raw materials, useful in ceramic glazes, will be found in Appendix A.

## Fusion Buttons

An easy and direct way to find out how raw materials react to firing is to make fusion button samples. These are nothing more

**9-2** Fusion Buttons, melon scoop
Left to right: underfired, correctly fired,
  over fired

9-2

than small amounts of raw materials placed on clay slabs which are then fired. However, to reasonably assess any results, some consistency is necessary in making the samples.

First, roll out a slab. Make depressions by pressing a jar cap into it. Cut squares around each depression, leaving an adequate border. Bisque fire these tiles.

With iron oxide wash, mark the name of the particular raw material on a bisqued tile. Then, fill a melon scoop or other small round spoon with the dry raw material to be tested. Do not pack it too tightly in the scoop. Deposit the material by inverting the scoop onto the bisqued tile. Be careful not to disturb the dome of material once it has been set into place. Fire the sample.

If the sample remains powdery after firing, it obviously has not melted or fused at the particular temperature. If it has melted completely and flowed into a puddle, the sample has been fired too high. If the sample appears as a slightly smaller glassy dome, then the raw material may be suitable for use at that particular temperature.

Fusion buttons can be used to discover at which temperature a particular material can best be used in a glaze by firing samples to different cones.

Rudimentary glazes can also be formulated using fusion buttons. Dry mix equal parts of different glaze materials together. Make samples and fire them at different temperatures, until the proper result is achieved. Of course, after an adequate sample is found, additional testing on tiles and small test pots should be carried out before any glaze is pronounced satisfactory.

Before describing how a glaze is formulated, a few words may be necessary to explain how chemistry is involved in the design of a glaze. Elements combine with one another to form compounds in exact, but simple multiples. For example, one atom of silicon (Si) will combine with two atoms of oxygen (O) to form one molecule fo silica ($SiO_2$). One molecule of soda ($Na_2O$), one molecule of alumina ($Al_2O_3$), and 6 molecules of silica ($SiO_2$) will combine with one another to form one complex molecule of a feldspar ($Na_2O \cdot Al_2O_3 \cdot 6SiO_2$). Because of a difference in the structure of its atoms, the unit weight of each element is different from every other. Consequently, each element has a different atomic weight. Therefore, when 1 atom of silicon combines with 2 atoms of oxygen, 28 parts by weight of silicon combine with $2 \times 16$ or 32 parts by weight of oxygen to form 60 parts by weight of silica. A chart of atomic weights of common elements and their oxides will be found in Appendix B.

## Molecular (Empirical) Formula

For many years, the standard convention for showing how oxide compounds relate to each other in a glaze has been the *molecular formula,* sometimes referred to as the *empirical formula.*

The following table illustrates this grouping of the more common elements used in a glaze. The materials in the RO column are considered bases; those in the $R_2O_3$ column as amphoteric or neutral in reaction; and those in the $RO_2$ column as acids. In the molecular formula, glazes are composed under three headings with R expressing the elemental part of the material and O, the oxygen content. The RO materials are the fluxes required to bring about a melt, the $R_2O_3$ materials are modifiers that affect glaze activity and the $RO_2$ materials are the glass formers or opacifiers.

| RO | | $R_2O_3$ | $RO_2$ |
|---|---|---|---|
| **Bases** | | **Neutrals** | **Acids** |
| BaO | MgO | $Al_2O_3$ | $SiO_2$ |
| CaO | MnO | $B_2O_3$ | $TiO_2$ |
| CdO | $Na_2O$ | | $ZrO_2$ } opacifiers |
| FeO | PbO | $Fe_2O_3$ | $SnO_2$ |
| $K_2O$ | SrO | $Sb_2O_3$ | |
| $Li_2O$ | ZnO | $Cr_2O_3$ | |

In the molecular formula, the amounts of the various oxides are expressed in *moles* which represent the *relative number of molecules* present and not their weight. This is done to change the formula into a usable recipe. The **Calculation Formula** of the glaze constituents to be used and the **Equivalent Weight** of the oxides they contain are made to correspond to this mole relationship. The equivalent weight is the weight of the raw material needed in a glaze to give one molecule of the oxide when fired. The calculation formulas and equivalent weights of compounds used in glazing are listed in Appendix C. It should be noted that with most materials, the equivalent weight equals the molecular weight of the raw formula. In some cases, because the compound gains or loses atoms in firing, the equivalent weight will differ. Always use the adjusted equivalent weight when calculating the molecular formula.

To have the molecular formula operate correctly, an arbitrary convention must be used—*that of making the moles in the RO column add up to one, or unity.* This aids in noting the relationship of the fluxes to the amount of silica present in a glaze. It also offers a convenient way to organize the calculation.

**Note: All the following formulas are used for practice calculation only and are not actual glazes. Regarding the use of lead in glazes, see ''A Note About Lead'' in Appendix A.**

## A Simple Glaze

As an example, suppose a simple low temperature matt glaze is desired. To obtain the matt surface, lithium oxide and a small amount of sodium oxide are to be used as the fluxes. A por-tion of alumina, or neutral material, is needed to control the glaze flow and devitrification. Sufficient silica, or acid, is needed to cause a good melt. A glaze formula is set up this way:

| Bases | | Neutrals | | Acids | |
|---|---|---|---|---|---|
| $Li_2O$ | .8 | $Al_2O_3$ | .11 | $SiO_2$ | 2.24 |
| $Na_2O$ | .2 | | | | |

To turn this into an actual batch recipe, raw materials must be chosen which will supply the oxides necessary to fulfill the glaze formula. One way to do this would be to use lithium carbonate to supply the lithium oxide, soda ash as the source of sodium oxide, clay for all of the alumina and some of the silica, and flint to give the remaining silica. In their unfired state, many compounds contain water and carbon which are driven off when fired. Other materials contained in the raw formula may also be totally or partially burned out. To make glaze formulation less complicated, some chemical actions are simply disregarded. To avoid confusion, the choice of a glaze material should always be based on its **Calculation Formula** and its corresponding **Equivalent Weight.**

The calculation for this example is set up in a chart as follows: Arrange the oxides in the glaze formula in the top horizontal row with their moles listed directly beneath them. Arrange the chosen raw materials in a vertical row along with their calculation formulas. Fill in the mole of each material needed to fulfill those required in the glaze formula.

Note that the calculation formula for clay calls for one molecule of alumina and two of silica. Therefore the amount of available silica molecules is twice that of alumina and must be so designated in the chart. Add each column of figures and check the totals against the required moles in the glaze formula.

| Material | Calculation Formula | Moles | Oxides in Formula / Moles in Formula | $Li_2O$ .8 | $Na_2O$ .2 | $Al_2O_3$ .11 | $SiO_2$ 2.24 |
|---|---|---|---|---|---|---|---|
| Lithium Carbonate | $Li_2O$ | .8 | | .8 | | | |
| Soda Ash | $Na_2O$ | .2 | | | .2 | | |
| Clay | $Al_2O_3 \cdot 2SiO_2$ | .11 | | | | .11 | .22 |
| Flint | $SiO_2$ | 2.02 | | | | | 2.02 |
| | | | Total | .8 | .2 | .11 | 2.24 |

After the needed moles are fulfilled in the chart, multiply the mole of each raw material by its equivalent weight to derive a weight factor.

| Material | Moles | X | Equivalent Weight | = | Weight Factor |
|---|---|---|---|---|---|
| Lithium | | | | | |
| Carbonate | .8 | × | 74 | = | 59.20 |
| Soda Ash | .2 | × | 106 | = | 21.20 |
| Clay | .11 | × | 258 | = | 28.38 |
| Flint | 2.02 | × | 60 | = | 121.20 |
| | | | | | 229.98 |

One additional step should be taken to make the weight factors into a percentage batch. To do this, divide the total weight factor into 100 to derive a key:

$$100 \div 229.98 = .435$$

Multiply all the weight factors by this key.

| Material | Weight Factor | × | Key | = | Percentage Batch | |
|---|---|---|---|---|---|---|
| Lithium | | | | | | |
| Carbonate | 59.20 | × | .435 | = 25.752 | | 26 |
| Soda Ash | 21.20 | × | .435 | = 9.222 | | 9 |
| Clay | 28.38 | × | .435 | = 12.345 | or | 12 |
| Flint | 121.20 | × | .435 | = 52.722 | | 53 |
| | | | | 100.041 | | 100 |

The percentage batch will give the correct proportion of each compound needed to mix a glaze of any amount. For ease in weighing, amounts in the percentage batch can be arbitrarily rounded off to an exact total of 100.

To solve the following problems, use simple oxide compounds.

### Problem A

| | | | | | |
|---|---|---|---|---|---|
| $K_2O$ | .4 | $Al_2O_3$ | .35 | $SiO_2$ | 2.5 |
| $Na_2O$ | .4 | | | | |
| CaO | .2 | | | | |

### Problem B

| | | | | | |
|---|---|---|---|---|---|
| $Na_2O$ | .3 | $Al_2O_3$ | .38 | $SiO_3$ | 4.3 |
| BaO | .3 | | | | |
| CaO | .2 | | | | |
| ZnO | .2 | | | | |

Solutions to the problems will be found in Appendix E.

## A Complex Glaze

Even if a more complex glaze is desired for a better surface and melt, the batch is calculated from the glaze formula in the same manner as before. Care must be taken to properly fulfill all the requirements of the glaze formula.

| | | | | | |
|---|---|---|---|---|---|
| $K_2O$ | .30 | $Al_2O_3$ | .35 | $SiO_2$ | 2.75 |
| CaO | .45 | | | | |
| BaO | .25 | | | | |

Choose each material from the raw materials chart by its calculation formula. The calcium oxide can be fulfilled by whiting, and the barium oxide by barium carbonate. Although a number of compounds containing potassium oxide could be chosen, in this example the pure potash feldspar, microcline, is used. Its formula is $K_2O \cdot Al_2O_3 \cdot 6\,SiO_2$, and it has an equivalent weight of 556.

Set up a chart (see top of next page) and fulfill needed moles by a raw material.

Note that in the case of microcline there is 6 times the amount of silica as there is potash. Therefore its mole is 6 times .3, or 1.8. With clay, the silica is 2 times .05, or .10.

| Oxides in Formula | | | K₂O | CaO | BaO | Al₂O₃ | SiO₂ |
|---|---|---|---|---|---|---|---|
| **Material** | **Calculation Formula** | **Moles** | **Moles in Formula** $\rightarrow$ .30 | .45 | .25 | .35 | 2.75 |
| Microcline | $K_2O \cdot Al_2O_3 \cdot 6SiO_2$ | .30 | | .30 | | | .30 ... 1.80 |
| Whiting | CaO | .45 | | | .45 | | |
| Barium Carbonate | BaO | .25 | | | | .25 | |
| Clay | $Al_2O_3 \cdot 2SiO_2$ | .05 | | | | | .05 ... .10 |
| Flint | $SiO_2$ | .85 | | | | | .85 |
| | | **Total** | | .30 | .45 | .25 | .35 | 2.75 |

After correctly filling the chart, multiply the moles by their equivalent weights to find the weight factors. Then derive the key and multiply all the weight factors to find the percentage batch.

| Material | Moles | X | Equivalent Weight | = | Weight Factor | X | Key | = | % Batch | |
|---|---|---|---|---|---|---|---|---|---|---|
| Microcline | .30 | × | 556 | = | 166.80 | × | .3077 | = | 51.324 | 51 |
| Whiting | .45 | × | 100 | = | 45.00 | × | .3077 | = | 13.846 | 14 |
| Barium Carbonate | .25 | × | 197 | = | 49.25 | × | .3077 | = | 15.154 or 15 |
| Clay | .05 | × | 258 | = | 12.90 | × | .3077 | = | 3.969 | 4 |
| Flint | .85 | × | 60 | = | 51.00 | × | .3077 | = | 15.692 | 16 |
| | | | | 100 ÷ | 324.95 | = | .3077 | | 99.985 | 100 |

To solve the following problem use anorthite as the feldspar.

## Problem C

| | | | | | | |
|---|---|---|---|---|---|---|
| CaO | .3 | Al₂O₃ | .34 | SiO₂ | 2.60 |
| Na₂O | .3 | | | | |
| BaO | .2 | | | | |
| MgO | .1 | | | | |
| ZnO | .1 | | | | |

To solve the following problem use albite as the feldspar and dolomite as the source of magnesium oxide.

## Problem D

| | | | | | |
|---|---|---|---|---|---|
| Na₂O | .4 | Al₂O₃ | .45 | SiO₂ | 3.4 |
| CaO | .3 | | | | |
| MgO | .2 | | | | |
| BaO | .1 | | | | |

Solutions will be found in Appendix E.

## A More Complex Glaze

The following formula is typical of a glaze which calls for a compound that appears to have oxides in amounts greater than can be used.

| | | | | | |
|---|---|---|---|---|---|
| K₂O | .5 | Al₂O₃ | .25 | SiO₂ | 1.80 |
| CaO | .3 | B₂O₃ | .30 | | |
| ZnO | .2 | | | | |

Pearl ash and zinc oxide can supply the needed potassium and zinc oxides. Colemanite can be used to supply both the calcium oxide and boron. Whiting, clay and flint will also be needed.

If colemanite is used to fulfill all the calcium oxide it will contribute more boron to the formula than can be used. Instead, think of the colemanite as supplying all the boron and only

156

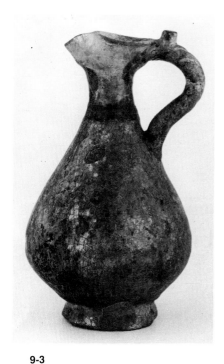

**9-3** Pitcher
12-13th century Mesopotamian
Egyptian Paste
7¹/₂″ (19 cm) high
Courtesy: Museum of Fine Arts, Boston
Gift of K. Aharonian

some of the calcium oxide. The following ratio will derive the needed amount:

$$\frac{\text{What is needed in the formula (WIN)}}{\text{What is present in the material (WIP)}} = \text{amount to be used}$$

Therefore, to find the amount of colemanite to be used in the example, using the WIN/WIP formula:

$$\frac{.3 \quad B_2O_3}{1.5 \quad B_2O_3} = .2 \text{ mole of colemanite}$$

Multiply all the oxides in colemanite by .2 and insert these moles in the chart. All the boron is now satisfied along with most of the calcium oxide. Whiting will fill the remaining calcium oxide. Clay and flint complete the formula.

9-3

| Material | Calculation Formula | Moles | Moles in Formula | $K_2O$ | $CaO$ | $ZnO$ | $B_2O_3$ | $Al_2O_3$ | $SiO_2$ |
|---|---|---|---|---|---|---|---|---|---|
| | | | Oxides in Formula | .5 | .3 | .2 | .3 | .25 | 1.8 |
| Pearl Ash | $K_2O$ | .5 | | .5 | | | | | |
| Colemanite | $CaO \cdot 1.5B_2O_3$ | .2 | | | .2 | | .3 | | |
| Whiting | $CaO$ | .1 | | | .1 | | | | |
| Zinc Oxide | $ZnO$ | .2 | | | | .2 | | | |
| Clay | $Al_2O_3 \cdot 2SiO_2$ | .25 | | | | | | .25 | .5 |
| Flint | $SiO_2$ | 1.3 | | | | | | | 1.3 |
| | | | Total | .5 | .3 | .2 | .3 | .25 | 1.8 |

The batch is calculated as follows:

| Material | Moles | X | Equivalent Weight | = | Weight Factor | X | Key | = | % Batch | |
|---|---|---|---|---|---|---|---|---|---|---|
| Pearl Ash | .5 | × | 138 | = | 69.0 | × | .3586 = | | 24.743 | 24.7 |
| Colemanite | .2 | × | 206 | = | 41.2 | × | .3586 = | | 14.774 | 14.8 |
| Whiting | .1 | × | 100 | = | 10.0 | × | .3586 = | | 3.586 or | 3.6 |
| Zinc Oxide | .2 | × | 81 | = | 16.2 | × | .3596 = | | 5.809 | 5.8 |
| Clay | .25 | × | 258 | = | 64.5 | × | .3586 = | | 23.129 | 23.1 |
| Flint | 1.3 | × | 60 | = | 78.0 | × | .3586 = | | 27.971 | 28.0 |
| | | | | | 100 ÷ 278.9 = .3586 | | | | 100.012 | 100.0 |

157

The WIN/WIP formula is also required when a complex feldspar is to be used in a glaze formula.

| | | |
|---|---|---|
| Na$_2$O .18 | Al$_2$O$_3$ .38 | SiO$_2$ 2.50 |
| K$_2$O .10 | | |
| CaO .23 | | |
| ZnO .26 | | |
| BaO .23 | | |

In the example the feldspar used has an equivalent weight of 571 and the formula:

| | | |
|---|---|---|
| Na$_2$O .50 | Al$_2$O$_3$ 1.01 | SiO$_2$ 6.65 |
| K$_2$O .28 | | |
| CaO .22 | | |

To use the feldspar, divide the amount of N$_2$O in the glaze formula by the Na$_2$O in the feldspar to find its mole.

$$\frac{WIN}{WIP} = \frac{.18}{.50} = .36 \text{ mole of feldspar}$$

Multiply each oxide in the feldspar by .36 and insert the number in its proper column.

Whiting is used for the remainder of the calcium oxide. Zinc oxide and barium carbonate fulfill their formula requirements. Clay and flint fill the needed alumina and silica.

| Material | Calculation Formula | Moles | Oxides in Formula / Moles in Formula | Na$_2$O | K$_2$O | CaO | ZnO | BaO | Al$_2$O$_3$ | SiO$_2$ |
|---|---|---|---|---|---|---|---|---|---|---|
| | | | | .18 | .10 | .23 | .26 | .23 | .38 | 2.50 |
| Spar | Na$_2$O .50 Al$_2$O$_3$ 1.01 SiO$_2$ 6.65 <br> K$_2$O .28 <br> CaO .22 | .36 | | .18 | .10 | .08 | | | .36 | 2.39 |
| Whiting | CaO | .15 | | | | .15 | | | | |
| Zinc Oxide | ZnO | .26 | | | | | .26 | | | |
| Barium Carbonate | BaO | .23 | | | | | | .23 | | |
| Clay | Al$_2$O$_3$·2SiO$_2$ | .02 | | | | | | | .02 | .04 |
| Flint | SiO$_2$ | .07 | | | | | | | | .07 |
| | | | Total | .18 | .10 | .23 | .26 | .23 | .38 | 2.50 |

| Material | Moles | X | Equivalent Weight | = | Weight Factor | X | Key | = | % Batch |
|---|---|---|---|---|---|---|---|---|---|
| Feldspar | .36 | × | 571 | = | 205.56 | × | .3375 | = | 69.377 |
| Whiting | .15 | × | 100 | = | 15.00 | × | .3375 | = | 5.063 |
| Zinc Oxide | .26 | × | 81 | = | 21.06 | × | .3375 | = | 7.108 |
| Barium Carbonate | .23 | × | 197 | = | 45.31 | × | .3375 | = | 15.292 |
| Clay | .02 | × | 258 | = | 5.16 | × | .3375 | = | 1.742 |
| Flint | .07 | × | 60 | = | 4.20 | × | .3375 | = | 1.418 |

100 ÷ 296.29 = .3375          100.00

To solve the following formula use borax.

**Problem E**

| | | | | | |
|---|---|---|---|---|---|
| Na₂O | .3 | Al₂O₃ | .2 | SiO₂ | 3.4 |
| MgO | .3 | B₂O₃ | .35 | | |
| ZnO | .2 | | | | |
| BaO | .2 | | | | |

To solve the following formula use Kona F-4 feldspar.

**Problem F**

| | | | | | |
|---|---|---|---|---|---|
| Na₂O | .27 | Al₂O₃ | .56 | SiO₂ | 4.60 |
| K₂O | .17 | | | | |
| CaO | .24 | | | | |
| ZnO | .15 | | | | |
| BaO | .17 | | | | |

The solutions will be found in Appendix E

## To Find a Glaze Formula from a Batch

Sometimes it is necessary to take a batch recipe and return it to its glaze formula. This is important when a glaze material becomes unavailable and a substitution is needed, when comparing two glazes, or if a glaze does not fire properly.

To find a glaze formula from a batch, divide the percentage batch weight of each material by its equivalent weight.

| Material | Batch | ÷ | Equivalent Weight | = | Mole Factor |
|---|---|---|---|---|---|
| Lithium | | | | | |
| Carbonate (Li₂O) | 26 | ÷ | 74 | = | .351 |
| Soda Ash (Na₂O) | 9 | ÷ | 106 | = | .085 |
| Clay (Al₂O₃•2SiO₂) | 12 | ÷ | 258 | = | .047 |
| Flint (SiO₂) | 53 | ÷ | 60 | = | .883 |

Write this as a formula. Note that clay has twice the silica as alumina. Therefore, multiply .047 by 2 for the correct amount of silica and add it into the SiO₂ total.

| | | | | | |
|---|---|---|---|---|---|
| Li₂O | .351 | Al₂O₃ | .047 | SiO₂ | .883 |
| Na₂O | .085 | | | | + .094 |
| | .436 | | | | .977 |

To make the RO column equal one, or unity, divide its sum into 1 to get the key.

$$1 \div .436 = 2.294$$

Multiply all the glaze constituents by the key to derive the correct formula.

| | | | | | |
|---|---|---|---|---|---|
| Li₂O | .351 | × | 2.294 | = | .805 |
| Na₂O | .085 | × | 2.294 | = | .195 |
| Al₂O₃ | .047 | × | 2.294 | = | .108 |
| SiO₂ | .977 | × | 2.294 | = | 2.241 |

The figures may be rounded off and put into a glaze formula.

| | | | | | |
|---|---|---|---|---|---|
| Li₂O | .8 | Al₂O₃ | .11 | SiO₂ | 2.24 |
| Na₂O | .2 | | | | |

The same method is used to write the formula of a more complex glaze batch. In the example, albite is used as the feldspar. Its formula is Na₂O•Al₂O₃•6SiO₂ and it has an equivalent weight of 524.

First, divide the batch weight of each material by its equivalent weight to find its mole.

| Material | Batch | ÷ | Equivalent Weight | = | Mole Factor |
|---|---|---|---|---|---|
| Albite | 52.9 | ÷ | 524 | = | .101 |
| Whiting | 11.2 | ÷ | 100 | = | .112 |
| Barium Carbonate | 12.7 | ÷ | 197 | = | .064 |
| Zinc Oxide | 3.8 | ÷ | 81 | = | .047 |
| Clay | 4.2 | ÷ | 258 | = | .016 |
| Flint | 15.2 | ÷ | 60 | = | .253 |

Arrange all the oxides horizontally in a chart with all the raw materials and their calculation formulas vertically. Fill in the mole factors.

Note that the $SiO_2$ in albite is 6 times the $Na_2O$ and in clay it is 2 times the $Al_2O_3$.

| Material | Calculation Formula | Moles | Oxides in Formula | $Na_2O$ | CaO | BaO | ZnO | $Al_2O_3$ | $SiO_2$ |
|---|---|---|---|---|---|---|---|---|---|
| Albite | $Na_2O \cdot Al_2O_3 \cdot 6SiO_2$ | .101 | | .101 | | | | .101 | .606 |
| Whiting | CaO | .112 | | | .112 | | | | |
| Barium Carbonate | BaO | .064 | | | | .064 | | | |
| Zinc Oxide | ZnO | .047 | | | | | .047 | | |
| Clay | $Al_2O_3 \cdot 2SiO_2$ | .016 | | | | | | .016 | .032 |
| Flint | $SiO_2$ | .253 | | | | | | | .253 |
| | | | Total | .101 | .112 | .064 | .047 | .117 | .891 |

Add the numbers in each oxide column and arrange the totals in a formula.

| $Na_2O$ | .101 | $Al_2O_3$ .117 | $SiO_2$ .891 |
|---|---|---|---|
| CaO | .112 | | |
| BaO | .064 | | |
| ZnO | .047 | | |
| | .324 | | |

Divide the sum of the RO column into 1 to get the key.

$$1 \div .324 = 3.086$$

Multiply each oxide by the key to derive a unity formula.

| $Na_2O$ | .101 | × | 3.086 | = | .3116 |
|---|---|---|---|---|---|
| CaO | .112 | × | 3.086 | = | .3456 |
| BaO | .064 | × | 3.086 | = | .1975 |
| ZnO | .047 | × | 3.086 | = | .1450 |
| $Al_2O_3$ | .117 | × | 3.086 | = | .3610 |
| $SiO_2$ | .891 | × | 3.086 | = | 2.7496 |

The equivalents may be rounded off and arranged in a glaze formula.

| $Na_2O$ | .31 | $Al_2O_3$ .36 | $SiO_2$ 2.75 |
|---|---|---|---|
| CaO | .35 | | |
| BaO | .20 | | |
| ZnO | .15 | | |
| | 1.01 | | |

**Problem G**

| Lithium Carbonate | 11 |
|---|---|
| Zinc Oxide | 24 |
| Whiting | 5 |
| Clay | 19 |
| Flint | 41 |

**Problem H**

| Nepheline Syenite | 45.3 |
|---|---|
| Whiting | 9.7 |
| Barium Carbonate | 23.2 |
| Zinc Oxide | 8.8 |
| Clay | 13.0 |

The solutions will be found in Appendix E.

## Limit Formulas

The following table lists the approximate effective range of oxide amounts that can be used in a glaze at a given temperature. The oxides are listed in decreasing order of fluxing activity.

Use the information as a general guide. It can be helpful in constructing a new glaze or correcting a faulty one. Remember that in practice the RO column must equal *one*.

**Low Temperature:** C/012-C/05 (876°-1031°C/1609°-1888°F)

| | | | | | |
|---|---|---|---|---|---|
| PbO | 0 -1.0 | Al$_2$O$_3$ | .05 -.25 | SiO$_2$ | .5 - 2.5 |
| K$_2$O | .1 - .8 | B$_2$O$_3$ | 0 -.8 | | |
| Na$_2$O | .1 - .8 | | | | |
| Li$_2$O | 0 - .8 | | | | |
| BaO | 0 - .3 | | | | |
| SrO | 0 - .3 | | | | |

**Mid Temperature:** C/04-C/4 (1050°-1168°C/1922°-2134°F)

| | | | | | |
|---|---|---|---|---|---|
| PbO | 0 -.5 | Al$_2$O$_3$ | .15 -.35 | SiO$_2$ | 2.0 - 3.0 |
| K$_2$O | .1 -.6 | B$_2$O$_3$ | 0 -.6 | | |
| Na$_2$O | .1 -.6 | | | | |
| Li$_2$0 | 0 -.6 | | | | |
| CaO | .1 -.3 | | | | |
| BaO | .1 -.5 | | | | |
| SrO | 0 -.5 | | | | |
| ZnO | 0 -.3 | | | | |
| MgO | 0 -.2 | | | | |

**High Temperature:** C/5-C/12 (1177°-1306°C/2151°-2383°F)

| | | | | | |
|---|---|---|---|---|---|
| K$_2$O | .2 -.4 | Al$_2$O$_3$ | .25 -.5 | SiO$_2$ | 3.0 - 5.0 |
| Na$_2$O | .2 -.4 | B$_2$O$_3$ | 0 -.4 | | |
| Li$_2$O | 0 -.4 | | | | |
| BaO | 0 -.8 | | | | |
| SrO | 0 -.8 | | | | |
| ZnO | 0 -.5 | | | | |
| CaO | 0 -.5 | | | | |
| MgO | 0 -.4 | | | | |

## Chemical Analysis of a Feldspar to Formula

To accurately use a feldspar in a glaze formula it is necessary to know its formula and equivalent weight. A feldspar comes from the manufacturer with a percentage analysis which must be made into a calculation formula.

Suppose a feldspar has the following analysis;

| | |
|---|---|
| SiO$_2$ | 50.63% |
| Al$_2$O$_3$ | 27.00 |
| K$_2$O | 13.20 |
| Na$_2$O | 9.10 |
| LOI (loss on ignition) | .07 |

Divide the percentage of each compound by its atomic weight to derive its mole factor. For simplification, loss on ignition is discarded.

| Material | Percentage | ÷ | Atomic Weight | = | Mole Factor |
|---|---|---|---|---|---|
| SiO$_2$ | 50.63 | ÷ | 60 | = | .844 |
| Al$_2$O$_3$ | 27.00 | ÷ | 102 | = | .265 |
| K$_2$O | 13.20 | ÷ | 94 | = | .140 |
| Na$_2$O | 9.10 | ÷ | 62 | = | .147 |

Set up these figures as a formula.

| | | | | | |
|---|---|---|---|---|---|
| K$_2$O | .140 | Al$_2$O$_3$ | .265 | SiO$_2$ | .844 |
| Na$_2$ | .147 | | | | |
| | .287 | | | | |

To derive a unity formula, add the RO column and then divide that sum into 1 to find the key.

$$1 \div .287 = 3.484$$

Multiply each oxide by the key and arrange the answers as a formula.

| | | | | | |
|---|---|---|---|---|---|
| K$_2$O | .49 | Al$_2$O$_3$ | .92 | SiO$_2$ | 2.94 |
| Na$_2$O | .51 | | | | |

To derive the equivalent weight of the feldspar, multiply the moles by their atomic weights and add the weight factors.

| Material | Moles | X | Atomic Weight | = | Weight Factor |
|----------|-------|---|---------------|---|---------------|
| $K_2O$ | .49 | × | 94 | = | 46.06 |
| $Na_2O$ | .51 | × | 62 | = | 31.62 |
| $Al_2O_3$ | .92 | × | 102 | = | 93.84 |
| $SiO_2$ | 2.94 | × | 60 | = | 176.40 |
| Equivalent weight of feldspar | | | | = | 347.92 or 348 |

| Problem I | | Problem J | |
|-----------|------|-----------|-------|
| $SiO_2$ | 66.3% | $SiO_2$ | 67.10% |
| $Al_2O_3$ | 18.4 | $Al_2O_3$ | 19.10 |
| CaO | .4 | CaO | .94 |
| $Na_2O$ | 2.7 | $Na_2O$ | 6.56 |
| $K_2O$ | 11.8 | $K_2O$ | 5.91 |
| LOI | .4 | LOI | .39 |

Solutions will be found in Appendix E.

## To Calculate from Glaze Formula to Percentage Batch

1. Construct a chart showing oxides in formula and their moles horizontally with raw materials and their calculation formulas vertically.
2. If alkalies are present, fill in feldspar moles.
3. Fill single oxide moles—other than silica.
4. Fill two-oxide moles—other than alumina and silica.
5. Fill remaining alumina with clay.
6. Fill remaining silica with flint.
7. Multiply all moles by their equivalent weights to find the weight factors.
8. Derive key by dividing total weight factor into 100.
9. Use key to derive percentage batch weight.

## To Calculate from Percentage Batch to Glaze Formula

1. Divide the percentage batch weight of each material by its equivalent weight to derive moles.
2. Arrange all the oxides in a chart horizontally with the raw materials and their calculation formulas vertically.
3. Fill in the moles.
4. With complex materials, multiply the amount of each oxide by its mole and record the answers.
5. Add each oxide column.
6. Arrange the totals as a formula.
7. Derive key by dividing the sum of the RO column into 1.
8. Bring the formula to unity by using key.

By using the foregoing calculations, a glaze can be formulated from scratch or altered to correct firing problems; new materials can be substituted; or glazes can be accurately compared with each other. The only true test of the worth of a glaze is in its firing.

## Materials Handling

That innocent white powdery stuff used to make glazes is not really that innocent. Many raw materials are toxic; some can cause skin and eye irritation; others adversely affect the throat and lungs, and some are just plain poisonous. For specific information about each material, see Appendix A.

To help reduce the possibility of being affected by any of the materials used in glazing, a few simple precautions should be taken:

1. Store glaze materials in tightly covered containers in a dry area away from the general work area.
2. Always work in a well ventilated area.
3. Wear rubber gloves to keep materials from getting on hands and arms. Barrier creams, such as Kerodex 51 for dry work (Ayerst Laboratories), are also effective.
4. Wear glasses or goggles to keep airborne particles from getting in the eyes.
5. Use a NIOSH approved dust mask—or better yet, an approved respirator to prevent inhaling any dusts.
6. After mixing has been completed, cover all material containers and put them away.
7. Clean all surfaces used with a damp mop or sponge. Wash all mixing utensils.

**9-4**  Dick Studley
Bottle
Thrown marbleized Egyptian paste
16" (41 cm) high
Photo: Morgan Rockhill

**9-5**  Arthur Nelson
Vessel
Egyptian paste, steel wire
9 × 20" (23 × 51 cm)
Courtesy: Anna Gardner Gallery
Photo: Lee Fatherree

**9-6**  Arthur Nelson
Vessel
Egyptian paste, steel wire
10 × 18" (25 × 46 cm)
Courtesy: Anna Gardner Gallery
Photo: Lee Fatherree

**To mix a glaze,** weigh the raw materials separately. Dry mix them and then add water until the mixture has a consistency of light cream. Screen the glaze through a 50- or 60-mesh sieve for smoothness. If the glaze is too thick, add more water and rescreen. If the glaze is too thin, let it settle and then siphon off the excess water.

## Colorants

Colorants and opacifiers are normally introduced into a glaze as percentage additions. The following chart should be used only as a suggested guide for the amount of an oxide needed to color a glaze. In practice the actual color depends on the compounds in the base glaze, the particle size, purity and concentration of the colorant, atmospheric conditions, and the temperature to which the ware is fired. Colors on white clay will appear brighter than on dark clay.

Temperatures up to cone 013 (869°C, 1596°F) should be considered very low; those from cone 012 to cone 05 (876-1031°C, 1609-1888°F) considered as low; from cone 04 to cone 4 (1050-1168°C, 1922-2134°F) as medium; and temperatures above cone 5 (1177°C, 2151°F), high.

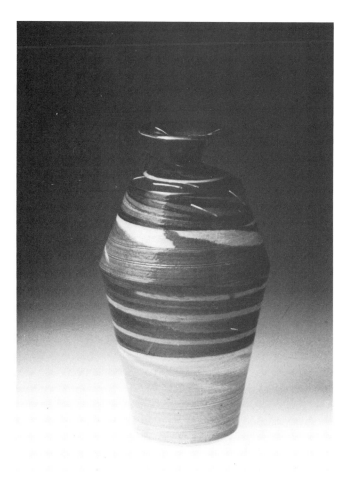

9-4

9-5

9-6

163

**9-7** Vase
Indian, 19th century
Thrown earthenware, alkaline glaze, wash
9″ (23 cm) high
Courtesy: Worcester Art Museum
  Bequest of Mary N. Perley

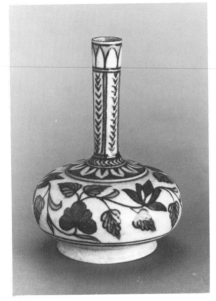

9-7

| Color | Oxide | Percentage | Temperature | Atmosphere |
|-------|-------|-----------|-------------|------------|
| *Red* | | | | |
| | Chrome—tin (1:5)—pink............1—2 | | all | oxidation |
| | Chrome (high PbO)—coral ...........5 | | very low | oxidation |
| | Iron (high SiO₂,KNaO)............2—5 | | low | oxidation |
| | Iron .......................8—12 | | high | reduction |
| | Copper.....................1—3 | | all | reduction |
| *Orange* | | | | |
| | Uranium (high PbO) ..............5—8 | | very low | oxidation |
| | Selenium (no PbO) ..............3—4 | | very low | oxidation |
| *Yellow* | | | | |
| | Antimony yellow stain (high PbO) ....3—5 | | low | both |
| | Chrome (high PbO,Na₂O) ............1 | | low | oxidation |
| | Uranium (high PbO) ..............5—8 | | very low | oxidation |
| | Vanadium tin stain ..............4—6 | | all | both |
| | Vanadium zirconium stain .........5—10 | | all | both |
| | Iron (high Na₂O , BaO) ...........1—2 | | high | reduction |
| *Green* | | | | |
| | Copper.....................1—5 | | all | oxidation |
| | Chrome ....................2—4 | | low-medium | oxidation |
| | Nickel (MgO).................3—5 | | low | oxidation |
| | Iron—celadon ................1—3 | | all | reduction |
| *Blue* | | | | |
| | Cobalt....................1/2—1 | | all | both |
| | Copper (high BaO) ..............2—4 | | high | oxidation |
| | Copper (high KNaO)—turquoise .....3—5 | | low | oxidation |
| | Nickel (ZnO) ................1—3 | | low | oxidation |
| | Iron (CaO or BaO) .............1/2—1 | | high | reduction |
| | Nickel (BaO,ZnO) ..............1—3 | | high | reduction |
| *Violet* | | | | |
| | Manganese (KNaO or BaO) ........4—6 | | medium | oxidation |
| *Tan* | | | | |
| | Iron (PbO)—amber ..............2—5 | | low | oxidation |
| | Iron ......................1—2 | | all | both |
| | Manganese...................2 | | all | both |
| | Rutile....................2 | | all | both |

(Chart continued on next page)

| Color | Oxide | Percentage | Temperature | Atmosphere |
|---|---|---|---|---|
| *Brown* | | | | |
| | Chrome (MgO,ZnO) ............. | 2—5 | low | both |
| | Iron ......................... | 3—7 | all | both |
| | Manganese ................... | 5 | all | both |
| | Nickel (ZnO) ................. | 2—4 | all | both |
| | Rutile........................ | 5 | all | reduction |
| *Black* | | | | |
| { | Cobalt ....................... | 1—2 | all | both |
| } | Manganese ................... | 2—4 | | |
| { | Cobalt ....................... | 1 | all | both |
| { | Iron ......................... | 8 | | |
| { | Manganese ................... | 3 | | |
| *Grey* | | | | |
| | Nickel ....................... | 1—2 | all | oxidation |
| *White* | | | | |
| | Tin .......................... | 5 | all | both |
| | Zirconium .................... | 8—12 | all | both |
| | Titanium—blue-white ......... | 8—12 | all | both |
| | Antimony—yellow-white ....... | 10—12 | low | oxidation |

## Color mixing

Three methods for mixing colorant into glaze can be used: the Line Blend, the 50-50 Dry Blend and the Triaxial Blend.

**Line Blend** A straight line blend can be used to proportionately combine two colored glazes. As an example, a six-point line is shown.

Point 4 is therefore a mixture of 40 percent glaze A and 60 percent glaze B.

165

**50-50 Dry Blend**   Many more gradations of color can be derived from a single base glaze by combining a number of colorants in a logical manner. For this method flat tiles at least one and one-half inches square need to be made and bisque fired. In an example using five colorants, 21 tiles are needed. Mark them on the back with underglaze pencil or oxide wash as follows:

| B | 1 | 2 | 3 | 4 | 5 |
|---|---|---|---|---|---|
|   | B + 1 | B + 2 | B + 3 | B + 4 | B + 5 |
|   |   | 1 + 2 | 1 + 3 | 1 + 4 | 1 + 5 |
|   |   |   | 2 + 3 | 2 + 4 | 2 + 5 |
|   |   |   |   | 3 + 4 | 3 + 5 |
|   |   |   |   |   | 4 + 5 |

B is the base glaze and numbers 1 to 5 are each a specific percentage of different coloring oxides. Weigh a 100 gram portion of dry base for each colorant and place it in a numbered bag or clean glass jar. Add the percentage of desired colorant to each container except the base container. For instance, three grams of copper carbonate added to one container would be a 3 percent addition of copper. Dry screen the glaze at least three times through a coarse sieve or kitchen strainer to ensure thorough mixing.

To mix a test sample, start with the second row of tiles. Weigh 10 grams from container B and 10 grams from container 1. Grind them together with a spatula on a glass slab, adding water from a syringe. Avoid adding too much water. Dip tile B + 1 in water and then apply the mix with the spatula. When the tile is dry, clean off the edges. Weigh 10 grams from container B and 10 grams from container 2 and mix them. Continue in this manner until all the tiles have been coated with glaze. The top row of tiles is coated with mix directly from each container. When they are dry, fire the samples.

After the tiles are fired, they may be glued to a board in their original positions. To find the amount of oxides needed for a particular color, start at the desired tile and look vertically to the top to find one colorant. Again, starting at the desired tile, look horizontally to the first empty space at the left and then read to the top of that row to find the other. For instance, for tile 2 + 4, the top of the vertical row is colorant 4 and the first horizontal empty space to the left is colorant 2. When mixing the glaze, add to the base one-half the percentage of colorant in row 4 and one-half the percentage of colorant in row 2.

**Triaxial Blend**   This is a method of choosing a color blend using three oxides. Points along the outer edge are simple line blends of the two constituents on the line. Inner points are read by counting spaces from each line inward. Count the spaces in from line *BC* to get the percentage of *A*; from *AC* to get the percentage of *B*; from *AB* to get *C*.

In the example, if each space equals 20 percent, then point *X* would be 40 percent colorant *A*; 40 percent colorant *B*; and 20 percent *C*. These amounts are then weighed and mixed into the base glaze.

All three methods can also be used to compound wet mixed colorants provided that the glazes are accurately weighed in 100 cc. amounts. Water should be added to the lighter mix until the glazes weigh out equally. Carefully measure each glaze in a graduated cylinder before combining. Shake well and then apply to a tile.

The line blend or the triaxial blend can also be used to formulate a clay body.

## Glaze Types

*Egyptian Paste*  The earliest glazes were apparently developed seven thousand years ago by Egyptians who mixed soluble sodium salts and a bit of copper into their clay. As the clay dried, the salts came to the surface. In the firing, they melted to form a vibrant blue glaze. As time passed, a mixture of soda ash, clay, sand and copper was used instead. The mixture was painted on the surface of an object and then fired at a very low heat.

*Low-Fire Alkaline Glaze*  An alkaline glaze is fluxed by alkalies such as sodium oxide or potassium oxide. Both active fluxes, soda and potash can cause a glaze to run or craze if overfired or if mixed with too little alumina. Early Mediterranean alkaline glaze tended to craze or peel and was often soluble in food acids. Alkaline glaze has been widely used, however, because it encourages bright yellow and blue colors and melts easily at low temperatures. To overcome the drawback of solubility, most alkaline fluxes are now introduced into a glaze in fritted form.

*Lead Glaze*  Lead sulfide, or galena, was probably first used as a glaze material by ancient Babylonians. Dusted or painted on a raw pot, the lead would fuse to a shiny glaze when fired. A simple lead glaze is often made with as much as 50 percent of a lead compound. It is more commonly used with other fluxes to improve luster, control glaze melt and develop colors. Low-fire glaze is easily scratched and can take on a dull appearance. Fired above cone 01 (1117°C, 2045°F), a lead glaze becomes more durable. **Lead compounds are poisonous. The use of lead should be kept to a minimum or completely avoided.**

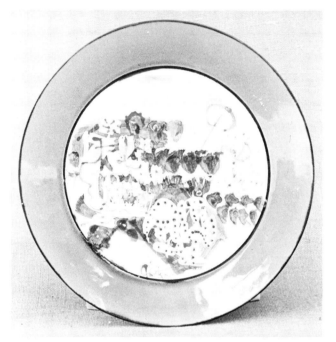

9-8

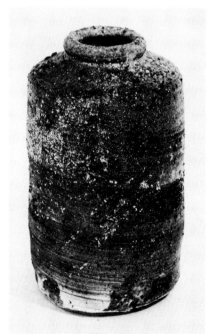

9-9

167

**9-10** Thomas Clarkson
Covered vessel
Thrown white stoneware, ash glaze,
  oxides, reduction fired
$10^1/_2 \times 11''$ (27 × 28 cm)
Photo: Erin Garvey

***Aventurine Glaze*** Usually a low temperature, high lead base is used for this type of glaze. An addition of seven to twelve percent of iron oxide melts into solution during the heat cycle. As the ware slowly cools, the iron crystallizes on the surface as red or gold crystals. Other low temperature fluxes can be used for varying effects.

***Ash Glaze*** The first ash glaze was probably accidental, caused by wood ash falling on a pot fired in a crude kiln. The composition of natural ash, be it wood, rice hull or other vegetable matter, varies greatly with the material. Ash generally contains from 30 to 70 percent silica, 10 to 15 percent alumina and other materials such as potash, lime or magnesia. Most ash will melt to a watery looking glaze at about cone 10 (1285°C, 2345°F). For better glaze quality, fit and control, ash is usually mixed with small amounts of clay, whiting or feldspar. Before ash is mixed into a glaze, it should be put through a coarse sieve to screen out unburned material. **Wear rubber gloves and use a respirator mask because ash is caustic.** Dry screening through a 60-mesh sieve will leave soluble salts in the ash, which may be preferred for mottled glaze effects. To remove soluble salts, mix the ash with water and screen through a 60-mesh sieve. Allow the mixture to settle and then siphon out the water, drawing off the soluble materials. A second washing may be desirable. Dry the ash thoroughly before use.

***Slip Glaze*** Many common earthenware clays when fired above cone 8 (1236°C, 2257°F) will melt to a smooth, glossy, brownish glaze. Much Chinese and Colonial American ware was fired with local slip glazes. To test a local clay, simply put a small amount of the dry clay in a bisqued dish and fire to the desired temperature. If it melts completely, it may be used as a glaze without modification. Often a small amount of frit or feldspar will bring about a better melt. Most slip glazes have a two- or three-cone firing range.

Slip is best applied on leather hard ware. This allows the glaze and ware to shrink equally. Otherwise, the glaze may crack in drying and crawl when fired.

***Frit Glaze*** A frit is an artificial fusion of ceramic materials. Fritting renders raw glaze materials nearly insoluble and less toxic. The raw materials, often lead or alkaline fluxes, are melted in a special kiln with silica and other compounds. When the mixture becomes molten, a hole at the bottom of the kiln is opened and the contents run slowly into cold water or onto a cold steel plate. The glass-like nuggets are then dry milled to the desired fineness. It is a time consuming process and the use of commercially available frits is therefore recommended.

Below cone 06 (991°C, 1816°F) many frits function well by themselves as glazes. Additions of clay, flint or whiting will control glaze fit and melt.

***Crackle Glaze*** A crackle glaze is one that has been deliberately made to craze by using oxides with high expansion rates in the glaze base. Most often, crazing is considered a fault, but if properly controlled, it can become effective decoration. To accent the network of fine cracks in a fired glaze, strong tea or carbon ink can be brushed on the ware and then rubbed off. The color seeps into the cracks leaving a web of dark lines. Another way to accent crackle is to rub a coloring oxide into the craze. By refiring the ware to a slightly higher temperature the dark crackle is sealed into the glaze. In raku firing, strong secondary reduction will accent crazed glaze.

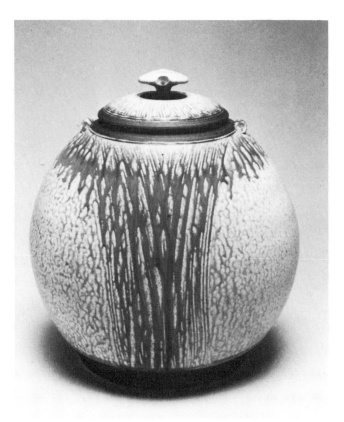

9-10

168

**9-11**  Jug
18th century American
Thrown earthenware, slip glaze
Courtesy: Museum of Art, Rhode Island
  School of Design, Providence, RI

**9-12**  Regis C. Brodie
Bottle
Thrown porcelain, slip glaze, salt glaze
8″ (20 cm) high

*Matt Glaze*  A dull glaze that has been applied thinly or underfired is not a matt glaze. A true matt glaze is fully matured and smooth but without gloss. An excess of barium above .2 moles will change most glazes to matt. Barium tends to form a glass with boron and therefore may not matt a glaze with high $B_2O_3$. Increased alumina in a glaze makes it more refractory and tends to create a matt surface. A matt glaze may not be good to use on table ware because its tiny crystalline surface structure is hard to clean.

*Bristol Glaze*  Bristol glaze was purportedly developed in nineteenth century England as a substitute for the more dangerous raw lead glaze. Using zinc oxide as the flux, Bristol glazes have been developed from cone 2 (1142°C, 2088°F) to cone 14 (1388°C, 2530°F). The more common firing range is between cone 5 (1177°C, 2151°F) and cone 9 (1260°C, 2300°F). Contrary to popular notion, Bristol glazes are not necessarily stiff, rough, and hard to use. They can be glossy, matt, clear, colored, or opaque depending upon the constituents of the glaze. The general composition of zinc oxide, alkalies, alkaline earths, clay, and silica has a high viscosity which allows a Bristol glaze to mature without running or shifting. Because the glaze is resistant to weathering, abrasion and most acids, it is used to a great extent in architectural ceramics. One drawback is that if the glaze is improperly applied, it could separate and crawl during a firing. Bristol glaze is normally used for glazing raw ware and single firing over an extended time up to 50 hours. By substituting calcined zinc and calcined clay, the glaze can be used on bisque fired ware with much less chance of firing faults.

*Salt Glaze, Raku, Crystalline and Reduction Glaze*  all require special firing and are discussed in Chapter Ten. *Luster Glaze* is discussed in Chapter Eight.

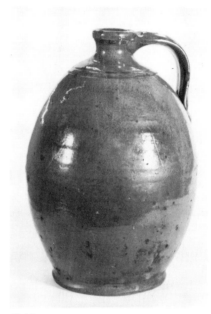

9-11

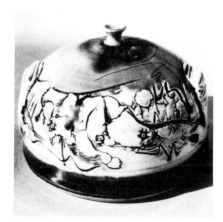

9-12

**9-13**  Stacia Kenet
Bottle
Thrown porcelain, crackle raku glaze
12 × 9 × 9″ (30 × 23 × 23 cm)
Photo: Steve Shipps

**9-14**  Author
Raku bowl
5 × 3″ (13 × 8 cm)

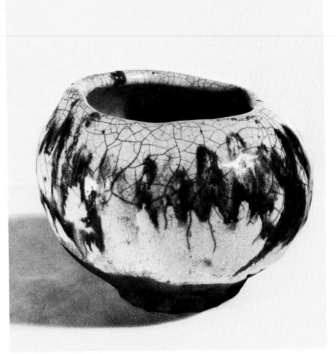

9-14

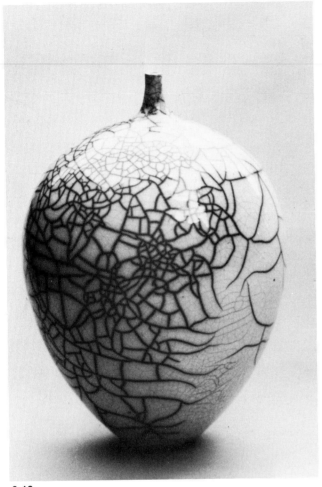

9-13

# CHAPTER 10 Firing

While it is true that some ancient unfired clay fertility figures and adobe structures have withstood the ravages of time, bone dry clay pieces in contact with water will soon return to their original muddy state. In order to achieve greater strength and permanency, clay must undergo the process of firing. During a firing, many chemical changes take place which permanently alter the state of the clay.

## Chemical Changes

The earliest of these changes is at about 100°C (212°F) when the atmospheric moisture leaves the ware in the form of steam. If this temperature is reached too quickly, the clay will explode. Silica undergoes its first chemical change from alpha cristobalite to beta cristobalite at about 220° to 275°C (428°-527°F). *Water smoking* or evaporation of chemically combined water from the clay, occurs from 450° to 600°C (842°-1112°F). Considerable abrupt shrinkage takes place at this time as kaolinite changes to metakaolin. Therefore, the temperature rise should be gradual to keep the ware from splitting. Silica changes again around 537°C (1063°F) from alpha to beta quartz. By 700°C (1292°F) all organic and inorganic compounds such as carbon and the carbonates have become decomposed or oxidized. At 870°C (1598°F) silica changes once more, this time into its tridymite formation. Another major and sudden shrinkage takes place at 950° to 980°C (1742°-1796°F) when the metakaolin changes to spinel. From 1050° to 1100°C (1922°-2012°F) mullite crystals begin to grow through the combination of alumina and silica, giving the clay its strength. As the temperature continues to rise, more silica slowly forms a glass around the mullite crystals, increasing the hardness of the clay. While the glassy phase continues, further shrinkage takes place at 1200°C (2192°F) when the silica changes to the more complete form of cristobalite.

Impurities and varied composition control the extent of maturation in clay bodies. Iron loaded earthenware clays mature, that is, reach their highest point of favorable vitrification, at about 1090°C (1994°F), while most stonewares mature at 1290°C (2354°F), and pure kaolins mature at about 1650°C (3002°F) or higher.

## Cooling

The cooling cycle of a firing is as critical as the heat rise. If the clay cools too rapidly, remaining uncombined silica inverts, or reverses, its reaction at about 573°C (1063°F) and conse-quently contracts, causing the ware to crack. Care should therefore be taken to have a slow steady heating and cooling cycle. Such temperature control can be easily regulated by using a well insulated kiln. Although specific types of kilns are discussed in the chapter on Kilns, Wheels, and Studio Equipment, a kiln is basically a container in which clay objects can be heated.

## Kiln Furniture

How to safely put ware into a kiln so that it will not be damaged is both a challenge and an art. When loading or stacking a kiln, a supply of kiln shelves and various sized kiln posts should be on hand to allow maximum use of the interior kiln space. For lower temperature work, lightweight and fairly inexpensive refractory clay shelves are available. They may be used at higher temperatures around 1260°C (2300°F). If used frequently at this higher range, they can weaken rapidly and fail when least expected. The more expensive silicon carbide shelves, although somewhat brittle, have a higher heat conductivity, heat more evenly throughout, withstand higher temperatures for longer periods of time, and are therefore recommended, particularly for large, fuel burning kilns. However, repeated oxidation firings can weaken the silicon carbide bond over time and contribute to shelf failure.

Refractory kiln posts of varied heights can be obtained commercially; hollow types conduct heat better than solid ones. Firebrick *soaps* (9" × 2 1/2" × 2 1/4") can also be used as kiln posts, especially in larger kilns.

## Kiln Wash

The upper surface of kiln shelves should be given a thin, even coating of kiln wash to prevent dripped glaze from permanently sticking after a firing. Equal parts, by weight, of flint and kaolin mixed with water to the consistency of thick paint can be applied with a wide brush or paint roller. Two percent of bentonite added to the dry ingredients before mixing will help prevent the wash from settling in its container and also give a better bond to the shelf. Kiln wash adheres more easily to a shelf that has been warmed than to a cold one. Clean any drippings of wash off the sides and bottom of the shelves before they are used. Rewash the kiln shelves frequently between firings, but do not allow a heavy buildup of wash to occur as this can make the surface uneven and also decrease shelf conductivity. Occasional scraping and wirebrushing of the shelves will prevent

10-1

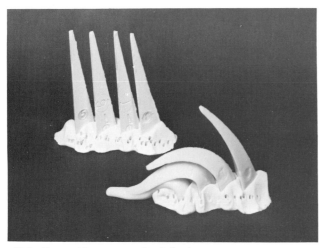

10-2

10-3 Pyrometric cones: unfired, fired

this. Never kilnwash the roof or walls of a kiln or the underside of the shelves because flakes of wash might fall into the ware below and spoil the glazes. Another way to prevent glaze from sticking to kiln shelves is to dust them with a thin coat of alumina hydrate powder before setting the ware. The powder also acts as a cushion allowing ware, especially porcelain, to move more freely as it shrinks during firing.

Glaze which has stuck to a washed shelf during the firing can be carefully chipped off with a chisel. Keep the chisel at an acute angle to the shelf and tap lightly with a mallet to free the glaze but not break the shelf. If, by chance, an entire pot becomes stuck to the shelf, hold the pot and gently strike the shelf around it with a leather, wood, or rubber mallet. Do not hit the pot because it might break. Keep tapping until the piece can be removed.

## Special Equipment

Special equipment such as tile setters, plate racks, pins, stilts, and so on is commercially available for specific stacking problems. Generally, these items are not required to fully load a kiln. Tile setters are special nesting refractory racks on which flat tiles can be placed to reduce warping and protect the glazed surface while taking up less space in the kiln than if the tiles were placed singly. **10-1,** Plate racks are usually refractory saggars with porcelain dowels put through the sides to support a number of plates. Pins and stilts, made of high refractory materials, are used to support single pieces which have been totally glazed.

## Pyrometric Cones

In the long history of ceramics, the pyrometric cone is a fairly recent development. At first, no method of heat registering was used and luck played a great part in the success or failure of a firing. For many centuries *draw trials* were used. A number of small rings of clay were placed in the kiln near a spy hole. As the temperature increased, rings were periodically removed from the kiln with a long iron hook to check the clay and glaze consistency. **10-2,** Some potters use this method today, often, however, in conjunction with cones.

In the early 1700s Josiah Wedgewood developed the first method for scientific measurement. Because the clay bulk decreases as the firing temperature rises, he was able to put draw trials into a calibrated steel box, checking their shrinkage,

until a trial had shrunk to the size he determined to be correctly related to the maturing of his clay.

In the 1880s the German ceramist, Hermann Seger, developed pyramid shaped cones which were made up of controlled clay bodies designed to fuse at specific temperature intervals. Today the full series of cones numbers from cone 022, which is just above red heat, to cone 42. Because there is no international standard regarding temperature scale, there are variations between Seger cones, primarily used in Europe, and Orton cones which come in two sizes and are used in the United States. The Orton cones are designed to measure *heat work*, that is, the time/temperature effect in firing ceramics. There is a temperature variation of 14 °C (25°F) between the small cones and the large cones which are heavier and bend earlier.

Normally, three consecutively numbered large cones are placed side by side in a plaque or pat of clay. The lower temperature, or *guide cone,* is placed to the left, the *desired temperature cone* in the center and a higher, or *guard cone,* to the right. The cones with their stamped numbers facing out, are set in the clay at an angle of 8 degrees. Small cones are also set with the numbers facing to the side. With a fork, punch holes in the clay pat to allow rapid, even drying and to prevent explosion during the fire. The Orton Foundation offers a self-supporting cone which eliminates any variation in the setting angle by simply standing it flat on a level kiln shelf.

As each cone nears its fusion point, it begins to soften and bend. Temperature is generally considered to have been reached when the tip of the cone has bent to the level of the base. After the guide cone has bent, the kiln should be checked at more frequent intervals until the firing cone has fully bent. The heat is then shut off and the kiln allowed to cool slowly. Do not reuse unbent cones because chemical changes have taken place in them which will give incorrect information.

When stacking a kiln, cone pats should be placed so that they do not bend against a pot and can be easily seen through the spyholes of the kiln. For better control of multilevel electric or large fuel kilns, which often have uneven heat distribution, each spy hole should have its own set of cones. As the heat in the kiln increases, the cones become easier to see because of the interior color of the kiln. However, in the upper heat range the intensity of color can become great enough to hide the cones.

**Use a polarizing filter or Number 5 or 6 welder's goggles to protect the eyes and aid in seeing the cones.** Setting the cones in the kiln with no ware behind them will also help. Blowing a steady stream of air into the spy hole will momentarily cool the cones making them visible for a short time. **Do not get too close to the open hole.** The reverse blast of heat or flame coming out after blowing could cause permanent eye damage.

Additionally, small pyrometric cones are used as the trigger for electric kiln shut-off equipment. Recently, pyrometric *bars* have been introduced specifically for this purpose.

## Pyrometers

Pyrometers are available for measuring the actual temperature inside a kiln at a given moment. A pyrometer is a bimetallic thermocouple, protected by a porcelain sleeve, attached to a galvanometer calibrated for temperature. When the thermocouple is heated, electromotive force is generated and the current flow is registered on the meter. Many kilns come equipped with a pyrometer installed. Inexpensive pyrometers can be purchased separately and installed on most kilns. Pyrometers are valuable as indicators of temperature change during all stages of firing and can show when kilns should be speeded up or slowed down. They are also useful in checking the cooling of a kiln when cones no longer react.

Highly accurate photoelectric optical pyrometers are used to some extent in industry, but their cost is prohibitive for most individuals. Many types of automatic shutoffs, pre-programmed temperature control panels and other mechanical devices are constantly being introduced on the market. For best results, however, the ultimate control is the attentive potter.

10-4

## Kiln Log

A kiln log in which times and temperatures are noted for each firing is helpful in reproducing successful firings and in noting potential problems before they become disastrous. For instance, if an electric kiln starts to take longer than normal to reach temperature, elements should be changed before they break in mid-firing. If an electric kiln does take considerably longer than usual to gain temperature, it is a good indication that an element has broken. Although an extra long firing might mature many of the glazes, it is best to shut off the kiln, let it cool, and then replace the element. Refiring the kiln to temperature will not harm most glazes.

Fuel kiln logs should note damper settings and air/fuel settings at hourly intervals. If a pyrometer is used, the temperature should also be noted to determine the rate of temperature increase. Because weather conditions affect firing, these should be noted as well.

## Stacking a Kiln

Shelves should be stacked on kiln posts with a three-point support to maintain level and insure greatest stability. Each set of supports should be placed directly over the lower set for rigidity. If a shelf post wobbles, dampen the bottom end and press it into a bit of dry flint and then onto a small pat of fireclay. Set the post firmly on the shelf. After the firing the clay can be easily separated from the shelf and post. It is best to set the posts first and then place the ware accordingly. To make stacking more compact and easier, pieces of similar height should be placed on the same shelf allowing at least one-half inch of space to the underside of the shelf above to afford good heat circulation and leave room for the initial clay expansion. In larger fuel kilns with multiple sets of shelves, a staggered arrangement helps equalize the circulation of heat. To prevent kiln shelves from unduly warping, bisque fire on the uncoated side and glaze fire on the side that has been kiln washed.

A kiln that is well packed will generally fire much more efficiently than one that is loosely stacked.

## Kiln Ventilation

Kilns need good ventilation because of all the fumes, gases, heat, and smoke exiting from the earliest stages of firing. The ideal situation would, of course, be to set a kiln on a hill in the center of an open field away from vegetation and dwellings. Even then, those involved with the firing would still be subject to possible inhalation of toxic fumes.

Because this solution is not always practical, the next choice would be to have the kiln in a separate shed or room off the studio.

### Fuel kilns

A fuel kiln should have a sheet metal hood above it, with an exhaust stack exiting through the roof or wall of the building. While many updraft kilns usually have a hood and stack to help draw heat and flame through the kiln, even an enclosed downdraft kiln should have a hood over it to help draw off escaping heat, toxic fumes, and gases. In some stacks, where an exhaust fan is necessary, the fan must be heat resistant.

10-5

An increasing number of studio potters are now harnessing the waste heat and gases from their kilns by constructing afterburners which "scrub" the exhaust and utilize it to heat their studios or living quarters. For more information about the proper construction of exhaust hoods or afterburners, consult a qualified industrial ventilation engineer.

## Electric kilns

Each time an electric kiln is fired, such toxic agents as sulfur dioxide, carbon monoxide, lead oxide, sulfuric acid, formaldehyde, nitrogen oxide, and other metallic fumes and unburned hydrocarbons are released into the surrounding atmosphere. It is curious that in their literature, no kiln manufacturer recommends the use of an exhaust hood over any of their products. Recently, such electric kiln venting equipment has become commercially available from other sources.

If the installation of an exhaust hood is not feasible, a kiln should at least be placed near a window or outside door where a strong fan can exhaust waste heat and toxic gases. Simply opening a window or door is not sufficient. In fact, the air currents thus created most often spread the toxic agents throughout the area.

## Bisque Firing

Most studio potters first fire their ware at a low temperature and glaze fire at a higher one. Industry often first fires high then glaze fires low. In either case, this first fire is called the *bisque,* or *biscuit,* fire. Generally , the bisque fire is heated to a temperature between cone 010 and cone 05 (887°-1031°C, 1634°-1841°F), depending on the type of clay used. This burns out all the organic materials, drives out the chemically combined water, and irreversibly changes the composition of the clay while still leaving the ware porous enough to accept glaze. Clay having been fired in this manner can no longer be recycled.

Because of the lower firing temperature and the fact that bisque ware is unglazed, there is no danger of the pots sticking together if they touch during the firing. Therefore, smaller pieces can be placed inside larger ones to save space in the kiln. Objects that are the same size, such as plates or cups, can be set in stacks lip to lip and foot to foot to help prevent warping.

In a fuel kiln, ware should not be placed in a direct line with the flame. The use of *bag walls, muffles* or *saggars* will help. In an electric kiln, ware should have at least one inch clearance from the elements. Both of these preconditions will prevent rapid, uneven heating of the raw ware which can only invite disaster.

Although some potters prefer to stack a bisque kiln without shelves and fire by eye, for safety and consistent results, shelves and pyrometric cones should be used.

After the kiln has been filled with ware that is bone dry and the cones are properly placed, the firing is ready to begin. Although there are many variations in the way different kilns are fired, a basic bisque firing should start at a low heat for several hours, leaving the door ajar or spy holes open to allow the atmospheric moisture to escape from the ware and from the kiln bricks and shelves as well. Close the kiln and slowly increase the temperature at a rate of about 50 degrees an hour until the water smoking stage has passed. The kiln can then be fired at a rate of 100 degrees an hour by turning switches up at two hour intervals for electrics or increasing fuel/air mixture every few hours until temperature is reached. As an electric kiln nears temperature, it may be necessary to turn one or two switches back from high to equalize the heat throughout. Shut off the kiln, close dampers tight, and allow the kiln to cool slowly. Ideally, cooling the kiln takes twice as long as it took to heat it.

## Glaze Kiln

A glaze kiln should be stacked in much the same way as a bisque kiln. Properly washed kiln shelves, three-point shelf support and correctly placed cones must still be used. The major difference is that because the ware has been glazed, no two pieces can touch. There should be at least a finger's width between each piece to prevent them from fusing together and to allow adequate heat or flame circulation throughout the kiln. Pieces should be checked to see that they are properly dry footed. If a piece must be totally glazed, use only high quality refractory stilts for support and be certain that the piece sits securely on the stilt.

The initial stages of the glaze fire can proceed more rapidly than a bisque fire because changes such as water smoking and the burnout of organic materials have already taken place. An advance rate of about 100 degrees an hour is sufficient to increase temperature at a reasonable speed. After red heat, glazes sinter and begin to fuse. As the temperature increases, glazes first cake, and then boil and bubble until they have melted into a smooth glasslike layer. Near the maturing temperature the firing should be slowed somewhat to allow all the volatile materials to escape and the glazes to smooth out.

When the cones start to bend, at least a half hour between the maturing of each cone indicates a good rate of firing. After temperature has been reached, the kiln should be cut back just enough to maintain that heat for another one-half hour. This soaking period allows evening of the temperature throughout the kiln and insures complete melting of the glaze. The kiln should then be shut off, damper closed, and cooled very slowly to allow the glazes to stiffen and the clay to contract evenly. Rapid cooling can prevent glazes from smoothing out. It can also leave pin holes and dunt (or crack) the clay.

Fast firing is generally not a good idea because it can crack ware, bring about glaze flaws such as crawling or pitting, and cause some glazes to remain underfired. In all cases it should be noted that a slow fire to a somewhat lower temperature will produce equal, if not better, maturing results than a fast fire with its necessarily higher temperature.

## Oxidation and Reduction Firing

There are two types of firing which are classified according to the atmospheric conditions inside the kiln; one is *oxidation* and the other is *reduction.* Oxidation occurs when the proper air/fuel mixture is achieved to bring about a bright clear kiln atmosphere. In the case of electric kilns, because there is no fuel to be burned, the atmosphere is considered to be oxidizing, or more correctly, *neutral.* By increasing the fuel or decreasing the air, a reduction, or smoky, atmosphere can be brought about in a fuel kiln. As an example of these two types of conditions, most campfires start off in reduction and, with luck, go into oxidation.

Both types of firing have their distinct advantages. Oxidation is appreciated primarily for its constancy of effect, brighter colors, its enhancement of under- and overglaze effects, as well as its lower firing cost. Reduction brings out subtle color variations in the clay body and glazes as well as accidental effects which impart a sense of the unexpected to the ware.

In earlier times, and to some extent in industry today, blemishes, uneven glaze surfaces and colors, and blacked clay were looked upon as something horrible. Great effort was expended to prevent these ''flaws''' from occurring. Saddled with only fuel burning kilns, potters developed muffle kilns with completely enclosed refractory chambers, kilns with muffle flues or tubes inside the chamber for the flame to run through, or individual saggers, refractory clay boxes to protect the ware from being touched by the flame. The advent of the electric kiln made all these practices unnecessary. Today, however, many studio potters and even some industrial firms actively seek the effects flame and smoke produce in clay and glazes and expose the ware to direct flame.

It is virtually impossible to fire reduction in an electric kiln. Some individuals have rigged oil dripping mechanisms or introduce mothballs, wood chips, or oil soaked rags into the firing chamber in an attempt to bring about a reducing atmosphere. These methods sometimes work but they also attack and corrode kiln elements, shortening their life span. **The use of mothballs releases toxic fumes.** The only way to safely bring about certain reduction effects using electricity is by local reduction. Local reduction is not an atmospheric change within the kiln. It is a chemical change in the glaze itself. By introducing small amounts of finely ground reducing agents, such as silicon carbide, into certain glazes, a reasonable facsimile of true reduction can be achieved.

Most often, fuel kilns are used for reduction firings. In the initial heating stages it is more efficient to fire in oxidation, that is, with a clear bright flame and proper air/fuel mixture. It is unwise to begin reduction below cone 017 (727°C, 1341 °F) because this can prevent carbonaceous material from burning out and also cause the ware to bubble or bloat. At cone 017, a reduction atmosphere can be brought about to impart a reduction color effect to the clay body. To change from oxidation to reduction, alter the air/fuel mixture to allow flames to just begin licking out of the spy holes. Close down the damper until some back pressure is also evident through the spy holes. However, closing the damper down too much will choke the kiln and possibly cause temperature drop. Maintain this light-to-medium reduction as temperature is increased until the final cone is reached. Heavy reduction during the firing not only wastes fuel but could cause bloating of the ware and possibly pit or pinhole the glazes. Slow, even firing with medium reduction will bring out the best glaze color and surface.

As the temperature increases, flames will begin to show through the damper or spy holes. At first, there should be a red-yellow tint to the flame and as the cycle progresses it should take on a green to blue hue. If much black smoke is in evidence and the flame is a bright orange, reduction is too heavy and unnecessary. Only a small amount of carbon monoxide is needed to obtain reduction and will acquire all free oxygen present to complete its own combustion, assuring good reduction. The yellow flame contains mostly unburned carbon which plays no part in reduction and is therefore wasteful.

Near the end of the firing cycle, some potters increase the amount of reduction for full saturation of its effects, but heavy smoking often serves only to deposit carbon on the glaze sur-

**10-6** Leon F. Moburg
Bottle
Thrown stoneware, fired to cone 10 with
cone 8 and 11 decorations
9 × 5¹/₂″ (23 × 14 cm)

face making it appear dull and dirty. A long soaking period, wherein the temperature and medium reduction atmosphere are maintained for at least 30 minutes, will better insure full development of reduction glazes. One or two minutes of oxidation, "clearing the kiln," are sometimes employed at the very end of a fire to diminish the possibility of surface scum and to brighten copper reds. The kiln should then be shut off and closed tightly during the cooling period.

Although most potters seem to prefer firing reduction in the higher temperature range from cone 8 to 14, more attention is now being paid to lower temperatures. This is primarily a fuel saving endeavor and also allows for experimentation with new glaze color effects. The use of cones in lower temperature reduction could be a problem because of the iron used in cones below cone 4. Contrary to some statements, cones compounded specifically for this purpose, called Orton Large Iron Free Cones (C/010-C/3), are readily available.

No matter to what temperature or in which atmosphere a kiln has been fired, it should be cooled slowly and not cracked until the temperature is at least 93°C (200°F) This prevents dunting, or cooling cracks, from spoiling the ware. To prevent the glaze from crazing, the ware should not be removed from the kiln until it can be done with bare hands.

## Local Reduction

Because electric kilns rely on electrical resistance instead of oxygen to produce heat, it is not possible to have a true reduction fire without introducing organic materials into the kiln during the latter stages of the firing. When this is done, there is always a certain amount of damage to the kiln elements as well as a **risk of possible personal injury.** A cleaner, safer way to do local reduction electrically is to mix internal reducing agents directly into the glaze.

The most successful use of the local reduction technique is in the case of copper red glazes. A soda alkaline base glaze works better than a potash base. In either case the glaze should be a fairly fluid one to allow gases to escape during the firing without bubbling the glaze. The amount of copper oxide or copper carbonate needed to induce a red color is surprisingly small, only 0.1 to 0.5 percent addition. The reducing agent most widely used is silicon carbide. It must be finely ground, a mesh of 300 or 400 will give the most even color dispersal. However silicon carbide of 200-mesh or larger can give an interesting speckled effect.

The copper and silicon carbide are added to the glaze in equal amounts along with 1 percent of tin oxide to promote the best color effects. Amounts of silicon carbide above 0.5 percent do not appear to affect the color but can cause excess bubbling and cratering of the glaze.

Boric oxide in a local reduction glaze can promote red, violet, and purple colors, while barium tends to brown out red tones. Colors other than red can be obtained through local reduction by using titanium for shades of blue and small amounts of iron for celadon greens.

Antimony sulfide or molybdenum sulfide can also be used as reducing agents in combination with the same amount of colorant and tin used with silicon carbide, but with varying results.

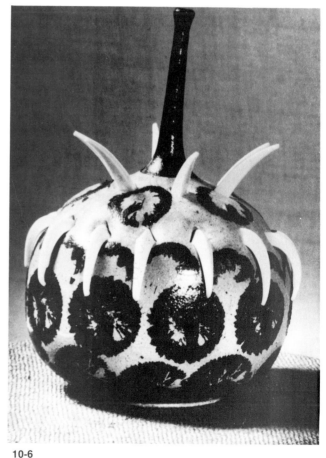

10-6

**10-7** Engel Kran, 1584
Pitcher
Thrown stoneware, stamped decoration,
  salt glaze
17″ (43 cm) high
Courtesy: Museum of Fine Arts, Boston
  William Francis Warden Fund

**10-8** Thomas Harrington, 1825
Water cooler
Thrown stoneware, salt glaze
20¹/₂″ (52 cm) high
Courtesy: Connecticut Historical Society
Photo: W. F. Miller

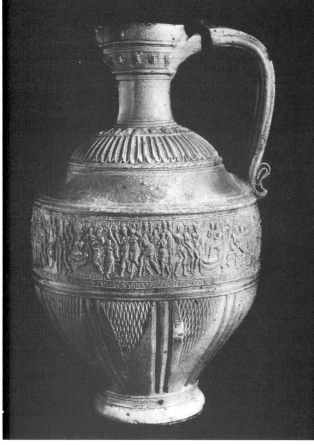

10-7

10-8

For best color dispersal, local reduction glazes should be applied more heavily than normal glaze, with more allowance at the foot of a pot for glaze shift.

Because it is not necessary to change the atmosphere inside the kiln, local reduction ware can be put into a regular oxidation firing along with other pieces. It is important, however, that the kiln be fired to the correct glaze maturing temperature and then soaked to allow all the silicon carbide to react. The kiln should then be cooled rapidly to decrease the chances of complete reoxidation which, of course, would cause the reduction colors to disappear.

## Salt Glazing

The use of traditional salt glazing techniques has been traced back as far as the twelfth century in Germany, when it is purported to have first been used. Basically, salt glazing is a one-fire process wherein the raw ware is stacked loosely in the kiln and brought up close to its maturing temperature. Common salt is then introduced into the kiln and immediately volatilizes, forming a glaze coat on the ware.

Chemically, a series of reactions occur:

(1) $2NaCl + 2H_2O \rightarrow 2NaOH + 2HCl \uparrow$
(2) $4NaOH + Q \text{ (heat)} \rightarrow 2Na_2O + 2H_2O \uparrow$
(3) $2Na_2O + XAl_2O_3 \cdot XSiO_2 \rightarrow 2Na_2O \cdot XAl_2O_3 \cdot XSiO_2$

At first, the salt reacts with water vapor in the kiln atmosphere and forms sodium hydroxide and hydrochloric acid fumes. Secondly, the heat of the kiln decomposes the sodium hydroxide into sodium oxide and water vapor. The sodium oxide then reacts with the clay surface and forms a sodium alumina silicate glaze. The hydrochloric acid and water vapor mix and exhaust out of the kiln. Herein lies the chief danger in salt glazing. If there is insufficient water vapor to mix with the hydrochloric acid, as is often the case, then deadly chlorine gas is formed. **Heavier than air, this yellow brown gas settles in the lungs if inhaled and can cause severe damage and, possibly, death.**

**It is strongly advised, therefore, that salt glazing be conducted in a very well ventilated area; an outdoor operation is considerably safer.**

### Preparing the kiln

During the fire, the salt reacts not only with the clay ware, but with everything else, including the shelves, posts, and interior kiln walls. Because this action will be repeated in subsequent firings, it is necessary to have a separate kiln and accompanying furniture set aside for salt glaze only. Best results are obtained in a down-draft type kiln with special ports for introducing the salt.

The walls of the kiln should be coated with aluminum oxide and the kiln furniture coated with a wash of alumina hydrate to slow the inevitable deterioration by the salt. Never use normal kiln wash because it will combine with the salt to become glaze and everything will stick together when fired. Each time the kiln is fired more glaze forms on its interior. It may take a number of firings to *season,* or *ripen,* a kiln, that is, deposit

enough soda on the walls to give a good even glaze to all the ware. Unfortunately, this sodium buildup eventually will cause the kiln walls to decompose and crumble, necessitating complete teardown and rebuilding.

### Temperature

The temperature to which the kiln should be fired depends on the maturing temperature of the clay or the firing effects desired. Salt glaze can be successfully done on earthenware with very interesting results. This low temperature technique is more commonly known as *vapor glazing.* It proceeds much like a normal single-fire salt glazing, but the maturing temperature is usually between cone 06 and cone 1 (991°-1136°C, 1816°-2077°F) with salting as low as cone 012 (876°C, 1609°F).

At these lower temperatures less toxic materials can be used to create salt-like glaze effects. Sodium bicarbonate, or baking soda ($Na_2O \cdot H_2O \cdot 2CO_2$), and sodium carbonate, or soda ash ($Na_2O \cdot CO_2$), are successful salt substitutes. Both materials are also considerably safer to use than salt. Their by-products are carbon dioxide and water, not hydrochloric acid and chlorine gas. The use of these substitutes somewhat minimizes the often sought after *orange peel* texture of traditional salt glaze. However, these materials bring out a richer and more varied coloration of the clay body and most slip glazes that may be used.

The more traditional salt glazing is done at temperatures from cone 4 (1168°C, 2134°F) to cone 10 (1285°C, 2345°F) and above.

### Firing

The kiln can be heated in oxidation to about cone 017 (727°C, 1341°F) and then given light reduction up to clay maturity to enhance the body color. Near temperature, the damper should be closed more and then scoops or small bags full of wetted salt should be thrown into the kiln. Four to 8 percent of borax added to the damp salt will improve the glaze surface and help prevent crazing. Salting should be done at 10 to 15 minute intervals, three to five or more times to produce adequate glaze coverage. Each time salting is done, the temperature drops. The kiln should be allowed to regain temperature before the next salting. Just how much salt should be introduced into the kiln depends a great deal on the size of the kiln and the desired results. Between 300 to 600 grams of salt per cubic foot of kiln space is suggested as a starting amount on which to base further tests.

**10-9**  Anne Shattuck
Basket
Thrown, handbuilt porcelain, salt glaze,
    stains
13¹/₂ × 8 × 7¹/₂″ (34 × 20 × 19 cm)
Photo: R. Gabriner

**10-10**  Amy Graubard
Pickle jar
Thrown stoneware, salt glazed
17 × 13″ (43 × 33 cm)
Photo: Tom Lang

**10-11**  Peter Starkey
Teapot
Thrown stoneware, salt glazed
8/₂″ (20 cm)
Courtesy: Westminster Gallery

Draw trials should be hooked out of the kiln to check glaze coverage between saltings. After the first salting, cones will no longer react properly as heat guides. The use of a pyrometer is recommended. When glazing is considered satisfactory, the kiln should be shut off, closed up, and allowed to cool slowly.

## Clays

Certain clay bodies react better to salting than others. High silica clays work best. Additions of titanium or magnesia to the body will improve glaze qualities. Iron bearing clays give colors ranging from tan to black depending on the amount of iron available. Other colors can be obtained either by applying engobes or washes to the clay or by adding small amounts of dry color chlorides to the salt mixture before salting.

## Glaze

Because salt vapors do not go down inside pots, interiors must be glazed in the usual manner. Most stoneware glazes work well, but some may be affected in texture or color. While lead glazes are not adversely affected by salting, they should be used with discretion, or not at all.

## Raku

Raku gained prominence in Japan as a part of the Zen tea ceremonies of the Toyotomi Shogunate, during the late 1500s. In the 1950s, it became the vogue in western ceramics because it is a method of fast firing clay and near instant gratification. More recently, some potters have begun to approach raku, which means *contentment,* with much greater personal involvement. To achieve this, the potter must really understand the interaction of clay, glaze, and flames because raku has its own process of natural selection. Pieces that are not well thought out or that are poorly made blow up in the kiln.

Working with raku requires an *open* clay body, a small simple kiln, long sturdy tongs, heat resistant gloves, shatterproof polarized goggles, water containers, and lidded containers filled with dry leaves, sawdust, or other combustible materials.

## Clay

The clay body should be a mixture of course-grained clays and organic materials or have from 25 to 40 percent grog added to it. This is necessary to allow the clay to withstand the thermal shock of being placed in the intense heat of the kiln and

10-9

10-10

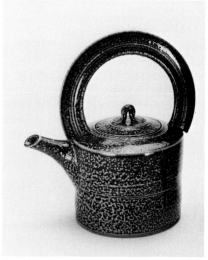

10-11

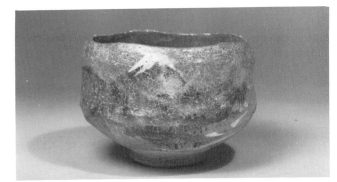

**10-12** Tannyu (ca. 1820)
Raku tea bowl
Earthenware, underglaze
4″ (10 cm) diameter
Courtesy: P. F. Bear Oriental Art and
     Antiques

then being rapidly cooled. Many stoneware clays and porcelain bodies can be used directly without any changes. However, any clay body should be tested before large scale use is made of it.

Because the clay, of necessity, will be quite porous and underfired, raku ware is not suitable for prolonged storage of food or liquids.

### Kiln

The kiln should be fairly small to allow rapid heating buildup between the frequent openings and closings of the door. The larger the kiln, the longer it will take to reheat. For best results, a fuel kiln should be used because of the initial, or *primary*, reduction effects that can be induced during the firing. The kiln should have a door that is easy to swing or slide open. Spy holes should be well placed for an unobstructed view of the pots as they are being fired.

If an electric kiln must be used, it is essential that the current be turned off each time before the door is opened. Inserting metal tongs into an electrified kiln could be FATAL!

Ceramic fiber kilns, such as the one shown in Chapter 11, provide easy access when loading or unloading pots. Its portability is also an asset when setting up a raku fire. Another advantage is that because the kiln material itself heats and cools so rapidly, the firing can be stopped between loads. This type of kiln is fast replacing firebrick versions as the chief method of firing raku. Many blanket kiln designs, from plans and materials to finished kilns, are commercially available

### Safety Equipment

Use long sturdy metal tongs when placing pots into the kiln as well as when removing them after temperature has been reached. Use a door hook to open and close the kiln door. Wear #5 or #6 welder's goggles to protect the eyes when viewing pots inside the heated kiln. Wear approved heat-resistant gloves to protect the hands and arms during the raku process. Heavy leather gloves are also satisfactory. Use metal, not plastic, cans for water and combustible materials. A garden hose or fire extinguisher should be handy in case of emergency.

### Pots

Traditionally, the pot is first pinched into a thick-walled bowl and then carved down to a refined shape. Any method can be used to make a raku form, but certain restrictions should be kept in mind. Corners, constricted shapes, poorly joined pieces,

**10-12**

and pots that are too thin or too thick in cross-section all run the risk of cracking or exploding in the kiln. To cut down on kiln losses, the ware should be bisque fired before glazing. It is possible to once fire raku ware, but a superior clay highly resistant to thermal shock must be used and the ware must be completely dried before being placed into the kiln.

### Glazes

Glazes must, of necessity, mature at very low temperatures and have high thermal resistance. Many raku glazes rely on high lead content for adequate fluxing, but good glaze bases can be formulated with frits, colemanite, and other materials. It must be remembered, however, that, because of the fast firing, not all of the chemicals will fully mature and combine. **Using raku pieces extensively for eating or drinking can lead to toxic illness.**

### Colorants

Because of the low temperature, usually around cone 022 to cone 08 (585°-945°C, 1085°-1733°F), not only can the usual colorants be used, but others which normally burn out at higher temperatures offer rich effects. Small percentages of tin chloride or silver nitrate will give good luster qualities to pots that undergo secondary reduction. These effects, although exciting, are not as long lasting as true primary reduction inside the kiln because they tend to reoxidize when exposed to air. Small percentages of selenium, cadmium, antimony, and chrome can give bright reds, yellows, and oranges when used alone or in combinations.

While the kiln is being heated, apply glaze thickly to the pots and then thoroughly dry them to get rid of any absorbed moisture. The pieces may be preheated by placing them on top of the kiln.

**10-13**  Harvey Sadow
*Chesapeake Veneer Series #41,* 1982
Thrown stoneware, multiple fired raku
10¹/₂ × 13″ (27 × 33 cm)

**10-14**  Marc Sijan
Slab-built earthenware, raku fired
Life-size
Photo: the artist

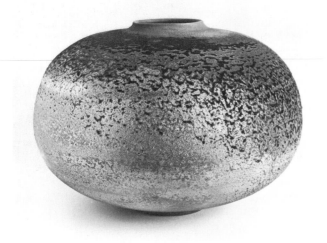

10-13

10-14

## Firing

Wearing gloves and goggles, grasp a pot carefully but firmly with the tongs. Open the door, place the piece in the kiln and quickly close the door. Glazes usually begin to mature, after being put in the kiln, in 3 to 30 minutes depending on kiln size, heat advance, and glaze composition. The best way to tell if a glaze is maturing properly is to look into the kiln through the spy hole. When the glaze has stopped bubbling and has taken on a smooth glossy surface, quickly remove the pot with the tongs. For secondary reduction effects, the pot is immediately placed in a bucket of leaves, sawdust, or grass and covered with additional combustible material. As soon as the heat of the pot ignites the material, cover the bucket and allow the piece to reduce for at least 3 to 5 minutes. This will thoroughly blacken the clay body, burn in luster effects, and bring out reduction colors. Remove the pot and let it cool naturally. If the immediate secondary reduction effects are to be retained, take the piece from the bucket with the tongs and quench the pot in water. If oxidation color effects are desired, plunge the pot into water right after removing it from the kiln, skipping the combustible material.

Careful observation and good use of the vagaries of the flame, reduction times, and methods can bring to raku a true sense of interaction between pot and potter.

## Wet Firing

Wet firing is a technique, unlike raku, by which a freshly made pot can be put into a hot bisque kiln, removed, glazed and fired again, all within a matter of minutes. This technique, developed by Gerry Williams, requires a small two-chamber gas kiln, a special clay body and glazes, all of which are simple to make.

The kiln is the important factor in the success of a wet firing. The basic firing principle appears to be that when a wet pot is closed up in a hot kiln, an envelope of hot wet air immediately surrounds it allowing rapid water removal but preventing explosion. The kiln must therefore have an easily responding draft control.

The kiln is built of K-23 firebrick using silicon carbide shelves as the two floors and roof. The two doors, one for each chamber, must be snug fitting and easily removable. The flame enters through the back of the lower glaze chamber under the floor and goes to the front. It then travels through the chamber to the back of the upper bisque and finally out the top of the front door.

Both stages of firing are conducted simultaneously. The lower glaze chamber maintains a temperature of approximately cone 4 (1168°C, 2134°F) and the upper bisque chamber about cone 010 (887°C, 1629°F). To gauge the temperature accurately a pyrometer should be used.

The clay body is made into a stiff mix from 50 Red Art Earthenware, 50 Jordan Stoneware, 1% barium carbonate, 3% nepheline syenite, and up to 20% fine sand. Add one part by volume of Babcock-Wilcox Bulk Kaowool to one part by volume of the mix, or 1 pound Kaowool to 100 pounds clay. The Kaowool, which is a silica alumina fiber, provides an excellent buffer against thermal shock. Standard stoneware and raku bodies do not work well with this method. However, this body can itself be used for raku.

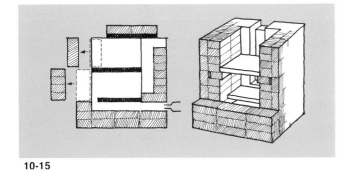

10-15

Two simple quick-melting glazes for wet firing are:

| Gloss | | Matt | |
|---|---|---|---|
| Frit 3314 | 81.7 | Lithium Carbonate | 16.7 |
| China Clay | 13.4 | Wollastonite | 26.1 |
| Tin | 4.9 | China Clay | 23.4 |
| | 100.0 | Flint | 33.8 |
| | | | 100.0 |

Other glazes which melt between cones 2 to 5 (1142°-1177°C, 2088°-2151°F) can be used.

The pots should be fairly small and can be hand built or wheel thrown. Slab pieces often do not survive. Wall sections should be thin and even. Do not allow any drying. Immediately upon the completion, use tongs to place the pot into the hot upper chamber of the kiln. The front door is closed while the back flue remains open until the pot is dry. This takes only a few minutes. Then the door is opened slightly and the flue closed. In this way heat flow and humidity are controlled until the pot has dried. Firing then proceeds normally for about one-half hour. The pot is removed, cooled and glazed. Slips or oxide washes can be applied over or under the glaze. The piece is then dried on top of the kiln. When dry it is placed in the hotter lower chamber and fired to temperature in about one-half hour. It can then be removed and, if desired, undergo secondary reduction in a bucket of combustible material.

**Remember, when working with a hot kiln, wear heat-resistant gloves and welder's goggles. Have a fire extinguisher nearby in case of emergency.**

## Woodfiring

Wood has been a major source of fuel since the earliest potter's fire. However, with the advent of gas and electric kilns in the United States, woodfiring fell into disfavor for years. This was partly due to the perceived lack of efficiency and consistency of results when compared to more "advanced" firing techniques. Recently , the special properties of wood-fired ware have begun to be "rediscovered"—the distinctive heat and smoke effects, fly ash glazes, muted colors and softer glaze surfaces.

### Kilns

High temperature woodfiring requires a well-insulated kiln with sufficient firebox area and proper chimney draft. Many kiln designs are available which are capable of achieving good results. Generally, multiple chambered kilns, such as *anagamas* or *nobori-gamas,* make the best use of the long flame characteristic of woodfiring. As the first chamber is being fired, the flame continues through the kiln warming all the other chambers. Each successive chamber, therefore, requires less fuel to reach temperature. In a typical two-chamber kiln, the second chamber could function as a bisque kiln with little or no additional fuel.

### Choosing wood

All wood can burn, and all wood species have approximately the same energy content or "caloric value." Why, therefore, is it necessary to choose wood for firing? In woodfiring, the

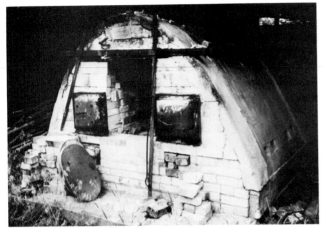

**10-16**

burning quality of the wood used is the important factor. Softwoods, such as pine or fur, burn faster and hotter than hardwoods, like oak and hickory. The low density woods ignite quickly and sustain flame sooner. Dense woods burn longer. Wood that has dried more than two years has lost too much of its moisture and resin content to be of much value. Wood that is too damp will expend much of its energy just drying itself. Wood size must also be taken into consideration. Large diameter pieces burn more slowly than small. Split pieces, having more exposed area, ignite faster than uncut logs. All of these conditions must be considered when planning to fire a woodburning kiln.

## Firing

While each woodfiring potter has his or her own method of firing a particular kiln, a typical firing works in stages. After the kiln has been stacked and closed, begin a slow warming period. This is usually accomplished by igniting kindling placed in the firebox and then adding unsplit wood, or "rounds." Thorough warming can take hours or days, depending upon the size of the kiln.

The next stage of firing involves stoking the kiln to build up temperature—a major activity. Large rounds are most effective at this point. This process, too, can take hours or days.

As the kiln approaches top temperature, use splits and other smaller pieces of wood to keep the fire raging. Many kilns have side ports specifically for this purpose. If the kiln has more than one chamber, shift the stoking activity to the next chamber,

use splits as needed until temperature is reached, and repeat the process until all the chambers are fired.

To soak the kiln and insure reduction, cut the air supply somewhat and use larger rounds in the firebox. When these logs have burned down, close all ports and allow the kiln to cool.

Many other factors affect firing the kiln: ash build-up, maintenance of coals, adequate fuel supply stacked strategically around the kiln, and particularly the rhythm of stoking.

Woodfiring is long and often tiring, but the results can be very rewarding.

## Primitive Firing

The earliest known firings were done directly on the ground. In some cultures, this remains the chief method for production of everyday ceramic ware. Interesting random color and smoke effects often occur on pots fired this way. Unfortunately, many pieces break because of the rapid heating and uneven temperatures common to on-ground firing. A variation of this method can be used to retain the unique smoke effects and, at the same time, gain some measure of control.

### Clay and decoration

Most clays can be used for primitive firing. Open clay bodies or high temperature clays resist heat shock best. Many studio potters prefer porcelain for the visual and tactile qualities of the smoked surface.

Any clay forming technique can be used to make pieces for firing. Carve or incise the clay. Spray or brush on colored slips or oxides. Burnish the ware to enhance the surface. All these decorating techniques adapt well to primitive firing. Using glaze is not recommended because of the difficulties with controlling firing temperature. Also, fuel particles could stick to the glaze and spoil the surface.

### Firing

When pots are completely dry, they are ready for firing. At this point, the ware could be fired directly. However, to prevent breakage, work should first be properly bisque fired in a conventional kiln.

After bisquing, place the pieces in a shallow pit outdoors and cover them with a mound of combustible materials. Dry straw,

**10-17** Sylvia Bower
Container
Thrown porcelain, terra sigillata, primitive
  fire
5¹/₂ × 2 × 2″ (14 × 5 × 5 cm)
Photo: the artist

**10-18** Ann Krestensen
*Crescent Moon*
Thrown and altered earthenware, terra
  sigillata, sawdust fired
21 × 16 × 9″ (53 × 41 × 23 cm)
Photo: the artist

**10-19** Karen Tretiak
Floor planter
Slab-built porcelain, pit fired, metal inlays
15 × 14 × 14″ (38 × 36 × 36 cm)

wood shavings, leaves, or pine needles, can give unique colorations to the fired ware. **10-17,** Special effects can sometimes be achieved by wrapping the bisqueware with seaweed, ferns, or very fine copper wire before placing it in the pit. For best reduction, ignite the combustibles at the top of the mound and let the fire burn down until it is out. Additional fuel can be thrown on the fire if necessary, but caution is advised. Dry material can explode into flame. **Always have an adequate supply of water or a fire extinguisher ready.**

Smoke effects can also be achieved with *sawdust firing.* In a cleared area outdoors, set up a loosely-constructed brick box or a metal garbage can with random punctures in it. The spaces or holes in the "kiln" provide oxygen for combustion, as well as help create variety with oxidized/reduced smoke effects.

Place a 4- to 6-inch layer of dry sawdust in the bottom of the kiln. Then place some of the ware to be fired on the sawdust. Fill the interiors of the pieces with sawdust as well. Add another thick layer of sawdust and more ware. Because the sawdust cushion burns away during the firing, be certain that heavier pieces are put in the kiln first and not more than three layers of pots are set. Otherwise, smaller pots could be broken at the bottom of the pile.

Crumple up some newspaper for kindling on top of the sawdust. Ignite the paper. When all the paper is burning, cover the kiln with a metal lid. Allow the fire to smoulder until it is completely out. Wait until the ware has cooled before handling.

## Crystalline Glaze

Normally, glaze is a non-crystalline substance when cooled. By specifically combining certain raw materials, crystals can be induced in a glaze. Most crystalline glazes are of the zinc-silicate family, high in zinc, with little or no alumina. Sodium-based glazes tend to develop crystals more easily than other glazes. Used in small amounts, titanium, rutile, manganese, and chrome will help produice crystals on the surface of a glaze. Fritted glazes often give better results than non-fritted ones.

Crystals have been grown successfully within a wide range of temperatures, from Cone 6 to Cone 13 (1201°C/ 2194°F - 1321°C/ 2140°F).

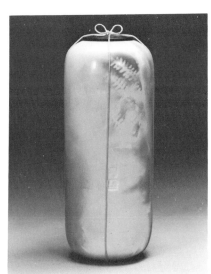

10-17

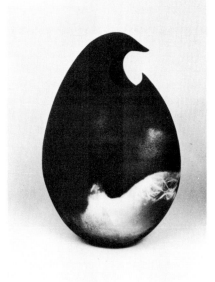

10-18

10-19

### Catch bowls

Because crystalline glazes have little or no alumina and must
be applied quite thickly, they run severely when fired. To pre-
vent destruction of pots or kiln shelves, catch bowls should
be used for each crystalline glazed piece.

Throw a number of small shallow bowls from the same clay
during production of the pots. **10-20,** A separate cylinder stand
should also be thrown for each piece. It is essential that the
diameter of the stand match the foot of the pot exactly. To do
this, invert and center the leather hard pot on the wheel.

Center the stand on top of the untrimmed foot and trace
around it with a pin tool. Remove the stand and trim the foot
of the pot to the line. When both pot and stand are bone dry,
sand their surfaces until there is a perfect match. Otherwise,
glaze will seep through any crevices during firing and seal both
pieces together.

After bisque firing all the parts, check the fit of the pot to
its stand and resand if necessary. Glue the stand to the pot
with a mixture of alumina hydrate and white glue. **10-21**

### Glazing

Glaze the interior of the pot first. It is not necessary to use a
crystalline glaze for this. Allow the pot to dry completely before
applying the exterior glaze. Apply the crystalline glaze by either
pouring, dipping, or spraying. For best results, the glaze should
be applied more heavily at the top, more thinly near the bot-
tom. The glaze coat can be as much as 1/8 inch thick.

It is possible to *seed* a glaze to insure that crystals will form.
Zinc oxide, granular rutile, titanium, and ilmanite can be
added in small amounts to the liquid glaze just prior to applica-
tion. Particles can also be placed on the glaze after applica-
tion. Add small amounts (less than 1%) of iron, cadmium,
molybdenum, or tungsten to the formula to alter the shape and
number of crystals, speed up their formation, or shorten the
amount of soaking time needed for complete formation.

Colorants for crystalline glazes and the colors they produce
are much the same as for other glaze types. It is important that
glaze and colorant be thoroughly wet mixed and passed
through a 60-mesh screen. Otherwise, the glaze might not pro-
duce crystals.

After glazing has been completed, place the pot and stand
in the center of one of the catch bowls. Set all three carefully
in the kiln.

10-20

10-21

10-22

186

### Firing

For the best crystal development, fire work to temperature in an electric kiln as rapidly as possible without damaging the ware. When temperature is reached, turn the kiln off and let it cool about 38°C (100°F). Then turn the kiln back on and hold it at that temperature from 4 to 6 hours. Allow the kiln to cool down slowly. The time and temperature factors are very important. Firing too high, cooling too rapidly, or soaking at the wrong temperature can all adversely affect the growth of crystals. A great deal of testing is necessary before control and consistency can be achieved.

### Finishing

One more important step is necessary to complete a crystalline glazed pot. After the piece has completely cooled, remove it from the kiln. The pot and stand are welded together by the glaze coating. **10-22,** To separate the two, **wear goggles and gloves,** hold the pot horizontally and tap the seam line with a log splitting wedge or pick hammer. Then finish the foot on a grinding wheel.

## Firing Defects

The reasons for failure to achieve sought after results in clay work and glazing are many. Even assuming skillful forming techniques, careful handling, and complete drying, defects can still occur when the ware is subjected to the heat of the fire.

*Cracks or Exploding* in the early stages of firing are caused by rapid water removal. To prevent this, be certain that the ware is well dried in low humidity and the kiln is initially heated very slowly. Making ware with excessively thick walls should also be avoided.

*Shrinkage Cracks* in tall pieces are caused by the top of the kiln being heated faster than the bottom. This can be prevented by slow heating during the early stages of the firing and careful stacking which helps insure even heat distribution throughout the kiln.

*Warping* happens when there is a variation in the fired shrinkage or density of the clay. Constructing ware with even wall thicknesses and firing the kiln slowly will prevent the occurrence of warping.

*Blebbing*, the appearance of raised bumps on the surface of the ware, is caused by air pockets in the clay which swell during the firing. Well kneaded clay and careful construction of forms, leaving no entrapped air, will prevent this flaw. **10-23**

*Bloating* is similar in appearance to blebbing but occurs, particularly in fuel kilns, when there is insufficient oxygen available in the 350° to 700°C (622°-1292°F) heat range to help remove all carbonaceous material from the clay. Keeping the kiln in an oxidizing atmosphere during this time will bring about complete carbon burn-out.

*Black Coring*, the blackened center of the clay walls, is caused by reducing high iron-bearing clays too early, which weakens their structure. To prevent this, body reduction should not be started much below cone 017 (727°C, 1341°F).

10-23

187

*Dunting*, sharp cracks in the clay, occurs during the cooling cycle, around 573°C (1063°F) as quartz inverts, or at 250°-270°C (482°-518°F) when cristobalite inverts. To prevent dunting, cool the kiln slowly and resist the temptation to open it too soon. Occasionally, dunting can occur during the heating cycle. Its characteristic cracks are smooth-edged because the matured glaze has melted into them. These cracks are an indication of a great variation in the thickness of the clay walls from base to upper sections. Ware constructed with even wall thickness will not dunt this way.

A number of defects in fired glazes can be traced to methods of application and firing, but one of the most common problems is closely associated with the interaction of glaze and clay body.

*Crazing* is the appearance of a network of cracks in a fired glaze. It is primarily a consequence of unequal contraction of clay body and glaze during the cooling cycle wherein the glaze contracts more than the clay. One way to correct this problem is to adjust the expansion properties of the clay body by increasing the amount of silica in the body or by substituting a finer mesh of flint. In clay, the flint remains a crystalline solid and, through its reversible inversion at 573°C (1063°F), can affect the fit of glazes. Since most studio potters work with one clay and many glazes, it is more practical to correct the problem glaze rather than the clay. This is accomplished by reducing the thermal expansion and contraction of the glaze through substitution of oxides which have a lower coefficient of expansion. Crazing may be corrected by one or more changes in the glaze, such as increasing the silica, increasing the alumina, or decreasing the feldspar or other soda or potash materials. Proper heating and cooling cycles will also reduce the possibility of crazing.

*Delayed or Moisture Crazing* can happen long after the glaze has been fired. Over a period of time a slightly porous clay body can absorb moisture to the extent of causing metakaolin to change to kaolinite. The resulting minute expansion of the clay could cause the glaze to fracture. This can be easily avoided by firing the clay to complete vitrification.

*Shivering* is just the opposite of crazing. A glaze which has cooled into excessive compression will split and peel away from the clay body. To remedy this, reduce the amount of silica in the glaze or increase the alkaline oxide content. Equivalent substitution of nepheline syenite for another feldspar can often prevent shivering. Decreasing the flint in the clay body can also help. **10-24**

*Fracturing* or breaking of the ware usually happens when glaze has been applied thickly to the interior of a piece and thinly or not at all on the outside. When the ware cools, the compression of the glaze causes the clay body, which is in tension, to break at its thinnest point. Increasing the silica content of the glaze and careful glaze application will correct this. **10-25, 10-26**

*Crawling*, also called *ruckling, beading,* or *curling,* is characterized by areas of ware left bare by the contraction of the fused glaze. In extreme cases, the glaze may roll off the pot onto the kiln shelf. **10-27**

The chief causes of crawling are related to the uneven shrinkage rates between glaze and clay body brought about by using too plastic a clay in the glaze, excessive glaze milling or grinding or high shrinkage glaze constituents, such as zinc or magnesium carbonate. Substitutions of raw materials with less shrinkage, such as calcined clay or zinc, will help correct this flaw. A tablespoon or two of some type of binder, gum, starch or acrylic medium, will bond the glaze to the clay better and minimize glaze cracks in drying. Too much binder can actually facilitate crawling because of its high rate of shrinkage.

The most common reasons for crawling are related to improper glaze application. Dust and skin oils; overfired bisque; flashed ware that has been unevenly bisqued; thickly applied glaze or a second glaze coating over a completely dry coat; or pots still wet from interior glazing which prevent the outside glaze from adhering well cause the glaze to crawl.

10-24

10-25

10-26

10-27

If cracks or tiny holes do appear on the dry surface before firing, light rubbing in a circular motion with a finger will fill glaze powder into the cracks.

Firing ware that is still damp, setting ware too close together for proper ventilation, and rapid heating through the water smoking stage can weaken the glaze layer, as well as its bond to the clay body, and cause crawling.

**Peeling** occurs when washes, slips or underglazes have been applied too heavily. They act as a dust coat and prevent the glaze from adhering. To avoid this, apply the wash thinly or add binder to the underglaze. **10-28**

**Bubbles** are often caused by glaze firing too rapidly. This prevents gases in the clay body and glaze from completely dissipating through the glaze layer. A slower firing near maturing temperature will often cure this fault.

10-28

10-29

**Pinholing** is the term for tiny holes which appear in a fired glaze. This may be caused by poor clay preparation, improper glaze application or incorrect firing. Fine grained clay bodies can cause a glaze to pinhole more easily than coarse or grogged clays because the compact density of the clay does not allow easy escape of gases during firing. If the clay body has not been well homogenized before use or if small airspaces remain after kneading, it is possible that the entrapped air could cause bubbles to form under the glaze coat. Underfired bisque ware can absorb glaze too quickly and form tiny air pockets in the glaze. Soluble alkaline sulfate salts in the clay body can form on the surface of the ware and, when dissolved into a glaze, can leave air pockets which, when fired, cause pinholes. Small additions of barium carbonate will render the sulfates insoluble and correct this problem. Soluble salts present in the local water supply can also make a glaze pinhole. These salts can be neutralized by adding a little vinegar to the water.

Glazes which have been stored for long periods begin to decompose and contain gases which can bring about this flaw. Drying the glaze, remixing and screening it will allow these gases to escape. The glaze can then be safely reused.

Ware saturated with water during glazing, violent spray glazing, air trapped between bisque and glaze layers during the dipping, overly thick glaze coatings, and a long time interval between glaze coats can all cause pinholing.

Starting body reduction too early can cause carbon deposits to form in the clay. These deposits can become a gas at higher temperatures and cause pinholes in the glaze.

Glazes that are fired to temperature too rapidly or are overfired will often pinhole. Slowing the firing near maturity and soaking the ware for a half-hour will allow more time for gases to escape and glazes to flow, healing possible pinholes.

**Blistering or Cratering** is a more severe form of pinholing wherein bubbles in the glaze burst and leave sharp-edged craters on the surface of the fired glaze. Thick coatings, particularly on the bottom interior of the ware, are apt to blister. Overfiring of a glaze can cause some of its constituents to vaporize and blister. Lead glazes tend to blister if they are subjected to a reduction atmosphere. **10-29**

**Running** glazes are those which shift down the sides of the ware and often right off onto the kiln shelf. An application of glaze that is too thick can cause running. Occasionally, the addition of too much colorant to a glaze or overfiring a glaze may cause it to run. To help prevent this, the amount of kaolin in the base should be increased to make the glaze more refractory.

**Dull Surface** of a glaze is often caused by excessive amounts of insoluble materials in the base, such as tin, rutile, or spinel stains. If the proportion of silica to alumina is too low, or if too much barium or calcium is in a glaze base it will have a dull, rough surface.

The greatest single problem which can bring about many faults in a kiln is inadequate temperature control.

**Overfired** ware may be under great tension, be too vitreous, or have even begun to melt.

Glazes will run, become too shiny, and often be a different color than expected. Seriously flawed, overfired work can rarely be corrected and should be discarded. Occasionally, however, overfiring can bring about pleasing results.

**Underfired** ware can be too porous, with glazes that are the wrong color, incompletely melted, and have rough pebbly surfaces. Often these problems can be corrected by simply refiring the ware to the proper maturing temperature.

Reapplying glazes to thin areas, filling pinholes or blisters, or applying a different glaze for color and surface effects may be done on flawed ware, which is then refired to the correct maturing temperature. However, because there is no absorption on a glaze-fired surface, reapplication of glaze is somewhat difficult. One way to accomplish this is to slowly heat the ware in a kiln or oven until it is hot. Then, wearing gloves, remove the piece and immediately apply a gum solution over the sur-

**10-30**  Jar
18th century Chinese
Thrown porcelain, double crackle glaze
9 × 9″ (23 × 23 cm)
Courtesy: The George Walter Vincent
    Smith Art Museum, Springfield, MA

**10-31**  Vase
18th century Chinese
Thrown stoneware, lava glaze
17¹/₂″ (44 cm) high
Courtesy: The George Walter Vincent
    Smith Art Museum, Springfield, MA

**10-32**  Satsuma Double-Gourd Vase
Late 19th century
Thrown stoneware, "sharkskin" glaze
15″ (38 cm) high
Courtesy: P. F. Bear Oriental Art and
    Antiques

face. As soon as the steaming has stopped, apply a thickened coat of glaze, preferably by dipping or spraying. Another method, which is easier to use, is to mix the glaze with acrylic medium and apply it directly without heating. The medium dries to a strong bond, allowing two or three coats of glaze to be applied if needed. In both cases, the work is then fired normally. Low-fired glazes may be applied to high fired ware in the same manner. The ware is then refired to the maturing temperature of the glazes used.

Sometimes, in the case of some glaze faults, the result can be quite pleasing. Controlled crazed glazes, called *crackle* glazes, were sought by Oriental artisans for their cobweb-like effects. Glazes which run, crater, pool or streak can often be attractive on a particular piece. Ultimately, it is up to the clayworker to decide if the foregoing glaze defects are only flaws or have become interesting variations.

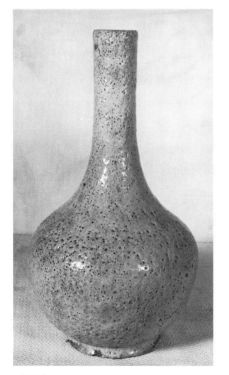

10-30

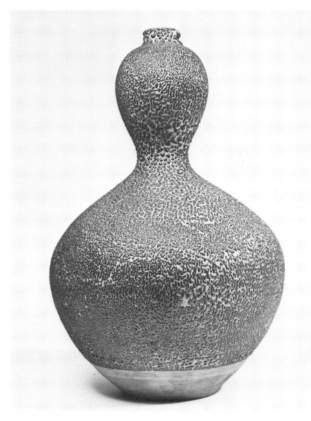

10-32

10-31

# CHAPTER 11 Kilns, Wheels, and Studio Equipment

## Kilns

Over the centuries, many different methods of heating clay to a stage of permanency have been developed, some of which are still in use today. Others have been discarded for their impracticality in modern times, and still others have been recently revived for their educational value, special effects, or just plain enjoyment.

Soon after it was realized that clayware which had been heated in a cooking fire was less apt to break than that which was not, open fire methods were used to harden clay objects. Some Africans as well as North and South American Indians still use the technique of stacking their ware in a mound which is then covered with combustible material such as dried corn stalks or dung cakes. The material is ignited and allowed to burn down. Because of uneven heating and thermal shock, this method is quite inefficient and losses are often high. Minor improvements in heat efficiency were gained by covering the combustible material with shards of pottery which acted as insulation. **11-1**

11-1

11-2

11-3

**11-1** On-ground firing
Itsukwi, Nigeria
Photo: Jean M. Borgatti

**11-2** Covered pit kiln
Lejre, Denmark
Photo: Susan Feinsod

**11-3** Mud teepee kiln
Lejre, Denmark
Photo: Susan Feinsod

Open pit fires and, later, closed or covered pit fires dug in the ground used the earth to insulate the heat and attain somewhat higher temperatures and longer firing times. **11-2**

Teepee-like kilns made of sticks tied together in a cone and covered with mud were used during the Iron Age. Replicas of these early kilns are still in use today in the tourist village of Lejre, Denmark. **11-3**

The first real advance in kiln design and efficiency was probably introduced in the Mediterranean area about five thousand years ago. Kilns were built of dried clay bricks into low circular structures which allowed fuel to be introduced below the ware. No longer were embers relied on to provide heat. Greater amounts of fuel could be introduced to increase the temperature more than had previously been possible.

The type of kiln in which fuel is burned below the ware and which allows the heat and gases to exit above is known as an updraft kiln. The Greeks, about twenty-seven hundred years ago, built dome-shaped updraft kilns complete with firebox, ware chamber, and a damper-controlled exit stack. The fire could be controlled from a slow heating at the start to a rapid hot flame at the upper temperatures. It could also be adjusted for oxidation or reduction when required for certain color effects. **11-4**

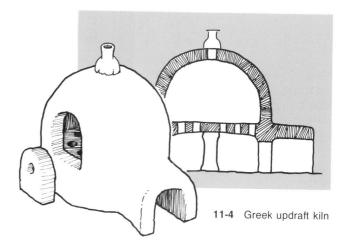

11-4   Greek updraft kiln

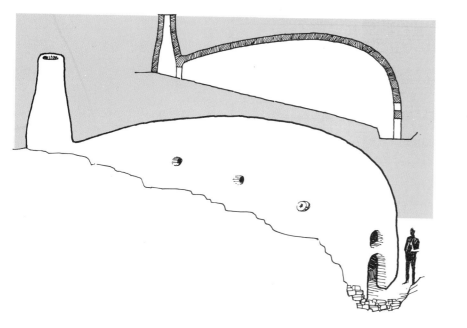

11-5   Chinese *ana-gama*

193

11-6   Korean split bamboo kiln

11-7   Five chamber hillside kiln
Franklin Pierce College, Rindge, NH
Photo: the author

The art of kiln building was already advanced in the Orient at a time when the Europeans were still using primitive, inefficient methods. The easy access to highly refractory fireclays and kaolins to make into bricks helped the Chinese develop better insulated kilns which retained more heat and reached higher temperatures. Hillside, beehive-shaped kilns, called *ana-gamas*, were the first successful type of kiln to incorporate the downdraft firing system. With the firemouth at one end of the kiln and no chimney in the roof, the heat and flame were forced to travel through the ware to the other end of the kiln before exiting, thus insuring a more even and complete distribution.**11-5**

The tubular *split bamboo* climbing kiln as used by the Koreans during the fifteenth century was one long uphill chamber with a few internal partitions. It was an improvement over the *ana-gamas,* but tended to fire erratically.

One of the most efffective types of kiln in terms of design was the multichambered hillside kiln, or *nobori-gama*, developed by the Japanese during the late fifteenth century. A vast improvement over the *split bamboo* kiln, it was constructed as a series of domed chambers connected in a line ascending a hill, making excellent use of the downdraft system. As the fire was built up by stoking wood in the lowest chamber, or firemouth, the flame and gases were forced to pass upward into the next chamber and then downward into the mouth of the following chamber and so forth before exiting at the stack. When the firemouth reached a high temperature, stoking was begun in the first chamber loaded with ware. After the first chamber reached the desired temperature, stoking continued in the second. Because the fire from one chamber heated the next, less fuel was required for succeeding chambers as the firing continued up the hill. This type of kiln has been in use in China and Japan for centuries and is now experiencing renewed interest among clayworkers in the United States. **11-6, 11-7**

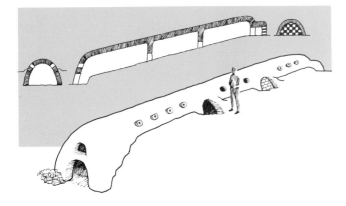

11-6

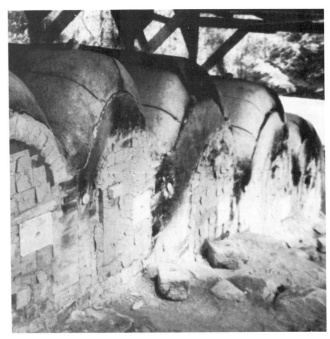

11-7

**11-8**  European bottle kiln

**11-9**  Saggars
Photo: the author

**11-10**  Section drawings
Left: plate muffle kiln
Right: tube muffle kiln

*Bottle* or *cone kilns* were first constructed in Germany in the early 1700s. Elongated in height and tapering to a narrow opening at the top, these kilns could attain temperatures high enough to mature porcelain. Some of the bottle kilns incorporated a bisque chamber in an upper level. Larger versions of the kiln were called *hovel kilns* because they had an outer bottle-shaped shell for added insulation, as well as weather protection for the firemen stoking the kiln. **11-8**

All of these kilns used wood for fuel, although, in later times, the Europeans used coal as well. Fuel was cheap, readily available, efficient at high temperature, and helped to create interesting glaze effects caused by falling ash, swirling smoke, and flashing flames. Problems arose, however, if the ware to be fired was to be free of these relatively haphazard effects.

Refractory clay boxes, called *saggars*, were employed to protect the ware from the flames. The drawback to using saggars was that one saggar was necessary to cover each piece or small group of pieces to be fired and, therefore, a great many were needed to stack a kiln. If a saggar broke during a firing (as was often the case), it could destroy many pots at one time. **11-9**

Eventually, the entire interior of the kiln became one large saggar, better known as a *plate muffle kiln.* The muffle was essentially a house inside the kiln built of refractory fireclay which shielded the ware from the flames encircling the muffle. This type of kiln and a variation called a *tube muffle* in which the flame goes through refractory tubes are still in use today.**11-10**

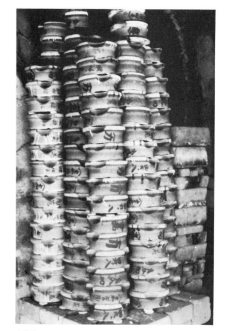

11-9

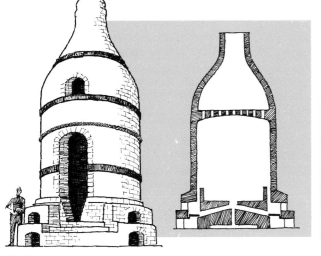

11-8

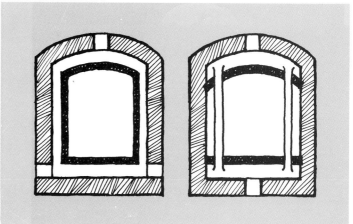

11-10

**11-11** One car shuttle kiln, model NDS 60
60 cubic foot capacity, gas fired
Courtesy: A. D. Alpine, Inc.

**11-12** Modular shuttle kiln
Denver Fire Clay Company
Gas fired
Courtesy: MSI Industries, Inc.

**11-13** Roller hearth kiln, model RHK
Gas fired
Courtesy: Ipsen Industries

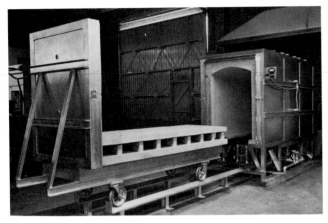

11-11

11-12

11-13

Because industry needed to be able to fire large amounts of ware at one time, a number of large kiln designs have been developed to facilitate this. A *car kiln* is basically a kiln with a floor on wheels. The car can be conveniently stacked outside the kiln and then rolled on tracks into it for firing. A *shuttle kiln* is a large kiln with a door at each end and two or more moveable cars, one of which can be stacked while the other is being fired. A variation of this is the *envelope kiln* which utilizes two or more stationary cars over which the kiln is rolled, shut, and fired.

All of the kilns mentioned so far are known as *periodic kilns*. That is, they are stacked when cold, heated to temperature, cooled, and then unstacked. The time lost when a kiln is not being fired, therefore, remains an important cost factor. To date, the best solution to this industrial economic problem has been the development of the continuous, or *tunnel kiln.* This long kiln is constantly heated with a series of burners and baffles that keep a low heat near the entrance of the kiln, gradually step up the heat towards the center and maintain cooler temperatures near the exit. The ware is placed on a moving belt, or rollers, and then travels slowly through the kiln. Highly sophisticated versions of this kiln repipe the expended heat over and over throughout the kiln to gain the greatest efficiency.

Today, many versions of both updraft and downdraft kilns are available to schools and studio potters. A few of them are quite good and worth the investment. However, building a comparable kiln can cost considerably less—or more, if not well thought out in advance. Location of the kiln is very important. Prevailing winds, safety factors, local fire, and zoning regulations must be taken into consideration. Should the kiln be fired with natural gas, liquified petroleum, oil, coal, or wood? How big should it be? How many chambers? Should hard or soft firebrick be used? What about housebrick? Commercial castable? Homemade castable? Insulating blanket? The questions are almost endless.

Currently it appears that studio potters have settled into two basic styles of kiln; one is a *sprung arch* and the other, a *catenary arch* kiln. Both types can be suitably designed for any of the fuels just mentioned, have great size range and can be constructed using any or all of the aforementioned materials. The sprung arch kiln is a box with a curved roof held together by a steel frame. The catenary, on the other hand, is a self-supporting curve arching directly from the floor and requires no additional bracing. The curve is determined by hanging a chain between two nails the floor width apart, forming an arch as long as the kiln is to be high. This is drawn on a template from which a construction form is made.

**11-15** Sprung arch kiln
40 cubic foot capacity, gas fired
Courtesy: Gerry Williams
Photo: the author

**11-16** Catenary arch kiln
40 cubic foot capacity, gas fired
Courtesy: Roger Harvey
Photo: Felicity Craven

**11-17** Catenary construction form
Courtesy: Roger Harvey
Photo: Felicity Craven

Many sets of plans, pamphlets, and books have been written explaining the processes involved in building a kiln. It would be wise to consult the good ones, as well as individuals who have actually built kilns, before undertaking such a project. The variables are infinite and something which works for one kiln may not work for another.

**11-14** Ceramic fiber kiln, walk-in model
Courtesy: Bailey Pottery Equipment Corporation

11-16

11-14

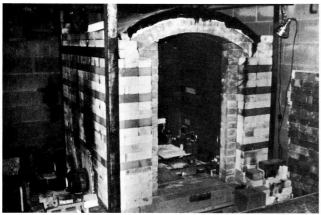

11-15

11-17

197

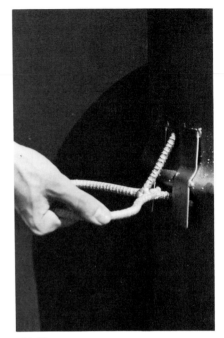

11-18                    11-19                    11-20

## Constructing a Gas Kiln

Recently, many potters have begun to examine the properties of the high temperature insulating blanket and its possible applications to kiln building. The following is a simple, but highly effective, barrel kiln incorporating Carborundum Company's Fiberfrax© blanket, as designed and built by James G. Winegar. These are the materials needed to construct a 10 cubic foot cone 6 portable gas kiln:

> 50 square feet of ³/₄ inch Fiberfrax© Blanket, 9 foot width, 6 pounds/cubic foot density
> 1/2 gallon F-180 Coating Cement or Sodium Silicate (Water Glass)
> One 55-gallon steel drum
> One 3 × 3 foot 18 gauge steel sheet
> Two 22-inch long ³/₈-inch steel rods
> Two feet of 2-inch steel angle iron
> Two cans 600°F heat resistant paint
> 40  1-inch × ¹/₄ inch carriage bolts and nuts
> 4  6-inch eyebolts and wing nuts
> 54 firebricks

The interior and exterior of the 55 gallon drum must first be cleaned of all residue. All paint must be wirebrushed or sand-blasted off. The upright barrel is then cut in half, from top to bottom, using a metal cutting blade fitted to an electric saber saw. The barrel is inverted and a 10 inch square draft opening is cut in the center of what is now the top. **11-18,** Two holes 2 inches in diameter are cut in the side of the barrel to serve as spy holes. **11-19,** Two detachable handles are bent from 18 inches of ³/₈ inch steel rod with a 4 inch rod welded perpendicularly to each handle for leverage. **11-20,** Two metal straps, 8 inches long, are welded parallel to each other on each side of the barrel into which the handles can be slipped.

After cutting and welding has been completed, the outside of the barrel is sprayed with heat resistant paint.

11-21

11-22

11-23

Later, the Fiberfrax© blanket will be rolled over the edges of the barrel to protect them from heat. **11-21, 11-22,** To secure the blanket over the edges, metal straps must be cut and bent to conform to the draft hole, bottom, and sides. **11-23,** The four straps for the sides have pieces of angle iron welded to them to later hold the eyebolt closures. Four of the pieces of angle iron are drilled and the other four slotted.

The straps are temporarily clamped to the barrel in their proper positions. Next, 1/4 inch holes are drilled through the straps and the barrel. This is for the bolts needed to later secure the blanket over the edges. In the example shown, forty holes were drilled. Remove the straps after drilling. To protect the bolts from heat, they are put through the holes, threaded end outward, before the Fiberfrax© is placed in the barrel.

After the bolts are placed, the Fiberfrax© is then measured and cut to fit the interior of the barrel. Regular scissors can be used for cutting. Two layers of Fiberfrax© are to be used. **11-24,** The pieces of the first layer are measured and cut to fit exactly to the edges of the barrel. The pieces are then secured to the inside of the barrel using Carborundum Company's F-180 cement or liquid sodium silicate. The cement is brushed on the metal in a thin, even coat. The pieces of Fiberfrax© are laid in place and pressed gently against the barrel. Both barrel halves are lined in the same manner.

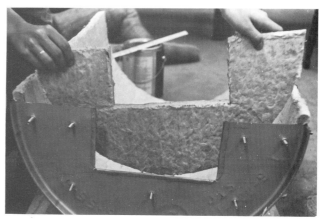

11-24

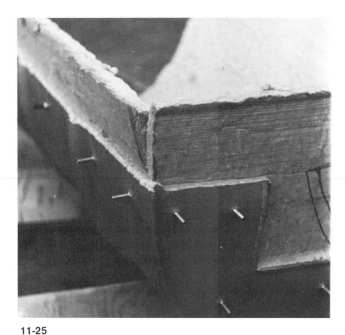

11-25

11-26

**11-25,** The second layer of Fiberfrax© is cut to size at least 4 inches longer than all the edges of the barrel. This excess will be turned over the edges and strapped down. Cement is evenly applied to completely cover the first layer of Fiberfrax©. The second layer is gently pressed on top. The cement is allowed to set for at least three hours before folding the blanket over the barrel edges. Cement is used to secure the blanket to the outside surfaces. The protruding bolts are pushed through the Fiberfrax© and the straps are placed on and bolted securely. The excess blanket at the draft hole and bottom of the kiln is cut into tabs which are turned over the edges and bolted securely with the straps.

**11-26,** Eye bolts are put through the holes in the side straps with the threaded end fitting into the slots.

The damper is made of a piece of square sheet metal, 12 × 12 inches. An off-center loop of metal is welded to the top to hold a kiln handle. Two layers of Fiberfrax© are cemented to the underside of the damper and the top is spray painted. The construction of the kiln is now complete.

A firebrick platform is built up of 3 layers of 18 bricks each, forming a 27 inch square. A burner port is made by removing one and a half bricks from the top layer, one brick in from the side. One brick is taken from the middle layer directly below. This forms a burner port with a step in it to push the flame upward into the chamber. It is offset to create a spiral flame motion. The extra firebrick can be cut to make two spy hole plugs. **11-27**

The kiln is ready to be fired with any type of natural or LP gas burner.

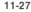

11-27

**11-28** Frontloading electric kiln
Unique PRO series
3 cubic foot capacity
Courtesy: HED Industries, Inc.

**11-29** Toploading electric kiln
Model 274S
9 cubic foot capacity
Courtesy: Crusader Ceramic Equipment

This type of kiln can also be fueled by wood or coal. Instead of a solid platform, a grate is constructed for the kiln to rest on. A four foot tall galvanized stack lined with a single layer of Fiberfrax© and set on top of the damper hole will increase the draft necessary to fire with these materials.

The kiln can be used quite easily for raku firings. If shelves are used, they should be of silicon carbide to withstand the thermal shock stresses of rapid heating and cooling. The glazed ware is stacked and the kiln heated. Because the Fiberfrax© blanket does not exhibit heat color as do firebrick kilns, temperature judgments must be made by relying on the melt of the glazes and color glow of the heating pots. When the raku glazes have fused, the burner can be quickly shut off and one side of the kiln unlatched and easily lifted away. The ware can then be rapidly removed from the kiln for secondary reduction while still red hot. The kiln can be restacked with more ware and fired up to temperature, usually within a half hour.

**Heat resistant gloves and welder's goggles are a must when firing raku with this type of kiln.**

## Electric Kilns

The chief boon to the recent growth of interest in ceramics has been the electric kiln. Unobtrusive, efficient and relatively inexpensive, the electric kiln has brought claywork within the reach of hobbyists, students, and professionals. Although it is possible to build an electric kiln, the proliferation of commercially available styles and sizes at reasonable cost makes entertaining this idea somewhat specious.

Electric kilns are constructed in two types, frontloading and toploading. Frontloading kilns are equipped on one side with a swinging or sliding door for easy reach when stacking. The main drawbacks to frontloading kilns are the awkward way that kiln shelves have to be guided into the kiln, the considerable cost involved for just the door bracing, and the gross weight of the kiln itself. Toploading kilns are generally less expensive because many of them are made up of removable ring sections and require no special bracing for the door on top. Drawbacks are the rapid cooling in comparison to the more heavily insulated frontloading kilns, the occasional problem of unnoticed bits of kilnwash or kiln shelf falling on the ware below, and pots slightly too tall being unknowingly damaged as a shelf is being set. An electric kiln is fired with metal elements placed in grooves in the chamber walls. These elements resist live electric current and in so doing, generate heat.

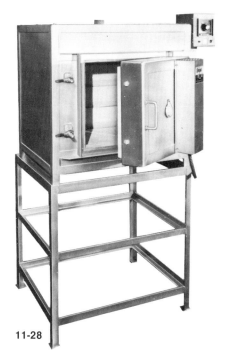

11-28

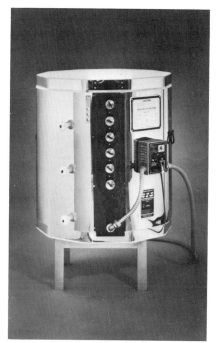

11-29

**11-30**  Elevator kiln
Courtesy: Bailey Pottery Equipment
  Corporation

**11-31**  Reflector solar kiln
62″ (1.6 m) diameter
Courtesy: Zeljko Kujundzic
Photo: The Seattle Times

**11-32**  Double lens solar kiln
28 and 12″ (71 and 30 cm) lenses
Courtesy: Zeljko Kujundzic
Photo: the artist

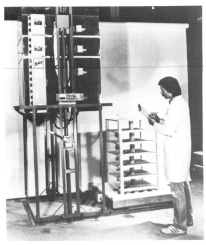

11-30

11-31

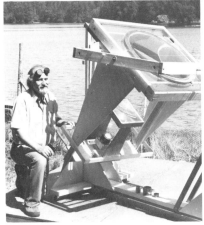

11-32

Three types of element wiring are available for electric kilns. For low temperatures, below cone 06 (991°C, 1816°F), Nichrome wires can be used. These are less expensive than Kanthal A wire, necessary for work up· to cone 5 (1177°C, 2151°F). The more expensive Kanthal A-1 wire elements are required for temperatures up to cone 10 (1285°C, 2345°F). Much higher temperatures can be attained by using silicon carbide rods as the heating elements. Because a transformer is necessary to operate them, the cost is prohibitive for the individual potter. The variations in cost between earthenware temperature kilns and those designed for stoneware are because of the different types of electric element and refractory bricks required for each.

For greater diversity and flexibility of firing temperatures, a higher temperature kiln, in the long run, will be more than worth the added initial expense. Kiln size is also important. Again, over a period of time, a larger kiln will more than pay for itself.

Although there is no danger of fire or blowout as with fuel kilns, for safety, an electric kiln should be at least 12 inches from any walls or other equipment and on a level cement or concrete floor. If the floor is wood, it should be covered with a sheet of transite or other fireproof material. The kiln can be placed on cement blocks for greater air circulation underneath.

**As discussed in Chapter 10, adequate ventilation is necessary to prevent the studio from filling with escaping gases from the clay and glazes during firing.**

It is very important that sufficient electric power be available to service the kiln. Be sure to have the correct line requirements for the kiln size. Often it is wisest to install a separate line and circuit breaker system specifically for the kiln rather than to rely on existing lines within the building. A separate meter is not necessary but would be advisable in a school or commercial operation to evaluate cost. A simple way to estimate the cost of firing a kiln is to multiply the kilowatt rating by the local unit cost of electricity and then multiply this by the firing time.

## Solar Kilns

Legend recounts that Archimedes proposed the first use of solar energy for the defense of Syracuse against the Romans in the third century B.C. He suggested that the defending army polish their shields and reflect the sun's rays at the Roman ships offshore. The intense heat would then cause the ships to burst into flames and sink.

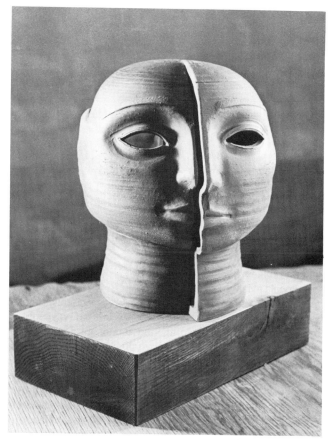

**11-33** Zeljko Kujundzic
*Twins*
Thrown, altered stoneware, sun fired
8″ (20 cm) high
Collection: National Museum, Geneva
Photo: the artist

An early apparatus which could loosely be called a solar kiln was developed by Ehrenfried Walter von Tschirnhaus around 1690. This furnace consisted of large "burning glasses," or lenses, which focused the rays of the sun onto a small refractory box, heating it and its contents to high temperatures. In collaboration with von Tschirnhaus, Johann Friedrich Böttger attempted to melt various substances into gold. Although they never made gold, they did develop Germany's first high temperature true white porcelain.

### Reflector kilns

Both methods of controlling the sun's rays (reflection and collection) have been used successfully in firing ceramics. In the late 1960s, some clayworkers began experimenting with various parabolic reflectors to focus sunlight on a small heavily-insulated "kiln" (usually a coffee can) suspended above the reflector. The major drawback to this method is the ungainly size of the reflector needed to concentrate sufficient sunlight to heat a firebox of other than modest size. Far more promising is the use of magnifying lenses or Fresnel lenses to track and focus the sunlight.

### Lens kiln

The actual construction of a solar kiln depends upon the size of the lens or lens system to be used. The focal point of the lenses will determine the position of the firebox as well as its capacity. The entire kiln must be movable in order to continuously track the sun during the firing process. The lenses must also be set in a movable cradle within the framework, so that precise focus can be maintained. While it is possible to manually aim the kiln during the firing, this can also be done by constructing an automatic tracking device timed to follow the movement of the sun.

Commercial Fresnel lenses are available in many sizes and focal lengths. However, to obtain very large-diameter lenses, it might be less costly to construct the liquid-filled type. This is made of a domed lens laminated to a flat base lens with two valves for filling and draining the liquid. The liquid should have a high transmission index. Carbon tetrachloride has been used, but it is not safe with all laminates because it sometimes dissolves them. White wine, which has an index twice that of water, has been used with excellent results.

11-33

### Firing

A typical firing sequence begins by placing a clay object into the firebox and setting it in position. **It is essential that anyone working with a solar kiln wear welder's goggles and heat-resistant gloves.** The kiln is turned toward the sun. The lenses are focused, starting with a wide or "soft" focus which is slowly sharpened. Temperatures over 1093°C (2000°F) can be reached in seconds, so the more slowly the focusing is done, the less chance of shattering the clay. Clay bodies with petalite or wollastonite in them are less likely to explode from the sudden application of heat. Once the desired temperature is reached, the kiln is simply turned away from the sun and the firebox allowed to cool.

Best results can be obtained during the midday period when the sun is at its zenith, providing the most direct flow of energy. It is essential that the concentration of sunlight remain steadily focused on the firebox for the duration of the firing. Even a passing cloud can cause the kiln to lose hundreds of degrees in just a few seconds.

There are still limitations to solar kilns at present. The size of lenses currently available restricts the size of object that can be fired. The rapid speed at which temperature is reached must be controlled. And, of course, the kilns do not work if there is no sunshine. However, the sun is a virtually inexhaustable, non-polluting source of energy, free to anyone who will take the time to figure out how best to harness it.

## Laser Fired Ceramics

Recently the Bezalel School of Art in Jerusalem has been experimenting with firing clay using a fixed position laser beam. The clay is in the form of a cylinder placed at a specific distance from the laser. The laser is turned on and the clay cylinder is slowly rotated in front of the beam. The beam melts the surface of the raw clay and instantly creates a shiny chocolate-brown glaze.

Ultimately these experiments seek the ability to create on site large sculptural forms with local earth, and fire them in place. Two problems have yet to be overcome. In order to fire such works, the laser must be movable, but still capable of maintaining a specific distance from the clay. Of greater concern is finding a way to mature the entire clay form. The laser beam in use now can only fire the surface and does not affect the interior.

## Wheels

It is said that Athene, the goddess of ceramics, invented the potter's wheel and used it to make vases. The ancient Egyptians ascribed to the god Khnum the first use of the potter's wheel with which he fashioned the world-egg. In either case, it can be assumed from excavated vessels that some type of wheel was actually in use in Mesopotamia around six thousand years ago. The wheel was most probably a smooth stone which rested on another and was turned by hand. In Mexico a similar type of wheel, consisting of two clay plates, is still used by many village potters. **11-34**

11-34

The first true momentum wheel was probably developed in early China. It was made of a large stone centered on a smaller pivot stone. At the top edge of the large stone a stick was inserted into a hole and was used as a crank to spin the wheel. Potters in Nepal and other countries still use this wheel today. **11-35**

Other types of wheels have been used over the centuries, some spun by one person while another did the throwing and still others powered by wind or water. Many European potters still favor the old-style treadle, or side-kick, wheel rotated by a foot operated swing arm.

The potter's wheel which offers the best mechanical advantage is a sit-down kick wheel. The wheel head is connected by a shaft through bearings to a balanced flywheel below. Clay is placed on the wheel head and the flywheel is then kicked up to speed. If the flywheel is heavy enough, 100 to 150 pounds or more, its momentum will continue long enough for a pot to be finished. If the wheel slows down, a few light kicks will easily bring it up to speed.

11-35

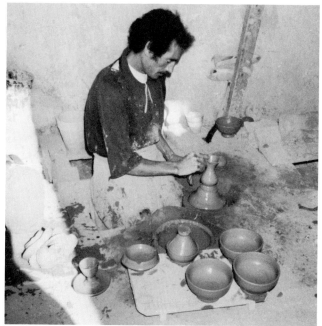

11-36

About as many different designs for wheels have been developed as there are potters. Plans, parts, kits and complete wheels of wood or metal are all commercially available. No matter what style of wheel is preferred, the primary concerns should be comfort, adequate flywheel weight, and smoothness of operation. A homemade wheel built with an automobile driveshaft and using a concrete filled tire as a flywheel can cost one-tenth as much as a commercial wheel and operate as efficiently.

For added convenience, most kickwheels can be modified to operate with a friction drive motor.

Electric wheels also come in many different styles, the best of which are those with variable speed control. Gear drive motors provide the best response. However, they are also the most expensive. Any other drive mechanism, such as a rubber cone or belt type, should be tested for limited slip and must have positive adjustment capability. Anything less should not be considered.

11-37

11-38

11-39

11-40

**11-37** Wooden kick wheel, model KW
Courtesy: Robert Brent Corporation

**11-38** Steel frame motorized kick wheel, model EJ
Courtesy: Robert Brent Corporation

**11-39** Electric potter's wheel, model RK-10
Courtesy: Shimpo-West Inc.

**11-40** Electric potter's wheel, model 321
Courtesy: Soldner Pottery Equipment, Inc.

## Studio Equipment

Along with a good kiln and wheel, other equipment is necessary for efficient operation. Some type of wedging surface is needed to properly prepare clay for use. It could be a large block of smooth plaster, a piece of unpolished marble, or a canvas covered plaster wedging table.

A good quality gram scale is needed to weigh glaze batches accurately. A household scale is useful for weighing clay or plaster.

A laboratory test sieve of 50- to 80-mesh is good for screening glaze or clay slip. A kitchen strainer can be used to sift coarse materials like grog.

Some glaze materials may need to be ground more finely before they can be used. A porcelain mortar and pestle can do the job well for small amounts. If a lot of grinding is to be done, a relatively expensive ball milling apparatus may be needed.

An aluminum or cast iron bench wheel is helpful when hand building or decorating. Plastic "lazy-susans" are not very reliable.

Inexpensive plastic buckets in different sizes are handy to store clay, slake clay scraps, hold water, and mix glazes. Airtight plastic containers are good for storage of glaze materials. Heavy plastic bags are useful for storing clay; lightweight bags protect ware from drying out too soon.

A studio can almost never have enough shelving. Glaze materials must be kept within easy reach; a place is needed to keep wet pots; damp pieces require room to dry; bisqueware requires a place to await glazing; and finished work must be stored as well.

Along with throwing tools, there can never be too many trimming tools or brushes. A carpenter's angle, a level, calipers, putty knives, heat lamp, funnels, sponges, syringes, paddles, a rolling pin, guide sticks, plaster bats or boards to place ware on, paper and cloth towels are a few items that can make a studio function smoothly.

An important point to remember is that clay, glaze, and plaster can rapidly clog plumbing. If some type of easily emptied sink trap is not installed, a bucket should be at hand to prewash everything before using the sink. Periodically, the bucket should be drained and its contents disposed of. If separate buckets are used, uncontaminated clay can be recycled.

# CHAPTER 12 Plaster

Plaster can be used to make bats for drying clay and bats for the wheel, as well as molds for making multiples of an object. Plaster is pulverized calcined gypsum, manufactured in many grades of hardness. In the ceramic studio, Regular Pottery Plaster or Number One Pottery Plaster are the best to use because of their hardness and porosity. Plaster is most economical when purchased in 100 lb. bags. It should be stored, airtight, in a warm dry place to prevent moisture from being absorbed.

For best results plaster should always be added to water by weight. The consistency ratio of Regular Pottery Plaster is 72; Number One Pottery Plaster, 66. This means that 72 pounds of water must be added to 100 pounds of Regular plaster and 66 pounds of water to Number One plaster for the correct mix. For smaller projects, it may be easier to figure a ratio of 1 quart of water to 2.75 pounds Regular plaster or 3 pounds Number One plaster.

## How To Make a Drying Bat

A wooden form is set up on a smooth surfaced table or board and secured with clamps. Clay is pressed around the outside edges of the mold to prevent the plaster from leaking out. The volume of the mold is measured. **12-1,** In the example, the mold is $14 \times 19^1/_2 \times 1^3/_4$ inches. Multiply these numbers together to derive the cubic measurement. $14 \times 19.5 \times 1.75 = 477.75$ cubic inches. This number is divided by 81, the approximate volume of a quart of Number One plaster, to find the number of quarts needed: $477.75 \div 81 = 5.89$ quarts. For a margin of safety, round the total to six quarts. Multiply this figure by 3.0 to get the weight of dry plaster: $6 \times 3.0 = 18$ pounds.

**12-2,** Commercial mold separator or tincture of green soap (available through most pharmacies) is applied to all surfaces that the plaster will touch. **12-3,** For reinforcement, chicken

12-1

12-2

12-3

12-4

12-5

wire is placed in the mold. Sift the 18 pounds of plaster into the 6 quarts of room temperature water and allow it to slake for 5 minutes. Hot water will set plaster too fast, cold water slows setting time. Stir gently from the bottom to mix the plaster and get out air bubbles. The best test for consistency is to draw a finger over the surface of the plaster. **12-4,** When the mark remains momentarily, pour the plaster gently but quickly into the mold. Jar the table or board a few times to force all the air bubbles to the surface and blow lightly on them to break them.

Allow the plaster to set. As the plaster sets, it crystallizes, giving off heat. **12-5,** When the plaster is cool, it is safe to remove the mold. The bat should be allowed to dry in a warm place for a few days before it is used.

A plaster bat for the wheel is made in the same way as a drying bat. A pie tin, pizza tin, or a commercial bat ring can be used to make different diameter bats. When making a drying bat, it is always a good idea to have a few pie tins ready to take any extra plaster mix. In any event, the bat ring should be measured, the mix calculated, and the plaster poured. After the plaster has set, a few light taps on the back of the tin will release the bat.

## Making Plaster Molds

The following methods of mold making are simple and direct. They also allow freedom to design an object for reproduction which does not have to be completely symmetrical.

## One-Piece Press Molds

A one-piece press mold is an easy way to make a limited number of multiples of a tile, relief or other simple object. The object to be reproduced is fashioned from a solid block of clay. It is important that there be no undercuts in the design. Otherwise, the object will not come away easily from the mold.

After the model is completed, place a wooden form around it with at least one inch clearance everywhere, including the top. **12-6,** Secure the form and put clay around the seams. Apply green soap over all the surfaces. Calculate the volume of the mold to find the amount of plaster mix needed. Estimate the volume of the model and subtract this amount from the total. Or, better still, have enough pie tins available to take the excess plaster. Mix the plaster and pour it. **12-7,** After the plaster has set, the model may be pulled out and the mold allowed to dry for a few days.

**12-9** Author
*Moses*
Press molded stoneware, walnut
24 × 14″ (61 × 36 cm)
Courtesy: B'nai B'rith Members'
   Insurance Program
Photo: the author

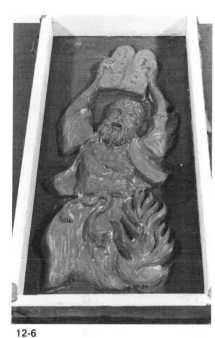

12-6

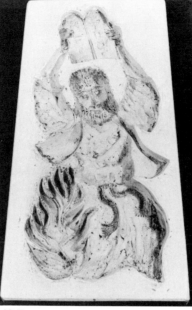

12-7

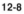

12-8

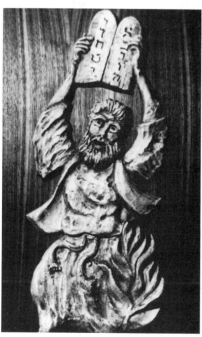

12-9

**12-8,** When the mold has dried, press clay into it. Force the clay into all parts of the mold, maintaining an even thickness throughout. After the mold has been filled, allow the clay to stiffen. Turn the mold onto some slats and allow the clay to continue drying. If there are no undercuts, the clay object will simply drop out of the mold after having shrunk sufficiently.

**12-10**  Palissy Ware
Plate
Molded, hand modeled earthenware,
    polychrome glaze
10″ (25 cm) diameter
Courtesy: Worcester Art Museum

**12-11**  Shellie Z. Brooks
*Floating Basket: Crater Lake II*
Press-molded cast earthenware slabs
10 × 14″ (25 × 36 cm)
Photo: Tom Lang

**12-12**  David F. Grisar-Silverman
*The Shell*
Press-molded stoneware, underglaze
14¹/₂ × 5″ (37 × 13 cm)
Photo: Charles Feil

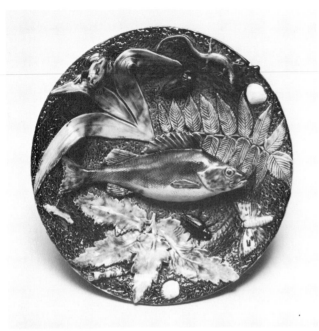

**12-10**

**12-12**

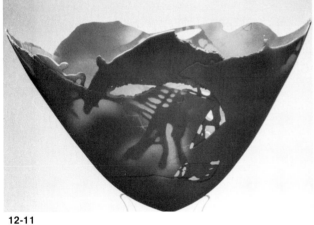

**12-11**

12-13

12-14

## Two-Piece Molds

Draw a line down the center of the model to be cast, making certain that there are no undercuts. Place the model on its side so that the line is parallel to the tabletop. **12-13,** Build clay around the lower half of the model up to the centerline and at least one inch away from all sides. **12-14,** Next, secure a flexible form or *cottle*, made of galvanized sheet metal or a strip of vinyl flooring, around the model and the clay. Soap all surfaces. Calculate the volume of the mold, mix and pour the plaster. After the plaster has set, turn the model over and remove the clay. **12-15,** To later position the mold halves, cut

12-15

at least three *keys* into the plaster mold. These small indentations are carved with a rounded knife or spoon to insure no undercuts. Secure the cottle around the model and half mold. Soap all surfaces well. Mix a second batch of plaster and pour **12-16**, After the plaster has cooled, remove the cottle, separa the two halves of the mold, and take out the model.

Allow the mold to dry completely before using. In the example, clay was pressed into each half. The halves were tied together and the clay smoothly joined. When the clay had stiffened, the mold was removed and the basic clay form altered to create a series of different heads. **12-17, 12-18, 12-19**

12-16

12-17

12-18

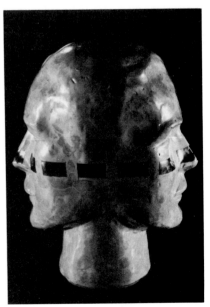

12-19

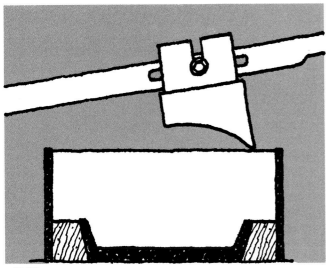

12-20

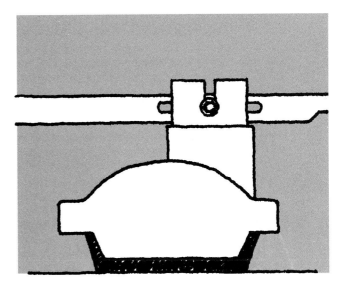

## Jigger Bats

### Template

Use a jigger arm and template to make jigger bats of the proper dimensions. For a plate bat, first draw a cross-section of one-half of the plate profile. Trace the inside curve onto a piece of thin sheet metal. A flattened tin can will do. Cut the metal with tin shears or a jeweler's saw and file the edge smooth. Tack the template to a board and position it correctly on the jigger arm.

### Cutting the bat

Secure a cottle around the wheelhead. Compute the amount of plaster needed, mix, and pour. As soon as the plaster has started to set, but before it gets hard, remove the cottle. Start the wheel turning and slowly lower the jigger arm, allowing the template profile to carve the plaster. **12-20,** When the arm has reached its horizontal position, the bat has been correctly cut. After the plaster has set, turn the wheel again and bring the template down to create a smooth surface on the bat. Trim the rim of the bat and remove it from the wheel. Allow the bat to dry completely before using.

A cup bat is made in the same manner.

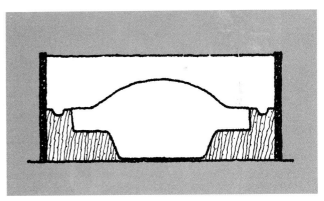

12-21

### Case Mold

Additional bats can be made in the same way or with the use of a *case mold.* In this instance, a case mold can be made in the same manner as the press mold described earlier. Make certain that the bottom half of the case mold has an opening so that plaster can be poured into it to make the bats. **12-21**

12-22

12-23

12-24

### Pouring the bats

After the case mold has dried completely, it is ready for use. Place it upside down and open it. Soap all surfaces very well to prevent poured plaster from sticking to the mold. Align the keys and close the mold. Tie or clamp the mold halves securely. Then mix the correct amount of plaster and pour until it just fills the mold. Gently tap the mold a few times to allow any air bubbles to come to the surface. Let the plaster set. After it has cooled, open the mold, remove the bat, and repeat the process.

## Horizontal Plaster Lathe

To make a symmetrical plaster model for slip casting, construct a simple plaster lathe. The measurements of the box depend on the size of the model or models to be produced.

**12-22,** The box shown was used to make three different models. The widest was 6 inches and the tallest, 9 inches.

### Pattern

Draw the silhouette of the desired form as accurately as possible. The use of graph paper is helpful but not necessary if the form is drawn well. Be sure to take the fired clay shrinkage into account. If the slip shrinks 15 percent when fired, the drawing should be made that much larger. Include a trim shelf and reservoir at the top of the piece.

### Template

Transfer the design to a piece of thin sheet metal. (A flattened tin can will do.) Either blacken the back of the pattern with soft pencil or use carbon paper.

Use a jeweler's saw or tin shears to cut out the design. Then file the edges smooth. Any ragged spots or uneven cuts will show up as score marks on the finished model.

Next, measure the thickness of the plaster lathe rod. Cut one-half that measurement off the rest of the template cutting edge. If this is not done, the finished model will be wider than planned.

Cut a piece of 1/4 inch plywood to the approximate shape of the template cutting edge. Leave enough wood so that it can be clamped to the guide board later. Fasten the template, with a 1/4 inch overhang, onto the plywood with carpet tacks. **12-23**

## Plaster model

Slide the guide board into the lathe until it touches the stops. Place the mounted template on the guide board so that the sheet metal just touches the rod. Secure the template to the guide board with C-clamps.

Wind string or twine around the rod within the open area of the template. This makes it easy for the plaster to adhere to something. **12-24**

Mix a small batch of plaster. When the plaster has just begun to set, daub it onto the rod. Slowly turn the rod as more plaster is added. It is better to apply the plaster in small batches, allowing a few moments for the plaster to set up, rather than adding all the plaster at once. Continue to build up the plaster while slowly turning the rod in one direction until the model is almost finished. Make the last batch of plaster just a little thinner than normal. When this batch is applied, turn the rod slowly and evenly and the template will trim a smooth surface on the model. **12-25**

When the model has set up, use a flexible metal scraper and wet/dry sandpaper to give it a smooth, hard surface. Carefully draw a center line on the model with felt tip pen. Remove the model from the rod with a slow twisting motion. **12-26**

## Mold

A two-piece mold is made from this model in the same manner as the press mold explained on page 211. Two-piece molds can accommodate most symmetrical forms. However, more complicated figures require more mold pieces.

**12-27,** Set the model on pads of clay so that the center line is parallel to the table top. Put clay in the holes left by the rod.

12-26

12-27

12-25

**12-28,** Build clay around the lower half of the model up to the centerline and at least one inch out. Conventional wisdom says that slip casting molds should be one inch thick on all sides for best absorption. However, a three inch thick mold absorbs water at the same rate and therefore casts the same. The thickness will allow more casts to be made before the mold becomes too wet to work well. The only drawbacks are that the mold will weigh considerably more and take longer to dry out before reuse.

Set up a cottle, made of four pieces of wood, around the built-up clay. Tie or clamp the wooden pieces firmly together. Press coils of clay around the outside of the cottle to prevent plaster from leaking out. Be sure to soap the model and the cottle well before pouring the plaster. Calculate the volume of the mold, mix and pour the plaster.

When the mold has set, turn it over and remove all the clay. Cut at least three keys with no undercuts in the plaster. Set up the cottle again. Soap all surfaces very well. Pour the plaster.

When the plaster has set, carefully separate the two mold halves, and take out the model. Allow the mold to dry completely before any final scraping or sanding is done.

The mold is now ready for use. **12-29**

12-28

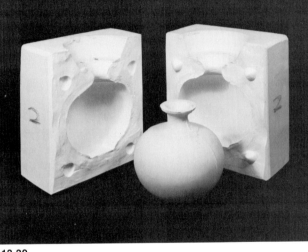

12-29

# CHAPTER 13 Slipcasting

## Preparing Casting Slip

It seems logical that to be able to pour clay into a mold it would need only to be thinned with water. This is not the case. To make clay thin enough to pour, about 100 percent by weight of water would have to be added. Not only would the mold be unable to absorb this much water but the clay particles would just clump together and settle to the bottom. This occurs because clay molecules, like those of all other materials, have positive and negative electronic charges. It is this phenomenon which holds these molecules together in whatever position they have been pushed by hand forming. To reduce the amount of water needed and to suspend the clay particles, a deflocculant must be added to the slip mixture. A deflocculant is an electrolyte which neutralizes the electronic charge in each clay particle, allowing it to float independently of other particles. If the clay particles are free to do this, considerably less water is needed to liquify the clay slip.

The two most widely used deflocculants are sodium silicate (water glass) and soda ash. Although they can be used separately, better results can be obtained by using them together in a combined amount not exceeding 1/2 to 1 percent of the total clay batch.

Because a good casting slip needs relatively little plasticity, larger amounts of less plastic kaolins can be used along with nonplastic fillers to reduce slip shrinkage and warping during drying and firing. Some clays, because of high iron or alkali content, will not make serviceable casting slips no matter how much deflocculant is added. Often, instead of formulating a separate casting body, it is possible to convert an existing throwing clay into a suitable casting slip. This allows greater freedom for design concept without measurably adding to the cost of raw materials.

A minimum batch of 500 grams of the claybody ingredients is dry mixed. Because most casting slips require only about 35 to 50 percent by weight of water, start by measuring 300 grams of water into a clean bowl. Slowly mix in the dry clay until the slip thickens. At this point, add 0.25 grams of soda ash along with 0.25 cc. of sodium silicate. (Note 1cc. sodium silicate weighs 1.3 grams) The slip should then become fluid. Dry clay, deflocculants, and more water are added by measure in this manner until all the clay has been mixed. Record the amounts of water and deflocculants used in the test to determine percentages needed for a larger batch. If the amount of water is much above 50 percent, the slip will probably not be satisfactory because of its high rate of shrinkage.

**13-1** Author
Vases
Slipcast porcelain, luster glaze
Left to right: 3$^1/_2$, 7 and 4″ (9, 18 and 10 cm) high

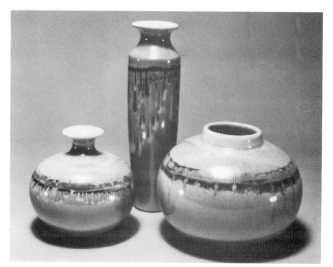

13-1

217

**13-2**  Marek Cecula
*Amphora* 1984
Slipcast porcelain
24 × 8″ (61 × 20 cm)
Photo: Bill Walter

**13-3**  Dorothy Hafner
*Floating Triangles Tea Set,* © 1984
Slipcast porcelain, underglaze
Teapot: 8¹/₂″ (22 cm) high
Photo: S. Baker Vail

**13-4**  Sandra Wyner
Coffeepot
Slipcast earthenware
8¹/₂ × 8 × 5¹/₂″ (22 × 20 × 14 cm)
Photo: Fred G. Hill

13-2

13-3

13-4

A simple test for fluidity is to stick a hand into the slip, withdraw it and spread the fingers apart. If the slip momentarily "webs" and then drains off smoothly, it is the proper consistency for casting. If the slip is too thick, stir in small amounts of water until the correct consistency is reached. If it is too thin, add more dry clay. Draining off water will draw away the deflocculants. The best test for quality is to pour the slip into a mold and note how well it builds up against the sides and how well it drains. The stiffened slip should easily come away from the mold and then dry with minimum warpage.

Larger batches of slip should be mixed thoroughly by hand or clay blunger and passed through a 60- to 80-mesh screen before use. Slip should be stored in airtight containers.

Dry casting scraps can be added to new batches of slip. This can possibly upset the delicate balance of deflocculant, so additions should remain under 10 percent of the total batch.

It is important to note that sodium silicate left to dry in the glass graduate will solidify and thicken the walls, giving inaccurate later readings. To prevent this, wash the glass with vinegar immediately after using.

Many good quality casting slips are prepared commercially. They are available in different colors and various firing temperatures.

Tests for pouring ability and fired quality should be performed before large quantities are purchased for use.

## Pouring the Slip

The slip casting procedure is fairly simple. Start by securing the mold halves together with rope, thick rubber bands, or commercial nylon straps with clips. An old tire tube can be cut into sturdy one- or two-inch wide rubber bands.

Stir the slip well and strain it through a 60-mesh sieve just before using to remove lumps. Pour the slip into the mold, filling it to the top of the reservoir.

As the mold absorbs the water from the slip, clay adheres to the inside of the mold and begins to form the wall of the object. After about five minutes, check the thickness of this wall by slightly tilting the mold and cutting into the adhered clay. When the wall has reached the desired thickness, pour out the remaining slip. Invert the mold over a container and allow the excess slip to drain. Check the mold in about three minutes. If the shine has gone from the clay, cut away the clay that has adhered to the sides of the reservoir and trim shelf.

Leave the form to set up in the mold for about twenty minutes. If the form is taken out of the mold too soon it will probably slump—either while it is drying, or when it is fired. If the form is left in the mold too long, it could become too dry and crack .

The times mentioned are only a general guide. The actual timing depends on the particular slip used and the condition of the mold. The wetter the mold is, the longer it will take to build up the correct wall thicknesses.

**13-5**  Shellie Z. Brooks
*Winged Vessel: Wings of a Junk*
Slipcast earthenware, handbuilt additions
10 × 9 × 3″ (25 × 23 × 8 cm)
Photo: Tom Lang

**13-6**  Peter Saenger
*White Tea Set*
Slipcast porcelain
6 × 8 × 8″ (15 × 20 × 20 cm)
Photo: Alice Sebrell

**13-7**  Victor Spinski
*V.W. Through the Wall — Fountain*
Slipcast low fire clay, stains,
    lusters, decals
8 × 12 × 4′ (2.4 × 3.7 × 1.2 m)

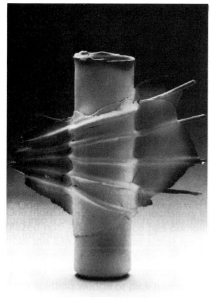

13-5

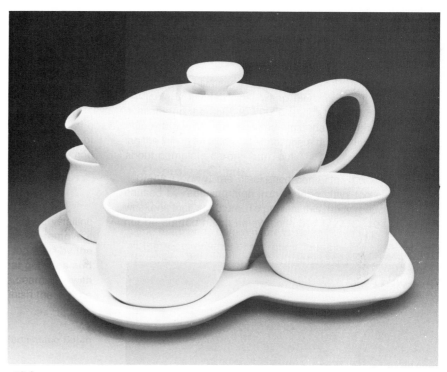

13-6

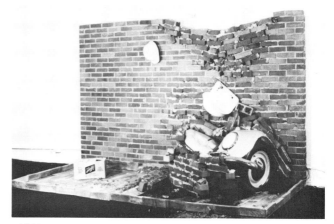

13-7

# CHAPTER 14 Marketing

Marketing ceramics is as complex as marketing in any other field. The following are notes on some basic aspects of marketing practices.

## Product

First it is necessary to decide what type of work is to be produced. Is it to be easily manufactured utilitarian ware, reasonably priced for rapid turnover? Will it be ware that is still utilitarian but individualized by special finishing effects and glazes which therefore demand a higher price? Or is it to be one-of-a-kind nonutilitarian objects which take longer to construct, are higher priced, and therefore appeal to a highly selective market?

Along with this decision, it is necessary to research the locale to discover whether the particular type of work is readily marketable. The artistic consciousness and monetary status of the community can play a large part in the successful marketing of a particular type of clay work. Handsomely fashioned candleholders might be snapped up by collectors in one area and yet remain on the shelves indefinitely in another. The same holds true for price. In some localities a style of casserole might sell for 35 to 40 dollars, whereas the same type in another place might bring less than 30 dollars.

## Outlets

The next step is to decide what type of sales outlet should be used. Should ware be sold directly from the studio, at a quality craft shop, in a department store, or through an exclusive gallery? Museums, craft associations, and other organizations often have well established sales outlets which take a small percentage of the sale price. They can be a valuable source of income but usually at a lower volume than a commercial establishment.

Although it may be possible to realize a greater profit by selling work directly from the studio, some important factors ought to be considered. Dealing directly with the public takes time away from production. During the half hour spent in conversation while selling a 10 dollar pot, a half dozen 20 dollar pots could be made. The added bookkeeping, selling, care of the display area, packing, shipping, and other duties of a retail sales operation might necessitate the hiring of additional help.

## Consignment

When dealing with retail outlets, work should be sold outright. Consignment selling can be a big headache. Virtually no other manufactured commodity is sold in this way. Somehow craftpeople have allowed themselves to become the financial benefactors of a great number of dealers. While it is true that a craftperson's percentage on the sale of consigned work may be higher than on work sold outright, 60 percent of nothing is much less than 50 percent of something. Suppose four different dealers each have 500 dollars worth of work in their stores for a period of three months and sell nothing. That amounts to 2000 dollars which has, in effect, been in limbo. It has not even earned the interest a bank gives for holding the same cash amount for that period of time. Further, it has cost the dealers nothing, and has given them no real motivation to push the work. On the other hand, had they purchased outright, the dealers would be much more strongly motivated to sell the wares in order to recoup their investment, and the craftsperson would have 1000 dollars to live on or put into further production.

Aside from not knowing which works are selling, months might pass before a craftperson receives payment for works that have been sold. In the event of loss or damage of a consigned work, a question can arise as to whose insurance covers the article, the craftperson's or the dealer's. There are other potential legal problems related to consignment. Suppose a dealer goes bankrupt or dies. All the creditors and heirs can rightfully assume that everything in the shop is owned by the dealer and is therefore part of the estate. Unless there are specific contracts to the contrary, the craftperson may be hard put to prove ownership of consigned items.

The only time a consignment agreement might be worthwhile is with an object that is large, experimental, or very expensive. In this case, while both dealer and craftperson could benefit from the exposure of the work, the dealer might not be in a position to buy. If the dealer is reputable and has purchased outright from the craftperson before, a special limited consignment arrangement could be written. This might state that the work would be shown for a period of, perhaps, 90 days with the dealer assuming full responsibility. If the object has not been sold by that time, the craftperson should remove the work, exchange it for another, or in some way end the particular agreement.

Under any other circumstances work should be sold outright.

The usual dealer's share is 50 percent of the list price. While this might at first seem high, when overhead, advertising and other requirements of operating a retail establishment are taken into consideration, the amount is not unreasonable.

## Discounts

Discounts should be avoided in most cases. If discounts are offered to friends or prices are lower in the studio than in a retail outlet elsewhere, problems can arise. If a dealer discovers that a craftperson is underselling to any extent, it is fairly certain that the dealer will not reorder from that individual. If the public finds out that some buyers are getting discounts, they will all rightfully expect similar treatment. Although discounts may guarantee immediate capital, over the long run the practice can harm a craftperson's reputation for integrity.

The only discounts that should be considered are the legitimate wholesale discounts for dealers, usually 50 percent; a trade discount for architects and designers, usually 30 to 40 percent; and a 1 or 2 percent discount on merchandise payments received within ten days of billing (rarely offered anymore). An individual who purchases a large number of works at one time totalling more than an amount predetermined by the craftperson may be entitled to a discount of up to 10 percent. Any other discounts may actually be illegal according to the Robinson-Patman Act, Federal legislation designed to prevent unfair price discrimination.

## Craft Fairs

At this point a few words need to be said about the craft fair. Taken at face value it can be a great advantage to many people. The craftperson can set up a display, have a happy few days, make some quick money, and go home. However, more often than not, the craftperson is the one who benefits least. A fair is usually run primarily as a money making proposition for its operators. The general public often regards a fair as a vast sideshow and bargain hunting event. This attitude is unfortunately perpetuated by some craftpeople who lower their prices or bring second rate work for quick sale. An individual who offers high quality work and demands a fair price often does not sell well. Good work shown alongside inferior work tends to look as poor.

Can a profit really be made at a craft fair? The time spent packing, traveling to the fair, unpacking, setting up a display, repacking, and returning to the studio should be taken into account. If the money generated by sales at the fair favorably offsets the lost production time, then showing at a fair should receive active consideration.

This is not to say that all craft fairs are bad. Many have earned well deserved reputations for quality and have been in successful operation for years. A few facts should be ascertained before undertaking the venture: previous average sales; volume of traffic; how it is financed, whether by admission fees, entry fees or percentage of sales; how well it is advertised; and if it is for professionals or hobbyists. These factors can help decide if it is worthwhile to enter.

## Trade Shows

Trade shows or "wholesale only" expositions, while having been around for years in other fields, are relatively new in the arena of crafts. The major difference between trade shows and craft fairs is the clientele. Trade shows are open only to those people involved in selling to the public—shops, galleries, dealers, museums, interior designers and decorators, architects, and the like.

Although fewer people attend such a show, the potential for sales is greater than at a craft fair. Wholesalers are generally interested in ordering or buying larger quantities of work at one time. This is a key consideration when thinking about entering a trade show. Can enough finished ware be produced in time for the buyers' deadlines?

Another important difference between the two types of shows is pricing: wholesalers are interested only in wholesale prices. Therefore if each work is marked with a retail price, it should be made plain to buyers through signs and in discussion that works are discounted at 50 percent. It is sometimes simpler to have works marked at wholesale to prevent confusion.

Because those attending a trade show are generally more knowledgeable about crafts and have a different attitude about what they see (Will it sell?), it is very important to be ready to answer any question asked about techniques, prices, delivery times, terms of payment, reorders, and so forth. In other words, if business sense does not come easily, think twice about becoming involved with trade shows. However, with a good mind for business and, of course, a good product, one or two successful trade shows could provide a year's worth of production and a good profit.

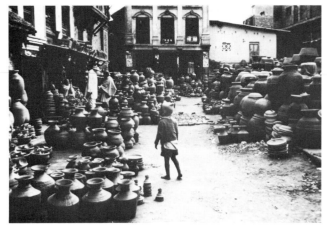

**14-1**

## Pricing

A number of different factors should be taken into consideration when establishing the list price of an object. It is essential, therefore, that accurate records be kept of all expenses. First, the cost of operating a studio should be determined. Find out what the yearly costs are for electricity, heat, telephone, rent, insurance and taxes. Determine the total cost of all materials and how much it costs to fire the kiln.

A personal living wage must be established. Wages for any assistants and the salary or commission of any salespeople or agents must also be included. Decide how much to pay someone who works on a wheel. If it is 10 or 15 dollars an hour, this should be figured into the studio operating cost.

The time that it takes to make an object—to trim, dry, bisque fire, glaze and glaze fire—must be taken into account as well.

Inventory, handling, packing, shipping, equipment depreciation, advertising and promotion must also be included in production costs.

Add all of these figures together to arrive at the total operating cost for a year. Break this down into an hourly production rate. Determine the time it takes to produce a certain object and multiply this by the hourly production figure to derive the actual cost of production.

At this point, the figure shows only the expense encountered to make an item with no profit margin. A reasonable profit for hand produced work is 100 percent of the production cost. This is added to the production cost to get the wholesale cost of an item. The list price, or fair market price, is twice the wholesale price.

The price of most claywork can be figured in this way. However, artistic merit should not be disregarded. If a work has an exceptionally fine glaze, or if the form has a unique appearance, more money can be included in the list price. One-of-a-kind objects often demand higher prices. The reputation of the craftperson can also warrant increased prices.

Competitive prices are also a determining factor in the list price of an object. In a certain area, if a six-inch hanging planter will sell within a 10 to 20 dollar price range, a similar planter priced at 40 dollars probably will not sell.

Even with all of this accounting, a periodic review and revision of prices should occur. The price of work offered for sale should be adjusted to reflect any increase in the cost of materials and production expenses as well as any national cost of living changes. Increased demand for a craftperson's work is also a legitimate call for an increase in prices.

A great deal of confusion can be dispelled if the price shown on the tag of an object is stated as its list price. It then is a simple matter for legitimate buyers to multiply this by their approximate wholesale, trade, or special discount to find their wholesale price. The general public also knows immediately how much the item will cost.

Fearful of lack of sales, many newcomers to the craft market, and even some experienced craftspeople, tend to underprice their ware. Not only can this reduce profit, but it may actually inhibit sales. Seeing a vase priced less than might be anticipated, a knowledgeable collector might wonder if the work is made of inferior materials, if there are hidden cracks, or if it is a copy. An impression of poor quality is immediately conveyed.

Once a price has been set, do not modify it under pressure. Too many craftpeople waver, and they lower prices on demand from potential buyers. Be polite, but be firm. Hedging on a price will only spur demand for lower prices on all items in stock, and shortly the entire operation can become a losing proposition. There is no need to be embarrassed by holding to the price a piece deserves, nor any reason why craftspeople should have less pride in their product than any other manufacturers. If a particular technique is used, it should be pointed out. The buyer should be made to understand that the handcrafted work has individual qualities which make it special.

## Information Cards

An increasing number of professional craftworkers have prepared information cards to be given with each work purchased. The card usually has the maker's name, logo, address, and telephone, along with a concise explanation about the materials and methods used to create the work. Instructions for care and use are often included as well.

## Criticism

Try not to take criticism personally. It can be very difficult to have an object turned down by someone who is divorced from the time, effort, and loving care involved in its creation. If selling is important, however, distance must be maintained between the object and the craftperson. If well designed and executed, a work will stand on its own merit and a craftperson can ask and receive a fair market price.

# Dictionary of Ceramic Terms

**absorption** The capacity of a material to soak up liquid.

**acid** One of three types of compound that constitute a glaze, the other two being basic and neutral, or amphoteric. The acid group is symbolized by the radical $RO_2$.

**adsorption** The collecting of liquid on a surface by condensation.

**aeolian** Wind-blown.

**agate ware** Ceramic objects made to resemble marble by combining layers of different colored clays.

**air-floated** Refers to powders whose particles have been separated by weight by exposure to a stream of air.

**alkalies** Base compounds of sodium, potassium and the alkaline earths. Functioning as fluxes, they combine with and lower the fusion point of silica at relatively low temperatures.

**amorphous** Without specific form. In chemistry, having no crystalline structure.

**amphoteric** Chemically neutral. Can function as an acid or a base.

**armature** A framework around which clay can be modeled.

**aventurine** A low temperature, high lead glaze with excess iron which produces tiny red/gold crystals when fired.

**baffle** A wall or barrier made of refractory materials which directs the flow of heat and flame in a fuel kiln.

**bag wall** *See baffle.*

**ball mill** A jar filled with carborundum chips which, when rotated, will blend or grind glaze or clay body ingredients.

**banding** A method of applying a glaze or slip decoration by holding a brush tip against a rotating pot.

**banding wheel.** *See bench wheel.*

**basalt ware** or **basaltes** Black, unglazed stoneware developed in 1772 by the Wedgewood potteries in England.

**bas-relief** Raised or indented patterns which remain close to the surface plane.

**bat** A disk or slab of plaster or other material used for drying clay or supporting clay forms while being worked.

**batch** The ingredients of a glaze formula weighed in correct proportions for a specific blend.

**bench wheel** A portable turntable for rotating pottery being formed, decorated or otherwise worked.

**binder** A substance used prior to firing to increase glaze adherence or greenware strength.

**bisque** or **bisquit** Clay which has been fired once, unglazed.

**bisque fire** First firing of a clay to drive out chemically combined water and carbonaceous materials prior to glazing.

**bitstone** Coarse silica sand used in saggars to support thin porcelain ware during firing.

**blistering** Air bubbles appearing in a glaze after fast firing.

**blowhole** An opening at or near the top of a kiln which facilitates steam escape or cooling.

**blowout** The explosion of clay in the kiln caused by the sudden escape of steam resulting from rapid heating or the presence of impurities.

**blunge** To mix clay or glaze with water to form a liquid suspension.

**blunger** A machine with rotating arms used to mix large quantities of clay slip or glaze.

**bone china** A creamy, transparent, English soft porcelain fluxed with ash from animal bone.

**bone dry** The condition of unfired clay that has no absorbed moisture other than natural humidity.

**bottle kiln** An updraft kiln in the shape of a tapering bottle, commonly found in Europe.

**b.t.u.** British thermal unit. The amount of heat needed to raise one pound of water one degree Fahrenheit.

**burnish** Using a smooth object to polish the surface of leather-hard clay.

**calcine** To heat to the temperature necessary to drive off the chemically combined water, carbon dioxide and other volatile gases.

**calorie** Metric unit of heat. The amount of heat necessary to raise one gram of water one degree centigrade.

**carving** Decorating by cutting into the clay surface.

**castable** A mixture of sand, cement and refractory materials used to make kiln walls and kiln furniture.

**casting** or **slip casting** A process of forming a clay object by pouring clay slip into a hollow plaster mold.

**catalyst** A substance which causes or accelerates chemical change.

**celadon** French name for jade-like green colors derived from iron bearing reduction glazes.

**chemically combined water** The water chemically bound to alumina and silica in clay molecules.

**china** Whiteware clay bodies glazed at a lower temperature than that at which they are bisqued.

**china clay** See *kaolin*. A white firing, highly refractory primary clay.

**chuck** A form *in* which ware is placed for stability during trimmings.

**chum** A form *on* which ware is placed for stability during trimming.

**chun glaze** A milky blue, opalescent, high temperature reduction glaze developed in fourteenth century China.

**clay** A compound of decomposed and altered feldspathic rock consisting of various hydrated silicates of aluminum along with non-plastics, such as quartz, and organic matter.

**coefficient of expansion** The percentage of change in length or volume per unit of change in temperature of a material.

**coil** Rope-like roll of clay used in hand building.

**collaring** or **necking** A method of narrowing the neck of a pot by squeezing in with the fingers as the pot revolves on the potter's wheel.

**colloid** A gelatinous, homogenous substance.

**colluvial clay** Clean aggregate of washed rock sediment at the parent site. See *primary clay*.

**combing** or **feathering** Decorating by gently drawing a coarse comb or feathertip through contrasting rows of wet clay slip or glaze.

**cone** or **pyrometric cone** A small triangular pyramid made of ceramic materials that are compounded to bend and melt at specific temperatures. The cone serves as a time-temperature indicator of heat work in a kiln.

**cottle** or **coddle** Any smooth flexible material, such as vinyl or galvanized sheet metal, which can be used to contain plaster when making a mold.

**crackle glaze** A glaze developing minute cracks which are considered decorative and are often accentuated by rubbed-in coloring material.

**crawling** Separating of the glaze coat during firing, exposing areas of unglazed clay.

**crazing** The undesirable formation of a network of cracks in the glaze caused by uneven clay or glaze contraction.

**crystalline glaze** Characterized by macrocrystal clusters embedded in opaque glaze.

**damp box** A cabinet in which unfinished clay objects are stored to retard their drying.

**damper** A device used to adjust the draft in a fuel kiln by opening or closing the flue.

**de-air** To remove air from clay.

**decal** or **decalcomania** Transfer print generally applied onto glaze fired ware and fired at a low temperature.

**defloculant** A substance used to bring about better suspension of a material in a liquid by neutralizing the electronic charge of its particles.

**deflocculate** To evenly disperse particles throughout a liquid.

**delft ware** Earthenware clay objects coated with a lead-tin glaze which usually have a blue overglaze decoration. Developed in Holland during the seventeenth century in imitation of Chinese porcelain.

**della robbia ware** Ceramic sculpture or relief plaques of glazed terra cotta, produced in Florence by the family of Lucca della Robbia during the fifteenth century.

**devitrification** The loss of gloss due to recrystallization of a glaze upon cooling.

**dipping** Coating pottery by immersing it in slip or glaze.

**dissociation point** The temperature at which a substance decomposes into its constituent parts.

**draw trial** A sample taken from the kiln as it is being fired to gauge the progress of the firing.

**dry foot** The bottom of a pot which has been cleaned of all glaze before firing.

**dunting** Cracking of fired ware in a kiln which has cooled too rapidly.

**earthenware** Clay that matures at a low temperature but remains porous.

**effervesce** To give off gas bubbles.

**efflorescence** Dry or crystallized white scum occuring on the surface of fired ware caused by unneutralized soluble salts.

**eggshell porcelain** Porcelain with walls so thin that it is translucent.

**egyptian paste** Low-fire self-glazing porous clay developed in ancient Egypt.

**electrolyte** A deflocculating agent. An electrical conductor which dissociates into ions in a suitable medium.

**elements** High resistance wire coils or bars used as the heat source in an electric kiln.

**emboss** To decorate a surface with raised ornamentation.

**empirical formula** See *molecular formula*.

**engobe** A slurry of glaze materials used as decoration on green or bisque ware.

**equivalent weight** See *mole*.

**eutectic** The lowest melting point of a mixture of materials, usually below the melting points of the individual materials.

**extrusion** The process of making shapes by forcing clay through a die.

**faïence** French term for tin-glazed earthenware first made at Faenza, Italy, during the fifteenth century, in imitation of Spanish majolica.

**fat clay** A very plastic clay.

**feathering** See *combing*.

**feldspar** A common mineral found in most igneous rocks from which some clay and glaze materials are derived.

**fettle** or **fettling** To finish or smooth the surface of leather-hard clay. Also to trim the excess clay from cast ware.

**filler** A material with little or no plasticity used to promote drying and reduce shrinkage of clay bodies or engobes.

**filter press** A machine which removes the excess water from clay slip by pressure to make it into plastic clay.

**firebox** A combustion chamber of a gas, oil or wood-fired kiln directly below or beside the ware chamber.

**firebrick** A refractory insulation brick.

**fireclay** A clay used in clay bodies for its heat-resistant quality. Also used in the manufacture of kilns and other refractory equipment.

**firing** The heating of clay or glaze to a specific temperature.

**fit** The correct adjustment of a glaze to a clay body.

**flaking** The peeling off of a glaze or slip from a clay surface.

**flashing** Flame touching a pot in the kiln or the resultant color change of clay or glaze.

**flocculate** To cause the aggregation of clay particles.

**flocs** Thin, plate-like oval crystals of a clay molecule.

**flue** The space around the ware chamber of a kiln through which heating gases pass from the firebox to the chimney.

**flux** A substance which promotes the melting of silica in a glaze.

**foot** The base of a ceramic piece.

**frit** A mixture of glaze materials that is fused and then reground to eliminate toxic effects or solubility of the raw materials.

**fusion point** The temperature at which a clay or glaze material melts.

**galena** European term for lead sulfide (PbS), formerly used in low temperature glazes.

**glaze** A glass-like coating fusion bonded to a ceramic surface by heat.

**glaze fire** A cycle during which glaze materials are heated sufficiently to melt and form a glassy surface coating when cooled.

**glost fire** Another term for glaze fire.

**greenware** Unfired clay objects.

**grés** French term for stoneware.

**grog** Fired clay that has been crushed into granules which may be added to a clay body to increase strength, control drying and reduce shrinkage.

**grout** Mortar or similar compounds used to consolidate objects by filling spaces between them.

**gum** A natural gum, such as gum arabic or gum tragacanth, which is used as a binder in glaze to promote better adherence to clay.

**hakeme** Japanese for "brush grain." A decorating technique of applying an engobe with a stiff broom-like brush.

**hard paste** A hard, white translucent clay body fired to cone 12 or above; a true porcelain.

**hare's fur** See *temmoku*.

**high relief** A strongly raised or deeply carved patter.

**hydrometer** An instrument for determining the specific gravity of a liquid.

**igneous** Produced under conditions which involve intense heat.

**impressing** Method of decorating by stamping into a clay surface.

**incising** Engraving a decoration into unfired clay.

**ironstone china** A term for certain mid-temperature soft paste porcelains manufactured in the United States during the eighteenth and early nineteenth centuries.

**jiggering** An industrial method of forming a pot on a revolving mold which shapes the inside while a template makes the outside contour.

**jollying** The reverse system of jiggering. A method of forming a pot between a revolving mold which shapes the outside and a template which shapes the inside.

**kanthal** A high resistance metal alloy used in the manufacture of heating elements for electric kilns.

**kaolin** See *china clay*. The anglicized form of the Chinese term for clay. Kao-Lin, meaning "high hill," probably refers to Kaoling, the mountain in China where this white clay was first discovered.

**kaolinize** The natural conversion by weathering of feldspar into clay.

**kiln** A furnace for calcining or firing ceramic products.

**kiln furniture** Refractory shelves, posts and other equipment placed in a kiln to hold ware during firing.

**kiln wash** A refractory mixture, usually of kaolin and flint, which is applied to the kiln shelves and floor to prevent fired glaze from adhering to them.

**kneading** Working clay on a surface with the palms of the hands in order to remove air from it and obtain a uniform consistency.

**lag** To provide additional insulation for the outside of a kiln.

**lamellate** See *flocs*. The microscopic plate-like formation which is characteristic of plastic clay.

**leather-hard** The condition of raw clay ware when most of the moisture has evaporated leaving it still soft enough to be carved or joined to other pieces.

**levigation** Refining dry clay by grinding with or without water.

**LOI** Loss on ignition. Amount of materials burned off during heating.

**long** Very fat or plastic clay.

**luster** A type of metallic decoration applied to a glazed surface and then refired to a temperature just high enough to melt and fuse the metal to the glaze.

**luting** Joining leather-hard or dry clay with slip or vinegar.

**majolica** See *faïence*. Earthenware fired with a tin-lead glaze and decorated with a luster overglaze. The name derives from Majorca, the island where it purportedly was originated.

**marl** Clay which contains a considerable amount of lime.

**matt** The nonglossy surface quality of a completely fired glaze.

**maturity** The firing point at which glaze ingredients have reached complete fusion or when clay has reached maximum non-porosity and hardness.

**mealy** Crumbly, nonplastic, powdery, dry.

**mishima** A Japanese decorating method of filling a design impressed in clay with a different colored clay slip.

**mold** A plaster or bisqued clay shape from which a clay form can be reproduced.

**mole** The weight of a raw material needed in a glaze to give one molecule of an oxide when fired.

**molecular formula** A glaze formula expressing the relative proportions of its constituent compounds.

**muffle** The inner lining of a kiln which prevents flame from directly touching the ware.

**muller** A grinding machine with rollers used to prepare large batches of clay.

**neat cement** A mixture of calcined clay and limestone without sand or other aggregate.

**necking** See *collaring*.

**neriage** or **nerikomi** A Japanese decorating technique of marbling or mosaic using colored clays.

**neutral atmosphere.** An atmosphere in a kiln between reduction and oxidation. This is only theoretically possible in a fuel kiln, but is the actual atmosphere present in an electric kiln where there is no flame.

**oil spots** See *temmoku.*

**once fire** or **single fire** A slow firing cycle which combines both bisque and glaze firings.

**open** A clay body that is porous in structure because of grain size, fillers or grog.

**open firing** A firing in which the flame touches the ware directly.

**opacifier** A substance whose small particles are relatively insoluable in a glaze. The reflectivity of these particles prevents light from penetrating the glass formation.

**overglaze** Glaze decoration applied on the surface of a fired glaze, which is then refired.

**overglaze colors** Colors containing coloring oxides or ceramic stains, flux and a binder used to decorate fired ware.

**oxide** A compound containing oxygen and other elements. Sometimes refers to metallic chemicals used for coloring clays or glazes.

**oxidation fire** A fire during which the kiln chamber retains an ample supply of oxygen.

**parian ware** A soft paste, unglazed porcelain developed in England during the nineteenth century in imitation of Greek white marble.

**paste** European term for a white clay body.

**pâte-sur-pâte** A method of decoration which consists of building up a low relief with repeated layers of engobe. From the French, meaning "paste on paste."

**peach bloom** A Chinese copper-red reduction glaze with a peach-like pink color.

**peeling** Separation of the fired glaze or slip from a clay surface because the clay has contracted more than the glaze.

**petuntze** A partially decomposed feldspathic rock found in China. Used in glaze and in porcelain clay bodies.

**pH** The measure of the relative alkalinity or acidity of a solution.

**pins** Refractory supports used to place ware in racks or saggars for firing.

**plaster of paris** Calcined hydrated calcium sulfate, or gypsum, used in ceramics to make molds and bats.

**plasticity** The quality of clay that allows it to be easily manipulated and still maintain its shape.

**porcelain** A strong, vitreous, translucent, white clay body that matures at cone 12 or above.

**porosity** The capacity of a clay body to absorb moisture.

**pressing** The forming of clay objects by squeezing soft clay between two halves of a mold.

**primary clay** Clay found at the original site where it was formed by decomposing rock.

**pug** To mix clay with water to make it plastic.

**pug mill** A machine with a paddle gear for grinding and mixing plastic clay.

**pyrometer** A bi-metallic strip which translates heat energy into electrical energy used to indicate the temperature in a kiln. Optical pyrometers perform the same function but use color as the indicator.

**pyrometric cone** See *cone.*

**raku** A technique of rapidly firing low temperature glazed bisque ware. Raku means "enjoyment of leisure" or "contentment" and was the method used to make bowls for the Japanese tea ceremony.

**raw** Unfired, in a natural state.

**red heat** The firing temperature at which the interior of a kiln begins to glow.

**reduction fire** A fire in which the supply of oxygen is inadequate to promote complete combustion. The carbon monoxide thus formed combines with oxygen from clay and glazes, altering their colors.

**refractory** The quality of resistance to high temperatures. Also, high alumina-silica material used in the manufacture of kiln furniture and interiors.

**residual clay** See *primary clay.*

**rib** A hand held tool made of hard material used to shape a pot when throwing.

**rouge flambé** A Chinese copper-red reduction glaze. From the French, meaning "burnt red."

**saddles** Refractory props used between plates when stacked on edge in a kiln.

**saggar** or **sagger** A fireclay box which protects ware from flame and combustion gases during firing.

**sagging** The slumping of a form while the plastic clay is still soft.

**salt glaze** To glaze raw ware by vapors from common salt introduced into the kiln during firing.

**sang de boeuf** A Chinese copper-red reduction glaze. From the French, meaning "oxblood."

**scaling** Flaking or peeling of glaze.

**secondary clay** Clay that has been transported from its original site by water, air or ice and deposited in layers elsewhere.

**sedimentary clay**  See *secondary clay.*

**sgraffito**  A decorative process by which a line is scratched through a layer of slip or glaze before firing to expose the clay body beneath. From the Italian, meaning "scratched out."

**shard** or **sherd**  A fragment of pottery.

**short**  Clay that is nonplastic and breaks or crumbles easily.

**shrinkage**  Contraction of the clay or glaze in either drying or firing.

**siccative**  A substance which promotes the drying of oils used in underglazes or overglazes.

**single fire**  See *once fire.*

**sinter**  To fire to the point where materials fuse sufficiently to form a solid mass upon cooling, but are not vitrified.

**size** or **sizing**  A solution used to prevent poured plaster from adhering to a surface.

**slake**  To pour dry material into liquid and allow it to absorb the liquid to its fullest capacity.

**slip**  A suspension of clay or glaze materials in water.

**slip clay**  A clay, such as Albany or Blackbird, containing sufficient flux to become a glaze when fired to high temperatures.

**slip glaze**  A glaze made chiefly from clay.

**slip trailing**  A decorating method which uses a syringe to apply slip to a clay surface.

**slurry**  A creamy mixture of clay and water.

**soak**  To maintain the kiln at a particular temperature for a period of time.

**soap**  A brick cut in half lengthwise to dimensions of $9'' \times 2^1/_2'' \times 2^1/_4''$.

**soft paste**  A mixture of white firing clays and ground glass frit which matures at about cone 05.

**soluble**  Capable of being dissolved in liquid.

**spall**  To chip or splinter off.

**spare**  The excess clay which is trimmed off castware.

**spinel**  Chemically, magnesium aluminate $(MgO \cdot Al_2O_3)$. In ceramics the term designates a large group of coloring materials with the formula $RO \cdot R_2O_3$.

**sprig**  A mold-made ornament of plastic clay applied to a clay surface to form a relief decoration.

**spurs**  Triangular refractory supports which keep glazed ware from touching kiln shelves during firing.

**spy hole**  The opening in a kiln wall or door through which cones may be viewed during firing. Can also act as a steam vent during the early stages of firing.

**stacking**  Efficient loading of a kiln with the maximum amount of ware.

**stain**  A prepared calcined pigment used to color clay bodies or glazes.

**stilt**  A ceramic tripod used to support glazed ware in a kiln during firing.

**stoneware**  A grey to buff, nontranslucent clay body which matures between cones 6 and 10.

**temmoku**  A rich purple-black Japanese glaze which may develop brownish "hare's fur" streaks or metallic "oil spots." The name comes from Tien-mu-Shan, "Mountain of the Eye of Heaven," a mountain in Chichiang province, China.

**template**  A pattern placed against a clay form as a guide in shaping.

**terra cotta**  A brownish-orange earthenware clay body, commonly used for ceramic sculpture or architectural ornament. From the Italian, meaning "baked earth."

**terra sigillata**  Originally referred to Roman stamped ware, or Arretine ware. Has come to mean the thin slip coating on Roman and Greek ware. Made of fine particles of decanted clay, it is applied thinly over a clay surface and then fired to a low temperature. From the Italian, meaning "stamped earth."

**thixotropic**  The property of becoming fluid when stirred or shaken. Can be induced by excess deflocculation in certain clays, allowing them to become elastic.

**throw** or **throwing**  Using the potter's wheel to make forms by hand from plastic clay.

**throwing stick**  Long-handled spoon-shaped stick for shaping interior of tall narrow wheel thrown forms.

**tin-enamel**  A lead glaze opacified by tin oxide.

**tooth**  The quality of roughness in clay caused by its coarse grain structure or the addition of grog or other fillers.

**trailing**  See *slip trailing.*

**translucency**  The ability to transmit a diffused light.

**trimming**  A method of paring away excess clay, usually from the bottom of a pot to form a foot, while the clay is leather-hard.

**turning**  See *trimming.*

**undercut**  The inward slant of a mold which can prevent clay from being released.

**underglaze**  A colored decoration applied on raw or bisque ware before the glaze is applied.

**vapor glaze**  To glaze raw ware by introducing soluable chemicals into the kiln during firing. See *salt glaze.*

**viscosity**  The property of a liquid to resist movement.

**vitreous**  The hard, glassy and nonabsorbent quality of a clay body or glaze.

**vitrify** or **vitrification**  To fire to the temperature at which a clay or glaze attains its mature, hard, glass-like quality.

**volatilize**  To pass off as a vapor.

**warping**  Distortion of a clay shape caused by uneven stresses during shaping, drying or firing.

**water glass**  The liquid solution of sodium silicate used as a deflocculant.

**water smoking**  An early stage of a firing during which the chemically combined water evaporates from the clay.

**wax resist** Wax emulsion or melted wax which is used to prevent slips or glazes from adhering to a clay surface. Can also be used to retard the drying of leather-hard ware.

**weathering** The exposure of raw clay to the natural elements which break down the particle size and render the clay more plastic.

**wedge** or **wedging** Mixing and de-airing clay by cutting it diagonally and slamming the pieces together.

**welding** Joining pieces of soft or leather hard clay.

**wet firing** A process by which freshly formed clay objects can be fired immediately without pre-drying.

**whiteware** Ware made from a white or light cream-colored clay body, usually fired to a low temperature.

# Bibliography

## Methods

Ball, F. Carlton and Lovoos, Janet. *Making Pottery Without a Wheel.* New York: Van Nostrand Reinhold Company, 1965, 159 p. illus.

Berensohn, Paulus. *Finding One's Way With Clay: Pinched Pottery and the Color of Clay.* New York: Fireside Book, 1987, 162 p. illus.

Chaney, Charles and Skee, Stanley. *Plaster Mold and Model Making.* New York: Van Nostrand Reinhold Company, 1973, 144 p. illus.

Conrad, John W. *Contemporary Ceramic Techniques.* Englewood Cliffs, New Jersey: Prentice-Hall, Inc., 1979, 180 p. illus.

Counts, Charles. *Pottery Workshop.* New York: Macmillan Publishing Company, Inc., 1976, 198 p. illus.

Dickerson, John. *Raku Handbook.* New York: Van Nostrand Reinhold Company, 1972, 112 p. illus. *

Fox, James. "Dry Throwing," *Ceramics Monthly,* vol. 21, no. 8 (October, 1973, pp. 22-26.

Green, David. *Pottery: Materials and Techniques.* New York: Frederick A. Praeger, Publishers, 1967, 148 p. illus. *

Hamilton, David. *Architectural Ceramics.* London: Thames and Hudson, 1978, 184 p. illus.

Kenny, John B. *Ceramic Design.* Radnor, Pennsylvania: Chilton Company, 1963, 322 p. illus.

Leach, Bernard. *A Potter's Book.* 8th American edition. Hollywood-by-the-Sea, Florida: Transatlantic Arts, Inc., 1960, 294 p. illus.

Nelson, Glenn C. *Ceramics: A Potter's Handbook.* 5th edition. New York: Holt, Rinehart and Winston, Inc., 1983, 360 p. illus.

Nigrosh, Leon I. *Low Fire: Other Ways to Work in Clay.* Worcester, Massachusetts, David Publications, Inc., 1980, 102 p. illus.

Parks, Dennis. *A Potter's Guide to Raw Glazing and Oil Firing.* New York: Charles Scribner's Sons, 1980, 118 p. illus.

Peipenburg, Robert. *Raku Pottery.* New York: Macmillan Publishing Comapny, 1972, 159 p. illus. *

Sanders, Herbert H. and Tomimoto, Kenkichi. *The World of Japanese Ceramics.* Tokyo: Kodansha International Limited, 1983, 267 p. illus.

Trevor, Henry. *Pottery Step-by-Step.* New York: Watson-Guptill Publications, 1966, 127 p. illus. *

Troy, Jack. *Salt-Glazed Ceramics.* New York: Watson-Guptill Publications, 1977, 160 p. illus.

Tyler, Christopher and Hirsch, Richard. *Raku.* New York: Watson-Guptill Publications, 1975, 176 p. illus.

Young, Joseph. *Mosaics: Principles and Practice.* Van Nostrand Reinhold Company, 1963, 128 p. illus.

## Materials Information

Andrew, A.I. *Ceramic Tests and Calculations,* New York: John Wiley and Sons, Inc., 1928, 172 p. *

*Ceramic Glazes as a Factor in Lead Poisoning.* Prepared for the Department of Consumer and Corporate Affairs, Canada, by J. R. Hickman. Issued by Hazardous Products Division, Standards Branch (March, 1971), 3 p.

*Ceramic Industry,* vol. 122, no. 1 (January, 1984, 138 p.

*Facts About Lead Glazes for Art Potters and Hobbyists.* New York: Lead Industries Association, Inc., 1971, 12 p. illus.

Grebanier, Joseph. *Chinese Stoneware Glazes.* New York: Watson-Guptill Publications, 1975, 144 p. illus.

Green, David. *Pottery Glazes.* New York: Watson-Guptill Publications, 1973, 144 p. illus.

Lawrence, W. G. *Ceramic Science for the Potter.* 2nd edition. Radnor, Pennsylvania: Chilton Book Company, 1982, 239 p. illus.

*Lead in Glazes.* Prepared for the Department of Consumer and Corporate Affairs, Canada, by K. E. Bell. Issued by Hazardous Products Division, Standards Branch (March 1971), 3 p.

McKee, Charles. *Ceramics Handbook: A Guide to Glaze Calculation, Materials, and Processes.* Belmont, California: Star Publishing Company, 1984, 160 p. illus.

Norton, Fredrick H. *Ceramics for the Artist Potter.* Reading, Massachusetts: Addison-Wesley Publishing Company, 1956, 320 p. illus.

—————. *Elements of Ceramics.* 2nd edition. Reading, Massachusetts: Addison-Wesley Publishing Company, 1974, 312 p. illus.

Parmelee, Cullen W. *Ceramic Glazes.* 3rd edition. Revised by Cameron G. Harman. Boston, Massachusetts: Cahner's Books, 1973, 624 p.

Rhodes, Daniel. *Clay and Glazes for the Potter.* Revised edition. Radnor, Pennsylvania: Chilton Book Company, 1973, 330 p. illus.

—————. *Stoneware and Porcelain: The Art of High-Fired Pottery.* Radnor, Pennsylvania: Chilton Book Company, 1959, 217 p. illus.

Shaw, Kenneth. *Ceramic Colors and Pottery Decoration.* New York: Frederick A. Praeger, Publishers, 1962, 189 p. illus. *

## Toxicology

Alexander, William. "Ceramic Toxicology," *Studio Potter,* (Winter, 1973-74), pp. 8-12.

Barazani, Gail. *Ceramics Health Hazards: Occupational Safety and Health for Artists and Craftsmen.* Revised. Boscobel, Wisconsin: Art-Safe, Inc., 1984, 20 p.

Seeger, Nancy. *A Ceramist's Guide to the Safe Use of Materials.* Chicago: The Art Institute of Chicago, 1982, 44p.

## Kiln Construction

Colson, Frank. *Kiln Building with Space Age Materials.* New York: Van Nostrand Reinhold Company, 1975, 128 p. illus.

Fraser, Harry. *Electric Kilns.* New York: Watson-Guptill Publications, 1974, 144 p. illus.

Harvey, Roger and Kolb, Sylvia and John. *Building Pottery Equipment.* New York: Watson-Guptill Publications, 1975, 208 p. illus.

Olsen, Frederick L. *The Kiln Book.* 2nd edition. Radnor, Pennsylvania, Chilton Book Company, 1983, 292 p. illus.

Rhodes, Daniel. *Kilns: Design, Construction and Operation.* 2nd edition. Radnor, Pennsylvania: Chilton Book Company, 1980, 256 p. illus.

Soldner, Paul. *Kiln Construction.* New York: American Crafts Council, 1965, 32 p. illus. *

## Design and Philosophy

Clark, Garth, ed. *Ceramic Art: Comment and Review 1882-1977,* New York: E. P. Dutton, 1978, 198 p. illus.

Collier, Graham. *Form, Space and Vision.* 3rd edition. Englewood Cliffs, New Jersey: Prentice-Hall, Inc., 1972, 304 p. illus.

Feininger, Andreas. *Forms of Nature and Life.* New York: Viking Press, 1966, 172 p. illus. *

Grillo, Paul Jaques. *Form, Function and Design.* New York: Dover Publications, Inc., 1975, 238 p. illus.

Hatterer, Lawrence J. *The Artist in Society.* New York: Grove Press, Inc., 1965, 188 p.*

Kepes, Gyorgy, ed. *Vision and Value Series.* New York: George Braziller, 1965, 6 vols. illus. *

Knobler, Nathan. *The Visual Dialogue.* New York: Holt, Rinehart and Winston, Inc., 1966, 342 p. illus. *

Krantz, Stewart and Fisher, Robert. *The Design Continuum.* New York: Van Nostrand Reinhold Company, 1966, 151 p. illus. *

Leach, Bernard. *A Potter in Japan.* London: Faber and Faber, 1960, 246 p. illus.

Neutra, Richard. *Survival Through Design.* London: Oxford University Press, 1969, 384 p.

Papanek, Victor. *Design for the Real World.* Chicago: Academy Chicago, Ltd., 1982, 312 p. illus.

Rawson, Philip. *Ceramics.* Philadelphia: University of Pennsylvania, 1984, 224 p. illus.

Stoops, Jack and Samuelson, Jerry. *Design Dialogue.* Worcester, Massachusetts: Davis Publications, Inc., 1983, 186 p. illus.

Von Eckart, Wolf. *A Place to Live.* New York: A Seymour Lawrence Book, Delacorte Press, 1967, 430 p. illus. *

Wildenhain, Marguerite. *Pottery: Form and Expression.* Palo Alto, California: Pacific Books, 1973, 157 p. illus.

## Historical and Contemporary Ceramics

Axel, Jan and McCready, Karen. *Porcelain: Traditions and New Visions.* New York: Watson-Guptill Publications, 1981, 200 p. illus.

Birks, Tony. *The Art of the Modern Potter.* New York: Van Nostrand Reinhold Company, 1976, 160 p. illus.

Charleston, Robert J., ed. *World Ceramics.* Secaucus, New Jersey: Chartwell Books Inc., 1976, 352 p. illus.

Clark, Garth and Hughto, Margie. *A Century of Ceramics in the United States, 1878-1978.* New York: E. P. Dutton, 1979, 372 p. illus.

Cox, Warren E. *The Book of Pottery and Porcelain.* Revised edition. New York: Crown Publishers, 1970, illus.

Lane, Peter. *Studio Ceramics.* Radnor, Pennsylvania: Chilton Book Company, 1984, 224 p. illus.

____. *Studio Porcelain.* Radnor, Pennsylvania: Chilton Book Company, 1980, 224 p. illus.

Litto, Gertrude. *South American Folk Pottery.* New York: Watson-Guptill Publications, 1976, 224 p. illus.

Miki, Fumio, *Haniwa: The Clay Sculpture of Proto-Historic Japan.* Translated by Roy Andrew Miller. Rutland, Vermont: Charles E. Tuttle Company, 1960, 161 p. illus.

## Marketing

Goodman, Calvin J. *Marketing Art.* Los Angeles: Gee Tee Bee, 1972, 318 p.

"The Handcraft Business," *Small Business Reporter,* vol. 10, no. 8 (1972), 16 p.

Nelson, Norbert N. *Selling Your Crafts.* New York: Van Nostrand Reinhold Company, 1967, 126 p. *

Nigrosh, Leon I. "The Craft Fair," *Craft Horizons,* vol. 32, no. 5 (October, 1972), pp. 51-66.

Scott, Michael. *The Crafts Business Encyclopedia.* New York: Harcourt Brace Jovanovich, 1977, 286 p.

*Taxes and the Craftsman.* Prepared for Members of the American Craftsmen's Council by Sydney Prereau. New York: American Crafts Council, 1964, 33 p. *

## Periodicals

American Ceramics (quarterly)
15 West 44th Street
New York, NY 10036

American Craft (bi-monthly)
401 Park Avenue South
New York, NY 10016

Ceramic Review (bi-monthly)
21 Carnaby Street
London, W1V 1PH,
England

Ceramic Scope (monthly, annual buyers guide)
Box 48643
Los Angeles, CA 90048

Ceramics Monthly (monthly)
Box 12448
Columbus, OH 43212

Crafts Report (monthly newsletter)
Box 1992
Wilmington, DE 19899

Studio Potter (semi-annual)
Box 65
Goffstown, NH 03045

*Out of print.

# Appendix A Ceramic Raw Materials

**ALUMINA,** $Al_2O_3$, Increases the viscosity, refractoriness and opacity of a glaze. Alumina also improves the tensile strength of a glaze as well as its hardness and resistance to chemicals. Used in small amounts, it will prevent recrystallization of a glaze upon cooling. When used in proportions from 1:4 up to 1:20 with silica, alumina regulates the oxygen ratio to control the surface quality of a glaze from a dry matt to a brilliant gloss. Alumina will also affect glaze color. Chrome oxides which usually give green tones, will tend toward red in a high alumina glaze. The normal blue tones of cobalt oxide will give pink hues in the absence of alumina. Depending upon the firing temperature, alumina can be added to a glaze formula from 0.1 moles at cone 010 (887°C/1629°F) to 0.9 moles at cone 12 (1306°C/2383°F). The most common sources of alumina for glazing are feldspars, clay and pyrophillite. To increase refractoriness in a clay body, alumina can be added by using kaolins, ball clays, feldspars, or alumina hydrate.

**ALUMINA HYDRATE,** $Al_2O_3 \cdot 3H_2O$, is used primarily in stacking and firing to prevent ware from sticking to kiln shelves. It is sometimes used in high temperature industrial ceramic bodies because of its fineness and purity.

**AMBLYGONITE,** $2LiF \cdot Al_2O_3 \cdot P_2O_5$, is the highest lithia-containing mineral, having between 8 and 10 percent available. It acts as a strong flux with alkaline reactions at temperatures around cone 2 (1142°C/2088°F) to cone 6 (1201°C/2194°F) and promotes a high gloss. Because it contains fluoride and phosphoric oxide, amblygonite will also tend to opacify a glaze **Fluorine gas released during firing can be toxic.**

**ANTIMONY OXIDE,** $Sb_2O_3$, although an opacifying agent, is used chiefly in combination with lead compounds to derive a yellow colorant. **This compound, commercially available as Naples Yellow, is poisonous.**

**APATITE,** $CaF_2 \cdot 9CaO \cdot 3P_2O_5$, is a natural source of calcium phosphate occasionally used in a glaze as an opacifier. It is used chiefly in commercial high temperature whiteware bodies.

**ARSENIC OXIDE,** $As_2O_3$, can be used in a glaze as an opacifier, but it is not as effective as tin oxide. **It is very poisonous and should be avoided.**

**ASBESTOS,** a fibrous hydrous-silicate mineral used for making fireproof articles and as an insulating material. Widely recommended in the past, its use is now discouraged because **inhalation of fibers can cause severe lung problems.**

**BARIUM CARBONATE,** $BaO \cdot CO_2$, is the primary source of barium oxide used to induce mattness in a glaze. It is a moderately active flux at temperatures around cone 6 (1201°C/2194°F) and higher. **In powder form, barium carbonate is toxic.** When used to prevent efflorescence in earthenware clay bodies, barium combines with the sulfur present to form barium sulfate ($BaSO_4$). This compound, used in x-ray diagnosis, is insoluble and non-toxic.

**BARIUM CHROMATE,** $BaO \cdot CrO_3$, is used to produce yellow to green colors in low temperature overglazes.

**BARIUM OXIDE,** $BaO$, is refractory. When used in amounts from 0.1 to 0.7 moles, it will produce increasing degrees of mattness in a glaze from a satin finish to a very rough, dry surface. Barium oxide is a moderately active flux at high temperatures but will also stabilize low temperature glazes in the presence of alumina and silica. Brilliant blue colors can be gained from copper in a high barium glaze. In high temperature reduction glazes, barium favors celadon green and iron blue colors. The major source of barium oxide is barium carbonate. **In their raw state, barium compounds can be poisonous.**

**BENTONITE,** $Al_2O_3 \cdot 4SiO_2 \cdot 9H_2O$, is a clay of volcanic origin. It is used as a plasticizer in clay and as a flotative in glaze. Because it has a high drying shrinkage, an addition of 1 to 3 percent should not be exceeded.

**BERYL,** $3BeO \cdot Al_2O_3 \cdot 6SiO_2$, is the chief commercial source of Beryllium Oxide, $BeO$. Used in high temperature porcelains, cone 10 or above, beryl can increase both impact and thermal shock resistance. In a cone 11-12 glaze, it can be used instead of a feldspar to give a hard matt surface. Care should be taken when using any Be compounds. **Both the raw material and the vapors produced in firing are toxic.**

**BISMUTH OXIDE,** $Bi_2O_3$, is a strong flux which can be used in amounts similar to lead oxide without the poisonous effects. Bismuth oxide can induce stable yellow colors under reducing conditions around cone 6 (1201°C/2194°F). Prepared by calcining bismuth nitrate, it is often used as a flux in silver luster glazes.

**BISMUTH SUBNITRATE,** $BiONO_3 \cdot H_2O$, melts at very low temperatures around 260°C (500°F). It is used in making pearlescent luster glazes.

**BONE ASH,** $13CaO \cdot 4P_2O_5 \cdot CO_2$, is made from ground up calcined animal bones. It is used as a flux in low temperature

glazes and as a minor opacifier. Because of natural bone variations, true bone ash does not have a constant composition. Preferable calcium materials are apatite and refined calcium phosphate. **Irritant.**

**BORAX,** $Na_2O \cdot 2B_2O_3 \cdot 10H_2O$, is soluble in water and can lose some of its water of crystallization during storage, affecting its weight. Care should be taken to store borax in airtight containers. Next to lead, borax is the chief flux for low temperature glazes. It brings about bright colors, reduced viscosity, and heals application defects. When used in a high fire glaze in amounts under 10 percent, borax can effect the same healing qualities. However, an excess of borax can bring about glaze defects. *Fused* or *Anhydrous Borax* is prepared by heating borax to a temperature of 735°C (1355°F). This drives out all the water leaving a compound of $Na_2O \cdot 2B_2O_3$ which is less apt to separate in a melting glaze and can be substituted for raw borax in a ratio of 53:100. **Can cause nasal and skin irritation.**

**BORIC ACID**, $B_2O_3 \cdot 3H_2O$, although soluble, is sometimes used to introduce boric oxide into a glaze when the sodium content of borax is not desired.

**BORIC OXIDE**, $B_2O_3$, is available in fused form as tiny glasslike pellets which are often used in frit batches. The borates help reduce glaze expansion and therefore help prevent crazing. Opalescence and mottled colors can be induced by the addition of boric oxide. Although the fused boric oxide is more stable than boric acid, it is still water soluble. The only natural source of insoluble boric oxide is colemanite.

**CADMIUM SULFIDE**, CdS, is used in low temperature glazes to produce yellow colors. Cadmium-selenium compounds give red and red-orange colors. Cadmium loses it color above cone 010 (887°C/1629°F) due to decomposition of the sulfide. **Excessive inhalation can cause carcinogenic effects.**

**CALCIUM CHLORIDE**, $CaCl_2$, is used as an electrolyte to flocculate glaze slips, that is, to thicken their consistency.

**CALCIUM CARBONATE** or **WHITING**, $CaO \cdot CO_2$, is a chief source of calcium oxide for glazing. Found naturally in the mineral calcite, marble and some chalks, it is used in moderate amounts as a flux in all temperature ranges.

**CALCIUM OXIDE**, CaO, because of its many desirable properties is usually used to some extent in most glazes from cone 010 (887°C/1629°F) upward. Calcium oxide, primarily a high temperature flux, will bring about a melt at low temperatures when combined with other fluxes. Glazes with calcium oxide in them are harder, more durable, less soluble, and have a lower expansion rate than glazes without it. The high refractory quality of calcium oxide will produce matt surface glazes when used in amounts above 0.4 moles. Calcium content does not readily affect glaze color, although combinations of calcium and zinc or calcium and chrome can produce pinks, while calcium and lead can give greens. In a high temperature reduction glaze, calcium oxide will help induce iron celadon greens. Chief sources of calcium oxide are whiting, colemanite, dolomite, bone ash, and wollastonite.

**CAROLINA STONE** is an altered granite produced in the United States to replace cornwall stone normally imported from England. It is used in a glaze as a substitution for feldspar and in a clay body instead of feldspar and china clay.

**CHROME OXIDE**, $Cr_2O_3$, is used in most glazes as a green colorant. In a high lead glaze below cone 08 (945°C/1733°F), chrome oxide can give brilliant red to red-orange colors. A soda-lead low-fire glaze will turn chrome oxide bright yellow. A zinc glaze will turn chrome to brown. A glaze with tin oxide and chrome in a ratio of 5:1 will give a pink hue. In most glazes a two percent addition of chrome oxide is sufficient to give a strong color. Chrome oxide in amounts of 40 percent or more is used in the formulation of black ceramic stains. Chrome oxide is slightly volatile above cone 5 (1177°C/2151°F) and can affect the colors of other nearby glazes in the kiln, especially those with tin. In reduction, chrome tends to go black. **Skin irritant. Inhalation can cause lung damage. Ingestion can be fatal.**

**CLAY, CHINA CLAY,** or **KAOLIN**, $Al_2O_3 \cdot 2SiO_2 \cdot 2H_2O$, is used in amounts up to 0.3 moles as a source of alumina and silica in glazes. Clay aids in controlling viscosity and gives the raw glaze better dry strength. Because china clays are relatively pure, they do not affect glaze color. Ball and other clays can be used in a glaze, but their impurities can affect color and also lower the maturing point. **Long term exposure to clay dusts can cause lung diseases.**

**CALCINED CLAY**, $Al_2O_3 \cdot SiO_2$, has been heated above red heat to drive off chemically combined water, to reduce its plasticity and to decrease shrinkage. Without this water the effective percentages of available alumina and silica per unit of weight are greatly increased over non-calcined clay. Equal results can therefore be had with approximately 14 percent less calcined clay.

**COBALT CARBONATE**, $CoO \cdot CO_2$, is a reliable blue colorant at all temperatures, and in both firing atmospheres. In an alkaline glaze, it gives a brilliant blue. In a magnesia glaze, cobalt carbonate tends towards purples and pinks. Additions of more than one percent of cobalt carbonate tend to give dark blue to black colors.

**COBALT OXIDE**, $CoO$, is the considerably stronger version of the blue colorant. Approximately one-half cobalt oxide is needed to derive colors similar to the carbonate. Cobalt oxide may need to be milled to reduce speckles in a glaze.

**COBALT CHROMATE**, $CoCrO_4$; **COBALT NITRATE**, $Co(NO_3)_2$; and **COBALT SULFATE**, $CoSO_4 \cdot 7H_2O$; are all water soluble and are used primarily for making low fire blue stains or luster glazes.

**COLEMANITE** or **GERSTLEY BORATE**, $2CaO \cdot 3B_2O_3 \cdot 5H_2O$, contains both calcium and boron. It is the only source of boric oxide that is insoluble except for commercial frits. Because boron melts at a low temperature, colemanite can be used as a low fire flux. It helps prevent crazing and acts as a mild opacifier. At higher temperatures, it can give an opalescent quality to a glaze along with brighter colors. True colemanite tends to be slightly soluble in water and can therefore flocculate a glaze if allowed to stand for a few days. The more commonly available gerstley borate is fritted and therefore does not do this as readily. Colemanite tends to vary in composition and new lots should undergo testing before being introduced into a glaze. **Can be corrosive to skin.**

**COPPER CARBONATE**, $CuO \cdot CO_2$, is a major green colorant. Up to 5 percent addition of copper carbonate will give a glaze deepening shades of green. Above five percent, the glaze surface will become opaque metallic black. In a low temperature high alkaline glaze, copper carbonate produces a turquoise blue. A colemanite based glaze will give a similar but slightly subdued color. Used in a high temperature barium glaze, copper carbonate will produce blue to blue-green. Although when copper carbonate is used in a lead glaze, it gives soft warm green colors, it also **releases up to ten times the amount of poisonous lead than might otherwise be freed.** Such a glaze should therefore not be used on ware for food or drink. In a reduction glaze, copper carbonate in small amounts will give red colors. If one to three percent tin oxide is added, brighter reds can be achieved. **Fumes released during firing can be toxic.**

**COPPER OXIDE**, $CuO$, has one and one-half times more available copper than does copper carbonate. Above cone 8 ($1236°C/2257°F$) copper becomes volatile and can affect nearby glazes in a kiln. **Fumes can be toxic.**

**CORNWALL STONE** is a natural mineral containing feldspar, flint, clay, and other minerals. It is used primarily as a flux, but can also help reduce glaze shrinkage in the unfired and fired state. Because it is high in silica, the addition of cornwall stone increases both the melting point of a glaze and its viscosity. Cornwall stone has a varying composition, usually around 0.4 moles of potassium, 0.2 each of soda and calcium, 1.1 alumina and 8.3 silica. The remainder is made up of small amounts of other minerals. Glaze tests should be made each time a new lot of cornwall stone is used. **May contain fluorides which when fired release toxic fluorine gas.**

**CROCUS MARTIS**, $FeO$, is a coarse form of impure iron oxide which can be used to speckle a glaze.

**CRYOLITE**, $3NaF \cdot AlF_3$, is used mainly as flux in the manufacture of glass. It is a violent flux at higher temperatures, causing a glaze to pinhole and blister. With proper temperature control, a glaze containing cryolite can have colorations similar to alkaline fluxes but with interesting striations. **Fluorine gas released during firing can be toxic.**

**CULLET**, $Na_2O \cdot CaO \cdot 2SiO_2$, is powdered glass which is sometimes used as a frit in a glaze batch to lower the melting point. It does not have a constant composition.

**DOLOMITE**, $CaO \cdot MgO \cdot 2CO_2$, is a natural mineral containing calcium oxide and magnesium oxide in an approximate ratio of 4:6. Although it is refractory, it is an effective flux alone at higher temperatures, and at lower temperatures when combined with alkaline fluxes. Dolomite will assist in forming a smooth buttery surface on a glaze and contribute to its durability. It can also be used in a clay body to increase its firing range.

**FELDSPAR**, $KNaO$, is an important mineral used as the principal flux in most high temperature glazes. Feldspars are natural frits made up of an alkaline portion, alumina and silica. Although rarely found in their pure state, there are three common forms of feldspar:

soda feldspar (albite) $Na_2O \cdot Al_2O_3 \cdot 6SiO_2$
calcium feldspar (anorthite) $CaO \cdot Al_2O_3 \cdot 2SiO_2$
potash feldspar (microcline) $K_2O \cdot Al_2O_3 \cdot 6SiO_2$

These formulas are theoretical and do not take into consideration other compounds and impurities which may be present. In actual use, a chemical analysis of a feldspar is required to

establish its exact formula. Because feldspars change with time, a recent chemical analysis of a spar should be requested at the time of purchase. Many feldspars will become glaze when fired to temperatures above 1250°C (2282°F). Glazes high in feldspar will tend to craze. Other fluxes should be added to prevent this. Potash feldspars form a harder glaze surface and decrease thermal expansion. Soda feldspars have a lower maturing temperature and promote brighter colors.

**FLINT** or **QUARTZ**, $SiO_2$, is the main source of silica for glazing. Adding flint to a glaze decreases its thermal expansion, adding it to a clay body increases thermal expansion. Used in a clay body, flint reduces dry and fired shrinkage and increases refractoriness. **Continued inhalation over time can cause silicosis, which may lead to serious lung damage.**

**FLUORSPAR** or **CALCIUM FLUORIDE**, $CaF_2$, is used as an opacifier and flux in the glass industry. It has a somewhat limited use as a glaze flux because its fluoride content tends to react violently with silica at higher temperatures, causing pinholes or blisters. At lower temperatures fluorspar aids in even colorant dispersal and imparts a higher gloss than does an equal amount of calcium carbonate. If the temperature is carefully controlled, fluorspar can induce unusual copper blue colors. Fluorspar and strontium combinations may be adequate substitutions for lead in a glaze. **Fluorine gas released during firing can be toxic.**

**FRIT**, a glass-like fusion of ceramic materials similar in composition to feldspar. Frits are primarily used to introduce water-soluble, toxic, or otherwise difficult materials into a glaze in a pre-fired state. Pre-firing reduces these chemicals to a highly concentrated, homogenous state that minimizes gas release, improves glaze fit and color distribution, and allows more uniform melting than if the materials were simply batch mixed and fired. While certain frits may form a glaze at low temperatures, most should be treated as a fluxing agent when used in a glaze formula.

**GALENA** or **LEAD SULFIDE**, PbS, is the raw material for lead compounds. It has been used since pre-history as a crude but direct source for lead in glazing. **Poisonous.**

**GOLD,** Au, is a widely used metallic overglaze decoration when prepared as liquid bright gold, powder or paste gold, or liquid burnished gold. The most brilliant of these is liquid bright gold. In a suitably fluxed liquid, it can be brushed, poured, sprayed or stamped onto a glaze fired surface. Fired to a low temperature over a gloss glaze, the gold is bright and shin-

ing; on a matt surface, it tends toward yellow. Gold-tin solutions and gold-salt solutions can be made to give purple and rose pink luster glazes.

**ILMENITE**, $TiO_2 \cdot FeO$, is a high iron mineral containing titanium. In powdered form, one to three percent ilmenite will tend to opacify a glaze and darken its color. Granular ilmenite used in a glaze or clay body will produce a speckled appearance. In conjunction with other colorants, one percent granular ilmenite may give dark spots with gold halos.

**IRON CHROMATE**, $FeO \cdot CrO_3$, is used to produce brown underglaze colors. From two to five percent can be added to a glaze to produce light to dark browns. In a low temperature tin glaze, dark pink tones are possible. Iron chromate is a non-staining form of iron which can also be used to darken a clay body. **Can cause skin irritation. Inhalation can cause lung damage.**

**IRON OXIDE** is commonly used in two forms: Ferrous Oxide, FeO, and Ferric Oxide, $Fe_2O_3$. The usual form of iron oxide in ceramics is ferric oxide, known as red iron oxide. It can be used as a brown colorant in both a clay body and a glaze, in amounts ranging from one to seven percent. Greater amounts of iron will tend to flux and effectively lower the maturing temperature of the clay or glaze. In a low temperature lead glaze, two to five percent iron oxide will give amber colors. In a higher temperature lead glaze, it will give warm tan to dark brown. In a high lead glaze, amounts in excess of seven percent will tend to crystallize into yellows and reds, forming an aventurine glaze. Zinc tends to muddy iron colors while tin turns them to cream tones. In reduction firing two percent or less of iron will give pale green colors known as celadons. If the glaze is opacified with calcium phosphate, one-half percent of iron can give a pale blue color. In a high soda-barium glaze, one to two percent iron can produce a rich yellow. Large amounts of iron oxide can bring about iron reds. Red iron oxide is a fine powder and will easily stain everything it contacts. Ferrous oxide, known as black iron oxide, is a coarse form of powdered iron. Non-staining, it can be substituted for red iron oxide in somewhat smaller amounts because of its greater iron to oxygen ratio.

**KAOLIN**, $Al_2O_3 \cdot 2SiO_2 \cdot 2H_2O$, is the Chinese name for a high temperature white burning clay. See Clay.

### A NOTE ABOUT LEAD

*Lead is an all pervading natural element. An average of 16 parts per million of lead is in the earth's crust and is found in*

soil the world over. Small quantities of lead are therefore unavoidably present in food and water. Industrial processes, auto emissions, and waste disposal emit tons of lead into the air each year. Although small doses of lead may slowly pass from the body, larger amounts remain, usually in bones. Eventually this can cause lead intoxication, permanent damage to brain or bones, and even death. Presently, about 15 to 20 ppm of lead in the bloodstream is accepted as the average adult accumulation, with 40 ppm considered dangerous. A simple blood test can indicate the amount of lead in the blood. Chemical therapy is available to reduce, if not eliminate, the amount of lead in the body.

For centuries lead has been a primary flux in glass and glaze. Its desirable properties of low fusability, brilliance, luster, and smoothness are not easily equalled by other fluxes. Properly fritted with other glaze materials into lead silicate or other forms, lead becomes virtually insoluable and safer to use in glazing. Firing a lead glaze to the proper temperature for which it is compounded will also help reduce the possibility of "free" lead remaining in the glaze or on its surface. When using lead compounds in the studio, adequate ventilation is desirable and an approved respirator mask should be worn. Firing of lead glazes should be done with good ventilation. The same procedures should be followed when working with silica, barium, cadmium, cobalt, or any other toxic substance.

A simple method of avoiding lead contamination in a glaze is not to use lead. Lead volatilizes and is no longer a usable flux above cone 6 (1201°C/2194°F).

**LEAD ANTIMONY**, $3PbO \cdot Sb_2O_5$, is known as Naples Yellow and used in a low temperature glaze to produce yellow colors. **It is extremely poisonous.**

**LEAD CARBONATE** or **WHITE LEAD**, $3PbO \cdot 2CO_2 \cdot H_2O$, is a major low temperature flux. Its relative purity, small particle size and ready fusability make it the most reasonable way to introduce lead into a glaze. **Over a period of time, inhalation of the dry powder can cause lead poisoning.**

**LEAD CHROMATE**, $PbO \cdot CrO_3$, is a low temperature green colorant. When used with tin oxide, it will give pink. It is also used to produce coral red stains. **Possible carcinogen.**

**LEAD OXIDE** as used in ceramics comes in two forms: Litharge, $PbO$; and Red Lead, $Pb_3O_4$. Litharge, or yellow lead, has a coarser particle size and contains less oxygen per unit of weight than red lead. Red lead is less expensive than white lead, but its characteristic color easily stains everything it contacts. Because of its higher lead content, red lead is often used in the preparation of frits. **Toxic.**

**LEAD SILICATES** are commercial frits compounded to reduce the toxicity of lead. The two most common forms are Lead Monosilicate with a composition of approximately 84 percent PbO and 16 percent $SiO_2$, and Lead Bisilicate, composed of 65 percent PbO, 33 percent $SiO_2$ and 2 percent $Al_2O_3$.

**LEAD SILICATE, HYDROUS**, $3PbO \cdot 2SiO_2 \cdot H_2O$, is used as a replacement for white lead to prevent pinholing caused by $CO_2$ release.

**LEPIDOLITE**, $LiF \cdot KF \cdot Al_2O_3 \cdot 3SiO_2$, is a lithium mica used as flux in a high temperature glaze. It tends to heighten glaze colors and decrease brittleness and thermal expansion. Lepidolite is used in a clay body to increase tensile strength and lengthen firing range. Not currently available. Use Litholite 400W as substitute.

**LIME**, $CaO$, is not found in a pure state in nature. It is generally combined in calcite or limestone. It is most often introduced into a glaze through whiting.

**LITHIUM CARBONATE**, $Li_2O \cdot CO_2$, is a good source of lithium for fluxing a high temperature glaze. It gives the glaze a high gloss and bright color response. It allows greater amounts of alumina, silica and calcium to be used, which gives the glaze greater durability and stability. Lithium carbonate can also be used in a mid-range glaze in place of lead. **In water can be a skin irritant. Ingested, can damage bone marrow.**

**MACALOID**, a refined naturally occuring sodium-magnesium-lithium fluoro-silicate which can be used as a plasticizer in clay bodies. Amounts under 3 percent added to dry ingredients can greatly improve the handling qualities of porcelain. However, increased additions can render the clay thixotropic.

**MAGNESIUM CARBONATE**, $MgO \cdot CO_2$, supplies magnesium oxide as a refractory in a low fire glaze to make it more matt and opaque. Added to a higher temperature glaze, magnesium oxide acts as a flux which gives a smooth, buttery surface. Cobalt blues turn purple or pinkish in a high magnesium glaze. **Fumes can be toxic.**

**MAGNESIUM SULFATE** or **EPSOM SALTS**, $MgO \cdot SO_3 \cdot 7H_2O$, will help prevent a glaze from settling in its container. A tablespoon per thousand grams is usually sufficient.

**MANGANESE CARBONATE**, $MnO \cdot CO_2$, is used as a colorant in glazing. If more than five percent is used, the glaze may become subject to pinholes or blisters. In mid-temperature alkaline glaze, manganese carbonate can impart a blue-purple to plum color. Above cone 6 (1201°C/2194°F) colors tend toward brown. **Irritant.**

**MANGANESE DIOXIDE**, $MnO_2$, acts in a manner similar to manganese carbonate. Because it is coarse grained, it tends to make dark specks and is therefore also used in clay bodies. **Inhalation of fumes can permanently damage nervous system.**

**NEPHELINE SYENITE** is an igneous rock having characteristics similar to a high soda feldspar. Its formula varies, but in general it has a ratio of 0.7 soda and 0.2 potash to 1.0 alumina and 4.5 silica. It has a lower melting point than many feldspars and is therefore a good flux for a mid-temperature glaze as well as at high temperatures. Nepheline syenite increases thermal expansion and can help eliminate crazing. It is also used in a clay body to increase its firing range and strength as well as decrease absorption. Fired shrinkage, however, is slightly increased.

**NICKEL OXIDE** is available in two forms: Green Nickel Oxide, $NiO$, and Black Nickel Oxide, $Ni_2O_3$. Amounts of nickel oxide around one percent can be used to moderate other colorants. By itself, nickel oxide will generally give grey to brown colors. Depending upon which fluxes are used and the amount of alumina in a base glaze, nickel colors can range from green with magnesia, brown with barium, to blue to brown with decreasing amounts of zinc. In barium-calcium combinations, it is possible to get purple to pink colors. **Irritant. Excessive inhalation could cause lung cancer.**

**OCHRE** is the name for a number of iron bearing surface clays which are used as glaze or slip colorants. They range in color from tans to brown or black.

**PEARL ASH** or **POTASSIUM CARBONATE**, $K_2O \cdot CO_2$, is soluable but may be used to alter colors produced by some colorants such as copper oxide. It is more often used as a potassium source for frits. **Corrosive to skin.**

**PETALITE**, $Li_2O \cdot Al_2O_3 \cdot 8SiO_2$, a source for lithia and silica in a mid- or high-temperature glaze. It can also be used effectively as a flux for a once-fired glaze. When fired above $1000°C$ ($1832°F$), petalite goes through decomposition and becomes beta spodumene. Used in a clay body, this unique feature offers nearly zero expansion and excellent heat shock resistance.

**PLASTIC VITROX**, a mineral similar in activity to potash feldspar and cornwall stone, is used as a source of silica, potash and alumina in a glaze.

**PLATINUM**, Pt, used as liquid bright platinum gives an overglaze luster color brighter than silver which is also less apt to tarnish. If added into a glaze, platinum gives a steel grey color.

**POTASSIUM DICHROMATE**, $K_2O \cdot 2CrO_3$, although soluble and **poisonous**, can be used in a low temperature glaze to give colors ranging from green to pink and red. For the latter, it is usually calcined with tin.

**POTASSIUM NITRATE** or **NITRE**, $K_2O \cdot N_2O_5$, because it is soluble, is usually introduced in fritted form as a source of potassium when a potash feldspar is not usable.

**PRASEODYMIUM OXIDE**, $Pr_6O_{11}$, is a rare earth useful as a brilliant yellow colorant in ceramic stains.

**PYROPHYLLITE**, $Al_2O_3 \cdot 4SiO_2 \cdot H_2O$, decreases cracking, shrinking and warping of a ceramic body while increasing its firing range. It is relatively nonplastic and is used mostly in wall tile clays. Because pyrophyllite increases the ability of both clay body and glaze to withstand sudden temperature changes, it can be used in amounts up to 25 percent as a clay body constituent for range-top cookware.

**RUTILE**, $TiO_2$, is an impure form of titanium oxide containing iron, chrome and vanadium. In powdered form it is used primarily as a tan colorant or to opacify and mottle a glaze. In the granular form, rutile will tend to give brown specks or streaks. In conjunction with other colorants, rutile will give variegated textures and colors. It is also used to color clay.

**SELENIUM**, Se, is used mainly in the glass industry as a colorant which when combined with other oxides can produce a range of color through half the spectrum. In a very low temperature glaze, selenium can give reds and oranges. Somewhat richer colors are possible when selenium and cadmium are combined as a glaze stain. **Selenium should not be used on tableware because in contact with food acids it could be toxic.**

**SILICA**, $SiO_2$ comes in many different forms. the one most commonly used in ceramics is finely ground quartzite, called *Potters' Flint.* Silica forms a hard glass when fired to its melting point of $1750°C$ ($3182°F$). Silica is the major acid in the $RO_2$ group. By varying its ratio to the RO group, the melting point of a particular glaze can be closely controlled. In glaze batches, silica is generally added as a mineral combined in clay, feldspar or other materials. **Inhalation can cause silicosis and other lung problems.**

**SILICON CARBIDE**, SiC, is used in the manufacture of high temperature kiln shelves and other refractory parts. Introduced into a glaze as fine ground particles, silicon carbide can act as a local reduction agent.

**SILLIMANITE**, $Al_2O_3 \cdot SiO_2$, is used as a constituent of high temperature refractory bodies such as those used in kiln furniture and fire bricks. It can be introduced into clay bodies in

small amounts to aid in controlling volume, and in adding mechanical strength and temperature resistance. A similar mineral, Kyanite, $3Al_2O_3 \cdot 3SiO_2$, is more readily available for use in wall tiles and electrical porcelains.

**SILVER CARBONATE**, $Ag_2CO_3$, becomes an overglaze luster when used in a low temperature glaze which undergoes light reduction resulting in metallic silver.

**SILVER CHLORIDE**, AgCl, is used as a metallic silver overglaze when mixed with bismuth in a lead glaze and fired in reduction. **Fumes generated during firing are toxic.**

**SILVER NITRATE**, $AgNO_3$, mixed with resin and lavender oil and applied directly to a fired glaze surface will give a silver-yellow metallic luster when fired.

**SODA ASH** or **SODIUM CARBONATE**, $Na_2O \cdot CO_2$, is a very active, but soluble, flux. It is usually added to a glaze in fritted form. In small amounts, soda ash acts as a deflocculant in a clay slip and can be used as a suspender in engobes. **Corrosive to skin and eyes.**

**SODIUM ALUMINATE**, $Na_2O \cdot Al_2O_3$, is sometimes substituted for soda ash as a clay slip deflocculant, to increase slip stability and dry strength.

**SODIUM ANTIMONATE**, $Na_2O \cdot Sb_2O_5 \cdot 7H_2O$, has better stability than antimony oxide and is therefore used to a greater extent in the preparation of yellow ceramic stains. **It is poisonous.**

**SODIUM BICARBONATE** or **BICARBONATE OF SODA**, $N_2O \cdot H_2O \cdot 2CO_2$, is used to some extent as a sodium compound in the formulation of ceramic stains. It can be used as a non-poisonous alternative to sodium chloride for salt glazing. It also acts as a deflocculant in clay or glaze slips.

**SODIUM CHLORIDE** or **COMMON SALT**, NaCl, vaporizes when introduced directly into a hot kiln. The vapor forms a soda-silicate glaze on the exposed surfaces of the ware being fired. The process is known as salt glazing. **Fumes can be toxic.**

**SODIUM NITRATE**, $Na_2O \cdot N_2O_5$, is an expensive sodium compound used chiefly as an oxidizer in frit preparations.

**SODIUM SILICATE** or **WATER GLASS**, $Na_2O \cdot XSiO_2$, has a silica content that can vary from 1.0 to 4.0 depending upon the manufacturer's requirements. The higher the silica content, the stronger the sodium silicate will act as a clay slip deflocculant.

**SODIUM URANATE**, $Na_2O \cdot UO_3$, is a low temperature colorant. When combined with zirconium in a high soda glaze, it gives a yellow color; with tin, orange; and in an alumina-free high lead glaze, bright red. **Radioactive.**

**SPINEL**, $MgO \cdot Al_2O_3$, is a natural mineral with high refractory qualities. However, the term "spinel" more generally designates a wide group of compounds with the molecular structure, $RO \cdot R_2O_3$. These spinels are used as stable colorants in underglaze and clay body stains.

**SPODUMENE**, $Li_2O \cdot Al_2O_3 \cdot 4SiO_2$, is a major source of lithium in glaze and clay bodies. Spodumene is an active flux at higher temperatures and will develop bright copper blue colors. Used in a whiteware or flameware clay body, spodumene undergoes an irreversible expansion which reduces shrinkage when fired. Using spodumene it is possible to develop a nonplastic clay body with zero shrinkage.

**STANNOUS CHLORIDE** or **TIN CHLORIDE**, $SnCl_2$, is widely used as a fuming agent in vapor glazing. Small amounts introduced into a kiln during the last cooling stages of a firing can provide a transparent mother-of-pearl luster to glazed ware. **Wear a respirator when using because fumes are toxic.**

**STRONTIUM CARBONATE**, $SrO \cdot CO_2$, is an active flux that can be used to replace lead in a glaze. It will raise the maturing point of the glaze, decrease its fluidity, and increase its thermal expansion. Strontium carbonate can also be used to replace zinc or calcium. In both cases, the glaze fit is improved, solubility is lowered, and hardness increased. In a clay body, replacing calcium or zinc with strontium carbonate will reduce pitting, pinholing, and blistering of applied glazes. At high temperatures, strontium carbonate lowers shrinkage, increases strength, and lowers porosity.

**TALC**, $3MgO \cdot 4SiO_2 \cdot H_2O$, is used in a glaze for both its magnesia and silica content. It is both a mild flux and opacifier. Talc is often used as a flux in a low temperature clay body. In a high temperature clay body, talc imparts high thermal and electrical shock resistance. In both high and low bodies, talc decreases moisture expansion, thereby reducing or eliminating delayed glaze crazing. Talc varies in composition and should be tested for lime content before it is used in a clay body. The higher the talc content, the better strength, lower absorption and lesser tendency to cause glaze shivering. **Inhalation can cause lung damage.**

**TIN OXIDE**, $SnO_2$, is the most effective opacifier of all. One or two percent will opacify a glaze and improve its gloss. Normally about five percent of tin oxide added to a glaze will completely opacify it. Because of its increasing cost, tin is being replaced as an opacifier by zirconia materials. They do not give the smooth texture imparted by tin, nor do they favor chrome

pink and vanadium yellow as does tin. Tin oxide is also used in the preparation of glaze and clay body stains. It will slightly lower the expansion of a glaze in which it is used.

**TITANIUM DIOXIDE**,$TiO_2$, is used as an opacifier when added to a glaze or underglaze. Two or three percent can give a milky opalescence. In higher amounts, it tends to form matt surface textures. In some zinc glazes, iron browns can become bright greens with the addition of titanium dioxide. In local reduction, titanium can give blue colors.

**URANIUM OXIDE**, $U_3O_8$, is a yellow to red-orange colorant when used in low temperature oxidation glazes. **Radioactive.**

**VANADIUM PENTOXIDE**,$V_2O_5$, is used as a colorant to produce yellow to brown hues. In reduction, it is possible to obtain green colors with vanadium pentoxide. It is a relatively weak colorant and must be used in amounts from six to ten percent to gain a pronounced color. Larger amounts tend to affect surface texture. Generally, vanadium is introduced into a glaze in the form of a vanadium-tin stain which produces stronger yellows than vanadium pentoxide alone. **Inhalation can cause bronchitis.**

**VOLCANIC ASH** consists of minute particles of volcanic glass. It can be used as a mid-range flux equalling approximately 70 percent feldspar and 30 percent flint. Its iron content will darken a glaze somewhat. In a low temperature clay body, volcanic ash will produce less warping, greater strength, and a longer firing range. Its composition and properties are variable and each new lot should be tested. **Can cause irritation to skin and eyes.**

**WHITE LEAD,** see Lead Carbonate.

**WHITING**, see Calcium Carbonate.

**WOLLASTONITE**, $CaO \cdot SiO_2$, is natural calcium silicate used as a glaze flux. As a source of calcium it tends to produce a smoother, brighter glaze than does whiting. When used in a clay body, wollastonite will reduce shrinkage, improve heat shock resistance, and lower moisture expansion.

**ZINC OXIDE**, $ZnO$, is a glaze flux which improves gloss, reduces crazing, increases the firing range, and heightens colors. Combined with alumina in a low calcium glaze, zinc oxide produces an opaque white matt glaze known as Bristol. Copper and zinc produce brilliant turquoise greens; zinc and tin can give pink; and zinc with iron or chrome makes brown tones. When used with titanium, zinc can promote a crystalline glaze. Large amounts of zinc oxide in a glaze will render it too refractory and cause crawling, pitting and pinholing. The use of Calcined Zinc Oxide will help prevent this. **Can cause skin irritation.**

**ZIRCONIUM OXIDE**, $ZrO_2$, functions as an opacifier at all temperatures. It is available in various fritted silicate forms such as Calcium Zirconium Silicate, Magnesium Zirconium Silicate, and silicates marketed as Zircopax, Superpax, Opax and others. Although these products are less expensive than tin oxide, twice as much of the material is usually needed to achieve the same opacity. **Can cause skin rash.**

# Appendix B

## Atomic Weights of Common Elements and Their Oxides

| Element | Symbol | Atomic Weight | Oxide | Atomic Weight |
|---|---|---|---|---|
| Aluminum | Al | 26.98 | $Al_2O_3$ | 101.93 |
| Antimony | Sb | 121.75 | $Sb_2O_3$ | 291.47 |
| Arsenic | As | 74.92 | $As_2O_3$ | 197.81 |
| Barium | Ba | 137.34 | BaO | 153.33 |
| Bismuth | Bi | 208.90 | $Bi_2O_3$ | 465.77 |
| Boron | B | 10.81 | $B_2O_3$ | 69.59 |
| Cadmium | Cd | 112.40 | CdO | 128.39 |
| Calcium | Ca | 40.08 | CaO | 56.07 |
| Carbon | C | 12.01 | $CO_2$ | 43.99 |
| Chlorine | Cl | 35.35 | $ClO_2$ | 67.43 |
| Chromium | Cr | 51.99 | $Cr_2O_3$ | 151.95 |
| Cobalt | Co | 58.93 | CoO | 74.92 |
| Copper | Cu | 63.54 | CuO | 79.53 |
| Fluorine | F | 18.99 | — | |
| Gold | Au | 196.96 | $Au_2O_3$ | 441.89 |
| Hydrogen | H | 1.00 | $H_2O$ | 17.99 |
| Iron | Fe | 55.84 | FeO | 71.83 |
| | | | $Fe_2O_3$ | 159.65 |
| Lead | Pb | 207.19 | PbO | 223.18 |
| Lithium | Li | 6.93 | $Li_2O$ | 29.85 |
| Magnesium | Mg | 24.31 | MgO | 40.30 |
| Manganese | Mn | 54.93 | MnO | 70.92 |
| Mercury | Hg | 200.61 | HgO | 216.60 |
| Molybdenum | Mo | 95.95 | $MoO_2$ | 127.93 |
| Nickel | Ni | 58.71 | NiO | 74.70 |
| Nitrogen | N | 14.00 | $N_2O$ | 43.99 |
| Oxygen | O | 15.99 | — | |
| Palladium | Pd | 106.40 | PdO | 122.39 |
| Phosphorus | P | 30.93 | $P_2O_5$ | 141.81 |
| Platinum | Pt | 195.09 | PtO | 211.08 |
| Potassium | K | 39.10 | $K_2O$ | 94.19 |
| Praseodymium | Pr | 140.90 | $Pr_6O_{11}$ | 1021.29 |
| Selenium | Se | 78.96 | $SeO_2$ | 110.94 |
| Silicon | Si | 28.08 | $SiO_2$ | 60.06 |
| Silver | Ag | 107.87 | $Ag_2O$ | 231.73 |
| Sodium | Na | 22.98 | $Na_2O$ | 61.95 |
| Strontium | Sr | 87.62 | SrO | 103.61 |
| Sulphur | S | 32.06 | $SO_2$ | 64.04 |
| Tin | Sn | 118.69 | $SnO_2$ | 150.67 |
| Titanium | Ti | 47.90 | $TiO_2$ | 79.88 |
| Uranium | U | 238.07 | $UO_3$ | 286.04 |
| | | | $U_3O_8$ | 842.13 |
| Vanadium | V | 50.94 | $V_2O_5$ | 181.85 |
| Zinc | Zn | 65.37 | ZnO | 81.36 |
| Zirconium | Zr | 91.22 | $ZrO_2$ | 123.20 |

# Appendix C  Ceramic Raw Materials— Formula and Weight Charts

| Material | Raw Formula | Molecular Weight | Calculation Formula | Equivalent Weight |
|---|---|---|---|---|
| Alumina Hydrate | $Al_2O_3 \cdot 3H_2O$ | 156 | $Al_2O_3$ | 156 |
| Amblygonite | $2LiF \cdot Al_2O_3 \cdot P_2O_5$ | 296 | $2Li_2O \cdot Al_2O_3$ | 162 |
| Barium Carbonate | $BaO \cdot CO_2$ | 197 | $BaO$ | 197 |
| Bismuth Oxide | $Bi_2O_3$ | 466 | $Bi_2O_3$ | 466 |
| Bone Ash | $13CaO \cdot 4P_2O_5 \cdot CO_2$ | 1340 | $CaO$ | 103 |
| Borax | $Na_2O \cdot 2B_2O_3 \cdot 10H_2O$ | 381 | $Na_2O \cdot 2B_2O_3$ | 381 |
| Boric Acid | $B_2O_3 \cdot 3H_2O$ | 124 | $B_2O_3$ | 124 |
| Clay (Kaolin, China Clay) | $Al_2O_3 \cdot 2SiO_2 \cdot 2H_2O$ | 258 | $Al_2O_3 \cdot 2SiO_2$ | 258 |
| Calcined Clay | $Al_2O_3 \cdot 2SiO_2$ | 222 | $Al_2O_3 \cdot 2SiO_2$ | 222 |
| Calcium Phosphate | $3CaO \cdot P_2O_5$ | 310 | $CaO$ | 103 |
| Colemanite (Gerstley Borate) | $2CaO \cdot 3B_2O_3 \cdot 5H_2O$ | 411 | $CaO \cdot 1.5B_2O_3$ | 206 |
| Cryolite | $3NaF \cdot AlF_3$ | 210 | $3Na_2O \cdot Al_2O_3$ | 420 |
| Cullet | $Na_2O \cdot CaO \cdot 2SiO_2$ | 238 | $Na_2O \cdot CaO \cdot 2SiO_2$ | 238 |
| Dolomite | $CaO \cdot MgO \cdot 2CO_2$ | 184 | $CaO \cdot MgO$ | 184 |
| Flint (Silica, Quartz) | $SiO_2$ | 60 | $SiO_2$ | 60 |
| Fluorspar (Calcium Fluoride) | $CaF_2$ | 78 | $CaO$ | 78 |
| Galena (Lead Sulfide) | $PbS$ | 239 | $PbS$ | 239 |
| Lead Carbonate (White Lead) | $3PbO \cdot 2CO_2 \cdot H_2O$ | 776 | $PbO$ | 259 |
| Lead Monosilicate | $3PbO \cdot 2SiO_2$ | 790 | $3PbO \cdot 2SiO_2$ | 263 |
| Lead Oxide (Litharge) | $PbO$ | 223 | $PbO$ | 223 |
| Lead Oxide (Red Lead) | $Pb_3O_4$ | 686 | $PbO$ | 229 |
| Lepidolite | $LiF \cdot KF \cdot Al_2O_3 \cdot 3SiO_2$ | 366 | $Li_2O \cdot K_2O \cdot Al_2O_3 \cdot 3SiO_2$ | 406 |
| Lithium Carbonate | $Li_2O \cdot CO_2$ | 74 | $Li_2O$ | 74 |
| Magnesium Carbonate | $MgO \cdot CO_2$ | 84 | $MgO$ | 84 |
| Pearl Ash (Potassium Carbonate) | $K_2O \cdot CO_2$ | 138 | $K_2O$ | 138 |
| Petalite | $Li_2O \cdot Al_2O_3 \cdot 8SiO_2$ | 612 | $Li_2O \cdot Al_2O_3 \cdot 8SiO_2$ | 612 |
| Potassium Nitrate (Nitre) | $K_2O \cdot N_2O_5$ | 101 | $K_2O$ | 202 |
| Pyrophyllite | $Al_2O_3 \cdot 4SiO_2 \cdot H_2O$ | 360 | $Al_2O_3 \cdot 4SiO_2$ | 360 |
| Soda Ash (Sodium Carbonate) | $Na_2O \cdot CO_2$ | 106 | $Na_2O$ | 106 |
| Sodium Bicarbonate | $Na_2O \cdot H_2O \cdot 2CO_2$ | 168 | $Na_2O$ | 168 |
| Sodium Chloride | $NaCl$ | 58 | $Na_2O$ | 117 |
| Sodium Nitrate | $Na_2O \cdot N_2O_5$ | 170 | $Na_2O$ | 170 |
| Spodumene | $Li_2O \cdot Al_2O_3 \cdot 4SiO_2$ | 372 | $Li_2O \cdot Al_2O_3 \cdot 4SiO_2$ | 372 |

| Material | Raw Formula | Molecular Weight | Calculation Formula | Equivalent Weight |
|---|---|---|---|---|
| Strontium Carbonate | $SrO \cdot CO_2$ | 148 | $SrO$ | 148 |
| Talc | $3MgO \cdot 4SiO_2 \cdot H_2O$ | 379 | $MgO \cdot 1.33SiO_2$ | 126 |
| Whiting (Calcium Carbonate) | $CaO \cdot CO_2$ | 100 | $CaO$ | 100 |
| Wollastonite | $CaO \cdot SiO_2$ | 116 | $CaO \cdot SiO_2$ | 116 |
| Zinc Oxide | $ZnO$ | 81 | $ZnO$ | 81 |

## Colorants and Opacifiers

| Material | Raw Formula | Molecular Weight | Calculation Formula | Equivalent Weight |
|---|---|---|---|---|
| Antimony Oxide | $Sb_2O_3$ | 292 | $Sb_2O_3$ | 292 |
| Apatite | $CaF_2 \cdot 9CaO \cdot 3P_2O_5$ | 1008 | $CaO$ | 101 |
| Arsenic Oxide | $As_2O_3$ | 198 | $As_2O_3$ | 198 |
| Barium Chromate | $BaO \cdot CrO_3$ | 253 | $BaO \cdot CrO_3$ | 253 |
| Cadmium Sulfide | $CdS$ | 144 | $Cd$ | 112 |
| Chrome Oxide | $Cr_2O_3$ | 152 | $Cr_2O_3$ | 152 |
| Cobalt Carbonate | $CoO \cdot CO_2$ | 119 | $CoO$ | 119 |
| Cobalt Oxide, Grey | $CoO$ | 75 | $CoO$ | 75 |
| Cobalt Oxide, Black | $Co_3O_4$ | 241 | $CoO$ | 80 |
| Copper Carbonate | $CuO \cdot CO_2$ | 124 | $CuO$ | 124 |
| Copper Oxide, Black | $CuO$ | 80 | $CuO$ | 80 |
| Copper Oxide, Red | $Cu_2O$ | 143 | $CuO$ | 72 |
| Ilmenite | $TiO_2 \cdot FeO$ | 152 | $TiO_2 \cdot FeO$ | 152 |
| Iron Chromate | $FeO \cdot CrO_3$ | 172 | $FeO \cdot CrO_3$ | 172 |
| Iron Oxide, Black | $FeO$ | 72 | $FeO$ | 72 |
| Iron Oxide, Red | $Fe_2O_3$ | 160 | $Fe_2O_3$ | 160 |
| Lead Antimony | $3PbO \cdot Sb_2O_5$ | 993 | $3PbO$ | 993 |
| Lead Chromate | $PbO \cdot CrO_3$ | 323 | $PbO \cdot CrO_3$ | 323 |
| Manganese Carbonate | $MnO \cdot CO_2$ | 115 | $MnO$ | 115 |
| Manganese Dioxide | $MnO_2$ | 87 | $MnO$ | 87 |
| Nickel Oxide, Green | $NiO$ | 75 | $NiO$ | 75 |
| Nickel Oxide, Black | $Ni_2O_3$ | 165 | $NiO$ | 83 |
| Potassium Dichromate | $K_2O \cdot 2CrO_3$ | 294 | $K_2O \cdot 2CrO_3$ | 294 |
| Praseodymium Oxide | $Pr_6O_{11}$ | 1021 | $Pr_6O_{11}$ | 1021 |
| Rutile | $TiO_2$ | 80 | $TiO_2$ | 80 |
| Selenium | $Se$ | 79 | $Se$ | 79 |
| Sodium Antimonate | $Na_2O \cdot Sb_2O_5 \cdot 7H_2O$ | 512 | $Na_2O \cdot Sb_2O_5$ | 512 |
| Sodium Uranate | $Na_2O \cdot UO_3$ | 348 | $Na_2O \cdot UO_3$ | 348 |
| Tin Oxide | $SnO_2$ | 151 | $SnO_2$ | 151 |
| Titanium Dioxide | $TiO_2$ | 80 | $TiO_2$ | 80 |
| Uranium Oxide | $U_3O_8$ | 842 | $U_3O_8$ | 842 |
| Vanadium Pentoxide | $V_2O_5$ | 182 | $V_2O_5$ | 182 |
| Zirconium Oxide | $ZrO_2$ | 123 | $ZrO_2$ | 123 |
| Zirconium Silicate | $ZrSiO_4$ | 183 | $ZrSiO_4$ | 183 |

## Typical Feldspar Formulas

All feldspars should have their chemical analyses (available from ceramic suppliers) changed into formulas and be test fired before being introduced into glazes or clay bodies. The following formulas are representative of analyses current to the publication date.

| Spar | $K_2O$ | $Na_2O$ | CaO | MgO | $F_2$ | $P_2O_5$ | $Fe_2O_3$ | $Al_2O_3$ | $SiO_2$ | LOI | Equivalent Weight |
|---|---|---|---|---|---|---|---|---|---|---|---|
| Albite (theoretical) | | 1.0 | | | | | | 1.0 | 6.0 | | 524 |
| Anorthite (theoretical) | | | 1.0 | | | | | 1.0 | 2.0 | | 278 |
| Microcline (theoretical) | 1.0 | | | | | | | 1.0 | 6.0 | | 556 |
| C-6 | .26 | .65 | .09 | tr | | | .002 | 1.03 | 6.51 | .24 | 566 |
| Cornwall Stone | .28 | .45 | .26 | .01 | .32 | .03 | .007 | 1.01 | 8.38 | .61 | 686 |
| Custer | .67 | .30 | .03 | tr | | | .004 | 1.06 | 7.20 | .30 | 631 |
| G-200 | .63 | .28 | .09 | | | | .003 | 1.03 | 6.38 | .16 | 570 |
| Kona F-4 | .27 | .57 | .16 | tr | | | .002 | 1.03 | 6.07 | .30 | 539 |
| Nepheline Syenite | .23 | .75 | .01 | tr | | | .002 | 1.03 | 4.56 | .30 | 448 |
| Plastic Vitrox | .29 | .56 | .15 | | | | | 1.86 | 14.81 | | 1149 |

## Typical Frit Formula

All frits should have their chemical analyses (available from ceramic suppliers) changed into formulas and be test fired before being introduced into glazes. The following formulas are representative of analyses current to publication date.

| Frit | | $K_2O$ | $Na_2O$ | CaO | ZnO | PbO | $B_2O_3$ | $Al_2O_3$ | $SiO_2$ | $F_2$ | Equivalent Weight |
|---|---|---|---|---|---|---|---|---|---|---|---|
| **Leadless** | | | | | | | | | | | |
| Ferro 3110 | | .06 | .65 | .29 | | | .10 | .09 | 3.03 | | 260 |
| 3124 | | .02 | .28 | .70 | | | .54 | .27 | 2.55 | | 276 |
| 3134 | (Pemco 54) (Hommel 14) | | .32 | .68 | | | .63 | | 1.48 | | 191 |
| 3195 | | | .31 | .69 | | | 1.11 | .41 | 2.80 | | 345 |
| 3819 | (Pemco 25) (Hommel 259) | .17 | .77 | .03 | .03 | | .75 | .39 | 2.70 | | 359 |
| 5301 | | .18 | .69 | .13 | | | .59 | .36 | 2.26 | 1.5 | 314 |
| **Leaded** *(See safety note concerning lead)* | | | | | | | | | | | |
| Ferro 3304 | (Hommel 61) | | .07 | | | .93 | | .15 | 2.58 | | 383 |
| 3419 | (Glostex G-23) (Hommel 33) | | .28 | | | .72 | | .56 | .90 | | 271 |
| 3493 | (Pemco Pb 742) (Hommel 373) | .08 | .10 | .31 | | .52 | .69 | .11 | 2.77 | | 373 |

# Appendix D  Clay and Glaze Recipes

The following clay and glaze recipes are offered as general examples. Actual results may vary depending upon local materials used. Samples should be made and tested before any formulas are mixed in large amounts.

## Clay Bodies

### Raku

| | | | |
|---|---|---|---|
| Fireclay | 50 | Stoneware | 20 |
| Ball Clay | 50 | Fireclay | 35 |
| + Grog 20-50% | | Talc | 10 |
| | | Sand | 35 |

### Cone 04 Oxidation

| *White* | | *Red* | |
|---|---|---|---|
| Stoneware | 30 | Earthenware | 60 |
| China Clay | 25 | Fire Clay | 12 |
| Flint | 15 | Ball Clay | 12 |
| Frit | 15 | Talc | 10 |
| Nepheline Syenite | 5 | Frit | 6 |
| Talc | 10 | | |

### Cone 4 to 6 Oxidation

| *Tan* | | *White* | |
|---|---|---|---|
| Earthenware | 50 | China Clay | 40 |
| Fireclay | 20 | Ball Clay | 10 |
| Flint | 15 | Flint | 26 |
| Ball Clay | 15 | Feldspar | 20 |
| | | Whiting | 4 |

### Cone 8 to 10 Oxidation or Reduction

| *White* | | *Dark* | |
|---|---|---|---|
| China Clay | 25 | Stoneware | 50 |
| Ball Clay | 25 | Ball Clay | 25 |
| Flint | 25 | Fire Clay | 20 |
| Feldspar | 25 | Feldspar | 5 |
| + Macaloid 1% | | + Grog 10% | |

# Glazes

## *Raku*

| White Reduction | | White Crackle | | Copper Lustre (Reduction) | |
|---|---|---|---|---|---|
| Gerstley Borate | 80 | Frit 3304 (Ferro) | 80 | Frit 5301(Ferro) | 80 |
| Nepheline Syenneite | 20 | Borax | 10 | Borax | 20 |
| | | China Clay | 5 | Bentonite | 5 |
| | | Colemanite | 5 | Copper Carbonate | 5 |

## *Cone 04 Oxidation*

| Gloss | | Matt | | Soft Matt White | |
|---|---|---|---|---|---|
| Frit 3124 (Ferro) | 80 | Potash Feldspar | 38 | Frit 3134 (Ferro) | 44 |
| Nepheline Syenite | 12 | Gerstley Borate | 22 | China Clay | 12 |
| China Clay | 8 | Barium Carbonate | 4 | Dolomite | 8 |
| | | Whiting | 11 | Whiting | 8 |
| | | Flint | 25 | Flint | 28 |

## *Cone 4 Oxidation*

| Gloss | | Matt | | Satin Matt | |
|---|---|---|---|---|---|
| Soda Feldspar | 44 | Potash Feldspar | 52 | Lepidolite | 36 |
| Gerstley Borate | 19 | Whiting | 19 | Wollastonite | 26 |
| Dolomite | 6 | Zinc Oxide | 9 | Barium Carbonate | 18 |
| Whiting | 2 | China Clay | 15 | Magnesium Carbonate | 3 |
| Zinc Oxide | 5 | Flint | 5 | Zinc Oxide | 4 |
| China Clay | 5 | | | Flint | 13 |
| Flint | 19 | | | | |

## *Cone 6 Oxidation*

| Gloss | | Matt | | Semi Matt | |
|---|---|---|---|---|---|
| Nepheline Syenite | 47 | Potash Feldspar | 53 | Nepheline Syenite | 60 |
| Gerstley Borate | 27 | Barium Carbonate | 20 | Barium Carbonate | 22 |
| China Clay | 6 | Whiting | 10 | Lithium Carbonate | 4 |
| Flint | 20 | Zinc Oxide | 12 | China Clay | 8 |
| | | China Clay | 5 | Flint | 6 |

## Cone 8 Oxidation

| Gloss | | Matt | | Matt Reduction (Vavrek) | |
|---|---|---|---|---|---|
| Potash Feldspar | 30 | Soda Feldspar | 56 | Nepheline Syenite | 45 |
| China Clay | 15 | Nepheline Syenite | 15 | China Clay | 20 |
| Whiting | 14 | Barium Carbonate | 7 | Barium Carbonate | 15 |
| Talc | 4 | Whiting | 13 | Whiting | 10 |
| Zinc Oxide | 6 | China Clay | 9 | Lithium Carbonate | 5 |
| Flint | 31 | | | Flint | 5 |

## Cone 10 Reduction

| Gloss | | Matt | | Semi Matt | |
|---|---|---|---|---|---|
| Feldspar | 33 | Nepheline Syenite | 26 | Soda Feldspar | 40 |
| Cornwall Stone | 32 | Dolomite | 14 | Talc | 20 |
| Dolomite | 11 | Zinc Oxide | 22 | Whiting | 10 |
| Whiting | 11 | Whiting | 1 | China Clay | 10 |
| China Clay | 3 | China Clay | 5 | Flint | 20 |
| Flint | 10 | Flint | 32 | | |

## Kiln Repair Paste

One part each: Ball Clay
China Clay
Flint
Feldspar

Mix with liquid Sodium Silicate. Mend broken part, let dry, fire.

# Appendix E Solutions to Glaze Problems

## Problem A

| Material | Calculation formula | Moles | Oxides in Formula | K₂O | Na₂O | CaO | Al₂O₃ | SiO₂ |
|----------|---------------------|-------|-------------------|-----|------|-----|-------|------|
| | | | Moles in Formula | .4 | .4 | .2 | .35 | 2.5 |
| Pearl Ash | $K_2O$ | .4 | | .4 | | | | |
| Soda Ash | $Na_2O$ | .4 | | | .4 | | | |
| Whiting | $CaO$ | .2 | | | | .2 | | |
| Clay | $Al_2O_3 \cdot 2SiO_2$ | .35 | | | | | .35 | .7 |
| Flint | $SiO_2$ | 1.8 | | | | | | 1.8 |
| | | | Total | .4 | .4 | .2 | .35 | 2.5 |

| Material | Moles | X | Equivalent Weight | = | Weight Factor | X | Key | = | % Batch |
|----------|-------|---|-------------------|---|---------------|---|-----|---|---------|
| Pearl Ash | .4 | × | 138 | = | 55.2 | × | .3166 | = | 17.476 |
| Soda Ash | .4 | × | 106 | = | 42.4 | × | .3166 | = | 13.423 |
| Whiting | .2 | × | 100 | = | 20.0 | × | .3166 | = | 6.332 |
| Clay | .35 | × | 258 | = | 90.3 | × | .3166 | = | 28.588 |
| Flint | 1.8 | × | 60 | = | 108.0 | × | .3166 | = | 34.192 |
| | | | | | 100 ÷ 315.9 = .3166 | | | | 100.011 |

## Problem B

| Material | Calculation Formula | Moles | Oxides in Formula | Na₂O | BaO | CaO | ZnO | Al₂O₃ | SiO₂ |
|----------|---------------------|-------|-------------------|------|-----|-----|-----|-------|------|
| | | | Moles in Formula | .3 | .3 | .2 | .2 | .38 | 4.30 |
| Soda Ash | $Na_2O$ | .3 | | .3 | | | | | |
| Barium Carbonate | $BaO$ | .3 | | | .3 | | | | |
| Whiting | $CaO$ | .2 | | | | .2 | | | |
| Zinc Oxide | $ZnO$ | .2 | | | | | .2 | | |
| Clay | $Al_2O_3 \cdot 2SiO_2$ | .38 | | | | | | .38 | .76 |
| Flint | $SiO_2$ | 3.54 | | | | | | | 3.54 |
| | | | Total | .3 | .3 | .2 | .2 | .38 | 4.30 |

| Material | Moles | X | Equivalent Weight | = | Weight Factor | X | Key | = | % Batch |
|----------|-------|---|-------------------|---|---------------|---|-----|---|---------|
| Soda Ash | .3 | × | 106 | = | 31.8 | × | .2286 | = | 7.269 |
| Barium Carbonate | .3 | × | 197 | = | 59.1 | × | .2286 | = | 13.510 |
| Whiting | .2 | × | 100 | = | 20.0 | × | .2286 | = | 4.572 |
| Zinc Oxide | .2 | × | 81 | = | 16.2 | × | .2286 | = | 3.703 |
| Clay | .38 | × | 258 | = | 98.04 | × | .2286 | = | 22.411 |
| Flint | 3.54 | × | 60 | = | 212.4 | × | .2286 | = | 48.554 |
| | | | | | 100 ÷ 437.54 = .2286 | | | | 100.019 |

## Problem C

| Material | Calculation Formula | Moles | Oxides in Formula → Moles in Formula | CaO | Na$_2$O | BaO | MgO | ZnO | Al$_2$O$_3$ | SiO$_2$ |
|---|---|---|---|---|---|---|---|---|---|---|
| | | | | .3 | .3 | .2 | .1 | .1 | .34 | 2.60 |
| Anorthite | CaO·Al$_2$O$_3$·2SiO$_2$ | .3 | | .3 | | | | | .30 | .60 |
| Soda Ash | Na$_2$O | .3 | | | .3 | | | | | |
| Barium Carbonate | BaO | .2 | | | | .2 | | | | |
| Magnesium Carbonate | MgO | .1 | | | | | .1 | | | |
| Zinc Oxide | ZnO | .1 | | | | | | .1 | | |
| Clay | Al$_2$O$_3$·2SiO$_2$ | .04 | | | | | | | .04 | .08 |
| Flint | SiO$_2$ | 1.92 | | | | | | | | 1.92 |
| | | | Total | .3 | .3 | .2 | .1 | .1 | .34 | 2.60 |

| Material | Moles | X | Equivalent Weight | = | Weight Factor | X | Key | = | %Batch |
|---|---|---|---|---|---|---|---|---|---|
| Anorthite | .3 | × | 278 | = | 83.4 | × | .3371 | = | 28.114 |
| Soda Ash | .3 | × | 106 | = | 31.8 | × | .3371 | = | 10.720 |
| Barium Carbonate | .2 | × | 197 | = | 39.4 | × | .3371 | = | 13.282 |
| Magnesium Carbonate | .1 | × | 84 | = | 8.4 | × | .3371 | = | 2.832 |
| Zinc Oxide | .1 | × | 81 | = | 8.1 | × | .3371 | = | 2.731 |
| Clay | .04 | × | 258 | = | 10.32 | × | .3371 | = | 3.479 |
| Flint | 1.92 | × | 60 | = | 115.20 | × | .3371 | = | 38.834 |
| | | | | | 100 ÷ 296.62 = .3371 | | | | 99.992 |

## Problem D

| Material | Calculation Formula | Moles | Oxides in Formula → Moles in Formula | Na$_2$O | CaO | MgO | BaO | Al$_2$O$_3$ | SiO$_2$ |
|---|---|---|---|---|---|---|---|---|---|
| | | | | .4 | .3 | .2 | .1 | .45 | 3.4 |
| Albite | NaO$_2$·Al$_2$O$_3$·6SiO$_2$ | .4 | | .4 | | | | .40 | 2.4 |
| Dolomite | CaO·MgO | .2 | | | .2 | .2 | | | |
| Whiting | CaO | .1 | | | .1 | | | | |
| Barium Carbonate | BaO | .1 | | | | | .1 | | |
| Clay | Al$_2$O$_3$·2SiO$_2$ | .05 | | | | | | .05 | .1 |
| Flint | SiO$_2$ | .9 | | | | | | | .9 |
| | | | Total | .4 | .3 | .2 | .1 | .45 | 3.4 |

| Material | Moles | X | Equivalent Weight | = | Weight Factor | X | Key | = | %Batch |
|---|---|---|---|---|---|---|---|---|---|
| Albite | .4 | × | 524 | = | 209.6 | × | .2915 | = | 61.098 |
| Dolomite | .2 | × | 184 | = | 36.8 | × | .2915 | = | 10.727 |
| Whiting | .1 | × | 100 | = | 10.0 | × | .2915 | = | 2.915 |
| Barium Carbonate | .1 | × | 197 | = | 19.7 | × | .2915 | = | 5.743 |
| Clay | .05 | × | 258 | = | 12.9 | × | .2915 | = | 3.760 |
| Flint | .9 | × | 60 | = | 54.0 | × | .2915 | = | 15.741 |
| | | | | | 100 ÷ 343 = .2915 | | | | 99.984 |

248

$$\frac{.35\ B_2O_3}{2\ B_2O_3} = 0.175\ \text{Borax}$$

## Problem E

| Material | Calculation Formula | Moles | Oxides in Formula | Na$_2$O | MgO | ZnO | BaO | B$_2$O$_3$ | Al$_2$O$_3$ | SiO$_2$ |
|---|---|---|---|---|---|---|---|---|---|---|
| | | | Moles in Formula | .3 | .3 | .2 | .2 | .35 | .2 | 3.4 |
| Borax | Na$_2$O·2B$_2$O$_3$ | .175 | | .175 | | | | .35 | | |
| Soda Ash | Na$_2$O | .125 | | .125 | | | | | | |
| Magnesium Carbonate | MgO | .3 | | | .3 | | | | | |
| Zinc Oxide | ZnO | .2 | | | | .2 | | | | |
| Barium Carbonate | BaO | .2 | | | | | .2 | | | |
| Clay | Al$_2$O$_3$·2SiO$_2$ | .2 | | | | | | | .2 | .4 |
| Flint | SiO$_2$ | 3.0 | | | | | | | | 3.0 |
| | | | Total | .3 | .3 | .2 | .2 | .35 | .2 | 3.4 |

| Material | Moles | X | Equivalent Weight | = | Weight Factor | X | Key | = | | %Batch |
|---|---|---|---|---|---|---|---|---|---|---|
| Borax | .175 | × | 381 | = | 66.675 | × | .2549 | = | 16.995 | 17.0 |
| Soda Ash | .125 | × | 106 | = | 13.250 | × | .2549 | = | 3.365 | 3.4 |
| Magnesium Carbonate | .3 | × | 84 | = | 25.200 | × | .2549 | = | 6.423 or | 6.4 |
| Zinc Oxide | .2 | × | 81 | = | 16.200 | × | .2549 | = | 4.129 | 4.1 |
| Barium Carbonate | .2 | × | 197 | = | 39.400 | × | .2549 | = | 10.043 | 10.0 |
| Clay | .2 | × | 258 | = | 51.600 | × | .2549 | = | 13.153 | 13.2 |
| Flint | 3.0 | × | 60 | = | 180.000 | × | .2549 | = | 45.882 | 45.9 |
| | | | | | 100 ÷ 392.325 = .2549 | | | | 99.990 | 100.0 |

$$\frac{.27\ Na_2O}{.49\ Na_2O} = .551\ \text{Kona F-4}$$

## Problem F

| Material | Calculation Formula | Moles | Oxides in Formula | Na$_2$O | K$_2$O | CaO | ZnO | BaO | Al$_2$O$_3$ | SiO$_2$ |
|---|---|---|---|---|---|---|---|---|---|---|
| | | | Moles in Formula | .27 | .17 | .24 | .15 | .17 | .56 | 4.60 |
| Kona F-4 | K$_2$O.31 Al$_2$O$_3$1.01 SiO$_2$5.56 Na$_2$O.49 CaO.20 | .55 | | .27 | .17 | .11 | | | .56 | 3.06 |
| Whiting | CaO | .13 | | | | .13 | | | | |
| Zinc Oxide | ZnO | .15 | | | | | .15 | | | |
| Barium Carbonate | BaO | .17 | | | | | | .17 | | |
| Flint | SiO$_2$ | 1.54 | | | | | | | | 1.54 |
| | | | Total | .27 | .17 | .24 | .15 | .17 | .56 | 4.60 |

| Material | Moles | X | Equivalent Weight | = | Weight Factor | X | Key | = | %Batch |
|---|---|---|---|---|---|---|---|---|---|
| Kona F-4 | .55 | × | 508 | = | 279.40 | × | .2323 | = | 64.905 |
| Whiting | .13 | × | 100 | = | 13.00 | × | .2323 | = | 3.020 |
| Zinc Oxide | .15 | × | 81 | = | 12.15 | × | .2323 | = | 2.822 |
| Barium Carbonate | .17 | × | 197 | = | 33.49 | × | .2323 | = | 7.780 |
| Flint | 1.54 | × | 60 | = | 92.40 | × | .2323 | = | 21.465 |
| | | | | 100 ÷ 430.44 = .2323 | | | | | 99.992 |

## Problem G

| Material | Batch | ÷ | Equivalent Weight | = | Mole Factor |
|---|---|---|---|---|---|
| Lithium Carbonate ($Li_2O$) | 11 | ÷ | 74 | = | .149 |
| Zinc Oxide (ZnO) | 24 | ÷ | 81 | = | .296 |
| Whiting (CaO) | 5 | ÷ | 100 | = | .050 |
| Clay ($Al_2O_3 \cdot 2SiO_2$) | 19 | ÷ | 258 | = | .074 |
| Flint ($SiO_2$) | 41 | ÷ | 60 | = | .683 |

| | | | |
|---|---|---|---|
| $Li_2O$ .149 | $Al_2O_3$ .074 | $SiO_2$ .683 | |
| ZnO .296 | | | |
| CaO .050 | | | |

1 ÷ .495 = 2.02 Key

| | | | | |
|---|---|---|---|---|
| $Li_2O$ | .149 | × 2.02 | = | .301 |
| ZnO | .296 | × 2.02 | = | .598 |
| CaO | .050 | × 2.02 | = | .101 |
| $Al_2O_3$ | .074 | × 2.02 | = | .149 |
| $SiO_2$ | .683 | × 2.02 | = | 1.380 |

| | | |
|---|---|---|
| $Li_2O$ .3 | $Al_2O_3$ .15 | $SiO_2$ 1.38 |
| ZnO .6 | | |
| CaO .1 | | |

## Problem H

| Material | Batch | Equivalent Weight | = | Mole Factor |
|---|---|---|---|---|
| Nepheline Syenite | 45.3 | 432 | = | .105 |
| Whiting | 9.7 | 100 | = | .097 |
| Barium Carbonate | 23.2 | 197 | = | .118 |
| Zinc Oxide | 8.8 | 81 | = | .109 |
| Clay | 13.0 | 258 | = | .050 |

| Material | Calculation Formula | Moles | Oxides in Formula | $Na_2O$ | $K_2O$ | CaO | BaO | ZnO | $Al_2O_3$ | $SiO_2$ |
|---|---|---|---|---|---|---|---|---|---|---|
| Nepheline Syenite | $Na_2O$.74 $Al_2O_3$.99 $SiO_2$4.36 $K_2O$.24 CaO.02 | .105 | | .078 | .025 | .002 | | | .104 | .458 |
| Whiting | CaO | .097 | | | | .097 | | | | |
| Barium Carbonate | BaO | .118 | | | | | .118 | | | |
| Zinc Oxide | ZnO | .109 | | | | | | .109 | | |
| Clay | $Al_2O_3 \cdot 2SiO_2$ | .050 | | | | | | | .050 | .100 |
| | | | Total | .078 | .025 | .099 | .118 | .109 | .154 | .558 |

| | | | |
|---|---|---|---|
| $Na_2O$ .078 | $Al_2O_3$ .154 | $SiO_2$ .558 | |
| $K_2O$ .025 | | | |
| CaO .099 | | | |
| BaO .118 | | | |
| ZnO .109 | | | |

1 ÷ .429 = 2.331 Key

| | | | | |
|---|---|---|---|---|
| $Na_2O$ | .078 | × 2.331 | = | .182 |
| $K_2O$ | .025 | × 2.331 | = | .059 |
| CaO | .099 | × 2.331 | = | .231 |
| BaO | .118 | × 2.331 | = | .275 |
| ZnO | .109 | × 2.331 | = | .254 |
| $Al_2O_3$ | .154 | × 2.331 | = | .359 |
| $SiO_2$ | .558 | × 2.331 | = | 1.301 |

| | | |
|---|---|---|
| $Na_2O$ .18 | $Al_2O_3$ .36 | $SiO_2$ 1.30 |
| $K_2O$ .06 | | |
| CaO .23 | | |
| BaO .28 | | |
| ZnO .25 | | |

# Problem I

| Material | Percentage | ÷ | Atomic Weight | = | Mole Factor | X | Key | = | Formula |
|---|---|---|---|---|---|---|---|---|---|
| $SiO_2$ | 66.3 | ÷ | 60 | = | 1.105 | × | 5.6497 | = | 6.24 |
| $Al_2O_3$ | 18.4 | ÷ | 102 | = | .180 | × | 5.6497 | = | 1.02 |
| $CaO$ | .4 | ÷ | 56 | = | .007 | × | 5.6497 | = | .040 |
| $Na_2O$ | 2.7 | ÷ | 62 | = | .044 | × | 5.6497 | = | .249 |
| $K_2O$ | 11.8 | ÷ | 94 | = | .126 | × | 5.6497 | = | .712 |
| | | | | | 1 ÷ .177 | | = 5.6497 | | 1.001 |

| Material | Moles | X | Atomic Weight | = | Weight Factor |
|---|---|---|---|---|---|
| $K_2O$ | .71 | × | 94 | = | 66.74 |
| $Na_2O$ | .25 | × | 62 | = | 15.50 |
| $CaO$ | .04 | × | 56 | = | 2.24 |
| $Al_2O_3$ | 1.02 | × | 102 | = | 104.04 |
| $SiO_2$ | 6.24 | × | 60 | = | 374.40 |
| | | | | | 562.92 |

| | | | | | |
|---|---|---|---|---|---|
| $K_2O$ | .71 | $Al_2O_3$ | 1.02 | $SiO_2$ | 6.24 |
| $Na_2O$ | .25 | | | | |
| $CaO$ | .04 | | | | |

Equivalent Weight 563

# Problem J

| Material | Percentage | ÷ | Atomic Weight | = | Mole Factor | X | Key | = | Formula |
|---|---|---|---|---|---|---|---|---|---|
| $SiO_2$ | 67.1 | ÷ | 60 | = | 1.118 | × | 5.376 | = | 6.010 |
| $Al_2O_3$ | 19.1 | ÷ | 102 | = | .187 | × | 5.376 | = | 1.005 |
| $CaO$ | .94 | ÷ | 56 | = | .017 | × | 5.376 | = | .091 |
| $Na_2O$ | 6.56 | ÷ | 62 | = | .106 | × | 5.376 | = | .570 |
| $K_2O$ | 5.91 | ÷ | 94 | = | .063 | × | 5.376 | = | .339 |
| | | | | | 1 ÷ .186 | | = 5.376 | | 1.000 |

| Material | Moles | X | Atomic Weight | = | Weight Factor |
|---|---|---|---|---|---|
| $K_2O$ | .34 | × | 94 | = | 31.96 |
| $Na_2O$ | .57 | × | 62 | = | 35.34 |
| $CaO$ | .09 | × | 56 | = | 5.04 |
| $Al_2O_3$ | 1.01 | × | 102 | = | 103.02 |
| $SiO_2$ | 6.01 | × | 60 | = | 360.60 |
| | | | | | 535.96 |

| | | | | | |
|---|---|---|---|---|---|
| $K_2O$ | .34 | $Al_2O_3$ | 1.01 | $SiO_2$ | 6.01 |
| $Na_2O$ | .57 | | | | |
| $CaO$ | .09 | | | | |

Equivalent Weight 536

# Appendix F Manufacturers and Suppliers

## Kilns

A. D. Alpine, Inc.
3051 Fujita Street
Torrance, CA 90505

Bailey Pottery Equipment Corp.
CPO 1577
Kingston, NY 12401

Crusader Ceramic Equipment
4717 West 16th Street
Indianapolis, IN 46222

L and L Manufacturing Co.
Box 348
144 Conchester Road
Twin Oaks, PA 19104

Unique Kilns
Division HED Industries, Inc.
Box 246
Ringoes, NJ 08551

Ipsen Industries
Box 6266
Rockford, IL 61125

MSI Industries, Inc.
3800 Race Street
Denver, CO 80205

## Kiln Controls

W. P. Dawson
399 Thor Place
Brea, CA 92621

## Pyrometric Cones, Bars

Bell Research   (bars)
157 Virginia Avenue
Chester, WV 26034

The Edward J. Orton, Jr.
  Ceramic Foundation   (cones)
Box 460
Westerville, OH 43081

## Wheels

A. D. Alpine, Inc.
3051 Fujita Street
Torrance, CA 90505

Robert Brent Corp.
4717 West 16th Street
Indianapolis, IN 46222

Shimpo-West, Inc.
14400 Lomitas Avenue
City of Industry, CA 91746

Soldner Pottery Equipment
c/o A.R.T. Studio Clay Company
1555 Louis Avenue
Elk Grove, IL 60007

## Trimming Wheels

Giffin Earthworks Inc.
Box 4057
Boulder, CO 80306

## Claymixers, Pugmills

Bluebird Manufacturing Co.
Box 96
Livermore, CO 80536

Peter Pugger
9460 Carmel Road
Atascadero, CA 93422

Shimpo-West, Inc.
14400 Lomitas Avenue
City of Industry, CA 91746

Soldner Pottery Equipment
c/o A.R.T. Studio Clay Company
1555 Louis Avenue
Elk Grove, IL 60007

## Extruders, Slabrollers

Bailey Pottery Equipment Corp.
CPO 1577
Kingston, NY 12401

Robert Brent Corp.
4717 West 16th Street
Indianapolis, IN 46222

## Protective Equipment

Art-Safe Inc.
Box 185
Boscobel, WI 53805

## Exhaust Hoods

Vent-A-Kiln Corporation
699 Hertel Avenue
Buffalo, NY 14207

## Hand Tools

Kemper Mfg., Inc.
Box 696
Chino, CA 91710

## Silkscreen Materials

Advance Process Supply Co.
400 N. Noble Street
Chicago, IL 60622

L. Reusche & Co.
2—6 Lister Avenue
Newark, NJ 07105

## Decals

CeramiCorner, Inc.
Box 516
Azusa, CA 91702

## Photoresist Products

KTI
2 Barnes Industrial Park Rd.
Wallingford, CT 06992

## Colorants, Stains

Mason Color & Chemical
  Works, Inc.
Box 76
East Liverpool, OH 43920

## Lusters, Overglazes

Hanovia Hobby Products
1 West Central Avenue
East Newark, NJ 07029

Med-Mar Metals
Box 6453
Anaheim, CA 92806

## General Ceramic Supplies

AMACO
American Art Clay Co., Inc.
4717 West 16th Street
Indianapoilis, IN 46222

A.R.T. Studio Clay Company
1555 Louis Avenue
Elk Grove, IL 60007

Cutter Ceramics
47 Athletic Field Road
Waltham, MA 02254

Westwood Ceramic Supply Company
14400 Lomitas Avenue
City of Industry, CA 91746

# Appendix G  Temperature Equivalents for Orton Standard Pyrometric Cones

| Cone Number | Large Cones | | Small Cones | |
|---|---|---|---|---|
| | 60 °C[1] | 108 °F | 300 °C | 540 °F |
| 022 | 585 °C | 1085 °F | 630 °C | 1165 °F |
| 021 | 602 | 1116 | 643 | 1189 |
| 020 | 625 | 1157 | 666 | 1231 |
| 019 | 668 | 1234 | 723 | 1333 |
| 018 | 696 | 1285 | 752 | 1386 |
| 017 | 727 | 1341 | 784 | 1443 |
| 016 | 764 | 1407 | 825 | 1517 |
| 015 | 790 | 1454 | 843 | 1549 |
| 014 | 834 | 1533 | 870 | 1596 |
| 013 | 869 | 1596 | 880 | 1615 |
| 012 | 876 | 1609 | 900 | 1650 |
| 011 | 886 | 1627 | 915 | 1680 |
| †010 | 887 | 1629 | 919 | 1686 |
| 09 | 915 | 1679 | 955 | 1751 |
| 08 | 945 | 1733 | 983 | 1801 |
| 07 | 973 | 1783 | 1008 | 1846 |
| 06 | 991 | 1816 | 1023 | 1873 |
| 05 | 1031 | 1888 | 1062 | 1944 |
| 04 | 1050 | 1922 | 1098 | 2008 |
| 03 | 1086 | 1987 | 1131 | 2068 |
| 02 | 1101 | 2014 | 1148 | 2098 |
| 01 | 1117 | 2043 | 1178 | 2152 |
| 1 | 1136 | 2077 | 1179 | 2154 |
| 2 | 1142 | 2088 | 1185 | 2165 |
| 3 | 1152 | 2106 | 1196 | 2185 |
| 4 | 1168 | 2134 | 1209 | 2208 |
| 5 | 1177 | 2151 | 1221 | 2230 |
| 6 | 1201 | 2194 | 1255 | 2291 |
| 7 | 1215 | 2219 | 1264 | 2307 |
| 8 | 1236 | 2257 | 1300 | 2372 |
| 9 | 1260 | 2300 | 1317 | 2403 |
| 10 | 1285 | 2345 | 1330 | 2426 |
| 11 | 1294 | 2361 | 1336 | 2437 |
| 12 | 1306 | 2383 | 1355 | 2471 |
| 13 | 1321 | 2410 | ——— | ——— |
| 14 | 1388 | 2530 | ——— | ——— |
| 15 | 1424 | 2595 | ——— | ——— |

† Iron-free (white) are made in numbers 010 to 3. The iron-free cones have the same deformation temperatures as the red equivalents when fired at a rate of 60 Centigrade degrees per hour in air.

Notes:
1. The temperature equivalents in this table apply only to Orton Standard Pyrometric Cones, *when heated at the rates indicated, in an air atmosphere.*

2. Temperature equivalents are given in degrees Centigrade (°C.) and the corresponding degrees Fahrenheit (°F.). The rates of heating shown at the head of each column of temperature equivalents were maintained during the last several hundred degrees of temperature rise.

3. The temperature equivalents were determined at the National Bureau of Standards by H. P Beerman (see Journal of the American Ceramic Society, Vol. 39, 1956).

4. The temperature equivalents are not necessarily those at which cones will deform under firing conditions different from those under which the calibrating determinations were made. For more detailed technical data, please write the Orton Foundation.

Conversion Factors:
*Centigrade to Fahrenheit* N × 9 ÷ 5 + 32; *Fahrenheit to Centigrade* N − 32 × 5 ÷ 9.

*Courtesy:* The Edward Orton Jr. Ceramic Foundation, 6991 Old 3C Highway, P.O.Box 460, Westerville, OH 43081

# Index

# Index to Contemporary Artists

**Leon I. Nigrosh** received his BFA in ceramics from Rhode Island School of Design, and his MFA from Rochester Institute of Technology. He has been head of the ceramic department at the Craft Center, Worcester, Massachusetts, a visiting professor at Rhode Island College and is currently a Lecturer in Studio Art at Clark University. He has had many one-artist shows and his work has been exhibited throughout the country. His writing has appeared in *Craft Horizons* and *School Arts*. He is the author of *Low Fire: Other Ways to Work in Clay.*